Advance praise for

Hip-Hop DJs a
Evolution of Technology

"A must-read for anyone interested in some of the lost and important stories of hip-hop DJ/turntablist history and technology."
—D-Styles, Scratch DJ innovator and member of the Invisibl Skratch Piklz and the Beat Junkies

"A precise and thorough documentation of the scratch DJ history in its purest form by an author who lives it."
—DJ Focus, Artist and inventor of the first optical crossfader for hip-hop culture and scratching

"André Sirois (a.k.a. DJ food stamp) takes us where previous histories of hip-hop have not: into the world of the technology companies that have long collaborated with and profited from DJ culture. This compelling and thoroughly researched work forces us to reconsider how technology is made. Rather than being conceived of and disseminated from on high, Sirois demonstrates how new technologies are shaped with users in mind and often developed in dialogue with them. We already know hip-hop as one of the most important artistic, political, and social developments of the late twentieth and early twenty-first centuries; Sirois makes clear that hip-hop is also a profound technological force of its own. This book is a must-read for anyone interested in understanding the full scope of hip-hop culture, as well as by anyone looking to understand the *synergy* between everyday practices and technological advancement."
—Loren Kajikawa, Author of Sounding Race in Rap Songs

"This is a very cool book...in so many ways. André Sirois presents fascinating stories and valuable analysis that not only illuminates the DJ industry, but also speaks more generally to the commodification of culture. The emphasis on intellectual property is serious and significant. Don't miss it!"
—Janet Wasko, Knight Chair in Communication Research, University of Oregon

Hip-Hop DJs and the Evolution of Technology

Toby Miller
General Editor

Vol. 27

The Popular Culture and Everyday Life series is
part of the Peter Lang Media and Communication
list. Every volume is peer reviewed and meets
the highest quality standards for content and
production.

PETER LANG
New York • Bern • Frankfurt • Berlin
Brussels • Vienna • Oxford • Warsaw

André Sirois

Hip-Hop DJs and the Evolution of Technology

Cultural Exchange, Innovation, and Democratization

PETER LANG
New York • Bern • Frankfurt • Berlin
Brussels • Vienna • Oxford • Warsaw

Library of Congress Cataloging-in-Publication Data
Names: Sirois, André.
Title: Hip hop DJs and the evolution of technology:
cultural exchange, innovation, and democratization / André Sirois.
Description: New York: Peter Lang, 2016. | Series: Popular culture and everyday life,
ISSN 1529-2428; v. 27 | Includes bibliographical references and index.
Identifiers: LCCN 2014027212 | ISBN 9781433123375 (hardcover: alk. paper) |
ISBN 9781433123368 (paperback: alk. paper) | ISBN 9781453913888 (e-book)
Subjects: LCSH: Turntablism. | Turntablism—Technological innovations.
Classification: LCC ML3531.S47 2014 | DDC 782.421649—dc23
LC record available at http://lccn.loc.gov/2014027212

Bibliographic information published by **Die Deutsche Nationalbibliothek**.
Die Deutsche Nationalbibliothek lists this publication in the "Deutsche
Nationalbibliografie"; detailed bibliographic data are available
on the Internet at http://dnb.d-nb.de/.

Cover design by Alex Camlin

The paper in this book meets the guidelines for permanence and durability
of the Committee on Production Guidelines for Book Longevity
of the Council of Library Resources.

Printed in the United States of America

TABLE OF CONTENTS

Acknowledgments vii
Introduction xi

Chapter 1. Re-coding Sound Technology and the Vinyl Archive 1
Chapter 2. Exchange and Rights in the DJ Product Industry:
Technics and Vestax Corporation 21
Chapter 3. Exchange and Rights in the DJ Product Industry: Rane
Corporation and Serato Audio Research 53
Chapter 4. The Hip-Hop DJ as Intellectual Property: Research and
Development 77
Chapter 5. The Hip-Hop DJ as Intellectual Property: Branding,
Endorsement, and the Nature of Convergence 117
Chapter 6. Scratching the Digital Itch and the Cultural
Negotiation of DVS 139

Epilogue 167
Notes 173
Glossary 197
Bibliography 201
Index 211

ACKNOWLEDGMENTS

Writing a book is by no means a singular effort but is authored collaboratively. To me it is a mixtape: a rearrangement of ideas, quotes, and theories into something bigger than those individual parts. So, what would a mixtape be without a shout-out section?

First, I need to thank all of my collaborators in this book (you can see the full list in the bibliography). I am extremely grateful to all the DJs, many of whom are my heroes and people I look up to in this craft, who took time out of their busy schedules to let me interview them and share their stories and ideas with me. Thank you! Special thanks to all the DJs (more than 50) who took the time to fill out my survey as well. I also want to express my gratitude to all the representatives from the DJ product industry and recording industry who gave me an amazing amount of access and shared with me important (and often unrepresented) perspectives.

I also want to thank all of the DJs who did not make it into this book but have had and continue to have a powerful impact on DJ technique and the advancement of DJ hardware. You are authors of this book as well!

I am beyond grateful to Mary Savigar and the crew at Peter Lang Publishing for the tireless work (and patience) with this project through the many drafts of this book. Also, respect to those who reviewed various drafts of this; your feedback was so helpful and important.

Most of the beautiful images in this book and on the DJpedia/DJistory flickr page are courtesy of the talented Zane Ritt. Zane, you're the man! Thanks for all you have done for this project and spending long days listening to me rant on about DJ mixers as you take pictures of them.

Biggups to my dude Alex Camlin who came through in the clutch and designed the dope cover for this book. Thanks my man!

Props are due to the School of Journalism & Communication and the Cinema Studies Program at the University of Oregon for supporting this project. Since this book is based off of dissertation research, special thanks to my committee members for guidance and encouragement: Julianne Newton, Bish Sen, and Daniel Wojcik. I want to show extra love to my advisor Janet Wasko for so much help on this project and pushing me to publish it. Also, big ups to all my colleagues and students over the years at UO for inspiration on this project. I need to show love to my master's thesis advisor, Shannon Martin, for all she did for me and pushing me to explore intellectual property law.

I have to give a huge shout-out to Loren Kajikawa for not only reading and giving me feedback on drafts of this project, but also for keeping me motivated and inspired to see this project through. And, thanks for inviting me to your classes to talk about DJ technology, show battle videos, and do demonstrations. I appreciate our friendship, my dude!

Major, major props to all the DJs who have directly influenced me, not only in writing this book but especially as a DJ. Many of the ideas here come from conversations with these people and cutting it up with them. So, big ups to Cue-Two, DJ Shade, Boondocks, DJ Jon, DJ Billy, Connah Jay, Celsius, Freeman, the GOLDEN DJs, and all the Skratchpad PDX fam. You all have helped me get better on the turntables. I am sure I am forgetting people here, but forgetting people is part of writing shout-outs.

Special props to my dude DJ Calibur for helping start DJpedia/DJistory with me, for many crazy Thursday nights on the turntables, and for our kitchen scratch sessions a la Flash in *Wild Style*.

I need to thank all the staff at UGHH.com for all you have done for me in the last 15 years and helping get the DJ food stamp name out there on reviews, mixtapes, and podcasts. Respect to all the people who still bump my mixtapes and show love to me.

Shout-outs to all the clubs, bars, lounges, venues, and radio stations that have given me avenues of expression in the last 16 years. Also, thank you to the incredible staff and friends at those places. I am also grateful to all the

MCs, b-boy/b-girls, bombers, and other artists who have put me on in various capacities.

I am grateful for my parents, Judy and Gee Sirois, and to the rest of my family for the love and support over the years. I also need to show love to Bobby "The C" Winn for being an amazing influence and believer in me since I was a kid.

Most importantly, I need to thank my wife Lindsey Shields. You are an amazing woman, and I need to show my appreciation for all your patience and encouragement as you looked at the back of my head at my desk while I worked on this. Without your selflessness, I would not have been able to write this book.

Last, a shout-out to my animals. They are not only my friends; their love and therapy is the ultimate cure to writer's block. So, thank you Spanky Davis the Wonder Chug and Inky the kitty. Special love to Doujah and Cheeva (R.I.P.) who lived to see me through most of this project; I dedicate this book to both of you.

INTRODUCTION

Imagine earning an hourly rate of $100,000–$350,000 at your job. Not a bad wage; you probably do something important. This rate is reportedly what Paris Hilton earns per hour at her job, and not her earnings for celebrity appearances at events or sex-tape royalties; this is her hourly DJ rate. Yes, DJ rate! DJ Paris Hilton claims that this puts her in the top-five paid DJs globally.[1]

We should look at some other numbers, and these are in millions of dollars: $46, $32, $30, $25, and $21. Totaling $154 million, according to a report in *Forbes*,[2] these are the combined 2013 earnings of the world's five highest-paid DJs (in order): Calvin Harris, Tiësto, David Guetta, Swedish House Mafia, and Deadmau5. According to the same report, the top-12 earning DJs saw a total of $268 million in 2013. Even DJ Pauly D, who got his fame from MTV's wildly (and, oddly) popular reality show *Jersey Shore*, made the list at number 12 by earning $13 million as a DJ in 2013. To put this in perspective, Calvin Harris's $46 million in earnings are more than double what LeBron James (for basketball only, at $19 million) or Brad Pitt ($23 million) earned that year. And President Obama got the same $400,000 annual salary that Paris Hilton earns in a night of DJing (I said she is important).

Some of these high-earning "DJs" are also music producers, so they see heaps of publishing royalties for songs they write and music they make, which pads

those numbers. But, with all the aforementioned DJs earning upwards of six figures per night to DJ at music festivals or in high-end clubs in global party epi-centers, such as Las Vegas and Spain's island of Ibiza, and with 50–150 gigs an-nually, there is no doubt much of those earnings are coming from packing clubs.

These are not 1 percent class, Koch brothers–type earnings, but within the context of DJing, this type of money marks a significant point for DJ culture, and even mass culture more generally. For DJs, the ascension from playing in under-lit, dirty clubs to global brands and multimillionaires is a notable transformation. The DJ stands as this generation's "new rock star," a phrase and concept that multinational corporations are embracing by placing DJs in television ads and as the faces of marketing campaigns.

The cultural industries are jumping on the DJ phenomena as well. For in-stance, Smirnoff sponsored *Master of the Mix*, a DJ "competition" reality show that aired on VH1 and served as one long ad for Smirnoff-brand vodka with DJing as the visual bait. Simon Cowell, one of the minds behind *The X Factor* and *Got Talent* franchises, has announced that he is developing a DJ compe-tition television show along with global telecommunications conglomerate T-Mobile and SFX Entertainment called *Ultimate DJ*.[3] Even McDonald's and Red Bull have started sponsoring DJ competitions. There is great value in DJs as pop-cultural icons, and companies in various industries are investing in their brand value and cashing in.

Looking at the title of this book, one may question what Paris Hilton, Pauly D, and these other EDM[4] DJs have to do with hip-hop, but what I am interested in is exploring the relationship between hip-hop DJs and million-aire celebrity DJs. Hip-hop DJs and celebrity DJs share the fact that they play and manipulate music for an audience, but I see the main connection being the technology that they use, and this book explores the hip-hop DJ's role in the evolution of DJ technology in both technique and technical innova-tions. In the case of Paris Hilton and the "cash kings" of DJing, the technical innovation in question is digital DJ technology that has, for better or worse, democratized DJing. Without the innovations and creative labor of hip-hop DJs and the industry that grew around them, celebrity DJs would not have the technologies they rely on when commanding these enormous booking fees.

Hip-hop DJs have made important contributions to the evolution of DJ technology of all types—from turntables to mixers to vinyl records to digital vinyl systems—and have paved the way for today's era of the celebrity DJ (or, celebrity as DJ, depending on how one sees it). Hip-hop DJs have made digital DJ technology possible through a series of technique and technical

innovations over the last 40 years. The influence has been pervasive because the needs of DJs, which are based on innovations in DJ technique, have been encoded into the hardware (the technical). Most of these celebrity DJs rely on digital DJ controllers, which are the remediation of the standard analog tools of a DJ: two turntables, a mixer, and vinyl records. These controllers work with software on a laptop, allowing DJs to select songs from a playlist and mix from one song to another ("beat-matching"). Controller systems also have algorithms that can beat-match songs with the press of a "sync" button, allowing anybody to DJ without having any skill or investment in the art form.

In the analog era, Paris Hilton and other celebrity DJs would likely not be able to DJ, or at least have to put in work to learn how to do it. Coming into the new millennium, companies realized that they could expand their market by making products that allowed anybody to be a DJ without investing time and money into learning the craft. To democratize DJing in this way, companies saw a need to make the most basic DJ skills easier; thus, they developed algorithms to automate some of these techniques. Without these types of DJ products, which come largely from hip-hop DJ innovations, there would not be the six-figure booking fees celebrity DJs currently enjoy. The ideas and innovations of hip-hop DJs have morphed into digital DJ products, whether it is advancement in DJ technique that indirectly led to product design or DJs' contributions to hardware designs directly in research and development (R&D). Also, hip-hop DJs have allowed companies to use their authorship as brand name to help authenticate these products within the market/culture, a tactic that ultimately leads to more sales. The era of digital DJing and celebrity DJs reflects the culmination of a long process that this book attempts to reveal by looking under the surface and defetishizing the technology as a complex system.

For this book, I came up with the following definition of the hip-hop DJ:

> The hip-hop DJ uses two turntables (or similar control surfaces) and a mixer to manipulate music (loosely quantified as a break) on 12" or 7" discs. The hip-hop DJ does not just play rap or hip-hop music, but takes music from any genre and makes it hip-hop by manipulating it and adding his or her own style to it. The hip-hop DJ must be able to take a small drum break or section of a song and use two copies of it to manipulate it on-time to produce new music. The hip-hop DJ is interested in collecting and archiving music, as well as sharing these collections with an audience.

The main idea is that a hip-hop DJ collects different types of music and rhythmically manipulates the collection using discs to make it hip-hop; essentially, mixing and extending rhythmic sections of songs from all genres and making

your own music out of other people's recordings. From there, it can take many forms, but based on formal and informal discussions, this is the root of the hip-hop DJ culture and art form.

The common scholarly and philosophical question asked, especially when speaking of digitization, is: How does technology affect us? While that question is surely important and attended to here, I am more concerned with the converse inquiry: How do we, hip-hop DJs, affect the technology? Surely there is an impact narrative to be written about the many ways in which new technology changes hip-hop DJ culture, but in this book I want to explore how hip-hop DJs' development and advancement in the techniques they use to manipulate music has changed technical innovations. My inquiry is rooted in the exploration of how uses and products change one another and examination of this dialectic as a technological system.

Therefore, technology is recognized and framed as a system or a network made up of technical innovations (i.e., buttons, discs, faders, knobs, software codes, etc.) and technique innovations (advancement in the human skill of using the technical objects). When I use the word *technology*, it is often referring to the network or system of relationships between man/woman and machine, and digital DJ technology is referring to everything that makes up the technology: code writing, hardware design, patent/copyright law, cultural uses, cultural misuses, marketing/branding, etc., as well as how technique innovation is encoded into the technical innovation. I adapt this idea from Raymond Williams, who described communication technologies such as television as symptomatic technologies.[5] Williams looked at how "technical developments" *became* technology through social uses and were the result of complex interaction among technological, social, cultural, political, legal, and economic forces. Williams thought that technology, then, is evolutionary rather than revolutionary. Technology as a network is made by dialectical tension between producers and consumers, and many times consumers as producers, which is the narrative glue of this book and hip-hop DJ culture. Societies both create and are created by technology.[6]

Generally speaking, once technical innovations change to accommodate technique innovations in hand movement and styles, those techniques also adapt, which allows manufacturers to release new products to cater to the market. The story of hip-hop DJ innovation represents a feedback loop that captures the dialectical relationship between culture and industry. Through research conducted for this book I demonstrate how innovation comes from DJs first, while technology companies and their technical innovations follow.

This point, which I want to make clear here and throughout, is that we (DJs) are, in a sense, the technology; we come up with new ways of using technical innovations as tools.

In this book I explore the processes by which hip-hop DJs influence technical innovations through a theoretical framework I call "technocultural synergism." This concept is something that came from my research and is based on the interviews in this book; it is grounded or emergent theory. Technocultural synergism, at its most basic form, is a way of looking at how grassroots culture and corporations converge to make "something" in a way that empowers some and not others. I look at how technocultural synergism creates new DJ products such as mixers, turntables, and needles, as well as digital DJ software.

I use this concept to analyze how cultures guided by open source logic converge with companies interested in capitalizing on that logic. Technocultural synergism is also a process where industry and culture come together to produce a greater whole, and its power extends beyond products. Technocultural synergism is a cycle of thesis and antithesis that produces new technological systems as its synthesis; however, it should be understood as political as it creates intellectual property and financial haves and have-nots, and needs to be addressed critically.

In this book I define *intellectual properties* (IP) as a matter of law (copyright, patent, trademark, trade secrets, etc.), ideas that are protected by those laws and commodified, and abstractly as ideologies pertaining to authorship and credit for these ideas. With this in mind, I explore technocultural synergism historically and through three dimensions of IP in relation to hip-hop DJ culture: (1) manipulation, (2) exchange, and (3) rights. Hip-hop DJs' creativity begins by *manipulating* IP on vinyl records using proprietary turntables/mixers and subverting their intended uses and meanings. When companies that make hardware realize the market for this type of IP manipulation, they cater to these uses by designing products for DJs (a more abstract and subtle form of IP exchange). To expand the market and allow DJs to have better tools, both culture and corporations *exchange* intellectual properties in R&D and branding. Companies exercise their *rights* by using patent protection or contracts/trade secrets, and "rights" in the form of access to capital, manufacturing facilities, or distribution networks, to exploit these ideas within the market. Because these technical innovations are encoded with the intellectual properties of hip-hop DJs (through R&D, branding, and designs to reflect advancements in DJ technique), technocultural synergism explores how hip-hop DJs are themselves *manipulated as intellectual properties*.

This book does not explore hip-hop DJ culture in relation to race, gender, age, or global dimensions—all valuable topics worthy of critical inquiry and books of their own.[7] Race is surely important to the story of hip-hop DJ culture as inequality, specifically between working-class black and brown youth and industries largely run by white men, has led to many of the innovations and contributions of hip-hop DJs not being properly credited or compensated. While the stories told here could have an impact for scholars interested in equity, the main academic contribution of this book is considering how hip-hop DJs are manipulated *as* intellectual properties. For the most part, in both academic and popular press, hip-hop DJs and producers who use digital sampling technology have been framed as "criminals" or heroes who appropriate intellectual properties to make music and culture. But, to date, there has been little to no discussion about how hip-hop DJs themselves can be manipulated as intellectual properties. While the subject of hip-hop DJs may seem narrow, the concepts in this book could be applied more broadly to the various ways in which our collective ideas become products that are organized and resold back to us.[8]

Under the matrix of technocultural synergism this book addresses and explores how innovation occurs within a political economy of the hip-hop DJ. I specifically frame hip-hop DJ culture as a creative network, where ideas bounce around the network and innovations in technique and style are the byproduct of networked creativity. There is no singular source or inventor; rather, DJs collectively innovate and reinvent. I understand this networked view may be a problem for a lot of DJs out there whose reputations, brands, and histories are based around stories and mythologies of singular invention and originality. But maybe it is something hip-hop DJ culture should reconsider. Reinvention through a creative network does not necessarily take away from individual originality or contributions, but may help some of us to open our minds about the nature of creativity in general. For those who are familiar with hip-hop history, arguments over who was the first to create something and get credit for it have been highly antagonistic. Thus, I ask questions throughout this book and show case studies as inquiry into the nature of innovation, which frames hip-hop DJ culture as open source.

From what I have seen, invention, as we commonly understand it as coming from one source, does not exist in hip-hop DJ culture; in fact, I would argue that innovation and invention are collective acts. Instead, hip-hop DJ technique and technical innovations are about the reinvention of everything else and making it hip-hop. Hip-hop DJs did not invent turntables or

mixers or records or drum breaks, but reinvented ways of using them. And, this reinvention process was not done in a cave somewhere, but instead these innovations came from and were disseminated through park jams, parties, practice sessions, VHS and cassette tapes, DJ battles, and eventually the Internet. These innovations were collaborative and open source in its truest meaning. However, like most of society, hip-hop culture has adopted the mentality of individualism fostered under capitalism and American intellectual property law, which is likely due to the culture's prioritization of originality and having unique style. Credit for innovation is important, and part of the goal of this book is to expand how we think about credit and to give some credit to people who have made major contributions to hip-hop DJ technique and technical innovations. While creation mythologies exist and are perpetuated, many stories remain untold and undocumented; this book tries to put some of these technocultural histories into a fixed form.

When I use words such as *open source* and *network*, they draw up a picture of the Internet and new media. And that is another claim I make here: Hip-hop culture (specifically hip-hop DJ culture) is a new media culture and itself new media. When hip-hop culture began its formation in the South Bronx, New York, in the early 1970s, years before personal computers and software that allowed people to sample from popular culture and make new popular culture, hip-hop DJs were pioneers of the remix (as practice and as ideology). Their mentality of diggin' for records, finding breaks, and sampling them manually with two turntables to create new music should be considered a revolutionary and evolutionary act. From my perspective, what these South Bronx DJs started was the foundation of the new media ideology present in popular culture today: sample, mix, burn, share, and repeat. Not only did hip-hop DJs pioneer a grassroots concept of the music remix, they also "remixed" the turntable and vinyl records by turning these read-only devices into read-write devices.

I am already making some bold claims here, so I think it is important to mention how I came up with some of these thoughts. The bulk of this book is based on formal interviews that I conducted in person, on the phone, or over email or Skype from fall 2009 until spring 2011. I interviewed at least 55 hip-hop DJs, many of them renowned and influential, as well as 16 people who work in the DJ product and recorded music industries. In addition, nearly 50 hip-hop DJs from nine different countries responded to an online survey. Throughout this book I often weave together quotes from these interviews with minimal authorial voice, which is a conscious decision. I want to give

my collaborators as much voice as possible, only sampling from my crate of transcripts, an approach I model after Nancy Macdonald's ethnography on the London and New York graffiti subcultures.[9]

I transcribed all of the interviews into more than 1,000 single-spaced pages of raw "data." While different theories and concepts are interwoven into the text, the interviews are where this theory of technocultural synergism came from. I went into the project inquiring about how hip-hop DJs were negotiating digital DJ technology, but I found that was only a small part of the larger story. Data also came from analyzing other archival media such as magazine articles, books, Web forums, ads, product manuals, marketing materials, annual reports, trade publications, interviews, and so forth. I cannot stress how important the interviews are to this book; they are the heart and soul of it, the "break."

In this book I address digitization and the cultural democratization granted by it, as well as explore how various industries, companies, and markets have accommodated or been swept away by DJs' adoption of and adaptation to digital DJ technology. By addressing digitization and hip-hop DJs, there is a narrative of the "life and death" of iconic brands, technical innovations, music delivery formats, and companies that also glues together the stories and case studies presented here.

The research for this book also comes from many years as a participant observer, which is why I have been saying "we." So, even now I am still in the field. At points in this book there are stories or claims that have no citations, which is because no citations exist as I have experienced these stories in everyday conversation with other DJs, or they are folk stories that have not been codified in an academic source. I have been a hip-hop DJ interested in scratching and breaks since 1999, when I started buying vinyl rap singles for a college radio show. I am still a working DJ who plays two to three nights a week to help subsidize my record buying habit and my adjunct instructor salary, and I still do a college radio show. While I started DJing in college, it was about my love of rap music, and there was no idea that it could become an academic pursuit. Hip-hop DJing was a life passion before it was an academic one, which may be a major flaw in this book.

I came across rap and hip-hop in the early 1980s. I was the byproduct of the great "Breaksploitation" era where the b-boy/b-girl image was pushed in popular media as "breakdancing." Growing up about an hour north of Boston in southern Maine, most of my contact with hip-hop and rap came through television, film, and music recordings. I first fell in love with rap groups such

as the Fat Boys and Run-D.M.C. in the mid-1980s. Some of the first images I remember of DJs were seeing Eric B. pretending to DJ with Rakim on *Soul Train*, and the Run-D.M.C. music videos that prominently featured its DJ, Jam Master Jay. Seeing DJs scratch in music videos and on *Yo! MTV Raps* was early inspiration for me.

Still, in the 1990s most of my contact with hip-hop DJing was through celluloid and magnetic tape: music videos, DJs on MTV, music cassettes, and mixtapes. My first exposure to a DJ battle was in the 1992 film *Juice*, which had a Hollywood version of a DJ battle between DJ GQ and DJ Majesty.[10] But for the most part, given where I grew up, I was never exposed to live hip-hop DJs except at a few concerts I snuck off to as a teenager. In the early 1990s, there were no access points for gear or information unless someone in your social network possessed both.

In 1999, I finally got my "DJ in a box" starter package and was living in an urban area of Connecticut, so I had better access to DJ battle VHS tapes, DJs, and equipment, and the Internet was starting to be more useful in respect to information dissemination. In college, when I was just learning, I met DJ Cue Two, who won a regional DMC DJ battle in 2001 and really showed me a lot about scratching, mixing, and making mixtapes.

Since then I have done a lot with hip-hop DJing, and it is still part of my everyday life. I worked for the underground hip-hop website UGHH.com for years making mix CDs that got global distribution; I have rocked stages with some of my favorite hip-hop artists and DJs; and I even have arranged scratches for albums; one song I did, "I'm Awesome" by Spose, has almost gone RIAA certified platinum (one million sold). Every week I go to record stores and thrifts to dig for vinyl to sample and cut up, I scratch with friends at our houses and just practice, and I play weekly gigs. By no means am I an amazing battle or scratch DJ, but I have honed my modest skill-set. I have had lots of conversations about the topics in this book with other DJs—both in person and online—on almost a daily basis. In this book are some of the discussions DJs have every day, as well as the beginning of a discourse I think we should begin having.

I think it is important to provide some information about my background. It helps explain my passion for the topic, my biases, and all the "field research" I have done before I knew that there was a field. My passion for this topic led to my doctoral dissertation, which is the work this book is based on. My writing here, at least academically, was inspired largely by Joseph Schloss's *Making Beats*[11] and Jeff Chang's *Can't Stop Won't Stop: A History of the Hip-Hop*

Generation.[12] In the canon of academic writing on hip-hop, I found these two particular works to be inspiring in both research rigor and writing. Also, both books appealed to the cultures they wrote about, which I hope this book will do as well.

Now that I have clarified some terminology, laid out the basic theoretical framework of this study, and provided some background information about myself, I want to look at how the book is organized. In this book I am specifically trying to outline *a* political economy of the hip-hop DJ, not *the* authoritative political economy. Clearly I had to leave people, products, innovations, and stories out of this project. For the most part, this book is organized somewhat chronologically, but this structure is in primary relation to the nature of technocultural synergism. Chapter 1 is where we historically look at how hip-hop DJs have manipulated intellectual properties by re-coding the uses of sound playback technology, as well as use ethnography to explore the meanings that hip-hop DJs associate with this technology and the vinyl record collection.

Historically, once hip-hop DJs established and popularized this type of manipulation, an industry formed to cater to it and treated this culture as a market. Thus, Chapters 2 and 3 outline the general industrial structure of the DJ product industry and profile companies and their products that I think have been most relevant to a political economy of the hip-hop DJ. Chapter 2 focuses on two iconic and now defunct Japanese manufacturing brands that created standard products and practices, as well as became "victims" to the digital age: Technics and Vestax Corporation. Chapter 3 focuses on current market leaders who produce industry standard mixers and digital DJ software, respectively: Rane Corporation and Serato Audio Research. In these chapters we start to see examples of how hip-hop DJs have exchanged intellectual properties with corporations, and analyze how technological standardization has happened in the market. Standardization of DJ products is understood in relation to intellectual property exchange and rights (both historically and presently), as well as exploring how cultural uses and the industry's manipulation of DJs *as* intellectual properties have helped to standardize DJ products.

Chapters 4 and 5 really get into the heart of technocultural synergism with case studies of technical innovations that highlight the exchange of intellectual properties between DJs and manufacturing corporations, as well as how the companies enjoy certain rights (legal, financial, or business relationships) to exploit these intellectual properties in the form of products in the marketplace. It is in these two chapters that I try to show how hip-hop DJs are themselves manipulated by industry *as* intellectual properties in R&D and

branding/endorsement. These chapters will hopefully redirect the discourse about hip-hop DJs as IP criminals to being valuable intellectual properties themselves; their ideas and dreams about manipulating IP have created a market, an industry, and a lot of economic and cultural value.

Chapter 6 loops us back to the issues I raise in the beginning of this introduction as digitization and the democratization of DJing are analyzed. Here I ask DJs about how digital DJ technology has affected the culture and how the culture has affected the technology. While the media and recorded music industry has touted the resurgence of vinyl records in recent years, I speak with industry professionals and explore the story of the vinyl 12" single—a format developed as a tool by and for DJs—to add a sub-narrative to the story of vinyl records in the digital era.

I hope that this book will show the value of participant observation, ethnography, collaboration, and emergent theory. In presenting technocultural synergism as I do here and giving us some questions to ponder about innovation and credit, my other goal is to present hip-hop DJs in another light when we talk about their (and hip-hop culture broadly) relationship to intellectual property law and the cultural industries. The other greater purpose here is to show how culture and industry are not separate entities, but in fact part of a continuum (a dialectical relationship that appears on the surface to be composed of discrete sides).

Before we move on to this version of the hip-hop DJ, I also want to make this clear at the beginning of this book: The real experts on all these topics are hip-hop DJs, not me. I am just fortunate enough to be able to cull and present their stories here.

· 1 ·

RE-CODING SOUND TECHNOLOGY
AND THE VINYL ARCHIVE

"For the true collector, every single thing in this system [(the collection)] becomes an encyclopedia of all knowledge of the epoch, the landscape, the industry, and the owner from which it comes.... Collecting is a form of practical memory."
—*Walter Benjamin*[1]

Historically, hip-hop DJs were archeologists of recorded music who dug up vinyl records to uncover small, useful fragments for manipulation. While practices and values have shifted in the digital era, hip-hop DJs remain archivists of these collections, literally collecting and curating the history of recorded music as it exists on these vinyl artifacts. Author and DJ Jeff Chang makes this point in the opening scenes of the documentary *Copyright Criminals* when he says that DJs/producers "are giving us snatches of our history, they're giving a reinterpretation of that history to us."[2] These collections are for use as tools in the production of new music, which is the foundation of hip-hop DJ style and culture.

By curating, archiving, and then reusing sounds from the past, hip-hop DJ culture demonstrates aspects of what some scholars describe as "new media" culture. In general, new media cultures blur the lines between producers and consumers, are open source and often decentralized networks that thrive on sharing information, and treat text and technology as manipulable read-write media. I want to begin exploring how, since its formation, hip-hop DJ culture is a "new media" culture, primarily through the culture's re-coding of the uses of turntables and vinyl records, which are, as Lessig puts it, "tokens" of read-only culture.[3] I believe that since the 1970s, hip-hop DJs have helped to

define the tastes and behaviors of the read-write cultures of today, and they have been a guiding force in making the subcultural acts of sampling and remixing into the acts of popular culture they are today.[4] Hip-hop DJ culture is founded on the notions that text and technology are manipulable, and it highlights how innovation and reinvention are the product of (and travels through) a creative network.

With a new media logic as its foundation, hip-hop DJ culture uses consumption as the starting point for production, therefore creating the meanings/uses of texts and hardware rather than accepting what is created by industries. The meanings ascribed to text/hardware often derive from use; thus, in this chapter I broadly ask: What do these hardware and texts, or hardware as texts, that hip-hop DJs use mean to them? By examining the meanings given to commodities through use, we see the power of technocultural synergism in its beginning phase: the DJ's manipulation of intellectual properties. I look at this theoretically and historically within hip-hop DJ culture to give context to the ethnography and interviews that make up the bulk of this chapter and remainder of the book.

It is the manipulation and the re-coding of recorded sound technology by hip-hop DJs that undermines the read-only ideology of sound reproduction encoded into vinyl records and turntables. This read-only ideology comes from more than 100 years of standardization and the exploitation of intellectual property rights by corporations. However, the hip-hop DJ's manipulation of this media ultimately created a market, and thus an industry to cater to that market, which I will highlight in forthcoming chapters. It is this re-coding that sets up intellectual property exchange and rights—the other components in the cycle of technocultural synergism.

DJ Culture, Sound Systems, and Discos

The histories of DJ culture and hip-hop DJing have been documented widely in both academic and popular media.[5] However, to understand the values and aesthetics that inform today's hip-hop DJs, we must briefly look to the past and also consider DJ culture as an ideology itself to ground this chapter and the remainder of this book.

From a scholarly perspective, in DJ culture, recorded texts are raw material for the DJ's art where creativity lies in how you recontextualize previous expression.[6] This mode of production is derivative composition, a compositional

methodology that Hebdige describes as a "cut 'n' mix attitude...that no one owns a rhythm or sound. You just borrow it, use it and give it back to the people in a slightly different form."[7]

"DJ composition is the interpretation and reconstruction of something that has been deconstructed at the turntable," writes the historian Poschardt.[8] According to Poschardt, DJs re-code technology by using the turntable (a mode of reproduction) as a means of production. DJ culture is signified by the cut (removing the sample from its original context) and the mix (where the sample is placed into a new text).[9] In his study of the history of hip-hop DJ culture, Katz loosely calls this form of creativity "analog sampling."[10] Williams suggests that borrowing from the past is not just a quality endemic to hip-hop DJ culture; it's true for hip-hop culture in general: "the fundamental element of hip-hop culture and aesthetics is the overt use of preexisting materials to new ends."[11]

Hip-hop's deep roots can be traced to the Jamaican "sound system" (a mobile discotheque) and "toasting"[12] traditions, which were employed and adapted in the South Bronx by DJ Kool Herc in the early 1970s. One of the main similarities between hip-hop DJs and reggae sound systems is that they share a partial reliance on previously recorded music and rhythms.[13] It is the stylistic practice of versioning that is at the heart of Jamaican music and, according to Jeff Chang, it was the "diagram for hip hop music."[14] Versioning is the practice of remixing or sampling an "original" sound or idea, where the original version takes on new meaning. For Tricia Rose, versioning in dub and sampling in hip-hop are about paying homage through the "invocation of another's voice to help you to say what you want to say,"[15] but using copyrighted material for new cultural expression subverts "legal and capital market authority."[16] Herc is credited with bringing the sound system culture to the South Bronx and making it appeal to black and Puerto Rican youth; however, years before Herc was in the parks, there were other New York City DJs in discotheques and parks elsewhere in the city.[17]

While pioneering hip-hop DJ Afrika Bambaataa states that hip-hop originated as an "anti-disco movement,"[18] Shusterman writes that hip-hop DJs were in fact influenced by the practices of disco DJs as hip-hop "appropriated disco sounds and techniques, it undermined and transformed them...."[19] Disco dance culture began in New York City in the late 1960s with DJs such as Francis Grasso, who would mix rock, funk, and soul music at underground gay clubs. Eventually, as disco clubs grew more commercial, the recording industry latched onto the culture and began mass producing recordings that were intended to be played at clubs.

Hip-hop can be considered a reaction to the co-opted elements of disco culture, but the DJ ideas and innovations of Grasso and other disco DJs were adopted by hip-hop DJs. For instance, disco DJs popularized the art of DJ mixing, that is, bringing in songs on beat and also weaving songs into a narrative based on a feedback loop with the crowd. While Grasso pioneered mixing between two records, which was called a "change" at the time, he also is credited with modifying the "slip-cueing" technique for DJ mixing. Grasso was one of the first DJs who required headphones to be part of the system so that he could preview one record in the headphones before he mixed it in with the record playing over the speakers. He would then hold the record and let the turntable platter rotate beneath (slip-cue) and then drop the record on time and on beat.[20]

To perform his mixing, and especially important to this book, the first DJ mixer[21] ever made, "Rosie" (designed by Alex Rosner), was designed for Grasso's use at the Haven Club in 1971.[22] According to Cross's thesis on the development of DJ mixers, "Rosie was revolutionary because it translated the needs of these new DJ techniques into an artifact, but these techniques were invented and polished by a user *before* the DJ mixer came along."[23] Therefore, we can see that, from the beginning of the development of DJ-specific products, technical innovations were encoded with DJs' technique innovations in mind.

Disco DJs and hip-hop DJs also share an affinity for remixing and the open drum section of a song: the break. While hip-hop DJs reconfigured breaks and mixed songs in live performance, the disco DJ remix was largely a recording studio activity. In the early 1970s, disco DJs/remixers such as Walter Gibbons and Tom Moulton pioneered the art of remixing and pressing records for the clubs, essentially employing the aesthetics of Jamaican dub versioning in a New York City style. Much of what these disco remixers did was add a drum break to the beginning, middle, and end of current popular music to make those tracks more rhythmic and mixable for DJs in clubs. And, by accident, Moulton pressed the first disco single to a 12" record (prior to this, most popular singles were available on 7" vinyl), which would later become a standard format adopted by the recording industry for DJs (the 12" vinyl single is discussed in more detail in Chapter 6). The 12" vinyl single allowed for wider and deeper grooves, which gave the records more bass and a higher volume than 7" versions. With this technical innovation, the vinyl record became a tool. These DJs also showed that they were more than disc jockeys, but were also authors, artists, and performers.

Hip-Hop DJ Culture and Technology

Hip-hop DJ culture[24] developed in the South Bronx borough of New York City in the early 1970s, in part a response to gang violence, social inequity, marginalization, and the need for urban youth to develop identity, community, and voice.[25] Also—and this in no way trivializes it—hip-hop culture was a bunch of kids looking to have fun and have something to do. While hip-hop culture developed as an African American and Latino (largely Puerto Rican) movement, it also began as a youth movement with most of the vanguard DJs, dancers, and artists being in their teens.

Much of hip-hop's early development has been credited to DJs Kool Herc, Afrika Bambaataa, and Grandmaster Flash, the pillars or "holy trinity" of the culture. Protégés of Bambaataa and Flash, such as Jazzy Jay, Grandmixer DXT (formerly known as D.ST), and GrandWizzard Theodore, were also important in the early development of DJ style and technique during its embryonic stages (as well as many other DJs[26]). The pioneering hip-hop DJs set up their homemade sound systems in public spaces to play records, a sonic magnet that was seminal in cultivating the hip-hop styles of the emcees, dancers, and graffiti artists. "It was the DJ style which helped to create the lifestyle which came to be known as hip hop," writes Toop.[27] The story of the hip-hop DJ could be considered the story of hip-hop because the culture began as live performances in parks and community centers in the South Bronx (1973–1979) that were given by these DJs.[28]

DJ Kool Herc—dubbed "The Father of Hip-Hop" because his style, selection, and technique became the foundation of hip-hop culture—threw his first party or "jam"on August 11, 1973. As Herc's parties grew in popularity, he eventually moved outside into the parks and tapped city lampposts to power his sound system. At the time, disco DJs in the Bronx were catering to older crowds of hustlers and numbers runners at discotheques; commercial radio was following by playing mostly disco hits.[29] But Herc became known for playing edgy, nonmainstream music at his parties, and this became a draw for teenagers looking for a party and creative outlet.[30] After noticing people's reaction to the break section of songs, Herc would just cue up and play these short rhythmic sections repetitively—a technique he coined the "merry-go-round"—isolating and prolonging these breaks.[31] Herc says, "As long as I kept the beat going with the best parts of those records, everybody would keep dancing, and the culture just evolved from that."[32]

By taking these records, manipulating them, and playing only short segments, Poschardt suggests that "Herc made the DJ an author, the originator…

he freed music from its old context and integrated it within the 'process of composition.'"[33] Herc and other DJs demonstrated that a completed work could be broken down into parts and used to create original music.[34] According to Chang, Herc's form of new media authorship was able to "release the music on the record from linear and temporal constraints."[35] "The breakbeat involves a freedom," writes Williams in his analysis of hip-hop's borrowing aesthetic, "a freedom of the DJ as listener to foster creativity with the collage of cultural information he or she had available."[36]

Herc also developed a reputation for having the most powerful sound system in the South Bronx, and in 1974 Herc started putting Coke La Rock (who is regarded as the first hip-hop MC or "rapper") on the microphone to hold down the party and make announcements. In the mid-1970s, DJs were still the center of the party, and emcees were just a component of the event; DJs were the "orchestra" for the emcees to rhyme over.[37] According to Grandmixer DXT, the "DJ is the source of energy…the DJ had to give the MC rites of passage to his set."[38]

Herc has been cited as one of the first DJs to obscure the labels of his records so that other DJs would not know what he was playing at his parties, a practice he learned from his father.[39] Other youth in the South Bronx who went to Herc's jams began to recognize some of the records he was playing. "All of them [records] was sitting in your house—they were all your mom's old and pop's old records," says DJ Jazzy Jay. "Soon as Kool Herc started playing, every motherfucker started robbing his mother and father for records."[40] Other teens began to give parties in their own neighborhoods and, eventually, in other NYC boroughs. Two of the most influential of the time were Grandmaster Flash and Afrika Bambaataa.

Herc brought the break to the fore and in the process set off the hip-hop DJ's mentality about finding vinyl recordings from different music genres that could then be translated to a hip-hop audience. Afrika Bambaataa, then, picked up on Herc's taste-making and pushed the boundaries of what it meant to be a crate-diggin' DJ. Known as the "Master of Records," Bam made the DJ an activist.[41] While Bambaataa would play the foundational breaks that Herc had unearthed at his parties, he was willing to dig deep into the archive of recorded music to open up the minds of his audience, and he turned looking for and buying records into regal disciplines.[42] Bam made his obscure selections standard plays for other DJs:

> I was one of the persons who had so much of the music that went onto influence hip hop and my crowd was just like "progressive" y'know they were just as crazy as myself,

so whatever I played a lot of other DJs would be scared to touch other forms of music, but when they saw the Zulu Nation dropping this they became OK on this. So if they got into a heavy metal record you had on and saw the crowd react well to it then these other DJs would start playing it at their parties.[43]

Grandmaster Flash was another DJ who got his start going to Herc's parties and brought the technical aspects to hip-hop DJing. At a young age, he developed a fascination with electronics and his father's record collection, so his mother enrolled him in a vocational high school. Flash took what he learned in school and figured out how to open up the faceplate of a light pole and power his sound system in the parks. Although he went to Herc's parties, Flash felt that Herc's merry-go-round was sloppy, and he made it his mission to tighten up this technique and extend a drum break infinitely. He thought that a DJ could be scientific with his style and considered himself a scientist.[44]

Grandmaster Flash made many important contributions to early hip-hop and DJ culture, and he was one of the first to theorize DJ practices, name his techniques, and retrofit technologies. At the time, DJ mixers that were used in the clubs and by disco DJs were expensive and had many functions,[45] but for teenagers such as Flash those technologies were unaffordable. Thus, most hip-hop DJs modified and used microphone mixers or came up with creative ways to use home stereo equipment.[46] Flash had the idea that if he could cue up records in his headphones, then he could play the breaks on time. One day, Pete DJ Jones let Flash on his system, one that had a headphone cue function, and Flash realized that his dream of a continual drum loop orchestrated by the DJ was possible. After this realization, Flash went into his laboratory and used his electrical expertise to retrofit a Sony MX8 microphone mixer using some preamps and Krazy Glue. He was now able to hear the record he was cueing up while the other played over the loudspeakers. Flash says:

> I couldn't afford a mixer with a built-in cue system where you could hear turntable one or two in advance. I had to actually get a single pole-double throw switch, crazy glue it to the top of my mixer, build an external mix on the outside just strong enough to drive a headphone, so when you clicked it over you would hear the other turntable in advance. But this whole idea of hearing the cut ahead of time took three years to come into being.[47]

Flash experimented with playing his breaks on time around the fall of 1974, and with his modified mixer he developed his "quick mix theory."

Flash describes his quick mix theory as "taking a section of music and cutting it on time, back-to-back, in thirty seconds or less. It was basically to take a particular passage of music and rearrange the arrangement by way of rubbing the record back and forth or cutting the record, or back-spinning the record."[48] Flash's quick mix theory was a way to piece together different breaks or take the same break and loop it using two copies of the same record, but to do it seamlessly and on beat.[49]

The quick mix theory was comprised of a series of other techniques that Flash named, perfected, and popularized. Flash also developed the "clock theory," which was a way of marking a record and using the mark like the hand of a clock. By implementing this technique, Flash was able to count how many full revolutions he would need to spin back the record he was cueing up in his headphones to bring the record back to the beginning of the break—essentially adding a visual element to early turntable technique. Once Flash developed this method, he said that he could control time.[50] To this day, hip-hop DJs mark their records with stickers, and digital DJ software allows for digital marks (cue points) within the programs, which are practices based off of the clock theory.

Flash is also credited with developing a series of other important techniques: the "punch phrase," which is essentially playing a guitar lick or horn stab over another record; the "dog paddle," which is spinning a record back at the edge of the disc; and the "phone dial theory," which is spinning the record back from the inner part of the record. Flash is also known as one of the first DJs to incorporate acrobatic body tricks into his performances. He is largely credited within hip-hop culture for taking a piece of felt, cutting it to the size of a record, ironing it with starch until it was wafer-like, and then using it as a "slipmat" between his records and the turntable platter. Slipmats are now a standard technology used in all DJ setups.[51] After Flash's theories were put to use, most DJs had to change their style.[52]

Flash also had an important mentoring role for GrandWizzard Theodore. While Flash is largely considered the first to come up with the idea of scratching a record rhythmically (what he called the "rub"), Theodore is credited with perfecting and introducing it to audiences; hip-hop DJs largely agree and credit Theodore as the "inventor" of scratching.[53] Flash says that "what Theodore would do with the scratch was make it more rhythmical. He had a way of rhythmically taking a scratch and making that shit sound musical. He just took it to another level."[54] It was the scratch that hip-hop DJing would most commonly be associated with, but scratching was different from

Flash's cutting because instead of moving back and forth between two re-
cords, Theodore would play an instrumental record on one turntable and then
scratch another record rhythmically over it.

Flash's innovations best illustrate the re-coding of sound reproduction
hardware into production hardware, a clear transition towards to read-write
practices. Furthermore, his innovations in technique, as well as naming and
the prioritization of receiving credit for such innovations, highlight credit
for innovation as a core value of hip-hop DJ culture and one that emanates
throughout the remainder of this book. Thus, Flash best represents the hip-
hop DJ *as* intellectual property, as well as the fusion between technical and
technique innovation, that is, the DJ as technology.

The DJ was the king of the early hip-hop scene in the Bronx in the mid-
1970s. Although Coke La Rock grabbed the microphone at Herc's parties
beginning in 1974, other DJs began forming their own crews with emcees
who would rock their parties. This was, in many ways, a division of labor, be-
cause the DJ could let the emcee handle the mic so the DJ could focus on the
music and manually looping breaks for the emcees to rhyme over. If the DJ's
timing was off, it would kill the emcee's flow, and thus these emcees relied on
the DJ—for his system, records, and skills. These groups began by putting on
much-hyped battles and then eventually performances complete with chore-
ography and costumes. It was this movement toward performance and away
from improvisation that would set the stage for hip-hop's encounter with the
recording industry in 1979.

It was around 1978 when the DJ moved into the background and the
MC moved into prominence, a shift that helped lead to the commodifica-
tion of hip-hop culture into rap music.[55] Hip-hop's role as a commodity, or as
Nelson George calls it, a "capitalist tool,"[56] began in summer 1979 with the
release of Sugarhill Gang's "Rapper's Delight." According to McLeod, this
record "forever changed hip hop music's (and hip hop culture's) relationship
with the music industry,"[57] thus turning breakbeat music into "rap," a shift
that pushed the DJ to the background. The rapper was easier to endorse by
corporate America because he could be turned into a writer, essentially an
"author," under the American media-legal system. Rap music was hip-hop's
"most commodifiable component,"[58] and it was the DJ who suffered when it
became commercial.

The rap record, then, threatened the art, power, economics, and culture
of the hip-hop DJ in two ways: (1) as hip-hop moved to studio-based rap
music, the DJ was initially replaced by session bands and songwriters; and (2)

people who were part of the live hip-hop culture bought rap on records and consumed it at their leisure, giving them little incentive to go to the clubs and park jams. Moving into the 1980s, the hip-hop DJ continued to fade into the background as digital sampling technology became the dominant method of producing the music.

As we have seen, historically hip-hop DJs have had a close relationship with analog records and turntables, but digital technologies were introduced into the culture in the late 1970s and early 1980s with digital sampling equipment. According to Schloss in his study of the values and aesthetics of producing hip-hop music, the story of hip-hop DJs and digital sampling is one of dialectical influence: "Innovations are accepted only if they conform to a preexisting aesthetic, but once accepted, they subtly change it. Sampling was initially embraced because it allowed DJs to realize their turntable ideas with less work."[59] Digital sampling technology, then, remediated DJ techniques and therefore is an extension of the hip-hop DJ's analog sampling practices outlined here (primarily the practices of chopping and looping sound fragments).

Digital sampling is a case where technology caught up to the DJ as the manual or analog sampling of early DJs prefigured the cut-and-paste techniques used in digital sampling. Essentially, session musicians and then sampling technology remediated DJ technique in a way that specifically suited the recording industry. As the DJ became a producer, he could potentially get writing credit and publishing royalties from rap songs that he produced.[60]

The 1980s and 1990s were important decades for hip-hop DJ culture. With the DJ falling out of the eye of the mainstream in rap music culture, hip-hop DJ technique and technology developed in the underground. These important eras are discussed in detail in Mark Katz's book *Groove Music*[61] as periods marked by expansion and legitimization as DJ technique and culture expanded (both geographically and in respect to skill articulation). Katz also describes this as the time when DJ hardware advanced along with the technique, and as the era when the industry that caters to this market solidified itself and grew exponentially (this time period is where much of the rest of this book will focus), specifically what he describes as the era of "turntablism."

"Turntablism" is a neologism for distinguishing a DJ who merely plays records from one who manipulates records to create an entirely new composition.[62] Turntablism is, in some ways, a "political" and empowering movement that brings the hip-hop DJ to the forefront and gets back to the framework established by the pioneering hip-hop DJs in the 1970s. It does not discredit but deemphasizes the role of the emcee/rapper. DJ Babu is generally credited

for coining *turntablism* around 1995. In his 1994 mixtape, *Comprehension*, Babu has a composition with D-Styles and Melo-D called "Turntablism." And, in 1995, Babu defined turntablism on one of the first DJ "how-to" videos, *Turntable Wizardry Stage 1*. However, the origins of the term have been contested as both DJ Supreme and Turntablist Disk have laid claims to originating the term as well. Babu considers a turntablist someone who uses the turntable in the "spirit" of a musical instrument.[63] For Disk, the turntablist is a musician who uses one turntable, one mixer, and one sound to make music. "If you can grab a plain sound and make it musical and make people like it or love it in your own style or way, flip it, you are a turntablist," says Disk. "You make your own music."[64]

Thus far, I have tried to frame and contextualize the hip-hop DJ's relationship to sound reproduction hardware and vinyl records, specifically manipulated and re-coded uses of them to make music and culture. While these types of manipulation are key in understanding technocultural synergism, this brief historical outline describes the tastes, values, and practices that inform the DJs I interviewed for this book and whose ideas are shared throughout its pages. In the next sections, I explore how technology is used by the hip-hop DJs I interviewed and what meanings they ascribe to them.

Technique and Technology

Since hip-hop's beginnings, much of the core technologies used by its practitioners have changed little. For instance, the hardware for emcees is the voice and then a microphone to amplify it; for graffiti, it is aerosol paint, caps, and hand styles; and for b-boys and b-girls, the technology is their bodies. However, since the beginning, the hip-hop DJ has had a symbiotic relationship with the hardware used. To be a DJ, one had to be able to get the gear and the records, and then have the skills to manipulate and command them for a crowd. No other element of hip-hop required this sort of investment in the acquisition, maintenance, knowledge, and use of hardware, nor did technical innovations affect these other elements like DJing. This is much of the reason why there is a large industry centered on DJ products, and one that is not controlled by DJs. While other elements of hip-hop culture have fed into various industries, especially the recording and media industries, there is nothing quite like the dialectic between hip-hop DJs and the DJ product industry.

The hip-hop DJ, then, is an archivist and a technologist who ascribes meanings to tools through use. During this process of ascription, technical innovations are enfolded into the art form and thus bear meaning beyond the commodity nature of those tools. DJs in this book noted that innovations such as Technics 1200 turntables, loose crossfaders such as those on the Vestax PMC-05Pro, and, for most, Serato Scratch Live digital DJ software were the most important technical innovations within hip-hop DJ history. However, manipulating those technical innovations requires advancement of the human mind and body, or what Bourdieu describes as "embodied" cultural capital; essentially knowledge related to using commodities.[65] Thus, it is this use exemplified through embodied cultural capital that gives meaning to faders, buttons, and knobs.

"But the biggest technological advance has been the DJ technique and then scratching, I guess," DJ Quest tells me. "The thing that has advanced the most is that DJs have been practicing and just fuckin' scratch techniques have evolved beyond what a lot of people can comprehend...but the thing that has advanced the most, and I'm proud to say, has been the hand."[66] This point that Quest makes is central to this book and technocultural synergism as I present it. The common misconception, I argue, is that technical innovation leads the way in innovation in technique, but I have found that it's the converse: technical innovation follows innovation in technique, or as Quest puts it, advancement in hand movement. Innovation starts with us, DJs (or broadly, humans), manipulating equipment, whether it's finding new ways to use existing machines and influencing them in that matter, or more directly by designing, inventing, and engineering technical innovations. These new uses are reflected in new hardware in a constant feedback loop. Thus, technical innovation is more of a reflection of us rather than us being "affected" by it. Innovation is a cycle, a dialectic, and a network.

Like Quest, many others suggest that the relationship is two-way, and that "progress" is driven by the interdependence between man and machine. For instance, DJ Daddy Dog explains, "Our trade gets advanced along with the equipment we do it with...so it goes hand-in-hand I think."[67] Qbert thinks the creative network advances the art and technology of hip-hop DJs. "You need all the parts, everything together," says Qbert, "it's all one energy, put it that way."[68] While suggesting the turntable and records as the likely starting points of DJ culture, Nu-Mark claims, "Without music there is nothing. It's all so interwoven; the whole thing is really connected. The mixer was a big thing, but all the stuff is connected."[69] As machines have evolved, some feel that

some DJs have restricted themselves to the set boundaries of the machine, which counters the ideology of pioneering hip-hop DJs to push the capabilities of equipment. For Ricci Rucker, "Technology should work for you, not vice versa."[70] For the most part, the DJs I spoke with recognize the importance of this relationship.

Part of hip-hop DJing is taking elements from the past and reinventing them in a new context, a core concept from the early days in the South Bronx.[71] But, unlike other elements of hip-hop, the art of the DJ is also about keeping up with new technical innovations. DJ Babu tells me that the hip-hop DJ culture is a "hand-me-down" culture:

> I just think that's another part of what we do as DJs and turntablists; it's just a bit of being technically savvy, being up on technology and trying to think out-of-the-box. Trying to think of and do things that the technology wasn't intended to do. Everything in our culture is hand-me-down. We take whatever our big brothers left us and we try to make the most out of it and put our own little twist on it and make it dope.[72]

Babu is alluding to how there are certain skills and values that have been historically handed down within hip-hop DJ culture, as well as how each generation takes technical and technique innovations of the previous generation, and, through use, somehow makes them their own thing. Williams makes this a central point in his book *Rhymin' and Stealin'*, where he claims that hip-hop borrows not only from other pasts in various contexts but also from its own past as a matter of historical authenticity. As a way of demonstrating historical authenticity, Williams writes that "borrowing is hip-hop culture's most widespread, and arguably effective, way of celebrating itself."[73] And Babu describes hip-hop DJs as manipulators of our history and reinventors of elements of the past. In the context of technocultural synergism, Babu evokes how hip-hop DJ culture manipulates the past as intellectual property; this past, and in fact, the entire history of hip-hop, is based in manipulating vinyl records using turntables.

Using Turntables and Vinyl Records

One would be hard-pressed to find a turntablist/hip-hip DJ who does not consider the turntable a musical instrument. As someone who has invested years into developing techniques and performing them for live audiences, it is difficult, in fact, to think of it as anything else. For those who remain

unconvinced, Mark Katz's book *Groove Music*[74] presents a thorough argument explaining how the turntable became a musical instrument in its own right: standard techniques and ways of creating sound patterns developed, DJs have created musical albums/songs, and there are notational systems for DJ composition. Thus, nearly everybody I interviewed considers the turntable an instrument, although a limited instrument, because it is mainly used rhythmically and not melodically. While it can be used for melodies, a typical turntable with +/- 8 percent pitch does not provide that much melodic range. DJ Platurn and Turntablist Disk compare the turntable to a guitar, with records as its strings and the hip-hop DJ plucking those strings.[75] Steve Dee considers the turntable the "ultimate instrument because it plays all instruments."[76] Like Steve Dee, Nu-Mark believes the turntable is an "infinite" instrument because it can be any instrument that the DJ wants it to be. Nu-Mark tells me that it is the "most powerful instrument out there period, end of story. The turntable can not only reproduce any sound, but can do it in any tone at any tempo and at any time...there are no limits to the turntable, that's the thing about it."[77]

Stephen Webber, who started teaching turntablism classes at the Berklee College of Music in the early 2000s, suggests that instruments have always come from the redefinition of uses. "Every musical instrument that we have started out as something else," Webber explains. "The string section, cello and violins, came from the bow and arrow...so the turntable started out as something that played music and already is easier to think of as a musical instrument than something like a bow and arrow would be."[78] In the context of hip-hop DJs, Katz suggests that the transformation of an object to an instrument is a process that "requires not a single individual but a community."[79] The notion that this type of metamorphosis is a communal process remains core to this book and my assertion that technique/technical innovations within hip-hop DJ culture are the byproduct of collective intelligence within a network.

The turntable becomes an instrument when it is put to use as one; not everyone who owns a turntable treats or uses it as a musical instrument. "It's all what's in the mind and the hands of the person using it," says Mr. Len.[80] Although gramophones were marketed and "played" as instruments in the early 20th century, up until the work of hip-hop DJs, turntables were used solely as reproduction devices. But Rob Swift thinks that DJs engage in a redefinition of its intended uses. "You don't just have to let a record play from

beginning to end, you can do stuff with the record that's playing, you can manipulate the vinyl and coax sound out of it."[81]

The definition of an instrument for DJs Kico and Babu is anything that allows you to manipulate sound, a contention held by most of the DJs I interviewed. But Babu says that the musicality of the turntable is dictated by whatever sounds are encoded into the vinyl record's grooves, which makes it a distinct instrument (as Nu-Mark suggests, "infinite"). For example, a drum cannot play guitar sounds, but a DJ with a turntable can play both a drum and guitar if the record has those sounds. For Babu, it is about how those sounds are applied that defines what type of instrument the turntable is going to be at that moment: "In a nutshell, that's how I always look at the turntable and how I've always looked at the sampler; like these are tools that give us the ability to touch sound."[82]

The 2009 DMC World Champ, DJ Shiftee, tells me that it is a matter of having control over sound, and with the popularization of digital vinyl systems (DVS), you can control any sound that can be recorded: "So if you can control a record and control a mixer and control the way that sound comes from a turntable...not only is that an instrument but you are every instrument ever if you want to be."[83] Steve Dee suggests that hip-hop DJs manipulate historical time and musical time concurrently. For instance, DJs can play older music, sample it, or flip it in a way that makes it new using old technology: "We are manipulating time because...you are taking a portion of time and manipulating that time using time."[84]

For Mike Boo, the turntable is also a way to control and manipulate vibrations and make both "beautiful" and "terrifying" noises. "The turntable is vibrations," Boo says. "The needle is running along a groove cut into wax; that groove is like a little road and when you pull it back and forth, or if you just let them play, it's all just vibration—manipulated vibrations."[85] According to JohnBeez, the turntable is an important instrument for hip-hop culture because "that's *the* instrument, the maestro of hip hop; that's where the foundation was built."[86] JohnBeez, like many others, cites the turntable as a symbol of the culture and the tool used to make music that the pioneering hip-hop DJs described earlier in this chapter. Its use, even its presence, is a symbol of historical reverence and authenticity. It is important to note how the meanings created by these uses play into technocultural synergism. Within this context uses are manipulations of intellectual properties and their intended uses/meanings. It is here in manipulation/use where hip-hop DJ culture becomes a creator of valuable intellectual properties.

Before the cultural and industrial standardization of DVS, the collection and use of vinyl records was required for the DJ and turntable to act together as a holistic instrument. Like hardware, the meanings of vinyl records are defined both by user and uses, and I want to explore what a record collection can mean. DJ Shame notes that like the turntable, vinyl records are important to hip-hop culture in general—in fact, they are at the core of hip-hop. "That's what hip-hop is, it's old records," Shame tells me. "It doesn't matter what kind of music it is, the hip-hop DJ is going to take something and make it hip-hop."[87] Shame's notion of making any kind of music hip-hop suggests the reinventive nature of hip-hop DJ culture, as well as how hip-hop DJs create a read-write culture through re-coding.

After a decade of technological and cultural negotiation, DJs have rationalized the use of digital vinyl (described in Chapter 6), which has changed the meanings attached to record collections. Records and collections, as well as prioritization of what is kept in or added to a collection, have taken on different meanings than they would have, let's say, in the year 2000 before DVS. For some, this has made their collection more valuable; for others, the utility value of DVS has allowed them to "trim the fat" from their collections. Some DJs are now selling their entire collections, either because they are out of the DJ profession/culture or DVS has replaced the need to curate and use their collection.

Records are valued for how they sound as an analog medium, as well as how they feel to the human hand. Teeko considers records to be an organic sound medium that help to create a powerful connection between the DJ and the molecular matter of the vinyl record:

> We are dealing with elements; we are dealing with molecular structures.... We're connecting directly with bumps on a groove, which create vibrations that pass through our fingers that also pass through a diamond needle to play the song. You're directly connected to the sound.... And when you listen to records as a listener, the analog frequencies are penetrating your system and your body on an organic, natural level, as opposed to digital representation for vibrations through MP3s, which are just zeros and ones that replicate these frequencies.[88]

Turntablist Disk and Shiftee both stress the importance of the tactility of the recorded sound on vinyl, while Ricci Rucker says that it is "music you touch to create."[89] The tactile nature of vinyl records and the connection through the human hand, according to Qbert, give the fingers ears. "Your fingers also hear sound, too. Blind people can hear sound through their skin. You can feel

that sound in your hand.... You can hear it in your hand."[90] While DJs ascribe somewhat spiritual meanings to records, what we see is that it is the ability to manipulate the sound with one's hands that is the connection. At the core of that connection lies the value of utility; it is simply easier to control sound when it is encoded into a 12-inch disc.

DJs describe their collections as a part of their identity. For some, like DJ Eclipse, who has approximately 30,000 records in his collection, part of his connection to his records deals with the work that goes into maintaining such a large archive. Some DJs also describe how the labor involved in collecting can be an educational process, which they claim is severely truncated with the MP3 and Internet.[91] Diggin' for records—actually flipping through, touching, and seeing all the information on a vinyl record—also provides DJs with information that may not be available online.

This information, then, allows DJs to seek out other music that a producer worked on or drummer played on; vinyl records represent starting points for further musical exploration. "Being able to sit there and listen to a record, read all the liner notes, that's part of the whole rush of finding some new dope shit," says DJ Shame, who has 20,000 records in his collection. "You're going to find that record with the great break on it by going out and getting your hands dirty."[92]

Kico describes the time and financial sacrifices that went into amassing his collection: "I remember the sacrifice that I made, like I didn't eat for a week because I wanted to buy those records...so for me they have more sentimental value if anything."[93] For Babu, sacrifice symbolized in a collection encourages respect between DJs. "Just to know that this cat went through that generation of having to run records down and be about records and losing sleep about getting a fuckin' record. I really cherish those days of having to do that."[94]

For other DJs, vinyl records are also about preserving memory and personal archivism. Jared Boxx, who owned the iconic Big City Records store in NYC, suggests that vinyl records last longer than other media, and therefore it is a preservation medium. "They hold the picture in sound for people," says Boxx.[95] DJ Shortkut also makes a photo-visual connection by likening his collection to a "photo album" that he can show his daughter so she can better understand his past. Vinyl records, then, represent nostalgia based on both the actual music and other meanings associated with the commodity that holds the music.

"It's like memory lane...I would sit down and go through a crate and find shit and be like 'Oh shit, I remember when I got this,'" says DJ JayCeeOh.[96] Hip-hop DJs I spoke with can often remember when and where they got an

important record, how much they paid for it, as well as other information such as what else they did that day, the weather, etc. Some records are valued for the music encoded into their grooves because the songs represent an important time in a DJ's life, while other records hold value because they are rare or sought after; sometimes these factors converge. For three-time DMC World Champ DJ Craze, his records are also a collection of memories, and "every time you take one out it just brings you back to that time in your life. Like the feeling."[97]

The element of memory preservation, in a similar vein as a photo album, can help to structure a collection. DJ Nikoless, who has about 16,000 records, structures his collection alphabetically and chronologically. He has studied the information on his records and says, "I can look at a record and tell you stories about so many records. Whether it's how I found it, whether it is where I was when I first heard it. Yeah, those records all have stories to me."[98] Therefore, records are history, and a collection is a personal archive of music and memory, or maybe music as memory. J.Period considers record collections as archival projects: "If anything, what they are to me is almost like archival originals of some document that is so valuable that I may need to refer to it.... There are things on those records that are infinitely valuable."[99]

While record collections take on multiple meanings for hip-hop DJs, much of the value associated with collections comes from how they are put to use. For working and professional DJs, records are (or were) tools that gain meaning through their use value, although this has waned in the age of DVS. For many hip-hop DJs, records are part of the productive forces used in the creation of the art and culture. DJ Quest compares his records to tools in his shed because they help him to "knock a job out." And, for him, having those tools in the digital age has increased importance. Quest says, "At the end of the day I could drop my laptop, god forbid, and fuckin' lose everything in there, but my bread-and-butter is my records. Those are the tools."[100] As an extension of this, DJ Nu-Mark's 35,000 records "mean the world" to him, but they also represent an investment of time and capital that he puts to use in DJing and production.[101]

In the digital age, the records that have little use value or sentimental value are the first to be thinned out of a collection. Both DJ JS-1 and DJ Nikoless stress the utility value of the pieces in their collection and, similar to others in this book, view themselves not as "collectors" of fine art but as record users. Nikoless extrapolates on the difference:

I have a very strong bond with my record collection. And I don't consider myself a record collector; I consider myself a record user. For me personally, I am from a time and I am the kind of person who always bought the records to hear them and to use them, and I still regularly go through my records and use them. I don't have them in plastic; I don't take care of them in that kind of way.[102]

Hip-hop DJs also move back and forth between collections for use and for the preservation of history. Some hip-hop DJs amass records as sellers who reintroduce them into the secondhand marketplace as well.[103]

Vinyl records—because of their size, sound, and the information that they contain—have utility value, and such use value can be based in emotion. Mike Boo, in a McLuhanesque fashion, also considers vinyl records tools and an "extension" of himself. Expanding on this notion, he says:

With every fuckin' record, people's hopes and dreams went into that record.... And for me to use that in my music it gives it a certain feel, not just sonically but it gives me a feeling of like, "Wow, I'm giving new life to the sound." These guys put their heart and soul into this shit; I am putting my heart and soul into this, and it is an extension of that energy.[104]

Again, we see how the emotion of music is bound in the use of those records and in the production of culture.

Understanding the uses and meanings associated with vinyl records and turntables is at the crux of the remainder of this book. Here we have seen how manipulation of intellectual properties in the form of vinyl records and turntables is at the heart of the culture and is the starting point for the industry that caters to this manipulation. While records, turntables, and mixers, as well as disco and Jamaican DJ practices, preceded hip-hop DJ culture, the hip-hop DJ community has collectively reinvented those techniques and technical innovations and thus re-coded their meanings in the process. Uses as manipulations help to define how the culture conceives and ascribes meanings to its tools, and therefore DJs see these tools as extensions of themselves and not simply as discs, buttons, and electronic components.

Turntables are considered an authentic medium of expression that allow DJs to touch and manipulate any sound that exists on vinyl. Hip-hop DJs collect records to use them, for historical preservation, and because of sentimental value. When vinyl records lack these attributes, then digital copies of the music become preferable for practical reasons. Vinyl records also have an educational and informational element to them, and they have value in their sound qualities and tactility. With the advent of digital vinyl systems, vinyl

records are still considered a medium of authenticity; however, authenticity is often judged in skill in manipulation and not entirely in the tools used (as we will see in Chapter 6, this was not initially the case when digital vinyl was first introduced).

How hip-hop DJs have collectively manipulated text and hardware supports my point that hip-hop DJ culture is open source and new media, because even in the analog era (as early as the 1970s), hip-hop DJs' practices prefigured and contributed to the common practice of the "remix" that lies at the core of creativity in the digital age.[105] And, because of how hip-hop DJs manipulate IP, the lines between producer and consumer have blurred, and culture has converged with industry. This reinvention through manipulation by a network of DJs created a market, and once a market was formed, a cultural industry developed to serve it. In regards to technocultural synergism, the manipulation of text and hardware is the starting point of intellectual property exchange and rights, which occurs through corporate and cultural convergence.

In the next two chapters, I will look at the DJ product industry both historically and in its present state, delineate stories and case studies of technical innovations from four manufacturing brands of importance to a political economy of the hip-hop DJ, and look at the nature of standardization and intellectual property within this political economy. In the next chapters, we will also see how the exchange and rights of intellectual properties take hold within technocultural synergism as a way of catering to the market for manipulation and read-write culture.

· 2 ·

EXCHANGE AND RIGHTS IN THE DJ PRODUCT INDUSTRY

Technics and Vestax Corporation

"It's always been possible for people who are not professional musicians or are not wealthy to make music.... There's an interaction between art and technology.... It's not that one dictates the other, but when a technological development comes out that musicians can use, musicians use it in a new way. That in turn inspires further technological development."

—Bob Moog[1]

In the autumn of 2010, a major death knell sounded for many hip-hop DJs. After years of rumors online causing a stir, due to a decline in global demand during the last decade, the Panasonic Corporation announced that it was discontinuing its line of Technics analog turntables, including the iconic Technics SL-1200 series.[2]

The Technics SL-1200 series turntable has been, and still is, the standard for most DJs, clubs, and radio stations worldwide. Technics originally became a popular brand among the pioneering hip-hop DJs in the 1970s, and later was the major global sponsor of the World DMC DJ Championships starting in 1989.[3] Broadly speaking, the Technics 1200s are an iconic symbol of DJ culture.

Panasonic's 2010 announcement was initially met with skepticism. But when retailers such as Guitar Center raised the price for 1200s to $949 ($549.01 more than the price just a week earlier), many DJs realized that this was no rumor. Only a decade before in the early 2000s, the DJ product industry was boasting how turntables were outselling guitars 2:1, Technics had announced it had sold more than 3 million units of the 1200 in 30-plus

years, and 12" vinyl singles were the format of choice for most hip-hop DJs. For many DJs, this "death" of the 1200s encapsulated the zeitgeist of the analog-to-digital transition for hip-hop DJ culture.[4]

We should look not only at why the production ceased but also how Technics became the standard in the first place. The ways that technical innovations become industry standards are rarely deconstructed, and often standardization is a process that is understood narrowly (usually as a company pushing its product on culture through advertising and using intellectual property rights to secure monopolies). As we will see, there are quite a few factors that play into standardization within a niche market.

The Technics 1200 example, which will be discussed further, presents an opportunity to witness the interaction of cultural uses, intellectual property rights, and format standardization. In my opinion, these are the structural forces that have helped give rise to the formation of a political economy of the hip-hop DJ. This chapter is a discussion of two former major players in the DJ product industry, as well as some technical innovations and common practices that helped establish those firms in the marketplace. Both these manufacturers have introduced products that have been important to the dynamics of hip-hop DJ culture. My goal is to begin highlighting the creative network and feedback loop between industry and culture to show how IP exchange and rights to exploit these ideas create dialectical tension between producers and consumers. This tension, what I refer to as "technocultural synergism," helps drive this culture and industry "forward."

To illustrate technocultural synergism as a dialectical tension within this political economy, I will profile two Japanese manufacturing brands whose products and corporate practices have achieved industry standardization: (1) Technics and (2) Vestax Corporation. Through the exchange of intellectual properties between companies and DJs, in this chapter I will begin to demonstrate how hip-hop DJs are themselves manipulated *as* intellectual properties, an aspect of technocultural synergism that is fully highlighted in Chapters 4 and 5. Technical innovations that achieve standardization are the product of a vast creative network—in this case, composed of DJs, brands, engineers, and corporations—and not the inventions of an individual genius. Thus, we will begin to see how convergence and collective intelligence function in the DJ product industry and hip-hop DJ culture.

The DJ Product Industry

To understand a political economy of the hip-hop DJ that I outline in the remainder of this book, it is important to look at the industry and the market more generally. The DJ product industry is part of the larger musical instrument and pro audio industry, often referred to as the "music products industry," which is comprised of approximately 12 product categories (e.g., guitars, keyboards, audio production, etc.) in a $16.6 billion global market. While some major diversified electronics corporations dominate this market, there are many smaller, privately held companies that make up this industry. According to reports by *Music Trades* magazine, the $6.81 billion American market grew 2.1 percent in 2013 and comprises 40.6 percent of the global market (the next two largest markets are Japan and China).[5] In respect to global and U.S. markets, and even in terms of structure, the music products industry and recorded music industry are strikingly similar, although the music products industry is significantly less concentrated.

Japan (34.32 percent) and the United States (31.17 percent) are the two largest countries in respect to manufacturing, followed by Germany (7.75 percent) and China (6.07 percent). These numbers often exclude huge diversified electronics conglomerates, such as Pioneer and Denon, because their DJ/music product revenues are lumped in with the other audio products they produce. The largest company in the music products industry is Yamaha Corporation, a highly diversified Japanese manufacturer of musical instruments/products, who saw $3.75 billion in related revenues in 2013. While these major companies are in the DJ market, it is the smaller, independent manufacturers of DJ products that work with DJs in R&D and branding, and try to participate in the culture to make innovative products. The larger companies follow trends by smaller companies, and those independent companies follow trends and innovations in DJ culture.

According to *Music Trades* data, Numark is the largest manufacturer of DJ equipment in the world. It is part of the large company inMusic, home to brands such as Akai and M-Audio, who saw $283.5 million in 2012 revenues. Rane Corporation is the 159th largest music products company in this industry, with revenues of $17 million in 2013. The market for DJ products in the United States was $138.7 million in 2013, up from $120.1 million in 2012. This market has been growing consistently since 2009 when it was at a lowly

$86 million. Although the growth seems small, DJ products are considered the fastest-growing market segment in the music products industry.

On the strength of a 38 percent rise in the sales of digital DJ controllers, this market segment's 15 percent increase is significant (controller sales increased 54 percent in 2011 and 30 percent in 2012). Industry professionals suggest that the rise in DJ controller sales coincides with the popularity of electronic dance music (EDM), where this type of technology is often used. Since 2005, the sale of turntables has decreased by $3.5 million with about 50,000 units shipping in the United States in 2013. It is important to note that many of these turntables are "prosumer" or USB turntables for record playback and not necessarily aimed at the pro DJ market, and there seems to be no data differentiation between turntables aimed at professional DJs and those aimed at everyone else. DJ mixers, however, had a great year in sales in 2013, up nearly 21 percent to $49 million. The product category that seems to be struggling the most here is CD turntables (CDJs), down 12 percent, which is likely due to the rise in popularity in DJ controllers, hardware that effectively combines two CDJs and a mixer.[6]

While changes in distribution and delivery formats of recorded music are reflected in the development and sales of new DJ products, in many ways the musical instrument industry is also structured like the recording industry. Manufacturers in the DJ product industry produce equipment and are involved in the marketing of new products to consumers. Some manufacturers import or purchase audio components and assemble products at their headquarters, while others contract factories to assemble components or complete products bearing their corporate brand. Some "manufacturers" are merely brands that design and engineer products and then rely on third parties for the actual manufacturing.

Typically, a manufacturer itself will distribute these products or hire another party for distribution. Some manufactures will handle domestic distribution, use regionally based sales firms, and/or use distributors located in other countries to reach international markets. Distributors are typically in charge of promoting products to retailers (both online and brick and mortar), educating retailers on new technologies, and getting products they distribute favorable placement within retail spaces. While some firms are fully vertically integrated from production to retail,[7] smaller companies sell directly to retailers or even to consumers.

Various musical instrument manufacturers and pro audio/electronics manufacturers produce equipment for the DJ product industry, which is comprised of multinational corporations, as well as smaller independent companies

(mostly based in the United States and Japan). For instance, Pioneer, a diversified Japanese consumer electronics company, also has a pro DJ equipment unit, Pioneer Pro DJ, and notably sells CDJ CD turntables, controllers, and its DJM line of mixers. Pioneer's 2013 sales were $4.8 billion; however, Pioneer is the exception and not the rule in the DJ product industry. On September 16, 2014, it was announced that Pioneer had sold its DJ division for $551 million to a private equity firm, KKR.[8] For the most part, though, DJ products are developed and manufactured by micro-companies, or within the smaller units of large musical instrument and pro audio manufacturers.

In the DJ product industry, it is not always the large manufacturers whose products, backed by substantial R&D and marketing budgets, achieve industry standardization; often it is the independent companies who are in closer contact with the market/culture. In some instances, it is the uses or misuses of hardware by DJs that gives way to standardization, and this is an important factor in this book: Technical innovations introduced by manufacturers follow and are reactions to innovations in DJ techniques. This relationship, though, is dialectical and a feedback loop between technique and hardware, corporation and DJ culture, and it is technocultural synergism in action. Standardization processes also demonstrate how the DJ is the technology.

Before moving on to profiles of Technics and Vestax, the story of the Shure M44–7 cartridge provides a case-in-point of how DJs' uses of a technical innovation can lead to industry-wide and cultural standardization.

Shure M44–7: A Case Study in Standardization

Shure Inc. is a privately held American manufacturer recognized in the pro audio industry for the production of microphones and monitors. A small part of its current business is in manufacturing needles for turntables; it is currently the eighth largest global manufacturer in the music products industry. Although it was released in 1963, it was not until the mid-1990s when Shure's M44–7 phono cartridge replaced the Stanton 500AL as the standard needle setup for most scratch and hip-hop DJs. And, it was not by any conscious or deliberate action by the company.

The standardization of the M44–7 happened almost accidentally through cultural use. Shure began manufacturing phono cartridges in 1958, but, because of the mass acceptance of the CD format in the 1990s, the phonograph section of the company was struggling and nearly shut down. DJ Shortkut,

one of the first Shure DJ product endorsees, was introduced to the M44–7 via D-Styles.[9] When they went to Japan on tour with the Invisibl Skratch Piklz (ISP), they found out DJs were using the cartridge there as well. At the time, ISP was the most popular DJ crew in the world and was beginning to work with companies in designing technologies and then endorsing them. ISP DJs bought a large stock of the M44–7s during this trip to Japan (you see a segment of this in *Turntable TV 4: Toiret for Godzirra*[10]) to bring back to the United States.

At that year's National Association of Music Merchants (NAMM) convention, ISP members approached Jimi Needles of Shure about the popularity of the M44–7 with hip-hop and scratch DJs. Representatives from Shure then flew out to the Bay Area to meet with members of ISP and Thud Rumble (DJ Qbert's brand, managed by Yogafrog) to figure out how DJs were setting up their cartridges to work for heavy-duty manipulation. Interestingly, the specs were completely different from how Shure expected the product would work. In 1997, Shure, working with ISP and Thud Rumble, redesigned the M44–7 for DJ use, and it was released to the public the following year. The DJs were able to convince Shure's CEO to restart the manufacturing plants in Mexico to begin reissuing phonograph needles (also including the M44G and SC35c). Shortkut says, "We were the first ones to actually get them to realize that 'Hey, your needles are dope. We'd like to work with you guys and really like you guys to put more emphasis on your product because it is dope.'"[11]

With a marketing campaign that included famous DJ crews such as ISP, the Beat Junkies, and the X-ecutioners, as well as some DMC battle sponsorship, the M44–7 phono cartridge quickly became the standard scratch product in global markets. According to Shortkut, the 44–7 revived Shure's phonograph division,[12] and it is currently the phono cartridge and stylus combination still used by most hip-hop DJs and turntablists. The M44–7 is the standard not because a company had a great vision for a product, but because of DJs' use of the product and vision for it. Shure simply interpreted this vision in its product design and was able to harness the brand value of credible and popular DJs to authenticate the product within the hip-hop DJ market and culture. By getting into the scratch DJ market at one of its peaks in the late 1990s, Shure benefitted from having the biggest DJs backing its product. This endorsement, along with the fact that the needle is excellent for manipulating and scratching records, transformed the 44–7 into a standard piece of equipment.

In this case, and in many others as we will see, a vast creative network innovates and is the driving force behind standardization. Standardization comes from the dialectic between bottom-up production (cultural or grass-roots) and top-down production (corporate). The catalyst in the "progress" of technical and technique innovation is technocultural synergism. While units of companies such as Pioneer and Shure are diversified in other industries and market segments within the music products industry, the primary interest of most of the corporate players in the DJ product industry is pro audio and DJ products. In other words, they are not devoting their time to developing products that drive hip-hop culture. They are relying on the culture to help lead their production. To further illustrate this dynamic, I spend the remainder of this chapter profiling two manufacturing brands that were integral to a political economy of the hip-hop DJ; in Chapter 3, I look at two manufacturing brands that currently are standard within this political economy.

In this chapter, I profile Technics and Vestax, which are both Japanese brands that are no longer producing hardware for the DJ market. Both of these brands, though, designed products that became standard with hip-hop DJs. Thus, the Technics 1200 is still largely considered the standard DJ analog turntable, and Vestax Corporation produced the standard mixers used by hip-hop DJs; its 05Pro is the blueprint for mixers used by hip-hop DJs today. Furthermore, Vestax is included because it is the company that is largely regarded as the first to listen to hip-hop DJs, include DJs in R&D, and use DJs' brands to market products.

Other manufacturers, such as Stanton, Gemini, Native Instruments, and Numark (who all make mixers, turntables, controllers, and other accessories), are integral to a political economy of the hip-hop DJ. Although products manufactured by these companies offer choice to consumers and thus competition to the featured companies, they are not considered the standard within their respective segments of the market.[13] Therefore, this discussion should be read as a version of a hip-hop DJ's political economy and not *the* political economy.

The analysis that follows is grounded in political economy, thus focusing on survival (the economics of production and reproduction) and control (the political) within social life.[14] I specifically use a political economy of culture framework to analyze the "consequences" of organizing and financing cultural production.[15] While this type of study has been done on recorded music technology, according to Théberge, there has been far less attention to industries that produce musical instruments.[16] Within the DJ products

industry I want to show the human element behind the machine, and thus consider the people who inhabit the machine.[17] My perspective is that there is a culture in the DJ products industry that is especially interesting when we deconstruct it through the lens of technocultural synergism, which illustrates the dynamics and politics of convergence. To do this, I do not consider technologies to be divine actors, but instead like Sterne who conceptualizes technology as "an apparatus, a network—a whole set of relations, practices, people, and technologies."[18] Thus, I want to look at the corporate culture of the DJ products industry, and specifically explore the creative network at work through technocultural synergism.

On the surface, DJ technologies appear as neutral devices; however, these devices are encoded with specific uses and, as we will see, the ideas of hip-hop DJs. Thus, DJ technologies represent sites for political struggle. While scholars have typically understood the cultural industries as those that produce and circulate media content as texts,[19] this book is predicated on the idea that technical innovations and hardware are themselves texts where there is a "struggle" over the production of meaning. The DJ products industry is a cultural industry because, as Mato suggests in his study of other non-media industries, it manufactures "products that besides having functional applications are also socio-symbolically significant...consumers acquire and use products not only to satisfy a need...but also to produce meanings according to their specific values and interpretations of the world."[20]

Since technologies are sites of continuous political and social struggle and not simply neutral electronic devices, Lysloff and Gay encourage us to understand music technology as material culture that "people use and experience in ways meaningful to their particular needs and circumstances."[21] The authors note how technologies are embedded in social institutions and cultural systems, and are thus related through dialectical influence. While "many technologies were developed in the interests of industry and corporate profit, and for the purposes of domination and exploitation," Lysloff and Gay argue that "their accessibility and availability provide people with more means to cope with and even resist or subvert those same forces."[22] This is, for me, a core principle of technocultural synergism.

Technics

Technics is a brand of the Panasonic Corporation (formerly Matsushita) that specialized in the production of high fidelity analog and digital turntables, as well as headphones, mixers, and keyboards. Technics debuted in 1965 to show off Panasonic's high-end audio products, but today the brand is most known in the DJ culture for its line of SL-1200 turntables, which became the standard among DJs in the years after its release in 1972.[23] Technics estimates that since 1972 it has sold 3 to 3.5 million of its SL-1200 series turntables.

Panasonic, much like Technics, began as a brand name that belonged to Matsushita Electric Industrial Co., Ltd. in the 1950s. Now known as the Panasonic Corporation, the brand is used for a range of consumer electronics, from digital cameras to microwave ovens. This highly diversified multinational corporation includes more than 680 companies with global distribution. According to its annual report, Panasonic received $87.9 billion in revenues in 2013 and it is the 83rd largest company in the world.[24]

At the peak of the hi-fi home audio craze in the 1960s/1970s, Technics began releasing a range of high-quality turntables. In 1970, it released its first turntable with a direct drive system (DDS), the SP-10. At the time, direct-drive turntables, which are powered by a motor system, competed in the market with belt-driven models. Instead of using gears, belts, and wheels to spin the record, DDS couples the turntable platter with the motor so that the platter will turn at the same rate as the record.[25]

The original SL-1200 (see Figure 2.1) was introduced in 1972 as an evolution of the 1100 model turntable. Designed with audiophiles and radio stations in mind, the 1200 competed in the market with the Kenwood and Thorens brands. At the time of the 1200's release, the Technics 1100A was already the preference of DJ Kool Herc. "So between Technic[s] and Thoren[s], they was fighting for the money market," says Kool Herc. "So I went Technic[s]. I went 1100A. But that turntable, people couldn't afford it. Too expensive. So they [Technics] pulled it off and put something more durable, and inexpensive with the 1200 shit. I don't fuck with the 1200s. I wouldn't."[26] Herc's great influence and dominance of the early hip-hop scene in the South Bronx is often regarded as one of the ways in which the Technics brand became popular among early hip-hop DJs. In essence, he was one of the first brand ambassadors for Technics, and early hip-hop DJs' uses of the brand made it a standard.

It was not until 1978–1979 that Technics released the SL-1200MK2 turntable, which became the industry standard for DJs. The Mark 2 soon became the turntable of choice among DJs because it dampened vibration and eliminated feedback in loud environments. Panasonic was able to make a series of improvements in the MK2 by adding a ground wire, a variable pitch fader instead of the dial that the SL-1200 had, and its then recently patented quartz DDS motor that vastly improved platter torque. And, the quartz motor is the most important factor here as it was really what made the MK2 a DJ turntable and not simply a record player.[27]

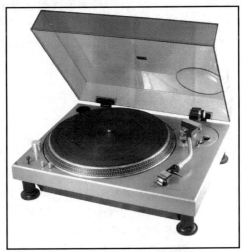

Figure 2.1. Original SL-1200 turntable, dubbed "The Middle Class Player System."
Photo by Zane Ritt / Courtesy of the DJistory/DJpedia Archive.

Technics was able to harness the cultural/industrial acceptance of the MK2 moving into the 1980s by using its brand recognition with DJs and a market monopoly granted by patent for the quartz DDS technology.[28] This synergy between branding, consumer acceptance, subcultural capital (attached to the DJs actually using the turntable in front of an audience), and patent rights was powerful and fueled the standardization of the Technics SL-1200 series. While performance of the product and its use by credible DJs bolstered its presence, arguably it was the 17 years of market monopoly for its quartz DDS motor granted under patent law that allowed the SL-1200 series to become the standard.[29] If another manufacturer wanted to use DDS instead of the belt-driven system during the duration of the patent monopoly, it would have to license the rights from Panasonic or come up with its own innovation. To

understand the role of patent law in standardizing the 1200s, it is vital to ex-amine the basics of its role in innovation.

Patents are based on economic incentives with an anti-monopoly ("lim-ited times") framework to structure those incentives. After the original rights expire, the patented idea falls under the collective ownership of the public (public domain). Patents are granted on any new or useful process, machine, composition of matter, manufacturing processes, etc., for a limited time of 20 years in which the patent holder has the exclusive right to exploit the idea in a market or license/sell to others. "Invention" is granted to the first to file for a patent in the United States and throughout the world. U.S. patent law sup-poses that innovation is cumulative and is based on prior art; therefore, those seeking a patent have the burden of proving that the idea seeking protection is novel (it is a new idea), utilitarian (it is useful), and non-obvious (it makes an "inventive leap"). Typically, combining technical innovations that have fallen into the public domain into a new innovation will not be patentable (this is often why products like DJ mixers, which combine public domain audio components, are not subject to patent protection).

On receiving patent protection, the patentee must make the information public so that it can spur further innovation; however, any direct use of that idea requires a licensing agreement and payment of royalties to the patentee during the term of the patent. After 20 years, the term of the patent expires and becomes public domain. Patent protection is territorial, which means you must file for patent protection in every country where you plan to exploit the idea.

Historically, the American patent system came to reward science-based corporations by granting them monopoly rights at the expense of independent inventors. As patent law evolved, it disadvantaged small corporations and inde-pendent inventors, and in the end negatively affected those whom intellectual property rights were intended to serve: consumers, citizens, society, and culture.[30]

In the case of the SL-1200, the only competition in the market for analog DJ turntables in the 1980s and into the 1990s was belt-driven models or turn-tables not made for DJing.[31] Belt-driven turntables have little torque and the needle, unless heavily weighted (often with quarters taped to the top of the needle that would wear records quickly), would skip when manipulating the discs. Hip-hop DJs, clubs, and radio stations did not have many other profes-sional options other than Technics during the time.

Although Technics began releasing entry-level consumer electronics in the 1980s, the brand also stopped manufacturing and providing parts for other pro-fessional turntable models that had adequate tonearms and DDS appropriate

for DJs (i.e., the 1100A or 1500 MKIIs). This manufacturing choice further helped to push the SL-1200 in the market, which worked in tandem with the DDS patent to limit competition. If you were a DJ or a club venue, your options were either the SL-1200 or a belt-driven turntable, and with the 1200s' durability in manipulation and sound, it quickly became the standard.

As hip-hop DJ technique developed in the 1980s/1990s, the SL-1200 essentially stayed the same and did not adapt to innovation in DJ technique. Thus, Technics was able to sell 1200s at a high price without putting money into marketing and R&D, essentially allowing Panasonic to exploit its intellectual property rights in the market without innovating.[32] Over the years, pioneering DJs such as Grandmaster Flash and Jazzy Jay claimed to have approached Technics with ideas and were completely ignored by Panasonic. While many of the pioneering hip-hop DJs used the 1200s, currently a lot of those DJs refuse to use 1200s and prefer other brands because the company refused to acknowledge their contributions to building the market for the brand. Because those DJs were the early, incidental brand ambassadors for Technics, helping to develop the culture using 1200s and having up-and-coming DJs watch them use the model at park jams, many pioneers felt slighted by the huge multinational company since they were, in many ways, responsible for the success of the 1200 within hip-hop DJ culture. In fact, by helping to create hip-hop DJ culture, not only did they help to build the credibility of the 1200 but they also created the market for it.[33]

Once the quartz DDS patent expired around 1996, a flood of manufacturers entered the market for DJ turntables, and finally Technics had competition. Led by Vestax's release of a straight tonearm PDX series turntable in the same year, other manufacturers such as Numark, Stanton, and Gemini began developing similar products with DDS and straight tonearms. New features included reverse platter rotation, expanded pitch range, BPM counters, and key lock, as well as numerous other additions that were the by-products of heavy R&D with industry-leading hip-hop DJs. While these other brands chipped away at the market, the 1200s still outsold the new options, proving how deep its roots had grown within the collective consciousness and practices of DJ culture. Almost any DJ coming up yearned to have a pair of the iconic 1200s, and having a pair was a sign of being established; 1200s made you authentic.

By the early 2000s, the SL-1200 had become an icon of the larger hip-hop culture through some media exposure, which was symbolic of the role pioneering hip-hop DJs played in the culture's formation. For instance, starting

as early as 1984, an outline of the iconic Technics SL-1200 S-shaped tonearm was on the sleeves of all the early records released by Def Jam, one of the earliest and most successful rap record labels.[34] To complement the tonearm tracing was an enlarged "D" and "J," the Def Jam logo that suggested the label's authenticity and credibility by associating itself with DJs.

Another example of the media's role in the standardization of the 1200s was inclusion in visual media. Beginning in the 1980s, the 1200s were featured in any rap video that included a DJ. In 1984, MTV aired its first rap music video, "Rock Box" by Run-D.M.C.[35] The video features the DJ, Jam Master Jay, manipulating a pair of 1200s and a GLi PMX 9000 mixer, and also has a shot where rappers Run and DMC are superimposed sitting on top of a huge Technics 1200 tonearm.

In the 1990s, the SL-1200 was an industry standard, and to reproduce authenticity in film, pairs of SL-1200MK2s were used in the infamous DJ battle scene in the 1992 film *Juice*. There were 1200s on the set of MTV's first rap program, *Yo! MTV Raps*, which first aired in 1988, and in countless rap music videos that featured DJs.[36] A common setup on *Yo!* was a pair of 1200s, a Gemini MX-2200 mixer, and DMC brand slipmats. And it was Technics's long relationship with the premier DJ battle put on by DMC (Disco Mixing Club) that was also vital in the standardization of the 1200s. With the dissemination of DMC U.S. and World DJ Championships battle video tapes to hip-hop DJs, which exclusively featured SL-1200s and ubiquitous Technics branding, a powerful form of product placement and synergy was established during the 1980s and 1990s.

The Technics and DMC synergy—as lived experience, on tape, and within a range of other cross-market promotions and commodities—was a major factor in increasing consumer awareness of Technics and an easy way for Technics to advertise to its audience. Although DMC DJ competitions began in 1985, the UK-based organization did not begin its sponsorship deal with Technics for its DMC World DJ Championships until around 1987. In 1989, winners of DMC Worlds began receiving a golden pair of SL-1200 turntables, and Technics became the main global sponsor of the competition (eventually the battle series was referred to as "Technics World DJ Championships"). It seems that by the 1990s, Technics had acknowledged who was using its products and saw the relationship with DMC as a major marketing opportunity. The 1200s were the only turntables allowed in DMC competition, even though other options were available by the late 1990s, and from 1997 to 2004 entrants were also required to use the Technics SH-DX1200 mixer.[37]

Also, gold 1200s were awarded to the World Champion until the 2010 World Championships.[38]

Sponsorship of the DMC battle circuit was integral to the success of the SL-1200, because the events gave the Japanese manufacturer direct access to its market and seems to have been the primary marketing conduit for SL-1200 turntables during the 1990s and early 2000s. Not only was the Technics logo ubiquitous at battles in the DMC circuit, but it was also included in all the videos that DMC produced and sold, videos that were important in disseminating hip-hop DJ techniques pre-Internet. The brand was so integrated into DMC that at the 1989 Technics World DJ Mixing Championships at Royal Albert Hall in London, the stage itself was a massive SL-1200.[39] This synergy, coupled with Technics's market monopoly as granted by patent rights, also helped in the standardization of the SL-1200s.

A statement from Panasonic finalizing the "death" of the 1200s was posted on the DMC website in November 2010 and reproduced as news all over the Internet: "After more than 35 years as a leading manufacturer of analogue turntables, Panasonic has regretfully taken the decision to leave this market.... We are sure that retailers and consumers will understand that our product range has to reflect the accelerating transformation of the entire audio market from analogue to digital."[40] The announcement prompted retailers to nearly double the retail prices of their remaining stock of new 1200s immediately after. Used 1200s started selling rapidly on eBay (although they had also sold well before) and at much higher prices than in the previous months.[41]

In terms of sales, even in its heyday, retailers were never fond of carrying 1200s because there was little profit to be made on them. For instance, in the late 1990s, Guitar Center used to have caches of 1200s and sold them as loss leaders. Because they retailed for $399.99, with a $400.01 wholesale price (not including tariffs and shipping), Guitar Center relied on the sales of DJ accessories such as mixers, cables, headphones, and needles to turn a profit; the idea was to keep you as a future consumer of more profitable products. Smaller pro audio and musical instrument retailers had a hard time keeping up with prices of larger retailers and would have to sell one SL-1200 for approximately $500–$625 to make a profit.

Profit margins are the reason that, when other manufacturers entered the market for DDS turntables by the late 1990s, retailers began pushing Numark and Stanton turntables where there was a higher margin. However, there was turnover with these other brands as some of them could not live up to the

1200s' durability. The 1200—beyond new, disruptive, digital products—may have been its own downfall, as it is an amazingly durable turntable, and there was no turnover. It is not rare for DJs to have 1200s last more than 20 years, and thus there was no repurchasing from damage or obsolescence by DJs.

What will live on beyond the highly durable SL-1200 is the Technics brand itself, iconography engrained in hip-hop DJ culture. The method that Technics used to gain market dominance was different from the companies and technical innovations that will be discussed in the following sections, but it is clear that it was use by DJs that was the main factor in its standardization. And, it is DJs' uses of the 1200s that have helped produce the meanings of the 1200s held collectively by DJ culture. The meanings ascribed to the 1200s by the culture, which I explore in the next subsection, along with the performance of the turntables are what helped to make them the standard.

The Death of a Standard

This chapter opened with a narrative about the "death" of the iconic Technics 1200s turntable, and in the last section we saw a story about the "life" of the turntable as it became a standard. When the majority of interviews were being conducted for this project in 2009, rumors were swirling about the possibility of the cease in production of the 1200s, so I asked DJs what it would mean for them if the iconic and standard line of turntables were actually discontinued. While the rumor proved to be true, looking at the meanings DJs ascribed to the 1200s in the face of their potential death helps to give deeper understanding to how technical innovations gain cultural meaning, as well as how standardization is a cultural process.

Hip-hop DJs had heard rumors about SL-1200s being discontinued for many years, yet Technics continued to sponsor DMC battles and new stock of turntables showed up in retail outlets. One of the problems in clearing up the rumors was that Technics is a Panasonic-owned brand that does not always communicate well with the public. (Technics is a small part of this diversified multinational). Many of the official statements came through DMC, not Panasonic itself.[42]

Whether DJs preferred the brand or not, there is little denying that 1200s are the standard in clubs worldwide, even years after production has ceased. DJ Craze says, "The 1200s are just the standard of DJing; there's no better turntables…. I don't think it's a perfect instrument but I know it's the perfect thing to rock with when you're DJing."[43] Technics SL-1200s became

the standard partly because of their durability, with many of the original SL-1200MK2s released in the late 1970s still working today. Mr. Len calls them "Tonka Trucks" for DJs: "These things will get beat up, they'll get dropped, all kinds of stuff will spill on them, and they manage to keep working. It's because they have been through the trials and people say, 'Well, we rely on these'.... The Technics have always just been there."[44] Roli Rho thinks that 1200s are the foundation of hip-hop DJ culture; they are also a sign of achievement as DJs gained more experience and a product that hip-hop DJs rely on. "I don't think people would ever live without Technics 1200s because that is the base of DJing right there, you got to get your 12s," Roli Rho explains.[45]

Skeme Richards thinks that 1200s became the standard almost accidentally: "It just so happens that Technics became the industry standard with the first person to pick them up and say that 'these were hot'.... So everybody looked at it like, 'Oh, so if this person is using it, it must be official.'"[46] Nu-Mark considers the 1200 "a perfect piece of machinery" and anything that would replace it, whether CDJ or controller, is merely trying to "mimic" the 1200. Thus, replacing a perfect instrument makes no sense to him. Nu-Mark says, "I look at it as a piece of art.... Why reinvent the wheel?"[47]

For DJ Neil Armstrong, discontinuing the 1200s means the "tool of the trade would be gone, which would be horrible," but he thinks that there are enough used units in the world that it will never truly disappear from DJ culture. "It won't die.... But who knows, that just might signal another company to pick up the reigns."[48] Interestingly, at the 2014 Musikmesse trade show, Pioneer unveiled a turntable that was strikingly similar to the 1200.[49] Fewer companies are interested in the turntable market and seem to be more concerned with the expanding controller market, but in August 2014 Pioneer released its PLX-1000 turntable, nearly the same design as the SL-1200.[50] Imitating the look of the 1200s is proof of how engrained they are in the culture as iconography.

DJ Daddy Dog, who calls the 1200s the "bread and butter" of hip-hop DJ culture, thinks because hip-hop vinyl is dying and that the format goes "hand-in-hand" with turntables, we may be witnessing "the death of the turntable" in general.[51] Although there are other options, for Daddy Dog "a true record head will not fuckin' go without his 1200s." While DJ JayCeeOh would lament the death of 1200s, and turntables more generally, he thinks that because new DJs will not be able to obtain turntables "they will never be able to say that they are a real DJ.... I think the method and everything is going to change, like it already has, but the percentage who appreciate the real shit will be smaller

but I think more respected in the long run." He further explains, "Like in 10 years from now for dudes who are still on Technics 1200s, motherfuckers will be like, 'All right, that dude is true to DJing.'"[52] Although DJ Eclipse would hate to see a day when 1200s are gone, he says, "I don't really see them going anywhere, but if and when that actually happens, yeah it would definitely be a sad day because the original art form wouldn't be around."[53] While Williams describes historical authenticity in respect to hip-hop's borrowing from the past, many of my collaborators suggested the use of the 1200s can also be seen as a signifier of this same type of authenticity but for hip-hop DJ culture.[54]

However, some people I spoke with suggest that Panasonic's lack of connection with the culture doomed the brand. DJ Steve Dee says, "I'm like, 'Good riddance, I hope they go and burn' because they never looked out for any of the people that made that one particular thing popular." He explains:

And I think that is kind of a shame that you have a whole thing [DJing] that is based upon the reality of someone else and they don't support that reality, they haven't done that. Like I said, Technics haven't embraced the people that have actually been selling their turntables without actually working for Technics. It's safe to say that I sold more turntables than Technics sold turntables.[55]

Steve Dee makes a valuable point about how known DJs, from hip-hop pioneers through the legendary DJs of the 1980s, were the unintentional brand ambassadors for Technics and helped in the standardization and sale of the 1200s. Because Panasonic had something "perfect" and it was accepted by DJs, DJ Nu-Mark thinks that Panasonic was able to disconnect from the culture; DJs were simply consumers of the brand and not active in branding or R&D like with other technologies/manufacturers.

Although DJ Quest has been a long-time user of Technics 1200s, he says, "I kind of wish that Technics would've been a little bit more connected to the DJs because they made a fuckin' killing off of us and I don't really feel like they have given a whole lot back." While he suggests that most hip-hop DJs use the 1200s because they became the industry standard, "It's unfortunate that we kind of became dependent on their shit…if it is the case that they are not going to make any more turntables, that really just kind of sucks because it's like they took the money and ran."[56] There seems to be a notion held by hip-hop DJs that companies in this market should "give back" to the culture, and, as we will see, this usually has taken form in involving DJs in branding and R&D, but event sponsorship could be seen in this light as well.[57]

Vinroc says that the death of 1200s would be a "real sign that the industry is really changing and the delivery methods for the music are changing." He thinks that the surge in the use of controllers or other hardware that does not use turntables, as well as a new breed of DJs who do not want to use turntables, will eventually take over the working DJ culture, especially as veteran DJs drop out. "The true key is once you start not seeing them [turntables] in clubs installments anymore, then they're done," Vinroc says. "And as soon as DJs don't demand it anymore, then it's done. And that day will come."[58]

It is evident that the digitization of DJ technology has had some sort of impact on the use and manufacture of new turntables (as noted earlier in this chapter, turntable sales are down $3.5 million since digital vinyl systems entered the market in 2005), which I will address in Chapter 6. But digitization has also negatively affected manufacturing brands that were not able to partake—largely due to licensing exclusivity with software companies—in producing DVS products. As we will see in the next section, Vestax Corporation has had a lasting impact on a political economy of the hip-hop DJ but failed to stay relevant in the age of the digital DJ.

Vestax Corporation

For many years, DJ mixers were not made for hip-hop DJs, but catered to club mixing and radio station use. For DJs interested in scratching, juggling, and battling, a 2-channel mixer with the crossfader placed in the center was the bare minimum, yet most manufacturers in the 1990s were still developing 19" mixers with rotary knobs, off-centered crossfader placement, stiff crossfaders that would bleed and were not replaceable, and complex control layouts. While the 10" styled mixers, mainly the Gemini MX-2200 and Numark DM-1150A, had gained popularity among hip-hop DJs by the early 1990s, many of those mixers had poor-performing crossfader-systems. Hip-hop DJs simply adapted the products they had access to.

In the early to mid-1990s the Japanese manufacturer Vestax actually began listening to hip-hop DJs and using their ideas in the design of its mixers. Furthermore, the company was introduced to the world's most popular crew of hip-hop DJs, the Invisibl Skratch Piklz (ISP), who would be important not only in R&D but in promoting Vestax products globally as endorsees. From this feedback loop came the PMC-05Pro line of mixers, made with hip-hop

and scratch DJs in mind, and the introduction of an improved crossfader-system (in respect to cut-in control, smoothness, and durability).

The smooth design of PMC-05Pro coupled with the new crossfader-system is why, for so many years (roughly 1995–2003), Vestax was the standard brand of 2-channel mixers used by hip-hop DJs. Not only is Vestax often cited as one of the first manufacturers to open their ears to DJs, include them in the R&D process, and use them to endorse products, but also the design of the PMC-05Pro is regarded as the blueprint for most 2-channel mixers we see today.

For this book, on several occasions I interviewed Chuck Ono, Vestax's Executive Vice President since 2003. Ono was hired by Vestax to enhance their products and recently was involved in the development of Vestax digital DJ controller product lines. Vestax Corporation is a privately held company whose world headquarters are based in Shibuya, Tokyo; thus, financial data is scarce, but Vestax totaled $8.4 million in revenues in 2008. According to 2010 data, the company employed 22–25 people and earned $12.77 million in revenues;[59] 2013 sales revenues were listed at $6.3 million. While many DJs think that Vestax is a large Japanese corporation, Ono says that it is in many ways a "grassroots" company that prefers working with its pro-artists than with other major corporations. In its company philosophy, Vestax compares corporate size to animal evolution: "Vestax believes that the history of animals shows that the ones that are too big become extinct, while insects who have downsized and diversified themselves are survivors. This is also true of companies: bigger is not always best."[60]

Vestax has traditionally distributed its DJ technologies outside of Japan to the valuable American market through third-party distributors. In 2002, after its founder, Hidesato Shiino, stepped down as Vestax President and was named honorary chairman of Vestax, Toshihide Nakama became the new president of the company. Vestax credits Nakama (aka "Toshi") as the "inventor of the legendary 'PMC-05 Pro' battle mixer,"[61] although throughout this chapter the network of innovation behind the PMC-05 line of performance mixers will be discussed.

In its corporate philosophy, Vestax looks at "quality" as time/capital invested in R&D and components, while innovation/creativity is said to be the main driving force behind the R&D of its new products. Customer satisfaction, according to Vestax, is increased by the company's support of music culture. "This might be demonstrated by providing instruments that are highly innovative, or by expanding the features of a product to allow new and creative

styles to develop. The end result however, is that music culture benefits in a positive way, always."[62]

Vestax began in the fall of 1977 when Hidesato Shiino started Shiino Musical Instruments Corporation (SMIC) in Shibuya, Tokyo, as a musical electronics company. Shiino, a master luthier, had considerable expertise in product development and marketing of musical instruments. By the end of 1977, SMIC diversified its interests by opening a string instrument store, PACO, which would also distribute SMIC-manufactured guitar parts. This vertical integration gave the new company a presence in production, distribution, and retail.

In 1982, Vestax, then operating under the brand name Shiino Vesta FIRE Corporation, became an original equipment manufacturer (OEM)[63] for the TEAC Corporation. Vestax began producing analog portable recording studios (called "portastudios") in 1984; eventually, other Japanese electronics manufacturers in the musical instruments industry approached Vestax about incorporating some of the company's patented parts into their instruments.

Vestax's interest in the market for DJ products began in the 1980s when the company used its patents, capital, and components to make DJ mixers— an extension of its other sound-mixing devices. Vestax's official foray into the DJ market, though, came in 1987 when it organized an all-Japan DJ battle; one year later, it opened DJ PACO, a DJ equipment store in Tokyo. Vestax continued to explore and sell products in the DJ market by debuting its PMC models with the PMC-30 and PMC-05 around 1989, the latter being a 7" mixer and one of the earliest to have a replaceable crossfader. Later that year, Vestax would change the future of the industry, not through technical innovation, but by the process for producing and marketing a technical innovation.

While I will explore the theme of intellectual property exchange and rights in respect to product design over the next three chapters (with specific focus in Chapters 4 and 5), it is important to begin discussing it here in the context of Vestax. Specifically, I would like to profile the Vestax 05 TRIX, 05Pro, and 07Pro mixers because of those products' impact on hip-hop DJ culture in both form/function and design process. While these innovations have historical importance, to me they are salient examples of technocultural synergism that changed how DJ products are designed and marketed.

After winning the DMC Technics European DJ Championships in 1989, the United Kingdom's DJ Trix approached Vestax about sponsoring him, and Trix began doing demos at trade shows for the company. At the time, Trix

was using the Vestax PMC-05mkII mixer, a product whose features he liked, but he thought that its layout design was all wrong. Trix thought he had a better design as he tells me: "I drew a design using the components of the PMC-05mkII but laid the mixer out as I wished, I also included the Vestax logo and my sig[nature]."[64]

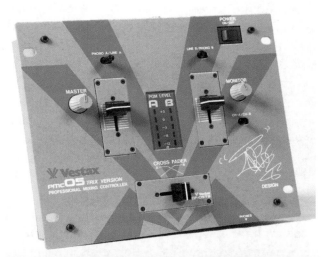

Figure 2.2. The Vestax PMC-05 TRIX (top) and DJ Trix posing with his signature mixer in the early 1990s (bottom). Top picture by Zane Ritt / Courtesy of the DJistory/DJpedia Archive. Bottom picture courtesy of DJ Trix.

Thinking that nothing would come of his design, Trix submitted it to Vestax. Around 1990, Vestax released the PMC-05 TRIX battle mixer (see Figure 2.2), a product that Trix says is a "carbon copy" of his initial concept. Aside from its design concepts, the mixer is notable because it made Trix the first DJ to have a signature mixer, which included his signature on the faceplate, and it marked the first major instance of a DJ's design concept being executed in a product. DJ Trix eventually would go on to run Vestax Europe and keeps one of his signature mixers in his office. Looking back, Trix thinks that the mixer represents the turn when hip-hop and DJ culture were taken seriously, and he says, "I am very proud of what I did still to this day, and to see every Vestax 05 layout has been born of my design is amazing."[65]

At the time of the PMC-05 TRIX's release, the only way manufacturers could get a sharper cut-in time for scratching was to use smaller crossfaders.[66] This short fader was awkward for DJs, but these faders were smooth in comparison to those in other mixer brands on the market. The solution to fader cut-in time would come after Vestax collected ideas from DJs and implemented crossfader curve control in the PMC-05Pro.[67]

The PMC-05 TRIX was one of the first symmetrical 2-channel mixers geared toward hip-hop/scratch DJs, and it came about because DJ Trix brought the idea to Vestax and it developed his concept. Thus began the Vestax catchphrase, "We give DJs what they want." Looking back, Chuck Ono, Vestax's former Executive Vice President, says, "I think that's his [Shiino's] main concept and that was definitely one of the key elements of having Vestax such a successful company in the DJ market as we were definitely one of the companies that listened to as many DJs as possible out there. I guess you could call him a pioneer in regards to that sense."[68]

Vestax started listening to DJs who were winning DJ battles and working at trade shows to help develop its product lines. The practice of listening to DJs' ideas about the products has since become standard practice in the DJ product industry; on the marketing side, popular DJs are used to endorse those products. DJs were interested and excited to have manufacturers listen because they wanted better tools and manufacturers were interested in building these tools to expand their market shares. Having companies listen was also a way that the art form of DJing was legitimized and it also helped to legitimize DJs who found themselves involved with products and companies. These listening, implementation, and branding practices illustrate early convergence between industry and DJ culture, and

thus highlight the dialectic of IP exchange and rights under technocultural synergism.

It was around 1994 when Vestax began developing the PMC-05Pro—a game-changing mixer that became the standard for hip-hop DJs because of its layout, smooth crossfader, and control over the crossfader's cut-in curve. Although Vestax cites its current president, Toshihide Nakama, as the "inventor" of this mixer,[69] it turns out that the PMC-05Pro, like most products in this industry, was the byproduct of a network of innovation and the exchange of IP. To me, the process Vestax employed and perfected with the 05Pro, that of technocultural synergism, highlights the value of manipulating DJs as intellectual properties. The 05Pro's story is worth exploring in some detail.

In 1993—when the standard battle mixer was the Melos PMX-2, the official mixer of DMC World DJ Championships at the time—then 18-year-old DJ Shortkut was working the trade-show circuit for Numark. According to Shortkut, at the time Numark and Vestax were the only companies with DJs in their booths demoing gear. Shortkut liked the PMX-2 but did not think the crossfader was as loose as it should be and said that it needed to have EQ controls. At a trade show Shortkut was eating lunch with a Numark representative and suggested that Numark would sell a ton of mixers to hip-hop DJs like himself if it would simplify the layout and make a smooth crossfader. Shortkut drew a sketch on a napkin,[70] but the Numark rep blew him off because the company was focusing on developing 19" mixers for club use. Shortkut tells me:

> Numark wasn't really feeling me. You know, I was just a little kid. I was working one of these trade shows and Vestax had a booth in the next hall. So during my breaks I'd go to Vestax and see their stuff, and I would feel their equipment and it was real nice. They actually had the loosest fader possible that I had seen so far. I started talking to them.[71]

Accompanied by DJ Rhettmatic at that year's NAMM, Shortkut started what would be a long relationship with Vestax. "And then I did a tour with Qbert in Japan, and I saw the Vestax people there and I started talking to them," says Shortkut. "Then we just developed a relationship and they kept asking for some ideas. Basically, the 05 pretty much went to them."[72]

Shortkut would later introduce other members of his crew, the Invisibl Skratch Piklz (ISP), to Vestax. It would be one of the most important synergies between DJs and a corporation, one that would revolutionize the market

and culture for scratch DJ products during the mid-1990s, and have an impact still felt today. According to Ono, Vestax also got more feedback, specifically from Rhettmatic, Mix Master Mike, and Qbert, as well as Japanese DJs Takada and GM Yoshi, before the PMC-05Pro was released to market. "And I think 05 kind of set a standard," says Ono, "any 2-channel mixer out there kind of resembles the image that the 05 created."[73]

"At first when we made it," says DJ Qbert, "they were like 'oh, this mixer is not going to sell, no I don't think anyone is going to buy it, it's too expensive,' and then they made it. They only made a few hundred pieces or whatever just to test it out, and all of a sudden, they sold thousands.... These guys just gotta freakin' listen to us!"[74] Actually, Vestax initially released a short run of 50 grey 05Pro mixers because the company feared that the retail price of $500 would be too high for hip-hop DJs used to paying about $200 for a mixer. But, with enough positive feedback from the limited run, DJs seemed willing to spend the money to have the crossfader control on a cleanly designed, Japanese manufactured mixer. So, Vestax released the now-classic gold-on-black 05Pro (see Figure 2.3), which eventually sold anywhere from 300,000–400,000 units.[75] As important as Shortkut and other ISP DJs were in the R&D of the 05Pro, Vestax was also able to harness ISP's global appeal and stardom, as well as its credibility, to help push the Vestax brand in the marketplace. In the eyes of hip-hop DJ culture, both ISP and Vestax made a splash in the years to come, which was the time period when the turntablist movement, and thus the DJ product industry, experienced rapid growth due to the hip-hop DJ market.[76]

Shortkut never got any royalties or even credit for his role in the mixer's development, but he humbly says, "To me, it was for the better good of the DJ."[77] And it was. Because of the control that its crossfader-system allowed, coupled with the fader's looseness, the 05Pro made it possible for DJs to realize their creative potential and manifest the ideas that existed in their heads. In part, the 05Pro allowed hip-hop DJs to come up with new scratch techniques, patterns, and styles—technique innovations that were eventually encoded into future technical innovations. The 05Pro was *the* mixer at the forefront of one of the most innovative periods for hip-hop DJ technique, roughly 1995–2000, and the expansion of the industry that catered to the culture as a market.[78] Shortly thereafter, other manufacturers followed suit and began catering to the market for hip-hop DJs and 10" battle style mixers, often replicating the 05Pro's design. Again, it is important to consider the role of DJs in the PMC-05's design and note that Vestax

actually implemented, produced, and marketed DJs' ideas. So, while the 05Pro did have a major impact on hip-hop DJ culture, hip-hop DJ culture also deeply influenced the 05Pro and ultimately the DJ product industry and Vestax.

Ono and Vestax know that working with DJs is "extremely valuable" in product development: "Well, these guys are definitely people who made the industry as well. Without your ISPs, without your Beat Junkies and your X-ecutioners…without these guys there wouldn't have been a DJ industry."[79] Again, what happened first with the PMC-05 TRIX mixer and listening to DJ Trix would serve as the foundation of Vestax's DJ product development. And, in the case of the PMC-05Pro, we begin to see how there is a dialectical relationship between the industry and the culture, a network. Before this, DJs just made-do with the products that were commercially available and would modify or use a mixer's built-in functions in ways unintended by the manufacturers. "Yeah man, it took a while but Vestax was really the first company to listen to a DJ," says Shortkut. "And that is why I was with them for a long time."[80]

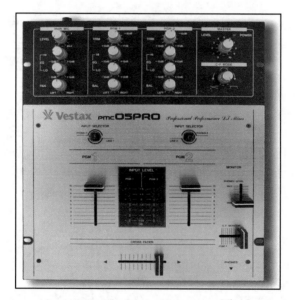

Figure 2.3. The original Vestax PMC-05Pro in the classic gold on black. Picture by Zane Ritt / Courtesy of the DJistory/DJpedia Archive.

Vestax and ISP, as a result of their relationship, gained increased exposure from the release of the 05Pro, as well as from subsequent collaborative technical innovations. However, it is important to note here how the 05Pro was

the product of feedback from numerous DJs and that Vestax pushed the asso-
ciation of ISP with its products because they were the most marketable DJs at
the time. This does not discredit the intellectual properties that Shortkut and
others gave to Vestax, but to suggest that the 05Pro, which was an important
technical innovation for hip-hop DJ culture, came about through a network
of innovation and not merely a singular source (including Vestax or Toshi
Nakama as "authors" of the 05).

Many times, in a network like this where there are uncredited beta tes-
ters who give feedback, it is a challenge to isolate the source of specific ideas
that get encoded into products. This is why "invention" is often associated
with the brand names (DJs and companies), and this relationship between
"invention" and brand name is a historical byproduct. Think about Edison's
phonograph; he had an idea for a machine that could read/write sound, his
machinists and engineers designed a product based on his idea, and Edison
was awarded the patent on it. But it was Edison's brand name as a great
American inventor that was associated with the phonograph that gave it
credibility in the market and helped to sell it. This association of brand
and invention often leads to commodity fetishization and belies the creative
network of engineers, machinists, salespeople, and artists who contributed
to the creation of the innovation. Thus, the 05Pro was not necessarily "in-
vented" by Vestax or ISP, but rather, those brand names became associated
with its invention. The DJs like Shortkut who supplied ideas often lie under
the surface of the brand name that is credited for the invention/design.
Furthermore, some DJs' roles in this development have been overlooked.
This is not unique to Vestax or even to the DJ product industry, but indus-
tries more generally that rely on beta testing and crowdsourcing (consumer
electronics, automobiles, etc.).

In other words, innovations from networks have largely been over-
shadowed by the credit given to brand names. This feedback loop clearly
demonstrates the theoretical thread of this book in technocultural syner-
gism by highlighting the manipulation, exchange, and rights to exploit
intellectual properties in a marketplace, and importantly, how DJs them-
selves are manipulated *as* intellectual properties. After the PMC-05Pro,
Vestax continued listening to DJs and developing new technologies to
cater to the hip-hop DJ market. While I will discuss these mixers and other
products in detail in the next chapters, I would like to briefly talk about
another important mixer that Vestax made for hip-hop DJs: the Vestax
PMC-07Pro.

In the late 1990s, DJ Go and his Mixologists crew experienced some suc-
cess on the international DJ battle circuit. Go, who lives in the UK and is of
Japanese descent, was a good match for Vestax because the Japan-based corpo-
ration had its European headquarters in the UK. In 1998, DJ Go designed the
Vestax 07Pro, a design he receives no credit for. Credit for its design is often
awarded to DJ Qbert, who was primarily involved in branding and endorsing
the mixer, but not necessarily design, which highlights how DJs' authorship
has been recognized as a brand but rarely as a designer (similar politics were
involved in the 05Pro).

"I got involved into designing the PMC-07 through Minoru Katae who
used to work for Vestax," says Go.[81] Because Go scratched Hamster (using
a reversed crossfader, discussed in Chapter 4), he wanted reverse crossfader
and channel fader switches on a mixer. At the time Go was using a Hamster
box that was designed and made by the UK's Prime Cuts of the Scratch
Perverts crew. While the U.S. DJs had their own style, the UK and European
DJs had a unique style of scratching, and were pioneering a DJ technique
called the Euro Scratch. This technique required reversing the channel fader
direction, and Go wanted to see this executed in a mixer. He brainstormed
with Alex Hazzard, formerly of Vestax UK, on a design, which he drew on
some notebook paper. Go submitted this design to Vestax and he claims that
when the 07Pro came out later that year, it was exactly his design minus the
3-band fader EQs.

"Being in regular contact with Vestax Japan at the time, they promised
me a fax confirming my involvement in the design, which I never received,"
Go explains. He eventually was able to get a free 07Pro from Vestax, but no
credit or compensation for his design; Vestax had a great deal of success with
the 07 (likely a combination of the features/design and branding by Qbert
and Mix Master Mike). "We decided to go and 'visit' the Vestax headquarters
directly to discuss what the hell happened with my credit for the design," Go
explains. "I still remember the conversation I had with Mr. Nakama, who
admitted that it was my idea for the 'hamster' switch, and the reverse option
on the upfaders with curve control." Go tells me that, beyond the Hamster
features, the dimensions and layout were exactly the same. I asked him if he
still had any of the original drawings but Go said he cannot find them: "I will
find the pieces of paper one day hopefully."

Go admits to me, like other DJs who have given ideas, that he wished he
were a bit more business savvy at the time. He tells me the experience was
a bit surreal, and while he would have liked to have seen some royalties on

07Pro sales, he is mostly upset that he has received no credit for the design of an iconic mixer. For Go, he just wants people to know that he designed a piece of hip-hop DJ history; he wants to be included in the legacy of the 07Pro and Vestax.

In the late 1990s, Vestax developed and marketed its own lines of turntables, and in the early 2000s Vestax released the PDX-2000 direct drive turntable. The PDX, another product of networked innovation and IP exchange, was aimed at the scratch and hip-hop DJs and competed in both price and function with the Technics 1200. The PDX line featured numerous advancements to accommodate the needs of the scratch DJ: an expanded +/- 50 percent ultra pitch range (the 1200s are only +/-8 percent), reverse playback, and a straight tonearm.

Although it was before his time at Vestax, Ono revealed that the story of the PDX, which was a product developed with DJs who were working with Vestax from 1995–1998, is often passed around the corporate office. Because the PDX-2000 was introduced at one of the great peaks of the turntablist and hip-hop DJ scene, the model sold well for Vestax and is what Ono calls a "turning point" for the company. "That whole thing just sparked up and DJing was just such a strong piece in this whole urban subculture that suddenly popped out to the mass public," says Ono. "It was just perfect timing to release the PDX-2000 for that specific market, you know turntablism."[82] Vestax has since released numerous PDX models over the years.

During the 2000s, and through technocultural synergism, Vestax developed two turntables with its pro artists geared toward DJs interested in scratching and making music: (1) the QFO and (2) the Controller One. Both of these products went through years of R&D between Vestax and its pro artists, with the QFO, a turntable/mixer hybrid developed with and branded by Qbert, being the product that got marketed to the public (see Figure 2.4). The Controller One (C1), developed initially with Ricci Rucker and D-Styles, is a turntable that can hit notes and play scales like a piano (I look at the R&D of the C1 in full detail in Chapter 4).

These products were developed for a niche market that existed within an already niche DJ market; however, this has always been a core ideal for Vestax. "Sure we are not going to make a lot of profit, I will be honest with you," says Ono. "Did the Controller One do millions of dollars? No, not at all, we are in the red on that one still. Did the QFO sell thousands? It didn't, but we made product that these DJs wanted." This is a defining factor for Vestax

because other manufacturers, such as Rane and Numark, have not really innovated or taken chances in this manner. Ono continues, "We take a lot of concepts and actually make something out of it…. We definitely do a little more interesting products."[83]

Together with DJ Qbert and his branding company, Thud Rumble, Vestax launched the QFO Qbert Signature Pro Turntable in 2004. The concept was a portable scratch instrument enabling you to scratch anywhere (initially guitar-style straps and a battery pack were available). Vestax produced handmade prototypes in four generations, and Qbert spent almost two years testing the device before it hit the market. Qbert explains: "So I just drew it, and then I gave it to Vestax. They designed it, and they were like, 'oh ok, let's make this thing.'"[84]

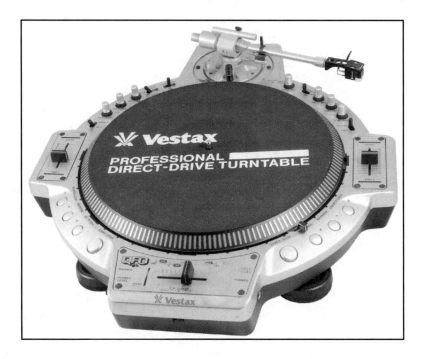

Figure 2.4. Vestax QFO Qbert Signature Pro Turntable. Photo by Zane Ritt / Courtesy of the DJistory/DJpedia Archive.

"When I was a kid I learned that you're supposed to draw it out, put your ideas on a piece of paper, and whatever that thing is on the paper pretty much comes to life after a while," says Qbert. "So I just drew the thing and showed

it to them and they took it from there."[85] The hype behind Qbert and the QFO allowed it to do fairly well in the market, even with a MSRP of $1,999 (Vestax did a limited run of 1,000 of these QFOs).[86]

While some DJs were praising the QFO, others were decrying it as nothing more than a gimmick, and thus there were a growing number of proponents of the Controller One turntable. Ricci Rucker introduced the idea for a turntable that could play notes like any other instrument to Vestax around 2003. Rucker had actually been writing about the idea for a few years on Web forums, initially calling it "The Melody." Rucker and D-Styles (who had a relationship with Vestax from his days with ISP) began developing the instrument.

The Controller One, however, did not reach the market until 2008, and was sold exclusively through DJDeals.com in the United States, retailing for about $1,999. Because distributors and retailers of DJ products were uneducated about or disinterested in the C1, Rucker and D-Styles distributed the product themselves at a lower price; other DJs ordered it through Ishibashi Music Corporation, Japan's largest pro audio and musical instrument retailer. Approximately 300–500 Controller One turntables were actually manufactured. The C1 is largely considered a market failure because so much money was spent on its R&D, which exhausted the marketing budget for the product and ultimately raised the price point, and it found itself competing with the budding digital DJ market.

Ricci Rucker describes the C1 as the "Rolls Royce of turntables," not only because of all the creative opportunities it opened, but also because of how it was made. Rucker says, "The Controller One is like the Moog of the 2000s: barely anyone knows how to use it, it's mad expensive, and it's original as hell. It's called the Controller One, cause you can control one record in any manner you want," says Rucker, "the imagination is the limit."[87] The C1 has a powerful and unique motor, and a hand-cut wooden body for optimal acoustics. The high-quality rubber feet of the turntable were made by Toyota to completely reduce feedback noise due to vibration. Although it never was released, Vestax was also supposed to produce a foot pedal so that notes could be changed by foot, an idea that Rucker was adamant about.

With the C1 Vestax started a new product category that it called Musical Instruments for DJs (MIDJ). The Vestax C1 press release said, "As we reach for the industry of MIDJ, we also need to educate the children that the turntable is an instrument, and that this can be a new culture and instrument added into the world of instruments. We want to achieve this, and bring new life in

the turntable."[88] The development of products such as the QFO and C1 are primary examples of Vestax's willingness to listen to world-class DJs and to try to deliver marketable products.

Aside from listening to DJs/musicians, Vestax also collects ideas from its global distributors at its annual International Product Meeting. At the meeting, brainstorming sessions are followed by drafting a product's vision. Then "a project team is organized and engineers from various countries gather for the same goal; realizing the 'Vestax product' with advanced technologies."[89] Vestax also claims that it attempts to develop better technologies than bigger corporations and to "exchange ideas of technologies and marketing with other companies in the industry that agree with Vestax's approaches."[90] Vestax has been praised as a company willing to innovate and try news things, often at the expense of sales.

One final twist to the Vestax story is that in fall 2014 rumors began that Vestax was closing its doors.[91] It seemed likely for the company as it was barely visible in the hip-hop/scratch DJ market, and had yet to develop its own software (only partnering with other companies) to work with its controller lines. Some possible evidence of this closure was that Vestax had no new products at NAMM 2014, its new Vestax to the Core store that had opened in Los Angeles closed in August after about six months in business, it has no American distributor, and its website and social media appear to be dead. No official statement has come from Vestax yet, but it recently filed for bankruptcy, which means it is either out of business or could be restructuring itself.[92]

What we see with Vestax's willingness to listen, its successes, and its bankruptcy is that it is a company that is bold and willing to take chances. Sometimes these risks proved profitable (e.g., the 05Pro and PDX-2000) and sometimes those risks were major financial losses (e.g., the Controller One and QFO). There are benefits to letting the world's greatest scratch DJs put dreams on paper and then try to interpret those dreams into a marketable product. However, maybe Vestax listened too much, or only to too few people, and in the end this may have contributed to some of its woes over the last decade.

This chapter started with the story of the Technics SL-1200 turntable and its process of standardization. By looking at the 1200s and some of Vestax's products, the process of technological standardization is explored as a dialectic between culture and industry. In standardization we begin to see technocultural synergism at work as intellectual properties are exchanged between culture

and corporations in R&D (the Vestax TRIX, 05Pro, and 07Pro), and begin-
ning with the Vestax 05 TRIX, how DJs' brand value is harnessed in authenti-
cating electronics. In this chapter we also begin to see how IP rights manifest
within technocultural synergism, not only as a matter of law (e.g., patent and
the 1200's motor), but also rights broadly conceived as the "right" to exploit
ideas in a market as products. The right to exploit manifests as resources, which
may be financial capital, engineering, or relationships with other manufactur-
ers, distributors, and retailers. But, IP rights show how manufacturers are key in
taking an idea and making it into a product, making the abstract into the real,
and the dream into a reality.

However, in the process of technical and technique innovation, inequal-
ities arise, which I suggest is the byproduct of when a network of creativity is
subjected to the ideologies of individualism fostered under American intellec-
tual property law and the capitalist ethos. These inequalities may be related
to financial compensation, but often are associated with credit for innovation
and who is considered the "inventor." Antagonism over credit for innovation
is embedded in hip-hop's history, but the problem centers on how credit is
awarded for innovation that comes from a network, especially when much
of this innovation stems from reinvention of the past. My thesis is that when
hip-hop DJs are manipulated as intellectual properties, then credit for inno-
vation becomes especially problematic. In this chapter, the Vestax 05Pro and
07Pro begin to demonstrate the problem of networked innovation as it relates
to brand name association. The association of brand names to innovation
often assumes or highlights a singular author (the brand), which masks the
true creative network that lies under the surface of technical and technique
innovation.

With standardization and IP exchange and rights explored here in the
context of two defunct manufacturing brands, in the next chapter I want to
look at two corporations whose synergy has produced products that are stan-
dards today: Rane Corporation and Serato Audio Research. While these com-
panies have market dominance, which is the byproduct of their partnership
more than a decade ago, the Serato Scratch Live (SSL) digital vinyl system
has had a lasting effect on hip-hop DJ culture and the DJ product industry
(this is explored in Chapter 6). Thus, in the next chapter I look below the
surface of this corporate synergy by profiling the companies and some of their
technical innovations, and explore the politics of and tensions that have
arisen in the contested invention of digital vinyl.

· 3 ·

EXCHANGE AND RIGHTS IN THE DJ PRODUCT INDUSTRY

Rane Corporation and Serato Audio Research

"People want to put stuff out there and participate. This is information. This is open source. It's just energy. You know, information wants to be free. It's trying to express itself."

—*DJ Focus*[1]

Rane has become a standard mixer brand in hip-hop DJ culture, but in 1998, when Rane released its first 2-channel battle mixer aimed at hip-hop DJs, it was a relatively unknown company among hip-hop DJs. In my estimation, Rane mixers have become a standard because of the quality of the products, Rane's customer service, its relationship to hip-hop DJ culture through endorsement and sponsorship, and, lastly, its decade-long exclusive licensing agreement to produce the hardware for Serato Scratch Live software.

On September 24, 2009, I spent a day at Rane Corporation in Mukilteo, Washington, with its National Sales Manager for Retail & DJ Products, Mike May.[2] While he has done a little bit of everything for Rane in his 20-plus years there, May primarily deals with DJ products, and, in his own words, "Now I get to drive the DJ bus,"[3] which he has been driving for more than a decade. I spent most of the day shadowing him, asking questions, and touring with May, but I also got to meet most management and staff. Rane allowed me to see the service department and the assembly floor where it manufactures most of its products. I was expecting something a bit more corporate and flashy but was surprised by how casual it was; the headquarters had a family feel.

It is important to note how this visit changed the course of my research. When I went to Rane I was mostly interested in its partnership with Serato

and inquiry into the relationship between hip-hop DJs and digital vinyl. However, when talking to May, he told me the story of the development of its TTM 54 mixer, which came through convergence with hip-hop DJs. While I knew of these types of partnerships generally, it was the first time I heard a story like this directly and began thinking that it would be imperative that I be looking at how hip-hop DJs have changed the design and production of DJ products. With that said, this visit changed the scope of this research project and expanded the inquiry vastly.[4]

Rane Corporation

Rane Corporation started as a small operation gearing its products toward live music and pro audio. Incorporated in 1981 in Mukilteo, the company got its reputation for high-quality electronics. Rane was initially founded by middle managers at a high-end consumer electronics company, Phase Linear Corporation. Based on his or her expertise, each owner became a separate department head. According to the company, "This organization created an unusually strong structure, since all department heads had a unique owner's perspective in making it succeed."[5] The quality and performance of its products exceeded some higher-end brands, but they were priced lower. Thus, Rane claimed that it produced a "new middle ground" for price point in the market.[6]

Headed by CEO George Sheppard, Rane is a privately held corporation; therefore, financial data are not public information. According to *Music Trades* data, Rane is an $18 million company with 102 employees,[7] which is up from $13.5 million and 80 employees in 2007. Although its DJ product division has grown in the last seven years, only a portion of Rane's revenue comes from DJ hardware as Rane is also in the markets for live sound and commercial installation.

For Rane, being a privately held corporation means that there are fewer "layers" and a direct conduit exists between decision-makers and other employees. Rane also has full control over the manufacturing process, as its products are assembled on-site (right through a door in the back of the office area). "If there is something that goes wrong with the product, and we get feedback on it," says May, "all it is is stepping into the next room, looking at the parts specifically and testing them."[8] Rane products are also serviced at the Mukilteo headquarters; in comparison to larger corporations, this gives Rane

a great deal of control over production and the exchange between producer and consumer, which Rane can leverage for additional sales and building a good reputation. Rane is one of the few brands in the DJ market with the "Made in U.S.A." label on its mixers.

Rane Corporation sees itself as being committed to its clients as well as to the music culture in general, thus placing "knowledge, integrity, pride and common sense" at the core of its corporate philosophy.[9] Rane's core corporate value is profitability, while its product values are (1) integrity; (2) quality and durability; (3) innovation; and (4) overcoming design or production problems.[10] Rane distributes its products domestically from its headquarters and uses sales representatives within regional territories, as well as a number of international distributors, to get its gear into the hands of retailers.

Rane's first foray into making DJ products came in 1984 when renowned club/disco sound designer Richard Long approached Rane to redesign his X3000 crossover using Rane's proprietary technology. Rane built the X3000A exclusively for Long, and then codesigned other products with him.[11] It was at the encouragement of Long that Rane entered the DJ market in 1986. Rane's first DJ mixer—the MP 24, a 19" mixer intended for club use—first shipped on September 8, 1986, and remained in production for nearly 20 years. Into the late 1990s, the company continued to produce 19" mixers that were oriented toward house music DJs and for club installation.[12] Because of its durable and high-performance products, Rane began garnering a strong reputation in the club industry and among club DJs, but the design of these 19" wide mixers naturally excluded a growing and valuable market: hip-hop DJs.

While at an American Engineering Society (AES) trade show in the late 1990s demoing its club mixers, Rane was approached by four hip-hop and scratch DJs who were interested in the brand: DJ Big Wiz, Sugarcuts, Marz1, and Peter Parker. All four of the DJs recognized the quality of Rane products but stressed that their overall layout and 19" width were not practical for hip-hop DJing. They suggested that Rane should make a product catering to hip-hop DJs since the turntablist movement was at its second peak in the late 1990s, and the Vestax 05Pro had already demonstrated the viability of 10", 2 channel mixers. A few weeks later, these DJs faxed Rane a drawing of some of their ideas, and then the senior analog engineer, Rick Jeffs, and another Rane salesperson flew to New York City to sit down with the four DJs and members of the 5th Platoon DJ crew. In 1998, Rane's first 2-channel battle mixer was born: the TTM 54 (the 54's R&D is extrapolated in the next chapter).

May suggests that Rane was "invited to the DJ party" and that those involved in the R&D process also helped to market the TTM 54 via word of mouth:

> DJs who had given us information about the mixer wanted to see this built. When we built it they were excited about it, and basically started a movement for us in the turntablist world because they went out and basically said, "Hey, Rane has come up with a really great product, you know about this company, you know about their reputation, you should try it." And from that we caught fire. I believe that's when we started to catch fire in the DJ world.[13]

Shortly after the release of the TTM 54, Rane put out a cheaper 2-channel battle mixer as one of its Mojo family of products, the TTM 52 (both the 52 and the 54 are no longer in production at Rane). The creation and success of the 54 are the product of technocultural synergism, and just like the Vestax 05Pro detailed in the last chapter, it demonstrates the importance of IP exchange with DJs, as well as how DJs are manipulated *as* IP.

One of Rane's major technical innovations relevant to a political economy of the hip-hop DJ came in 2001 when it applied for a patent on its contactless magnetic crossfader (eventually awarded in 2004).[14] However, May admits that the magnetic fader idea was not unique to Rane, but the way it was "implemented and executed is."[15] The crossfader uses nickel-plated neodymium-iron-boron magnets, space-age plastic with embedded Teflon, stainless steel bearing rods, and a stainless steel handle.[16] According to Rane, if the fader is maintained, it should never have to be replaced. This magnetic fader was initially released in the TTM 56 in 2001 and became the standard fader technology for most of Rane's products. At the time that this crossfader was introduced, many mixer manufacturers were still relying on income from the sale of replacement faders. In some ways, Rane helped to change the market to benefit DJs by setting a new standard for fader performance by a manufacturer. While the first contact-less crossfader was invented by DJ Focus several years prior (discussed in Chapter 4), Rane was one of the earliest companies to see the need to make a smooth, durable fader to accommodate the needs of DJs.

May calls patents the "audio medals"[17] of the industry—a sign of strong engineering and the ability to come up with ideas of use to consumers—and suggests that Rane is protective of its rights because within the audio industry there are companies that will copy an idea without giving credit. "There are some audio companies in the world today who have made a fair amount of money by doing some of that. They can remain nameless but they know who they are, and I don't have much credence for those folks."[18]

In 2002, after a surprise phone call from pioneering hip-hop DJ Grandmaster Flash and a considerable amount of development, Rane introduced the Empath mixer. This touring/club mixer combines the ideas of Grandmaster Flash with Rane's technology. The Empath puts the options of a 3-channel, 19" club mixer into a 10" mixer (the standard size for most 2-channel battle mixers) and is meant to be a flexible mixer for DJs in various settings. The Empath, however, is now on permanent display at the Smithsonian, and I will look at the synergism and exchange between Rane and Flash in full detail in Chapter 5 to explore the politics of name-brand DJs endorsing DJ products to authenticate them.[19]

Although Rane made technologies that were durable and had a great reputation for performance, Vestax controlled the market for 2-channel battle mixers in the late 1990s/early 2000s. As other manufacturers started moving production to countries such as China to reduce costs, the lower quality of their products became noticeable among hip-hop DJs, and Rane's reputation attracted new customers in the United States. And, in the years after it released the TTM 54, Rane moved from the fringes to the center of the DJ product industry. While Rane's technical innovations, patents, work with DJs in R&D, and use of DJs to market and endorse its product helped to make its mixers the standard, arguably it was its 2004 partnership with the New Zealand–based software company, Serato Audio Research, and the eventual success of the Serato Scratch Live (SSL) product that pushed Rane mixers toward industry and cultural standardization.

In 2004, Rane became the sole licensee and distributor of Scratch Live products, which included all hardware (audio interfaces, control records), and Whitelabel.net (a music distribution service that Rane and Serato provide to numerous record labels). Rane also services all Scratch Live products, although people at Serato handle customer service duties as well. Serato, though, is in charge of updating and adding code to the Scratch Live software while Rane manufactures the hardware. In fall 2013, other companies (e.g., Pioneer) entered into licensing agreements with Serato to make digital vinyl hardware for its new software, Serato DJ, which in effect ended this exclusive agreement with Rane. However, in respect to this book, it is worth exploring the Rane/Serato relationship in detail to show how synergy between corporations can lead to product standardization.

The Rane/Serato synergy began at a NAMM show in 2002. One of Serato's DJs was demoing Studio Scratch Edition, the precursory software to SSL. The DJ who was demoing the product was not happy with the mixer at the booth and wanted a Rane mixer. The Serato guys went to the Rane booth

and talked to Rick Jeffs, and he let Serato borrow a 56. Word got out at the show about this new Serato product as notable DJs stopped by to experience a digital technology that felt just like vinyl.

After NAMM 2002, Serato Audio Research, a software developer, needed to find a hardware manufacturer to design and produce the audio interface for the DVS product it was developing, and Rane responded in a positive way. After signing a nondisclosure agreement, the two companies began sharing intellectual properties. As May explains, "When people exchange their intellectual properties you have to find out, first of all, if you can trust someone, that they are not going to take advantage of you and that you can be like-minded in the approach that you take toward the industry."[20] Rane engineers then improved on Serato's prototype, which impressed Serato. Aside from Rane's reputation for quality and durability, the hardware manufacturer was also able to leverage its 20-year-old international distribution network in the pro audio business. For Serato, Rane's quality and distribution network would be key elements in the eventual standardization of SSL.

The Scratch Live product came to market in 2004, retailing for $500–$600. With the help of endorsements from DJs such as DJ Jazzy Jeff and A-Trak, who were both early proponents of the product, word of mouth quickly spread about Scratch Live and its reliability. Further helping to spread acceptance of SSL among DJs was the fact that laptop computers were becoming stable and could handle more information processing than previously.

By the mid-2000s, the MP3 format was becoming an accepted format for recorded music—by consumers and, begrudgingly, by the recording industry. This is not to say that SSL was fully embraced by all hip-hop DJs at first; in fact, there was pushback, but eventually computer stability, MP3 ubiquity, and product performance chipped at the resistance (I will look at this in full in Chapter 6). The popularity of SSL is revealed in an analytic survey I conducted where 80 percent of the DJs who use DVS use SSL. Out of 51 hip-hop DJs interviewed for this book, only four did not use any DVS, three used Traktor (all three were endorsed by Traktor's producer, Native Instruments), and the remaining 44 used SSL. Also, like other audio blanket terms such as *gramophone* or *CDJ*, most people mistakenly refer to SSL as "Serato." These are all signs that the software is the standard DVS.

"The Scratch Live business and our relationship with Serato has been outstanding and is a great benefit to our company. And, we are proud to be associated with them," May explains. "Our business got more vital and stronger as a result."[21] While Rane helped add credibility to the Serato product, as

SSL achieved standardization, eventually use of Serato's software helped to further solidify the Rane brand and the standardization of Rane's mixers. May recognizes that the success and standardization of the Scratch Live product have increased Rane's exposure. "I mean, we are cross-pollinating with both of our company's legacies and sharing the benefits of that," says May. "They were a smaller, I believe less well-known company. Not any longer, and that's because of the acceptance…. There is a success factor and that is based on the guys who use the gear."[22]

Unlike Technics, who primarily harnessed patent rights to curtail its competition, Rane used its brand reputation, along with an important relationship with Serato, to make its mixers the current industry standard. Rane also worked with DJs in R&D and used them to help design and authenticate its products. However, one thing that Rane has in common with Technics is a strong tie with DMC. Although both Rane and Serato began sponsoring the DMC World DJ Championships in about 2008, it was shortly after Panasonic's announcement that it was discontinuing the SL-1200 turntable that DMC announced that Rane and Serato would be the main co-sponsors of its 2011 World Championships. This co-sponsoring is notable in that 2011 was the first year DMC allowed the use of Scratch Live and other DVS software in its six-minute individual battle—DMC's main and longest tenured event.[23]

"DMC is responsible for fostering the culture of competitive turntablism and Serato are honoured to become a major sponsor of this iconic and prestigious event," says Sam Gribben, former CEO of Serato, in a press release published on the DMC website in 2010.[24] "Preserving the art of vinyl DJing, whilst introducing new technologies for future world champions is a key Serato philosophy. We look forward to a long relationship with DMC, ensuring that competitive DJing continues to move forward into new realms."[25] The only DMC category that remains vinyl-only after 2010 is the head-to-head battle, the DMC Battle for World Supremacy.

Rane is currently the main sponsor of DMC competitions. This synergy, combined with Rane's exchange of IP with credible DJs in both product R&D and endorsement, have helped make its mixers today's industry standard. Like Technics, Rane's increased visibility at the DMC battles has been a powerful marketing tool, but allowing DVS in DMC's most traditional battle category has been subject to praise, critique, and concern. While we have looked at Serato Audio Research primarily within the context of its relationships to Rane, in the

next section I want to outline Serato, its history, and its synergies within the DJ product industry and then explore the debate over DVS invention and patenting.

Serato Audio Research

Serato Audio Research was founded in 1998 by two computer science students, Stephen West and A.J. Bertenshaw, as a pure research company in New Zealand to sell Pitch 'n Time, a pro-audio algorithm product. West had developed the algorithm in 1994, and Bertenshaw suggested commercializing it. After selling the Pitch product primarily to the film industry, and reinvesting the revenues into R&D, West and Bertenshaw started to experiment with the idea of scratching music on a CD in a computer using the mouse. The two began experimenting by pressing timecode to vinyl records, but the technology did not allow for precise scratching and replication of the movement of the vinyl in real time. Through some beta testing with DJs, they were able to come up with a technology that used multiple position indicators and frequency resonation to allow for precise and fast movements with the control vinyl, a technology called NoiseMap. Serato brought this new technology to the 2002 NAMM show, and it was there that the company forged its relationship with Rane, described in the previous section.

The commercial release of Serato Scratch Live (SSL) was in April 2004. The success of the product was immediate, and Serato Audio Research went from a company known for producing a boutique studio product to an internationally recognized brand within the DJ community. "Now people know the brand who aren't even customers of ours," says Sam Gribben, Serato's former CEO, "People know Serato—especially in the US."[26] While SSL was not the first DVS on the market, it was the first standard and stable DVS. Gribben says, "I think that Scratch Live has proven that there is a real market for digital. There are many products out there that do similar things, but (for whatever reasons) it seems that Scratch Live has been a driving force in changing the attitude of the market—digital is really here, and here to stay."[27] This attitude change he speaks of is standardization—both culturally and technologically; it is acceptance of not only a product or system but also of a new way of DJing.

Due to the fact that Serato is a privately held company, financial data on it are sparse. However, from 2007–2009, Serato tripled the staff at its Auckland base to about 27 employees, most of which were involved in technology

research and development. Both West and Bertenshaw retain full ownership of Serato, and in 2014 Bertenshaw replaced Gribben as CEO.[28] In 2005–2006, the company's revenues were reported to be roughly $4.1 million.[29] However, with the successful standardization of its SSL product, making its mark in the ever-expanding digital DJ controller market, and now with the Serato DJ DVS software and partnerships with numerous hardware manufacturers, we can presume that revenues and resources have grown dramatically since 2006.

Like Rane, Serato relied little on advertising to push SSL, but instead used word of mouth within the DJ community, and endorsement by sponsored DJs. Gribben explains:

> We didn't spend huge amounts of money on advertising or promotion, but have been more about having direct communication with our customers. We've had a (website) forum for a long time and anyone can come to us with problems or suggestions and we are very open with them. We admit mistakes and respond quickly and I think users feel they are dealing with real people. You can get on and talk to the engineer that built a feature. A lot of our competitors have heavily censored boards and don't allow criticism of their products to go up.[30]

With SSL essentially marketing itself, capital was freed up to use in product development and to facilitate free upgrades of Serato's software.

With more than 50,000 registered users on the Serato Web forums, Serato is able to get software update ideas from the forum itself (for instance, the sample player upgrade or a feature where flipping the control records on the turntable triggers the next song in a playlist are examples of ideas farmed from its Web forums). With customer feedback shared on its forums and with customer service representatives, Serato is able to harness the ideas of its customers (part of its creative network) to give them better functioning tools with each upgrade, essentially crowdsourcing intellectual properties. In this respect, Serato has made itself open to criticism and not put itself above its customers.

Serato's list of "creative partnerships" with hardware and software companies has continued to grow since it first partnered with Rane in 2004. After three years of planning and development, Serato announced an integrated software and hardware solution for digital DJ controllers called ITCH in 2008.[31] The system uses the ITCH software, similar to the Scratch Live software, located on the DJ's laptop, but connects directly into the ITCH controller for audio file manipulation. The main difference between ITCH and SSL is that all the DJ's mixing is done inside the software with ITCH, instead

of through a DJ mixer. This has changed with the release of the Serato DJ software in 2014.

Although Serato/Rane's SSL is based on DJs using a mixer and promotes Rane's lines of DJ mixers, Serato expressed its interest in developing software geared toward controller application early on. "I think the future lies in hardware and software companies working together to engineer a product that best meets the need of the DJ," says Gribben. "I think that once DJs get used to the idea that they can get solid performance out of a software-and-controller combination, we'll start to see some interesting ideas come out of R&D labs around the world."[32]

With dwindling analog DJ products and CDJ markets, and a stabilized DVS market, the controller market represents a new breed of DJs and a new group of potential customers for companies. However, among all the DJs interviewed for this book, none have exclusively moved to a controller. In fact, hip-hop DJs, whether they primarily work with vinyl or DVS, rarely, if ever, use controllers. For hip-hop DJs accustomed to manipulating 12"/7" discs, transitioning to the 3"–6" jog wheel of a controller has not been embraced, possibly because such small surfaces compromise and affect manipulation capabilities. Furthermore, since manufacturers are developing controllers that can fit in a laptop bag, controllers are usually compressed versions of the two turntable/mixer setup, and all control features are squeezed into a significantly smaller workspace. Hip-hop DJs require a tactile medium, and controllers, like CDJs, lack that feel that is required for manipulation.

Aside from the development of DJ computer software and hardware partnerships, Serato has diversified into the digital distribution of music with Serato Whitelabel Delivery Network (Whitelabel.net). Whitelabel.net is a significant development because record labels are able to harness the DJ's cultural power as taste-maker and can test new songs in regional markets. Launched in November 2008, Whitelabel.net is a system that allows record labels to deliver promotional releases directly to DJs and, according to Gribben, allows DJs to influence the music industry: "DJs know which records work and which don't. Whitelabel.net provides a way for them to get this information directly to the record labels."[33] This system is made accessible to those who have registered their software with Serato.[34]

Whitelabel.net gives record labels statistics about individual DJs who download a specific song, but not information about how many plays, etc. Serato also has directly partnered with the world's two largest recording companies in this venture (Universal Music Group [UMG] and Sony Music

Entertainment), which represents the first collaboration between major recording companies and a DJ technology company.[35] While developing the service, UMG gave Serato input about distribution and how to make the service appeal to record labels.

Currently, Whitelabel.net distributes music for all of UMG's and Sony's subsidiary labels, and for a total of 515 major/independent labels. "Using their Whitelabel.net service, we can reach the DJ directly and quickly with new music. Whitelabel.net is more efficient than sending vinyl records and more secure than delivering conventional audio files over the Internet," says Vincent Freda, executive vice president of digital logistics for UMG.[36] Serato has a per-track charge for record labels to be able to use their service. Dave George, Serato's plug-in development manager, suggests that Whitelabel.net is used differently by different customers: "Majors may want to use it in a carefully targeted way while independents may want tracks to have as wide exposure as possible."[37]

Another Serato business related to the recording industry is Serato Pressings, which produces vinyl records that have the copyrighted Serato NoiseMap control tone on one side and an actual song on the other. Unlike Whitelabel.net, Rane is not involved in the Serato Pressings business. Instead, Serato works selectively with record labels in this venture. The record labels officially license the NoiseMap tone from Serato, and then pay royalties to Serato based on units sold. According to a former product manager for Serato pressings, Bill Mitsakos, "Serato is genuinely interested in preserving vinyl culture.... Serato Pressings allows us to work with record labels and the few remaining pressing plants to cut a collectible series of records."[38] The records are usually manufactured in limited pressings and are intended as collector's items, sometimes fetching big money on eBay after initial release. Interestingly, according to Serato, citing "industry sources," its regular control record used for SSL is the highest selling 12" vinyl record in the last 14 years.

Serato's most recent, industry-changing announcement came on September 4, 2013. In a video statement by Sam Gribben, the company announced that it was going to stop supporting SSL in 2015 (after nearly 40 software updates and 7 million downloads), and instead make its Serato DJ software its standard DVS *and* controller software.[39] Although Serato DJ Intro was released in September 2011 as a controller-only software with numerous hardware partners (alongside its ITCH software), the company found it complicated to effectively develop different software for DVS and controller hardware, and so Serato DJ 1.5 is the beginning of its dual-tier DJ software; essentially, it is a hybrid of SSL and ITCH.

This announcement was greeted with controversy from the DJ community for two main reasons. First, Serato DJ 1.5 will not work with the Rane TTM57 mixer or the SL1 hub, products that many DJs still use. By rendering the products obsolete, it forces DJs to learn new software, and, in the classic form of technical linkage,[40] to use the new software DJs will have to upgrade their hardware. Since SSL's inception, software upgrades have been free and worked with all the Rane hardware. DJs can continue to use the current version of SSL and the 57/SL1 past 2015; Rane and Serato promise to continue to support the 57 and SL1 indefinitely.

Second, controversy was mired in the switchover to new software for professional DJs. If you're a professional DJ, learning a new software while you're working is problematic, so Serato has engineered the software to be familiar. The main controversy in regards to the software itself is the inclusion of a sync feature. Sync is a common feature found in controller-specific software that allows a DJ to mix two songs together simply by pressing the sync button. Sync, in essence, is an algorithm that matches the two tempos of different songs automatically, and many DJs disdain the function because it means that DJs no longer have to learn even the most basic DJ skill: mixing. In regards to sync in Serato DJ 1.5, Gribben says, "It's an interesting one and a very divisive feature. Some DJs can't believe we haven't done it yet, others claim that it will destroy the art of DJing."[41] Sync functions are often considered corny, whack, and inauthentic by most hip-hop DJs, and generally anybody caught using sync is derided as a "sucker." Serato's rebuttal to such critiques of inauthenticity is that DJs don't have to use it and can ignore it.

Serato DJ 1.5 will work with newer Rane products,[42] and Serato DJ 1.5 will also work with two new mixers that will be retailing in the $2,200 range: the Rane Sixty-Four and the Pioneer DJM-900SRT. And here is where this software release benefits Serato economically. Whereas with SSL it had an exclusive licensing agreement with Rane to manufacture its DVS hardware, Serato can now license and form partnerships with other hardware manufacturers. In this case, they are joining up with Pioneer, the biggest company with a toe in the DJ product industry. Pioneer's DJM line of mixers is particularly popular in club installations and within the financially fruitful EDM scene (Rane is more popular among hip-hop styled DJs). With Rane as the sole manufacturer of Serato DVS hardware for nearly a decade, the company has a major advantage in the marketplace, but as its hardware monopoly crumbles, it will be interesting to see how or if this "licensing pool" will affect Rane's bottom line and viability moving forward.

Thus far, we have seen how Serato has formed a series of creative partnerships in which it licenses its technologies to other companies, or provides services that distribute other companies' intellectual properties. However, unlike some of the other companies discussed in this book, Serato has rarely been involved in patents, but instead licenses its intellectual properties to other companies that manufacture and distribute them, likely relying on trade secrets and nondisclosure agreements to protect its IP.[43]

Utilizing a series of noncompetition and nondisclosure agreements, trade secrets allow for a perpetual monopoly over secret information that gives an inventor an advantage over its competition. The holder of a trade secret is not necessarily guaranteed protection by federal law like a patent, but it is the holder's responsibility to share a secret with trusted parties. If another party discovers a trade secret through reverse engineering, and as long as they do not sign any disclosures, there are no laws barring them from entering into competition. Many companies in the DJ product industry use trade secrets and pitch and/or develop technologies with parties they trust. However, it has been a common practice in the industry for manufacturers to reverse engineer products and then incorporate those features into products, as well as simply using popular products' designs/features by other manufacturers in new products (a form of technological sampling, if you will).

Serato has achieved adopted more of an open source mentality and welcomes competition. Gribben says, "Competition is a good thing. It's good for the consumer, good for the industry, and ultimately good for us. We don't want to compete on price—quality is always going to be what separates us from the competition."[44] Scratch Live has acheived market dominance and standardization without using patents, although Serato is active in licensing its intellectual properties to other companies it has entered into working agreements with. Despite Serato's claim of being open source, the invention and ownership of the idea behind DVS is highly contested. Thus, in the next subsection, the history of the digitization of DJ products and the contested origins of DVS are explored.

Digitization and the Contested Invention of DVS

For its first 25 years, the hip-hop DJ scene relied solely on analog technology, because vinyl records, turntables, and a mixer allowed for hands-on manipulation of recorded music. According to Harrison, vinyl records are "hip hop's original and, therefore, most authentic medium,"[45] and the hip-hop DJ's most

prized possession, the 12" vinyl disc, is a standard tool of the trade.[46] Before the release of stable digital vinyl systems, according to Katz, hip-hop DJs and turntablists remained "resolutely analog in a digital age."[47] Thus, the digitization of DJ technology, especially with hip-hop DJs, was not a simple process.

In 1994, Pioneer Electronics put its CDJ-500 on the market, a DJ CD player that had functions such as pitch adjustment and looping capabilities. One thing the CDJ-500 did not allow for was hands-on manipulation of CD media, and thus garnered little acceptance within hip-hop circles. A major leap came in 2001 when Pioneer released the CDJ-1000, a CD player that emulated vinyl and allowed for scratching (it had a control platter on top whose movements would be translated into the audio). However, with the platter size of CDJs being less than six inches, few hip-hop DJs adopted the technology, or would only use it as a complement to their analog setup. Michael Endelman summed up digital negotiation in a 2002 article about CDJs in the *New York Times*:

> Hip hop D.J.'s are a stubborn and purist bunch, dedicated to the pairing of vinyl and turntables for reasons romantic as well as rational. In a genre that is obsessed with notions of authenticity, vinyl signifies a connection to hip hop's historical lineage, which starts with those South Bronx pioneers who began a global movement with little more than two turntables and a microphone.[48]

The Pioneer CDJ product line became a standard for electronic music DJs and in clubs around the world, to the extent that the term *CDJ* has become the commonly accepted way of describing any CD player that emulates vinyl, regardless of manufacturer.

During the same time when CDJs were becoming standard DJ tools in the electronic dance music scene, the MP3 was slowly growing into the standard consumer format for audio storage. With the small platters of CDJs hindering acceptance among hip-hop DJs, software developers were the first to design technology that would allow for the manipulation of MP3s using traditional vinyl records and turntables. The basic idea behind the digital vinyl system (DVS) is to press encoded timecode to a vinyl record; the timecode is then decoded and provides information based on the needle's position on the record, which then reflects changes in audio that is selected from a laptop.[49] DVS products usually use an audio interface, which is an analog-to-digital convertor (ADC). ADCs can be an external box that wires into a mixer and to a laptop, or the ADC can be inside of the mixer. The ADC communicates changes of the signal from the control records with the software, and then those changes

are reflected in the audio file that is routed through the mixer and eventually over the loudspeakers.

The first DVS to be commercially released was FinalScratch in January 2002, although the "idea" was in the public domain years earlier. The Dutch company N2IT developed the software for the system, while Stanton Magnetics, a private American corporation that had only been in the DJ product industry for a couple years, manufactured the ScratchAmp (the audio interface that connects to the DJ mixer). N2IT had been showing off working prototypes as early as 1998,[50] and eventually the intellectual properties for the software were licensed by Stanton, which was able to use its experience and connections in the DJ product industry to distribute FinalScratch as a package complete with the software, ScratchAmp, and vinyl control records used to manipulate MP3s.

At $3,000 and with stability glitches and issues pertaining to latency,[51] FinalScratch was slow to catch on with hip-hop DJs. At the time, laptops were also not reliable and MP3s were not a standard music consumption format, so it was challenging to get music digitally and computers had a hard time working the software. To help authenticate its product, Stanton brought in the three-time World DMC champion DJ Craze and the 5th Platoon DJ crew as FinalScratch product endorsees. The endorsements helped, and the system slowly gained some credibility with hip-hop DJs, but there were too many horror stories of DJs having to reboot their computers during the middle of their sets that loomed over FinalScratch's reputation.

Around 2003, Stanton began working with the German music software/hardware company Native Instruments (NI), and it was NI's Traktor FinalScratch software that began pushing DVS into the mainstream.[52] The partnership gave Stanton a Windows/Mac version of the software, while NI was able to use the FinalScratch timecode system in its own line of Traktor products. The companies had several successful years as the Traktor product gained respect with DJs, but in 2006 Stanton and NI ended their partnership. Shortly thereafter, NI released a competing product, Traktor Scratch Pro DVS. Stanton has since stopped manufacturing and developing the ScratchAmp audio interface and any other DVS product, but Traktor Scratch and Serato Scratch Live/Serato DJ continue to be market leaders.[53] But there is more to the invention narrative of DVS.

In 2007, amid countless blog and forum posts, hip-hop fans and DJs alike were talking about rumors surrounding the leader and main producer for the rap group Wu-Tang Clan, RZA. The source of the frenzy had nothing to do

with the typical absurdities surrounding the artist, but came from a video interview between KOTORIMAG.COM and RZA in which he claims to have "invented" Serato Scratch Live.[54]

"1997, I'm in Switzerland, a rainbow leads me to this Switzerland guy's house," said RZA.[55] The Swiss man had a technical system that allowed him to scratch digital sound in real time, a device the man called "The Replicator." RZA says he then talked business with the man and told him that "I want to bring this to the world." RZA claims to have founded a company called Wu-Electronics and invested $2 million into the development of 50 prototypes of The Replicator, which he says were then brought to an AES trade show without him. He claims The Replicator had been showcased at the AES show, and several months later Stanton's FinalScratch, the first commercial DVS, was being displayed at trade shows.

In the interview, RZA discusses both global and domestic patent rights, a process he claims to have spent $50,000 on. He further claims that a one-year lawsuit ensued, but that the full legal battle would have been too costly. Then Numark approached him with a deal for The Replicator, one that he calls "fucked up," and Wu-Electronics dissolved shortly thereafter. RZA suggests that The Replicator worked differently than FinalScratch and SSL. "That's another thing that I did to help hip hop out that hip hop might not know," he said. "I invested into that technology. The big companies took it and made it available to the world, but that was me who put the first $2 million into that technology. Nobody would have invested into that technology, nobody even believed that there was a market for it."[56] RZA suggests that if he had $10 million to put into R&D, marketing, and especially into a legal battle, then The Replicator would now be the standard technology.

RZA's claims were met with skepticism, especially because he is known for embellishment,[57] but on November 17, 2013, a video surfaced on YouTube of a 1995 demonstration by two Swiss DJs (Cutmaster Funk and DJ Steel) of a DVS-type technology called the Whirlwind Replicator.[58] It is strikingly similar to what RZA described in his interview. RZA's claims, however, demonstrate the contestation of invention and antagonisms over intellectual property rights in the market for digital vinyl systems, which I would like to detail further here.

Let us reflect back to Stanton's FinalScratch, originally developed by N2IT, and eventually developed in partnership with Native Instruments (NI). When Stanton and NI ended their partnership in 2006, and after the two companies parted ways, NI released a competing DVS product, Traktor

Scratch Pro. The fallout between these two companies caused a series of legal actions, ultimately bringing FinalScratch's original developer, N2IT, out of the woodwork to lay proprietary claim to the *idea* behind DVS.

Instead of finding an exclusive software developer to replace NI, Stanton released FinalScratch Open in 2007 as way of using the ScratchAmp 2 with other DVS software. According to Stanton, this would allow big and small software companies to take advantage of the FinalScratch hardware system for the control of their software. Because Stanton no longer had an exclusive software, it suggested that Open would benefit customers who already had a ScratchAmp: "We believe that by providing this technology free of charge to developers, as well as linking its use with the ScratchAmp, FinalScratch users will now enjoy an unbelievable new realm of possibility. FinalScratch OPEN now has the potential to become a cross software standard for vinyl control."[59] The company claimed that this would allow DJs who owned the ScratchAmp to choose the software that best-suited their style as long as the hardware/software combinations were compatible. With exclusive licensing agreements or partnerships between software developers and hardware manufacturers as standard practice, there has been little movement with Open.

Eventually the NI/Stanton fallout set off a number of patent disputes between N2IT and Native Instruments. In 2000 and 2002, N2IT filed for a patent for playing digital music using timecode encoded records, a technology used by most DVS products, and then developed it with Stanton and NI. In 2007, N2IT claimed that NI infringed on its patented timecode technology, and a year later the parties settled out of court. The end result is that NI agreed to pay a per-use license to N2IT for its patented idea that is used in Traktor Scratch, which is currently the largest competitor against Serato products in the DVS market. In this case, the validity of N2IT's patent was upheld; thus, there was fear that N2IT may start going after other DVS manufacturers, which would likely result in other lawsuits, presumably against Serato.

N2IT Holding B.V., based out of Amsterdam, has applied for and been rewarded several U.S. patents for disc mechanisms used in signal processing for DVS products.[60] N2IT, naming Mark-Jan Bastian as inventor, also applied for patents that protect an "apparatus for controlling a digital audio signal" and a "method for signal processing and an apparatus therefore." N2IT got patent protection, first in the Netherlands in 2000, on the *idea* of using timecode encoded vinyl for DJing.

In 2008, after the settlement, N2IT Holding B.V. filed a complaint against M-Audio LLC, claiming that M-Audio's Torq Conectiv Vinyl/CD infringed

on its patent.[61] "We filed this lawsuit for one simple reason," says Jeff Boggs, N2IT's legal representation. "N2IT's property is being knowingly and unfairly exploited. Our system of rewarding inventors for their innovative ideas is jeopardized when intellectual property rights are ignored."[62] By November 2009, the case had been dismissed, either because N2IT and M-Audio decided to settle out of court or because M-Audio's corporate parent, the $680 million Avid Technology, Inc., was ready to push back. One of the problems in this suit is that M-Audio does not own the Torq DVS technology, but in fact licenses it from Ms. Pinky, a small developer of low-cost DVS products. The general thought within the industry is that N2IT was going after some of the smaller DVS companies that use its patented idea to have some precedence to go after Serato.

In a recent article by Steven Carroll,[63] an engineer and designer behind the now defunct Intimidation DJ mixer company, he gives reason to believe that N2IT's patents are invalid because the *idea* behind DVS was already in the public domain as early as 1995 or 1996. Therefore, N2IT may have had the first commercial product using timecode encoded vinyl with FinalScratch and received a Dutch patent on the idea in 2000 (filing a U.S. application in 2002 and a European Union application in 2004), but a major flaw in its applications is that it failed to mention prior art, which may be The Replicator that RZA talked about.

In patent law, prior art is any information relevant to an idea/invention's claims of originality published before the patent application. Prior art can be published in any form, such as a research paper or a product demonstration, and must be cited in the patent application (almost all patents and innovations in general are comprised of prior art). To assess the validity of a patent application, the invention/idea seeking patent must not be described in prior art, even if the prior art has not received patent protection (although if prior art is patented, it significantly reduces the originality of the invention/idea being reviewed). Rules vary on a country-to-country basis, and, as an entity seeking patent protection you must apply in each country in which you would like to have patent rights.

Carroll, who was active at the NAMM and Musikmesse trade shows in the 1990s, lays out some of the inventors and ideas relevant to N2IT's claims of originality in his article. Carroll cites an invention by a Swiss man, André Rickli, which was demonstrated at the 1996 Musikmesse, as some of the original prior art to timecode encoded vinyl. However, Rickli's prototype did not use timecode vinyl (see Figure 3.1). The device had a

rotating disc on a large arm that was lowered onto the center of the turn-table and replicated the movement of the disc. When the disc was moved, it manipulated sound stored on the computer. Carroll suggests that Rickli was trying to find a manufacturer to help bring the product to market and that he may have gone into business with RZA. And, in the Whirlwind Replicator video that surfaced in 2013, the technology is nearly identical to Rickli's patent drawing.

Figure 3.1. Image of Rickli's drawing from his patent application, WO 97/01168, granted on January 9, 1997.

Carroll's article suggests that James Russell, who was a peer of Steve West (one of the founders of Serato) at the University of Auckland, also experimented with using turntables for digital audio playback as early as 1996. According to Sam Gribben, some of Russell's ideas made it into Serato's prototype for SSL, Scratch Studio Edition. "He [Russell] was exploring all kinds of optical, mechanical and even magnetic methods of tracking record movement," says Gribben. "Steve suggested that he could press a control tone onto the record. James incorporated the suggested method into his research paper, which was published at the end of 1996. It wasn't until 2001 that Serato commercialized the method."[64] However, Carroll challenges West's claims, questioning why West/Russell did not try to patent their idea or challenge the validity of N2IT's patent.[65]

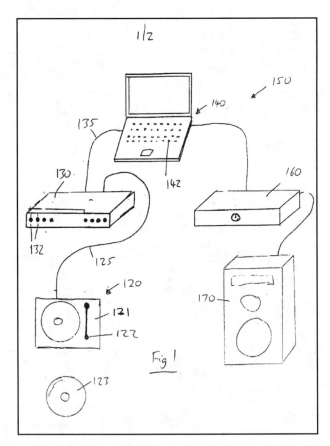

Fig 1

Figure 3.2. Steven Carroll's patent drawing (#9804037.1) for his DVS concept, filed in the United Kingdom on February 25, 1998.

Also, Chris Bauer's 1998 thesis at Middlesex University described the DVS concept, which he publicly demonstrated in autumn 1998 as the Spacedeck project. Bauer's innovation used SMPTE timecode, a relatively standard format in video at the time, pressed to vinyl, and the Spacedeck system used a computer to read the timecode signal, which was then replicated in the manipulation of a digital audio file. Bauer claims to have reached out to N2IT in 2001 to see if it had planned to patent the idea of timecode encoded vinyl, which it did, but was unwilling to discuss the matter any further with him. When FinalScratch gained market presence by 2003, Bauer hired a lawyer:

> i decide it is time to do something. N2IT's patent is not yet granted. i contact a patent lawyer, who writes to N2IT and tells them that unless they wish to start a conversation with me regarding their patent application and my project, i will make objections/observations to the EU patent office, citing my project and MA thesis. N2IT do not respond, so objections/observations are made, to the effect of the patent should not be granted as the invention is not novel.[66]

In respect to patentability, an invention is novel when it is new and therefore it has not been made known to the public before. Prior to N2IT being granted a patent, Bauer could not find any evidence that the company had built or exhibited DVS technology before he had. In January 2009, shortly after N2IT settled with Native Instruments and before its suit against M-Audio, Bauer was contacted by Serato's Steve West and Ms. Pinky's Scott Wardle about his thesis to add his research to their collections of prior art (presumably in anticipation of N2IT claiming that their DVS products infringed on the patented idea). From May until November 2009, Bauer was also in discussion with M-Audio's lawyers about the Spacedeck project, apparently in its preparation for the suit brought on them by N2IT.

Carroll also discusses his role in the concept behind DVS and using timecode encoded vinyl to control digital music, an idea that he claims he began developing in autumn 1997. Although he never developed the idea or made any prototypes, he spoke with third-party companies about trying to develop it for commercial use and filed for a patent in the United Kingdom in February 1998 (see Figure 3.2). With market conditions and the fact that MP3s were not a standard music playback format at the time, Carroll was unable to find another company to invest and develop the idea, and therefore stopped

pursuing patent protection. Shortly thereafter, Carroll left the industry, only to find out years later that the DVS idea had been developed and that there was debate over who had conceived the idea. Carroll admits that he is unaware of N2IT's history in the market but says, "It appeared to me to that they came from nowhere but somehow had managed to team up with Stanton to bring this to market, after-which they appear to have vanished."[67]

In respect to N2IT's case against M-Audio, on September 4, 2009, a judge in Virginia district court dismissed the case due to "inequitable conduct" on behalf of the plaintiff, N2IT. Most likely this is due to the fact that N2IT failed to cite prior art in its patent application, which would have ultimately led to its patent application being denied. The interesting thing about the series of lawsuits brought on by N2IT is that it seems to be spearheaded by John Acquaviva, one of the first DJs, along with Richie Hawtin, to do R&D and demo FinalScratch in the early 2000s. Mark-Jan Bastian (named as inventor on N2IT's patents) and Timothy Self, who incorporated N2IT, have not really been present in these suits. In a press release published on *Skratchworx*, Acquaviva is named as the CEO of N2IT, and he says, "FinalScratch is noted as an industry leader…. The unauthorized use of this technology is irreparably harming our existing business."[68]

Apparently N2IT is no longer a business; instead, it is what most would consider a "patent troll" as it is suing but not researching and developing DVS products, nor does it have any products on the market. Thus, other DVS products are not harming N2IT's nonexistent business. What also makes N2IT seem opportunistic is that Acquaviva, not the original founder/inventor, is leading the lawsuit charge. It is likely that Acquaviva bought the patent rights from the original founders to bring suit on successful commercial products in the DVS market rather than to further develop the product.

The important thing to note in all of this controversy regarding N2IT is that courts have recognized the patent on the idea of using timecode encoded vinyl, to the extent that Native Instruments pays (or paid) a licensing fee to N2IT. This could still lead to future lawsuits. It is unclear what happened in its suit against M-Audio, and what may happen in the future, but surely if N2IT's patents are recognized by the courts, it will not only change the industry but also affect the people intellectual property laws are ultimately in place to protect: consumers.

Technocultural synergism is a complex process that begins with the cultural manipulation of intellectual properties and re-coding the uses and meanings associated with those IPs. Chapter 1 deconstructed this phase of IP manipulation, while the last two chapters profiled companies that cater to IP

manipulation by producing hardware that encodes the ideas and technique innovations of hip-hop DJs. By analyzing the various ways in which these manufacturing brands have achieved industry standardization of some of their products, we begin to see how the politics of the exchange and the rights to exploit IPs in markets manifests.

Standardization within the context of technocultural synergism is a cultural process, although some examples here illustrate how patents and licensing, as well as industrial behavior generally speaking, plays into the process. What stands out in looking at manufacturing brands and their products is the importance of exchange with DJs in product design and branding. When DJs are used directly in R&D and indirectly through the encoding of technique innovation into products, as well as associating DJs' brand names and authenticity with products, technocultural synergism reveals the hip-hop DJ *as* intellectual properties that are manipulated by industry.

Other than standard products, IP exchange and rights create antagonisms over credit for innovations. While credit or lack thereof is part of the issue, I argue that the nature of innovation within hip-hop DJ culture, which is collaborative and reinventive, does not neatly fit into a system and ideology that rewards the singular author or genius. Using case studies and technocultural histories of products (some already mentioned), the next two chapters explore the hip-hop DJ *as* intellectual property to reveal some of the tensions created through technocultural synergism. The goal is to show that hip-hop DJ culture is itself a valuable intellectual property.

· 4 ·

THE HIP-HOP DJ AS
INTELLECTUAL PROPERTY

Research and Development

"The technology is already in us."

—*DJ Steve Dee*[1]

One of my favorite things to do when it comes to DJing is a scratch session. Typically, this involves a few DJs getting together, hooking up a couple DJ setups, and practicing and experimenting with scratch techniques. Sometimes we scratch over a beat, or sometimes we play as a band with someone playing drums, someone on bass, someone with a melody, and someone scratching various vocal samples. It is an open environment where people showcase their styles, techniques, and patterns. We also show each other what we are doing and break down techniques. We learn from one another; we listen and try to copy what others are doing, trying to bring our own style to it, building on what each other is doing. At the end of a session, I leave with some new ideas, learn new techniques and improve on old ones, and gain inspiration to keep advancing my skill-set. The session is where creativity flourishes freely.

To me, the session represents more than just practice time. The session demonstrates how sharing and collaboration help DJs and DJ culture to advance. Open sharing—done in the name of education and advancing creativity within a community—reflects what we see in some corners of the Internet and the ideology of new media. And, to me, this is the guiding logic of hip-hop DJ culture (or, maybe hip-hop DJ culture is the guiding logic of new media). What is being shared in the session, and in hip-hop culture more broadly,

are ideas about manipulating sound, in essence, intellectual properties about manipulating intellectual properties. This willingness to share ideas in the name of progressing the art form is an important characteristic of hip-hop DJ culture. But technique innovation can only go so far on its own, and therefore convergence between culture and industry is necessary to bring new technical innovations into the culture.

Although there is much to admire about hip-hop DJ culture, it would be wise not to romanticize its collaborative aspects. There are also clearly elements of individualism, competition, and proprietary behavior that have been enfolded into the network. While there is a self-governed hierarchy within it, hip-hop DJ culture creativity flourishes through a flattened and decentralized network. From what I have seen, though, when culture and industry converge, money and credit are given to some and not others, which compromises individual legacies, and then "viruses" enter the network and undermine the open source logic that is at the heart of the culture.[2]

Within the context of technocultural synergism, when ideas are exchanged and those rights are exploited in a market creating haves and have-nots, antagonisms arise in the hip-hop DJ network. These antagonisms are rooted in the fact that DJs are now themselves manipulated by industry *as* intellectual properties. It is here that technocultural synergism comes full circle: hip-hop DJs manipulate IP in the form of records and playback technologies; through this love of manipulation and to create better tools for the culture, they exchange ideas with manufacturers; these manufacturers have the "rights" to exploit these IPs in a market, and thus manipulate DJs *as* intellectual properties in the R&D and branding phases.

While you would think financial compensation or lack thereof was the root of antagonism, from what I have found it is actually credit for innovation that is the main problem. Although money would be nice, many DJs who are manipulated as intellectual properties allow this to happen because of a love for the culture, and thus being recognized for these contributions is a major priority. In most cases, it is nearly impossible to pinpoint innovation to one source since hip-hop DJ technique innovation and technical innovation are the byproduct of reinvention, based on prior art, and typically come from many sources within the network. However, innovation is selectively credited and compensated, and when hip-hop DJ culture meets industry, the logic of the singular author and individual genius constructed under capitalism seeps into the network. DJs who might feel they have a claim to credit for innovations that others are credited with often feel antagonistic and bicker with others.

In this chapter, I will outline some of the ways that hip-hop DJs' authorship has been recognized by the industry, as well as general conflicts over credit for such authorship, which I started addressing in the last chapters. I begin by examining issues related to research and development (R&D) and the exchange of intellectual properties in general, as well some case studies of innovations and how credit is given. The main goal of this chapter is to explore how important innovations are the by-product of larger creative networks rather than divine technologies/techniques invented by individual geniuses.

The creative authorship of the hip-hop DJ is seldom recognized by the industry as intellectual property because few DJs have received patents, copyrights, or even credit for their ideas. Because DJs use the copyrighted works of others as raw material in their art, they generally do not receive copyright or publishing credit for their music. As we will see, since hip-hop DJs make their ideas about equipment design and function public domain the minute they share them, rarely are they given the status of "inventor" or "author" within capitalist society. Even if a DJ hopes to safeguard an idea, DJs usually lack the resources to patent or manufacture and distribute gear. Therefore, hip-hop DJs' intellectual properties have been recognized most often as brands, a form of authorship that is highly valuable to industries, which I will discuss in Chapter 5.

Presenting hip-hop DJs as intellectual properties that are manipulated by industry through technocultural synergism, this book seeks to make an important theoretical contribution to discussions of hip-hop creativity and commerce. Both popular and academic publications most often portray DJs and sampling in relationship to intellectual property (and laws) by focusing on how IP is appropriated, stolen, and remixed by culture. Shifting our focus to technocultural synergism, which renders DJs themselves as IP, can help us see how the ideas and art of hip-hop DJs are also extremely valuable to the music and technology industries.

R&D and Exchanging Intellectual Properties

When the DJ-as-artist began taking shape in the late 1960s, the only tools they had at their fingertips had been designed for TV/radio broadcast or live sound. As the demand for DJs in venues rose in the 1970s, more products were made with the DJ technique in mind. Disco DJs were the first to get attention

from technology manufacturers, in terms of having products developed for
their use. At first, mixers were made to be installed in discotheques, and were
often custom-made for installation. In 1971, the first DJ-specific mixer (nick-
named "Rosie") was custom designed by Alex Rosner for Francis Grasso to use
at the Haven Club; its basic features reflected the needs of Grasso's mixing
technique.[3] Later that year, the Bozak CMA-10–2DL rotary club mixer be-
came the first commercially available DJ mixer. By the mid-1970s, manufac-
turers began recognizing and developing mixers for mobile DJs as well, most
notably the Clubman line of mixers manufactured by Meteor Light & Sound,
Co. and the GLi 3800 and 3880.[4]

However, it was the stepchild of the disco DJ, the house and club DJ,
who would make the DJ a cultural icon, and in the early 1980s most mix-
ers were manufactured with that style of DJing in mind. Hip-hop DJs in the
1970s/1980s were not recognized as a market by manufacturers, so they worked
with products made for other types of DJing. For much of the early 1980s, hip-
hop DJs used the GLi PMX-9000, a 19"-wide mixer made for club mixing, and
a favorite with DJ Cheese and Jam Master Jay. By the early 1990s, scratch and
hip-hop DJs began attracting the industry's attention, which was largely due
to the legitimization of rap music throughout the 1980s, as well as visibility of
the DJ in visual media and on recordings.

As we saw in Chapter 2, manufacturers did not start catering to hip-hop
DJs' needs until Vestax listened to DJ Trix and put out the mixer he designed,
the PMC-05 TRIX, in 1990. Until that point, hip-hop DJs would find a mixer
in a manufacturer's line that best worked for them; these mixers usually had a
horizontal crossfader, two channels (inputs for two turntables), were 10"–12"
wide, and had a phono/line switch (aka "clicker").[5] In general, these were the
most basic mixers in a manufacturer's line as most companies were designing
more complex 19" mixers for club DJs. In the 1980s, the favorite mixers of hip-
hop DJs were the Gemini MX-1100 or MX-2200, the Numark DM-500, and
for West Coast DJs, the Numark DM-1150a. These products worked for hip-
hop DJs and were thus adopted and adapted by them, but these products were
not made for or designed with scratching and manipulation in mind. This is
why the PMC-05 TRIX and Vestax's willingness to listen are monumental in
the history of DJing (although the mixer itself did not make a huge impact,
especially in the United States where it was rare). As we witnessed in the pre-
vious two chapters, hip-hop DJ mixers, and also turntables made specifically
for DJing, are byproducts of collective intelligence and convergence. In fact,
they are produced through a creative network and not by a singular genius.

Henry Jenkins theorizes collective intelligence and convergence culture in the context of fan consumption of popular media as it meets the digital era, suggesting that convergence is about active users/consumers who are empowered by new media technologies.[6] Collective intelligence is a process occurring in our minds and with social interactions between people, and to Jenkins "it is an ongoing process occurring at various intersections between media technologies, industries, content, and audiences."[7] Convergence is changing the relationship between producers (corporations) and consumers, a dialectic he calls "participatory culture." Jenkins delineates how media corporations are acknowledging these new patterns in consumption, and thus, two types of convergence are occurring. First, convergence is corporate, as multinational corporations have strengthened their control on market, but convergence is also happening at the grassroots level where "digitally empowered consumers" shape the production, distribution, and reception of the media content bombarding them from the corporate level. Convergence is where both a top-down push and a bottom-up pull collide.

Although there is much to admire about Jenkins's work, this "new" phenomenon that Jenkins discusses actually began occurring long before fans were actively participating in Web forums for popular television shows. While there also may be other instances, much of what Jenkins describes in convergence culture, participatory culture, and collective intelligence has been happening in hip-hop DJ culture since its inception. Another element missing from Jenkins's celebration of new media is that it often fails to delve into the power dynamics of convergence. Jenkins often suggests that consumers are empowered, but rarely does he turn to cases that might suggest otherwise. For example, consumers are still using corporately produced texts and technologies, and corporations are also incorporating consumers' ideas into future texts and technologies and then selling those products back to those consumers. So, consumers are empowered on one end and exploited as intellectual properties on the other end. What Jenkins overlooks is what I have been referring to as technocultural synergism.

In Chapter 2, the R&D process behind the Vestax PMC-05Pro was detailed to illustrate one of the early successful instances of manufacturers listening to input from hip-hop DJs. By listening to the technological desires of DJs, who were ultimately the end-users of its products, Vestax was able to develop commodities for that market. Shortkut says, "They were trying to spearhead that whole vision of 'well, we are directly working with DJs'.... So they set the standard now. What company now doesn't want to get the new DMC

Champion endorsing their shit? Back then that was unheard of."[8] Because of Vestax's success in the late 1990s, most companies in the industry have followed and learned to incorporate DJs in product design.

Shortkut explains, "I'm glad to see that companies are now listening to the DJs and getting input from the DJs, I mean why wouldn't they? And now they are listening so that's good, but mind you back in the '90s, like '90 to '93 when I was doing these kinds of things, they had no idea."[9] But what Vestax did and what the company laid the groundwork for in terms of R&D was getting feedback from credible and talented DJs. Disk, who also gave Vestax some feedback on the 05Pro, says, "The only thing I can say is for them [Vestax] taking the idea first and making it real because we wanted a fader that would be smooth and something that was comfortable for us.... They took an idea from us and they did it."[10]

I cannot stress the importance of Vestax's willingness to listen and the financial risk it took to make these types of products, regardless of if the motive was profit-driven. "We had a relationship with Vestax," says Babu, "and actually Shortkut and Rhettmatic both really had a lot to do with that first Vestax 05 mixer that came out, but they are not really officially credited with it."[11] But, both Disk and Babu give Vestax a lot of credit for making the 05Pro and being open to the ideas of DJs, but understand that Vestax listened to capitalize on products in the marketplace. Through all the research conducted for this book, I have yet to see any DJ be "officially credited" with designing a product. While some manufacturers may list DJs who contributed to design on a website, they are never given credit inside mixer manuals, on boxes, etc.

Babu, Shortkut, and the rest of the Beat Junkies crew went on to forge relationships with other companies, such as Shure and Rane, and were not only seminal in R&D but have been used to endorse products made by those companies as well (most manufacturers work directly with their pro artists and endorsees in product design). DJ Nu-Mark, who is endorsed by both Rane and Serato, thinks that in the digital age the companies who have the best products are those working with DJs because most manufacturers do not understand the DJ workflow. "It's the companies that don't consult musicians that are having a tough time right now.... You need to talk to the musicians first and foremost. And, a lot of these people don't think they need to," Nu-Mark says.[12]

Vinroc recently began an endorsement deal with Native Instruments, and has been giving them feedback on its Traktor Scratch DVS product:

They respect my opinion and I get back to them and tell them "It would be better if you did this and that." I had a meeting with them, they're like "Yeah, just tell us what you think," and I pointed out some things…. And I think that's overall, that's just research, y'know? They just want to know what the users think. How they can make it better.[13]

DJ Rob Swift, who is also sponsored by Rane and Serato, says that he has had "reps from companies visit me at home in my studio and ask me questions about how I record, what kind of equipment would I need to use in order to achieve certain ideas or goals as a musician, as a recording artist, DJing, and scratching. And I'll give them my opinions on stuff."[14] And, Rob Swift is pleased to know that these companies respect his opinions "to where they feel that your ideas will help them in the invention of this new piece of equipment or this new software."[15]

While Vestax set the standard of listening, some manufacturers have since adopted more aggressive approaches to acquire intellectual properties. Siya Fakher, director at EBSel, the company that developed the Pro X Fade crossfader, has seen this firsthand:

Regarding the intellectual property side of things, it's a lot subtler now than it used to be, but it still goes on today and much of it is as much the DJ not knowing how to conduct themselves in the environment they find themselves in. I've been to trade shows around the world, and whereas when I first started the manufacturer would listen to your ideas and dismiss you straight away yet miraculously those ideas would still find themselves onto a new product in the next few years (albeit a badly interpreted one)…today they like to wine and dine you, get you to relax and get comfortable before they penetrate!…Like I said, most of the problems are the DJs' own doing because of their lack of business know-how.[16]

Although manufacturers are listening to or soliciting feedback directly from DJs, in the digital age the Web has proven to be a great R&D laboratory. For instance, forums on the Serato website or at DJWORX (fka Skratchworx) publish plenty of customer feedback and are great places for manufacturing representatives to gather intellectual properties and get feedback on products. Mike May of Rane Corporation says, "And those things, when we hear somebody that we think is passionate and really has some good thoughts, those are things that we keep…those are recorded and stored."[17] Rane sometimes uses those ideas in its products. "So that can translate because ultimately the end-users are, hey, they are your best source, and DJs have provided us with some great input. We have outreach all the time from people who have come up with ideas," May explains.[18]

This is not unique to Rane, either, as many reps from other manufacturers participate in online forums. May suggests that there is a constant exchange of ideas on the Serato forums:

> People are usually on the forum because they have questions and you want to build a real good database of answers. So the forum is an exchange about people who either have problems, or it's the tips and tricks area in the forum where people jot information down for DJs to go and read. Anybody who is interested can go and check it out, it is an exchange of ideas and you can use the forum for another one of those resources to capture ideas, or get back to somebody and say, "You touched on this and it's interesting about your approach here, do you want to tell me more about it?"[19]

Some of the DJs posting in the forums are happy to share their ideas; some are more guarded about what they share. And, Mike May says that sometimes technically savvy DJs will come up with ways to use features in Serato Scratch Live that will influence future versions of the software:

> There are DJs who will discover in the software that things can be done in the software that maybe in the original application it wasn't designed that way, but they come up with something that is rather unique. And it could create a thought process where the engineers at Serato might say, "This is cool, we should tweak this control system a little bit and get this as a result because this person touched on something that we think a lot of people will be interested in."[20]

May says that in some cases, if a person has an idea that is unique that he or she wants to protect because "it is their intellectual property, they want to get paid for it," most of the time the person is "glad to give you the ideas because they want to see those ideas actually executed in a piece of gear."[21]

DJs post their opinions on products all over the Internet. Sometimes they air grievances on products they dislike, or they tout the positive aspects of products they use. "I mean some people like helping out," says Roli Rho. "There is a good amount of DJs that are humble and they put their two cents in and they don't want anything out of it, they just want the product to be good. And doing that stuff, it does help other DJs, it helps us."[22] Roli Rho suggests that it is up to DJs who use DVS and other gear to make the technologies "perfect," and it is their suggestions that help software developers design better functioning products. Roli Rho says:

> It takes DJs to perfect Serato because the forum and your comments, and the R&D and everything, it's really up to us. The thing is that Serato is not going to pay all of us, they can just look at the blogs and look at the comments and they try to straighten

it out from that. That is the way that I see it.... They are listening to us to make something perfect with all the test runs and everything, they will keep listening to us because we are the consumers that will buy their product.[23]

Roli Rho suggests that DJs are compensated with better tools. From the feedback and ideas of some DJs, all DJs who use that technology will benefit. DJs, for the most part, seem to freely give their input to benefit the larger cultural whole, but also their ideas benefit the manufacturer/developer financially and reputation-wise.

Having access to the opinions and feedback of end-users ultimately leads to the creation of better tools; however, in most instances manufacturers listen to improve tools to expand markets rather than with the greater good of DJs in mind. Manufacturers' investment in the development of new products is not primarily driven by altruism or contributing to the culture, but the products they make do benefit the culture. The motivations and tactics of each hardware manufacturer or software developer vary in different situations, but ultimately, having a good reputation and a solid product that end-users will advertise for free seems to be a common strategy.

Thierry Alari, an independent inventor who designed the Scratchophone, a portable scratching instrument, considers customers his most valuable asset. "I'm asking customers to think about new features for their own Scratchophone, I have a never-ending flow of good ideas.... I'm open to all crazy ideas. I'm just listening to users."[24] Part of the reason why DJs share so freely, other than my supposition that the culture is an open source culture, stems from the fact that companies ignored the techniques and ideas of hip-hop DJ culture for so long and did not reward it with products that catered to its forms of expression. Manufacturers' willingness to listen has encouraged a willingness to talk and share by DJs.

DJs' ideas are encoded into new technical innovations, sometimes through direct exchange with a company or indirectly online where corporations harvest ideas. This process has evolved from manufacturers completely ignoring DJs to listening to a select few of them, and now to the point where the Internet has allowed companies to collect and use feedback that is bandied about on the Web. Essentially, manufacturers are able to crowdsource ideas from the hip-hop DJ's creative network. Some manufacturers have developed products that do not do well in the market because they only collected ideas from one DJ. So, most often, if DJs are willing to contribute ideas, then the ears of companies are open. We have to consider the inherent problems

with crediting or compensating an idea from multiple users on the Internet or a creative network. It is possible that credit and compensation inherently comes from having better tools, though.

Credit for Innovations

Getting credit for one's ideas and innovations has never been a simple matter within hip-hop culture. There are still arguments among hip-hop's pioneers about who was the first to coin a term or "invent" a particular style or technique. In some ways, this bickering has become its own tradition within hip-hop, and arguments over who was the "first" have been particularly contentious. In some instances, the first person to come up with a technique or style does not get credit. Instead, the first to popularize or perfect an innovation gets credit, upsetting others in the creative network. The person credited as "inventor" is often the first to fix the idea in a medium (usually on a recording or video) or is a brand-name DJ whose name gets associated with an innovation. In addition, various writers and media perpetuate some of the claims (this book included).

Hip-hop culture and hip-hop DJs often choose to use the word "invent" to describe cultural innovations, for instance, claims that Kool Herc "invented" hip-hop, GrandWizzard Theodore "invented" scratching, DJ Jazzy Jeff or Cash Money "invented" the transform scratch technique, DJ Steve Dee "invented" beat juggling with "The Funk," DJ Qbert "invented" the crab scratch, or DJ Babu "invented" the term *turntablism*. There is substance behind all these claims, and hip-hop DJ culture collectively agrees who is credited regardless of the true source of innovation. While great individuals are part of the aforementioned innovations, most of these advancements come from a creative network comprised of many DJs, techniques, and technologies that are often left of out the story. This network reinvents the past as a way of conceptualizing the future, and innovations are the product of many collaborators rather than an individual genius. But hip-hop culture in general gets caught up in the discourse of invention by laying proprietary and individualistic claims on innovations. With the rise of the prioritization of intellectual property rights and laws in society (ones that favor crediting and compensating an individual or corporate person), natural people and subcultures also begin to take on this individualistic ideology.

It may be more appropriate to suggest that DJ Kool Herc popularized the style of breakbeat DJing, and hip-hop culture formed around that style. As we have seen in this book, Herc pulled from the prior art of the Jamaican sound

system and disco DJ cultures. Maybe GrandWizzard Theodore perfected the art of scratching and then popularized it, but DJs before Theodore scratched records (Grandmaster Flash, Theodore's mentor, claims he invented scratching as well). Theodore made it rhythmic and musical, and it was his vision of scratching that became the part of the foundation of modern hip-hop DJ style. The consensus in hip-hop DJ culture, though, is that Herc and Theodore pioneered those styles and influenced everybody else in the creative network, but let us not forget how a creative network influenced them as well. Mark Katz addresses this in his book *Groove Music*, noting that these techniques come from a community and the exchange of ideas. "To be recognized as an inventor, it is crucial to have demonstrated it [a technique] repeatedly and publicly, and to have influenced others through its dissemination," writes Katz.[25]

Although I have never seen DJ Jazzy Jeff claim to have "invented" the transform scratch technique, he was the first to record it on the song "The Magnificent Jazzy Jeff."[26] While DJ Cash Money is often given credit for the technique's "invention," Philadelphia DJs in the 1980s such as the Grand Wizard Rasheen, the Original Spinbad, Lightning Rich, Cosmic "Strictly Skillz" Kev, Tat Money, and Miz all contributed to the popularization and development of the transform scratch, a technique that had a major impact on hip-hop DJing. Jazzy Jeff put the transform scratch on an album, so there is a record (literally) of this innovation, which is why he has often been called the "inventor."

Maybe it is best to consider Jazzy Jeff the one who popularized the technique, which may also be a healthy way to think about Qbert and the crab scratch. Again, the crab scratch is a technique that Qbert gave a name to, made popular, and also was put on video demonstrating it, but the crab is also the product of a network of innovation that included other DJs and techniques (specifically Disk, who originally showed Qbert this technique, which was a variation of the "twiddle" scratch). And, it is not necessarily these DJs who are out there claiming that they invented these elements, but instead those who are writing about them and documenting it. From the days of Kool Herc and other pioneering hip-hop DJs, technique innovation has been an act of reinvention and not invention per se. But reinvention does not make these types of innovations any less significant (I would argue that all invention is, in fact, reinvention).

In the late 1980s, DJ Steve Dee introduced a technique or style to hip-hop DJing that he dubbed "The Funk." This was Steve Dee's take on cutting records by manipulating individual drum beats to make new patterns—essentially a

live composition. Other DJs at the same time had similar techniques, nota-
bly DJ Aladdin (the "Aladdin Shuffle") and the UK's Cutmaster Swift (the
"copycat"). "The Funk" style that he popularized, codified when Steve Dee
won the New Music Seminar Battle for World Supremacy in 1990, eventu-
ally became part of the prior art for "beat juggling," which is now a standard
hip-hop DJ technique. Katz looks at the contestation over credit for tech-
nique innovation and the problem of identifying a single inventor in hip-hop
DJ culture, which he suggests stems from the fact that this type of innovation
is incremental by nature; it's an act of progress.[27]

Steve Dee suggests that if DJs held patents to techniques, then they would
be able to get royalties from the industries that profit off of hip-hop DJ culture.
Or, it would give DJs some say as to what sort of products are introduced into
the market. He explains the theoretical value of patenting DJ technique: "and
once you do that it will allow you to do these things before these companies
take these intellectual properties and turn it into their own…and I'm trying
to talk with Theodore and Flash about doing these things because we could
actually live comfortably off of just that alone because now the technology is
gearing towards it."[28]

Patenting DJ techniques is plausible because in essence those techniques
are processes, essentially a means to an end, which could in theory be eligible
for patent protection. Proving and citing prior art for DJ techniques would
be nearly impossible and then highly contentious, and then who knows if
a DJ holding a patent would have a monopoly over the technique and pre-
vent other DJs from using it, or require a license for its use in performance.
However, once a technique is performed for an audience or described in
media, it essentially becomes property of the public domain. In some ways,
patenting technique would also undermine the open logic of the hip-hop DJ's
creative network, specifically what I describe in the opening section of this
chapter with the DJ session.

Steve Dee thinks that because new technologies encode the ideas and
techniques laid out, perfected, and popularized by hip-hop DJs, these products
would not exist without the intellectual properties that DJs have made public
domain. He feels like certain manufacturers have made a lot of money off of
the ideas of DJs but have not given much back to the culture. For Steve Dee,
if innovators became actual "inventors," this would give them more power:

> But the more that we have stock in our own craft, you know the intellectual proper-
> ties, we will be able to come back at these companies who just take what is not theirs.

And again, we have to get into the patents because once you do that you now put yourself in another realm—you are in another realm now.... We, the users, need to start looking at it as a business and our whole mindset has to change now and we have to start looking for and to the future to control these kinds of things so that it won't happen again....It's a shame that we don't have this kind of power when we have a market that we should be cornering and we don't even have a corner.[29]

Steve Dee thinks that patenting techniques would be the first step for DJs to get into the process of manufacturing, or at least allow DJs more control over how companies profit off of DJs' ideas because of how manufacturers encode those ideas into products.

Proving that you "invented" a certain scratch or DJ technique could be a problematic burden on behalf of the DJ seeking patent protection. Thus far in hip-hop DJ history, invention has been attributed to the person who gave a technique a name and then popularized the technique under that name, or had that technique fixed in a tangible medium. DJ Skeme Richards says that he can remember DJs "beat juggling" in Philadelphia in the early 1980s, and "They [Philly DJs] were doing exactly what the West Coast guys were when they named it 'beat juggling,' we were doing that in Philly in the early'80s, but we didn't make up names for scratches, we never made up names."[30]

Skeme thinks that when technique naming became popular is when DJing really became "corporate," in the sense that once techniques had names, they became commodities or rational expressions that could be sold in DJ instructional videos or in DJ classes. "Not to take anything away from everybody else, but it didn't start any one particular place," says Skeme. Skeme brings up a major point with respect to patent protection: prior art and point of origin. Techniques, arguably, are built on one another, are incremental, and are then met with a DJ's personal take on them (style). Thus, it would be difficult to point out individual divisions. Although it can be advantageous and partly accurate to credit specific people with innovation, DJ techniques come from a network of ideas, technologies, and DJs.

Kool Herc could not have made breakbeat DJing popular without records that had breaks recorded on them or without influences from Jamaican sound systems and disco cultures. His ideas did not occur in isolation. This is not to say that the innovations that came from Herc and the many hip-hop DJs since him are not spectacular, creative, and beautiful, but *invention* may be a problematic term to apply to these innovations since it suggests an individual

act and one that is often protected by intellectual property law/rights. You get paid royalties and exercise licenses when you "invent" something and have rights to exploit that invention in a market by being granted a limited monopoly. While it seems irrational now, if Herc was truly the "inventor" of hip-hop, and thus rap music, he could ask for royalty payments or charge licensing fees from famous rappers or DJs. Innovators, if they are lucky, receive credit for their contributions; inventors get credit and financial compensation. There is a clear difference beyond semantics.

This discussion about DJ techniques and IP rights brings up another question: Can you trademark technique names? Using "The Funk" as an example, the short answer is maybe. Trademarks are usually used to distinguish the source of goods or services. If it does not distinguish one's goods from those of others, it is either a descriptive or generic term and not protectable as a mark. If Steve Dee sought trademark protection to require others to credit him when they performed "The Funk," it would have been unlikely because "The Funk" as a technique is not protectable as a mark (but, maybe under patent or copyright). Anybody could copy the technique and make up their own name for it.

If Steve Dee was able to acquire trademark rights for "The Funk," he would need to make sure that no one uses that name for the technique without his permission. If DJs perform "The Funk" and call it that and Steve Dee does not stop them, the term would become a generic term and he would lose any trademark rights.[31] Steve Dee would have to market himself in media as "Come see Steve Dee perform 'The Funk'" so that "The Funk" primarily identifies the technique as coming from a particular source: Steve Dee. The more consumers think of "The Funk" as a brand and not merely a technique, the more likely it will remain protectable as a mark. But, if consumers think of "The Funk" as words to describe the technique, then it is generic and not protectable. Terms such as "crab" scratch, "turntablist," or even "scratch" likely are all now generic terms, so trademarking technique names is a possible way to get credit but also highly unlikely.[32]

Although it will be interesting to see the results of Steve Dee's attempt to patent "The Funk," there are other practical instances where DJs would have benefitted from patent protection, or at least some knowledge of intellectual property laws, for instance, DJ Shortkut and the drawing he did on a napkin that became the design of the Vestax PMC-05Pro mixer. "Yeah if I did learn how to put a fuckin' patent down on a mixer then sure I'd be fuckin' well-off right now," says Shortkut. "At the same time it's like it's

cool, as long as those guys know in their heart, you know where you really got that idea, right?"[33]

Shortkut admits that he did not even think about patenting his ideas but was so happy to have a manufacturer listening to him. Although extremely humble, the experience made Shortkut a bit more apprehensive when giving his input on products. He thinks that the ideas he did give to Vestax ultimately benefitted the hip-hop DJ, which is most important to him. Protecting ideas is often an afterthought for most DJs, but it does seem that DJs are most interested in putting the ideas out there in return for products that will benefit the culture. When asked about all of the ideas he has contributed to manufacturers, Qbert says: "When I was a kid, I learned about Mercedes-Benz. They invented the seat belt, and they [said], 'We're not going to patent it. Everyone should have a seat belt in their car.' I thought that was nice. People should be like that. It's beyond money, it's about karma."[34]

D-Styles, a scratch innovator who was down with Shortkut and Qbert in the 1990s when all these ideas were flowing to Vestax, has an open source mentality about the exchange of ideas, credit, and compensation. "Vestax was the only company at the time that was willing to take risks and actually listen to our ideas," D-Styles says. "It wasn't about getting compensated back then. It was more about wanting your ideas to come to life. I didn't care about getting any credit or royalty checks. Give me a free mixer and I'm happy was what it was about."[35]

It is highly unlikely that Shortkut could have gotten a patent on a napkin sketch because designing a technology does not necessarily generate an idea that is technologically new and thus patentable. A great deal of product development and financial investment goes into R&D and prototyping, and applying for a patent will cost anywhere from $5,000 to $12,000,[36] which is where the rights granted under technocultural synergism become especially important. Shortkut's drawing of a 2-channel mixer design most likely would not be considered unique enough to be granted patent protection, and, unlike copyright protection, there is a great deal of risk and a burden that goes into receiving a patent. It does seem problematic that there were no resources for Shortkut at the time, and still that there is no system in place for DJs to protect their ideas; in fact, if you cannot afford an attorney, it will be nearly impossible to apply for patent protection or use other protective measures (nondisclosure agreements, etc.).

In *Groove Music*, Katz writes about the development of the Vestax 05Pro, what he considers a "triumph of vernacular technology" and an important shift for the culture toward legitimization.[37] However, he ambiguously states,

"Although we can criticize Vestax for exploiting young DJs who had no business experience or lawyers to represent their interests, it has long been sensitive to the needs of DJs, producing beloved scratch mixers for more than 15 years."[38] However, I still feel compelled to ask whether "listening" to DJs and making products they want outweighs crediting and compensating them for their contributions. This question is especially important when listening is about making better products to increase sales (although Vestax has listened, spent a lot of money on R&D, taken risks, and made products that sell poorly, such as the QFO and C1). Since technologies represent political sites of struggle, intellectual property exchange and rights need to be addressed critically, and we should consider these power dynamics as being meaningful and representative of larger dialectical tension (note that these dynamics in respect to exchange and rights are not endemic to Vestax, the DJ product industry, etc.).

Elliot Marx, the owner of Audio Innovate, a company whose inno-FADER is one of the leading aftermarket upgrade crossfaders, says, "Actually I think patents in the DJ market are worthless to be honest."[39] For Marx, investing money into patent protection, which is ultimately reflected in the retail price for consumers, is a way of "sinking money" into something that has no benefit to end-users. "The market is small enough that I think DJs will get much better variety and quality of products if companies work more on a trade secret basis to protect technology rather than with patents.... The best thing to do is develop relationships with people you trust. You can license ideas without patenting."[40] He suggests using trade secrets and nondisclosure agreements to protect ideas, a common tactic in the DJ product industry.

Marx further explains: "Well look, if you scribble a picture on paper for an hour or so a manufacturer, for good reason, would probably laugh at you if you asked for royalties."[41] But he also thinks that if DJs have spent months testing and consulting on a project, they should be compensated. His advice to DJs with ideas is to prove that they are serious:

> Seriously, if you have a great idea, make a prototype of it, get lists of materials, drawings, etc., everything so a manufacturer knows you are serious and will take the product to a competitor if they don't move on it. The closer you are to a product that can hit the streets, the more likely a manufacturer will take on a project and give you money as long as it's a marketable idea.[42]

Marx thinks the problem is that DJs may have some great ideas but typically only have an idea with no research or development behind it. And, with just an idea and nothing tangible, it becomes public domain when you share it.

Manufacturers deal with the exchange of intellectual property with hip-hop DJs in different ways, and thus handle credit and compensation on a case-by-case basis. Rane's Mike May says, "I think that many times that's all about someone's business savvy and what they think they really are providing, and then that stuff has to be negotiated on the front side."[43] May acknowledges that some DJs get skipped over in respect to credit and compensation but claims that happens in other industries, as well. May explains, "And if someone has been forthcoming and there are people who supply us with the information, we know how to treat those people reasonably. We're not somebody who is out trying to steal ideas."[44]

Ono, Vestax's former Vice President, says that the exchange of intellectual property between Vestax and its endorsed DJs is about benefits beyond cash compensation. He says, "It's also been a concept at Vestax that there has never been any monetary capital passed back and forth with a DJ or Vestax at all.... Where some companies, and definitely in different industries, when you sign, you are signing with a huge bonus with that company to carry that brand. At Vestax it is all 100 percent voluntary."[45] DJs who endorse Vestax products, and ultimately become involved in R&D, do it so that they will be included at Vestax events and in the company's promotional materials. In other words, Vestax receives the credibility of DJs, and DJs get the credibility of Vestax's brand. This benefits DJs because promotional opportunities can lead to revenue in other ways; this is a mutual marketing relationship.

Marx says that product feedback is a critical part of the R&D process at Audio Innovate. "Most DJs are just happy we listen to their contributions and give them outstanding service," says Marx, but he notes that some DJs have unrealistic expectations about how they will be compensated. Because the market is so small and "hyper-competitive," DJs must make meaningful contributions to be compensated. Marx explains, "Our philosophy is to reward DJs who make significant contributions to Audio Innovate, whether it's by helping out at trade shows, doing website design, helping with product testing and specification.... Compensation can be in the form of product, free advertising, and cash, depending on the situation."[46]

"But over the years we've definitely given our, how would you say, 'tech advice,' to all the companies that we've worked with," says DJ Babu of the Beat Junkies.[47] He says he has been part of endorsement deals, but that there was no financial compensation. "We get free gear and they put ads out for us, and stuff like that, and they definitely ask us about the stuff they are making," Babu states. Babu says that he and his crew members have made R&D contributions, but have never designed a technology from the ground up. He also feels that he has been fairly compensated for his ideas. Turntablist Disk explains his R&D experiences succinctly: "You give them a little idea, they give you a bunch of free mixers and kind of just say, 'Oh whatever,' and that's enough ideas."[48]

Again, one of the problems with credit and compensation is that product feedback comes from many sources within the network. Roli Rho says some DJs do not get credit for contributions made on technical innovations, even though they were the individuals who originally came up with the idea. For DJs who lack a brand name but still give their input to companies, Roli Rho says that some DJs can be "blacklisted" by other DJs when the technology comes out and they try to take credit for their contributions. "I feel bad for the people who do invent stuff for us and do not get recognized for it, that's the only thing that is sad. I wish people did get recognized for it," says Roli Rho.[49] He claims that DJs who have ideas can get "shitted on" by companies and other DJs, but trying to claim your contribution after the fact is a major faux pas. Roli Rho thinks that if DJs had better resources to protect their ideas and if the system was geared to help them, then much of the conflict over credit would disappear. "I don't know exactly how it [patent] works because I never created something to actually sell to a company," says Roli Rho, "but if I ever did I probably would get suckered out, too."[50]

Thus far I have highlighted some of the challenges, issues, and struggles in hip-hop DJ culture and the DJ product industry in respect to intellectual property exchange and rights, as well as antagonism surrounding credit and compensation for ideas within technocultural synergism. The goal has been to explore this rather generally. The next sections look specifically at R&D case studies of a few technical innovations relevant to hip-hop DJ culture, including the Rane TTM 54 mixer, the Hamster switch, the Controller One turntable, the Fretless Fader, and the innovations of DJ Focus. This discussion is from the viewpoint of the DJs involved and considers the stories behind these innovations, what I call "technocultural histories."

Rane TTM 54

In Chapter 3, I briefly reviewed the development of Rane's TTM 54 performance mixer in the context of the standardization of Rane's 2-channel mixers. In this section, I further explore how Rane's TTM line and 10" battle-styled mixers went from an idea to a product, especially from the perspective of the DJs involved in the process.

Around 1997, DJs Big Wiz, Sugarcuts, Marz 1, and Peter Parker were at an AES convention[51] trying to sell advertising space to manufacturers for a Tableturns magazine that they wanted to start.[52] The four DJs approached the Rane booth where Rane tried to sell them on its MP 24, a 19" mixer designed for club mixing and somewhat useless for hip-hop DJs who need something more compact so that the turntables are closer together. Big Wiz says, "I had always loved and hated Rane at the same time for making such a great product but one I couldn't use…while the companies that made performance mixers basically made an inferior product."[53] Big Wiz explains that the pre-TTM Rane mixers were "like someone giving you the hottest car in the world but locking the doors and not giving you the keys…yeah it's a great car but you can't do anything with it."[54] After the DJs listened to Rane's sales pitch, they suggested that they had ideas for a product that would appeal to the growing market for 2-channel battle-styled mixers aimed at hip-hop DJs. Sugarcuts tells me that Rane was open to their ideas and they discussed detailed design concepts. After some brainstorming sessions, Marz 1, who was also a graphic designer, drew up a design of their ideas, as Big Wiz explains:

> We had a very clear idea of how it would look…. So, after we decided what we wanted, he [Marz 1] laid it all out…size and everything…even the color scheme. We knew exactly what we wanted and where it needed to be and how it should look etc…. even down to the placement of the EQ knobs and how the knobs for the faders should be…no one made fader knobs like we wanted so Rane had them made especially for the TTM mixers.[55]

While the DJs were able to agree on the design, Sugarcuts explains that everybody involved had different ideas on how to protect their ideas:

> I remember when we were designing the mixer we had a big argument about whether we should be getting royalties for the design, and for me I just don't think like that. Obviously money is really nice, but at the same time I thought that contributing to this mixer would impact our careers more than the money that we made from

the mixer. I would probably stand by that, but had we gotten in on the 56 and then maybe 57, maybe it would have been different. But I think that they [Rane] did a really good job of treating me well.[56]

Sugarcuts does not think that the four DJs deserved royalties based on units sold. "At that moment I was the one who said, 'We shouldn't ask for royalties' because I thought there was a bigger picture there and I agreed with that and I agree with that now," explains Sugarcuts.[57] He thinks that the ideas that they contributed were for the greater good of hip-hop DJ culture. "And I am all for technology and I'm all for the tools of the trade becoming better because then DJing becomes better and I don't think you can spend time looking back and hoping for something that wasn't there," he says.[58] Sugarcuts also says:

> I think what we did definitely changed Rane's financial future, but again, if all we got was royalties off of the 54, it wouldn't have changed my financial future. So I can't really spend that much time thinking about that. So to get some 54 royalties and then end up having to get a lawyer to make sure that ideas that we gave them turned into the 54 and into the 56 and into the 57…would we have made a good amount of money? Yeah, but again if we didn't do it, would they have had trouble finding another DJ to help them out to do it? No. Should our name be on the front of the mixer? I would say no.[59]

Although Sugarcuts would not get into the details of the argument over protecting their ideas, the group decided that having better tools and more options for hip-hop DJs was more important to them than royalties.

The DJs faxed Rane their design concepts, and Rane thought it could build the instrument and sent them some of its sketches and eventually some prototypes. The exchange of ideas continued between Rane and the four DJs. Mike May says:

> It is the exchange of ideas and getting things on the money…. Regardless of what business you are in you say you are listening to the people who want products designed, well sometimes that really happens and in many cases you use that as a marketing line but it isn't really true. In this case, I believe that we really did listen and were more respectful and tried to build a product that could be useful to that community. And the result was the TTM 54.[60]

May insists the feedback that they received from Big Wiz and Sugarcuts was integral to the execution and ultimate success of its 2-channel mixer line. Also, local Seattle DJs Supreme La Rock, EROK, and DV One had some of the early prototypes and gave Rane feedback in the development stage. Both

Big Wiz and Sugarcuts, however, suggest that the Rane TTM 56 is actually closer to their original design concept than the 54. Big Wiz explains that "at the time, there were things that weren't yet cost effective or able to be done in the time frame they wanted to get the mixer out by or things that couldn't be done within the size of the mixer."[61]

In 1998, when the TTM 54 hit the market, the standard mixers for hip-hop DJs were the Vestax brand (05Pro and 06Pro); recall that at the time Vestax was using the ISP DJs heavily in its marketing. Without a major advertisement/endorsement push, Rane was able to work its way into the market. Sugarcuts admits that the four DJs were surprised that Rane listened and then actually made the product, especially since "we were probably the least renowned as DJs."[62] Rane did not use the DJs in marketing campaigns but did supply them with mixers, and the TTM 54 gained popularity through word of mouth within the culture. Sugarcuts released Tableturns's videos that included some of the world's greatest scratch/hip-hop DJs using Rane mixers. Sugarcuts says:

> I think that it's easy in hindsight to forget the impact that Tableturns had on the mixer because so many DJs were all about Vestax, and the Tableturns video was the first time we saw any of these great DJs on our Rane.... And all these great DJs tried Rane. It's clear that without the turntablist community that Rane would have never taken off in the 2-channel mixer community anyway.[63]

The Rane TTM 54 was used at all of the Tableturns events and DJs were able to try the product while there. Word of mouth quickly spread.

It is clear that Big Wiz, Sugarcuts, Marz 1, and Peter Parker helped to lay the groundwork for what is today's industry standard for 2-channel mixers. Big Wiz says, "Now it's like my ideas are validated. I have confirmation that what I thought would be so great really is! Everybody has an opinion on things and think they know what would be good...some of them are right but most of them are wrong. I now know mine are right on the money and that feels good."[64] Sugarcuts believes that the ideas that the four DJs gave Rane helped the company to move into the market for hip-hop DJs and was integral to the future success of the company. "And that [the 54] obviously led them to really being able to connect with the younger DJ market and I believe probably impacted them greatly in going into the deal with Serato," says Sugarcuts, "and from there everything changed, as they say."[65]

Hamster Style

The early Rane TTM 54 and 52 had three "Hamster" buttons. With most button functions on the mixer being standard for the time, the Hamster buttons stood out. The Hamster buttons reversed the direction of the three faders. Essentially, when the crossfader was set all the way onto PGM 2 (turntable two), the crossfader passed the audio signal from PGM 1 (turntable one). Because the channel faders only control signal level and do not fade between signals, the Hamster button changed the direction that you push these faders to turn the signal on/off. But why did the Rane mixer say "Hamster" and not something like "crossfader reverse"? It is because the switch's name actually came from a style of scratching: Hamster style.

Hamster style scratching is when a DJ always scratches and mixes with the crossfader Hamster (or crossfader reverse) switch on. The Rane TTM 54 seems to have been the first mixer to bear a "Hamster" switch, but a crossfader reverse switch was first put on the Vestax PMC-06Pro and 05Pro LTD (a DJ Qbert limited signature mixer), both released between 1996 and 1998. This style of scratching and feature on mixers gained popularity first among West Coast scratch DJs because it imitated the hand movement of the "clicker" (phono/line switch), which was the favored way to click the sound on and off while scratching (over using the crossfader). The clicker had a much sharper cut-in time because, before the Melos PMX-2 or Vestax 05Pro mixers, crossfaders had a slow curve made for mixing and not for scratching. The clicker was simply an on/off switch for the sound.

The term "Hamster style," however, comes from DJ Quest of the Bullet Proof Space Travelers (fka the Bullet Proof Scratch Hamsters crew). DJ Quest tells me that the first type of Hamster switch did not come from a manufacturer, but from the independent inventor DJ Focus.[66] Prior to Focus, DJs had to plug their turntables in backwards to the mixer, which created a problem when multiple DJs were using a setup. Because Focus's main DJ partner scratched regular and Focus scratched Hamster style, he came up with what Focus calls an "external switch box." This was a box where you plug the turntables into it; it had two outputs, and those outputs went to the mixer, and the switch that was on this box was your Hamster switch. "And that led to us doing the hamster switch modifications in the mixers themselves," says Focus, who eventually made the switch on the front of the mixer.[67] DJ Quest explains, "So he was the first to make a hamster switch before all these companies put it in their mixers."[68]

THE HIP-HOP DJ AS INTELLECTUAL PROPERTY

Although he says he did not "invent" the style, Quest coined the name "Hamster style." DJ Quest learned this style accidentally after plugging his turntables backward into his first mixer, a Pyramid PR-4700. When he began DJing in 1986, he learned how to scratch backwards. "Hamster style" was used as a term beginning in 1992, as Quest tells me:

> What it was is that during a TV show shoot for *Home Turf*, we were doing all these demos and I was asked to bring my turntables down and there were all these DJs that were involved with that. There was a lot of names that had come down and it was sort of like getting into the history of scratching and DJing and I was one of the DJs that had come up to do a demo. Actually my demo was a battle, which was with Positively Red. So when the battle is done they had Kevvy Kev, who is pretty old school here in the Bay Area and has a radio show, *The Drum*, which has been going on for years, and so he is real knowledgeable about the art. So they had him come out to do a quick tutorial about how to DJ and as he got on the decks he couldn't figure out why he couldn't get the sound to play out because nobody used the shit like that, so he was like "I don't know what's going on, I don't hear anything." Then I was sitting in the back and had to say it real loud, I said, "It's Hamster style." So basically from that moment on that was used to describe the backwards set up of the tables into the mixer, therefore the fader being reversed.[69]

After that day, the people who scratched backwards had a name for their style, and "Hamster style" quickly spread.

DJ Quest says that Rane approached him in the late 1990s about calling their fader reverse switches "Hamster" switches (to me, a sign of Rane's integrity surrounding credit for DJs). At that time Hamster style was largely the accepted term for scratching the backwards style. Although Quest does not hold a trademark on "Hamster style," both Rane and Vestax reached out to Quest and his crew about using it on their mixers:

> But yeah, Rane actually approached me back in '98 when the first 54 came out and they took care of me. They were like "Yeah, whatever, we want to use the name…." It is what it is and they hooked me up and I have a real good relationship with them. It's not as if it is something that we had a copyright on necessarily, but still acknowledging…for instance, Rane actually on their catalog wrote out a paragraph where they credited us for using that name. So I think that's kind of more or less what we were trying to get out of that if anything at all, just some recognition.[70]

Rane's recognition of Quest in his crew in this way shows the power of the hip-hop DJ *as* intellectual property. Vestax supposedly began including a Hamster switch on the request of DJ Qbert, who scratches Hamster style as well. In

fact, Vestax put a custom Hamster switch on the Grey 05Pro that Qbert had back in 1995 (the 05Pro did not have this switch).

DJ Quest and the Bullet Proof Scratch Hamsters wanted recognition for a style that they had helped to popularize, and Rane delivered. However, after reviewing a number of Rane mixer manuals, the only one to include the Hamster story is the Rane TTM 52i manual. The image of a hamster in an exercise wheel is included with the title "The origin of *Hamster*" and this text:

> A few years back, there was a crew of turntablists who called themselves *The BulletProof Scratch Hamsters*. They approached several mixer manufacturers with an idea for "reversing" the crossfader program material. In other words, they wanted to have Program A appear where Program B was, and vice versa. This idea was intriguing enough to make one manufacturer comply and they began offering this feature on a popular model (internally). In turntablist circles the reversal feature is referred to as *Hamster* in homage to the idea originators. This capability has evolved to a point where the performer wants (maybe needs) to *Hamster* on the fly instead of opening the mixer up and selecting one way or the other. Rane has obliged this growing request by allowing the artist to reverse on the fly with the crossfader and, uniquely, with the up and down faders as well.[71]

Without a trademark, DJ Quest and his crew could not stop manufacturers from using "Hamster" on their products and therefore could not collect royalties. Rane gave them some credit in their manual and established working relationships as a way of rewarding the crew for their intellectual properties.

DJ Quest says he did not worry about companies using a term that he helped to popularize, but receiving credit for those contributions is what was most important for him. With recognition, he says, other opportunities came and helped put him and his crew in the mind and consciousness of the public. Quest says, "If you start out young doing things and you start out doing them with the business mind, then you know you can cash in on those things later; however, if that was my goal then I probably wouldn't have developed my skills on the turntables." Quest continues, "Business is something that just kind of goes with it. But that was never the point; trying to get money off of people for using this or that."[72]

Controller One

It took approximately five years for the Vestax Controller One (C1) turntable to develop from an idea to a reality (a process briefly detailed in Chapter 2). By the time the C1 hit the market, the cultural interest in being a scratch

musician had waned considerably; the second great boom in the turntablist movement was ending, and interest in product development and marketing had turned to the digital DJ controller market where profit margins are high and risk is low.

The year 2008 was not necessarily the greatest to launch a $2,000 turntable, plus this complex and nuanced product came out with little marketing or preparation. According to Chuck Ono, Vestax never got out of the red on the C1. With an estimated 300 to 500 manufactured, and with a factory that produced important parts for the C1 being destroyed in the 2011 Japanese earthquake/tsunami, we will not be seeing any more soon. In this section I want to explore the development of a turntable that can play musical scales and melodies, and then focus on the perceptions of the DJs involved in its R&D.

What I believe predicated the development of the C1 was the desire for hip-hop and scratch DJs, during the period of 1996–2002, to legitimize their art form and instrument.[73] DJs and companies were trying to use and show to the rest of the world how the turntable was a legitimate instrument and not just means of reproducing sound. One avenue toward using the turntable as a "real" instrument was the development of notation systems for it; some adapted Western notation while others developed "turntablature" systems. In Miyakawa's study of turntable notational systems she looks at how, from the perspective of DJs/artists involved, writing down turntable music was an attempt to legitimize scratching as a valid medium of music-making and the turntable as its instrument. In looking at numerous DJs' notational systems, she writes that "these DJs share central assumptions about the power of notation to legitimize the instrument and reach new audiences."[74] It was largely the quest for legitimacy of the art and instrument that contributed to the idea of the C1.

In the mid- to late-1990s, DJ Focus was publicly talking about adding keys and using pedals to change notes on turntables. Ricci Rucker began talking about an idea for a turntable that could play notes in the early 2000s. Ideas for the turntable further developed on Rucker's radio show, *Transmissions Radio*, on 90.5 FM KSJS.[75] This was a radio show devoted to scratch music created by DJs, and also featured live turntable sessions. Teeko was also a frequent guest on the show and says that many of the ideas for the C1 came when they would take breaks. Teeko explains: "We'd be like, 'Yo, what is your dream turntable? How would your shit be? How would you control the pitch?'...Then Ricci was talking about the foot pedal that would spin the platter faster. That was the first part of the Controller One. And then we got into other ideas about buttons for keys."[76]

"Me and Ricci used to talk about 'what if we had a turntable that had different buttons that had exact pitches and also had a foot pedal so it would free up your hands,'" says D-Styles, which they both thought was the best way to change pitch (the foot pedal).[77] When D-Styles and Ricci were in Japan judging a DMC battle, "I made it a point to meet with Vestax and talk about this idea and if it was possible," D-Styles explains. In Japan they made a sketch and brought the idea to the attention of Chuck Ono, who had been heavily involved in product development at Vestax.

Ono says, "So the scratch game obviously was wanting a new instrument, more than a turntable obviously."[78] For Ono, making product is not about making it for one artist: "When we [Vestax] make product we want to focus on not just one artist but we want to focus on as many artists as possible. We also focus on what the market demand is. And obviously knowing that with the Controller One and the scratch market being very niche markets, we knew that this product was not going to be selling like a regular PDX."[79] After the initial meeting, Vestax started reaching out to other DJs it endorsed or had working relationships with for ideas.

Mike Boo says that when Rucker returned from his trip to Japan, Rucker said, "Hey man, you got any ideas on what you want in a turntable, now is the time."[80] A few months later, Mike Boo and his crew, Ned Hoddings (Ricci Rucker, DJ Excess, and Toadstyle), flew to Japan for the Vestax World Finals. Mike Boo explains:

> The day after the competition we all had a meeting at the Vestax headquarters just brainstorming on the turntable. And Woody, which he doesn't get a lot of credit for this, but I will tell you right now that he had a huge huge huge impact on the layout of the turntable. He did a little AutoCAD design of how the turntable looks right now. That's all Woody. Like the buttons on the side…that was his idea. And we were just brainstorming and I had always envisioned a turntable with MIDI capabilities.[81]

One of Mike Boo's major contributions was the MIDI capability built into the C1.

The UK's DJ Woody, who began his working relationship with Vestax in 2002 after he was crowned World Vestax Champion, was also flown to the 2003 Vestax World Finals. Woody had been telling people at Vestax Europe that he was interested in product design and working on a turntable for the turntablist. Woody tells me, "Once Vestax intended to make this more than just a 'pipe dream' I was informed of the initial meeting and was subsequently sent the initial designs to give my opinion on…. From there I

was booked to perform at the World Vestax Finals in Tokyo (this was 2003), which conveniently doubled as a meeting to discuss the C1 design at Vestax headquarters."[82]

At the meeting, design and concept ideas were discussed, and Woody also submitted his illustrations. "My contact was directly with Vestax on any design ideas," says Woody. "Further designs were passed back to me for my opinions and once the prototype was ready I was invited to test and critique this at the next UK trade show."[83] After this second meeting at the World Vestax Finals, Mike Boo went back to California and was talking with Teeko about the ideas for the turntable, and Teeko had some ideas to contribute as well. A few months later, Boo was flown back to Japan for other business, but he told Teeko he was going to meet with the people at Vestax to discuss the C1 further. And, Boo says, "Teeko paid his own money, he paid $900 just to go out to Vestax and give them his idea of the memory button on the turntable."[84]

For the love of the craft and its development, Teeko got himself to Japan. "That's how much he believed in this turntable and that's why he is out there holding the flag right now for that turntable," explains Mike Boo. "He believed in it so much that he went out there, got his own ticket and gave them his idea so he could create his own scales, not to stay with regular musical scales. That was a great feature that he added."[85] Ono notes that both Teeko and DJ Woody displayed "great passion" when it came to bringing the C1 to market.[86] At this meeting, Teeko was able to see the prototype of the instrument for the first time. "But yeah, we sat down and they showed us the Controller One and we had a whole bunch of ideas, and we were definitely convincing them to make a product," Teeko says. "I remember at the time I couldn't wait to get my hands on it; I was never guaranteed one and it took me such a long time to get one."[87]

While still in development, DJ Woody was working on designs for the C1's layout. Initially, Ricci Rucker envisioned changes in notes on the C1 being accomplished with a special foot pedal, an accessory that Vestax began developing but was never released. DJ Woody saw problems in controlling notes using your foot:

> I passed on various ideas for the Controller One but the main design change, which was actually implemented, was putting the note buttons around the side of the platter. The initial idea was for this turntable was that it should primarily be controlled via foot pedal. My problem with this idea was that in order to achieve any particular note you would have to pass through every other note in the scale to get there. Even

if you could train your foot to be so precise in a live environment you would still only be pitch bending. For this reason I saw complex and precise melodies an impossibility on this system, and so recommended placement of note buttons in the "active area" of the turntable, close to the natural scratching hand position.[88]

Not all of the DJs involved with the C1's R&D agreed with moving from foot control to hand control for note changes. Woody says, "Part of the problem perhaps is that you had different contributors that had different ideas on how they would use this thing. Vestax did not offer much as a mediator on the process, which in hindsight was probably needed for the end design. I always enjoyed going crazy with buttons so that style suited my style."[89] Ricci Rucker, who is known for being passionate and opinionated, really wanted the foot pedal control. From all accounts, the R&D process got a bit contentious.

When the C1 came to market in 2008, there was already a considerable amount of hype behind it that had been building on the Internet and on Web forums during its five years of development. But when the C1 came out, it had limited marketing. Although Rucker and the rest of the Ned Hoddings crew wanted Vestax to put out a tutorial DVD that would showcase and explain the new instrument, most of the budget had been spent on R&D. In the end, there was not enough money to market the instrument properly or to educate the public, which is essential when trying to standardize, or at least sell, new products.

Rucker says that there were numerous reasons why the C1 failed but stresses that there needed to be more education on the instrument because it was not just another product; it was a new idea in the form of a product. "It was the financial climate; digital DJing took over," says Rucker.[90] He does consider the experience with the C1 to be a valuable one. Rucker explains, "Most importantly, this experience allowed me to see the process of an idea to manifestation…. I thought about it, wrote it down, talked about it with people, and now it's here in my hands. Sometimes you gotta put something crazy into existence just to remind yourself that you are a creator."[91] He suggests that creators of new products "put AT LEAST 3 times the amount into a marketing budget that you spent in developing."[92]

When the C1 was in development, there were a lot of people suggesting that it was the future of turntablism and DJing, and that having melodic control was the next step for the art form. "It's the first musical instrument that really doesn't take the form or shape of any other traditional instrument," says Teeko. "I get on the Controller One and find an enormous amount of range and expression and tangibility that I never found in any other instrument,

any other turntable."[93] JohnBeez, a C1 player and the inventor of the Fretless Fader (discussed in the next section), says that the C1 creates a whole new level of artistry for DJs because it "combines all the techniques developed over time for scratching and puts that back with traditional music."[94]

Regardless of the C1's potential, there are a limited number of C1 turntables in the world. DJ Woody explains, "Firstly, it's a niche product. Everybody who would ever be interested in buying this turntable already knew about it virally several years even before its release.... It failed commercially, of course, but realistically this was never going to be a big seller. Creatively I think there's a lot more to be achieved with it."[95] Mike Boo understands the commercial failure and the reluctance of Vestax to continue making the C1. Boo suggests, "They [Vestax] are in the business of making money, and staying in business so they can make more product."[96] He feels that Vestax put the responsibility of promoting the instrument on the DJs who helped to develop it: "They put all this money into making the product and they dropped the ball on it by not spreading the word about it.... It's a complicated instrument and three people can't spread the word. They [the DJs] needed some corporate backing and Vestax to help expose so many more heads to it."[97]

Although DJs may find it easy to blame Vestax for not marketing the instrument properly, most likely it did not promote the C1 because in 2008 the turntablist and scratch DJ culture had diminished. And, because the market was limited, so was the production of the C1, which is one of the reasons for the high retail cost. The C1 was, and still is, a scarce commodity. A combination of factors led to the C1's demise, but many of the DJs felt that the final price point was the ultimate problem. The C1 is a custom-made instrument with a body that is hand-carved out of wood blocks and made with expensive components. It allows you to play scales and chord progressions, and it can be controlled from another MIDI device. Ono explains: "With the Controller One a lot of the components and parts, just engineers' time and money spent into the R&D of this product, is something that we obviously can't recoup at such a low-margin.... I think for this product it just comes down to price and size of market. It is a niche market."[98]

To Vestax's credit, it has taken these ideas that would only appeal to a small market, absorbed the financial risk, and turned those ideas into products. While these risks in innovation investment are not the only reason the company has experienced financial woes, this has surely added to the problem when they do not pay off in the market (it has been reported that Vestax has filed for bankruptcy[99]). Devoted DJs continue to use the C1 and many think somebody will pick up where Vestax left off. One possible candidate is JohnBeez.

Fretless Fader

In the history of hip-hop DJing, there have been many DJs who have had ideas for technical innovations. Few have had the resources, know-how, or drive to actually build or develop these tools. Instead, they pitch their ideas to manufacturers and participate in the R&D and branding processes, that is, if their ideas are not simply used by companies. The most notable DJ-as-inventor is DJ Focus, who inspired the devoted Controller One player JohnBeez to take an idea and make it a reality.

Vestax began developing a foot pedal to control note changes on the C1, but it never reached the market. Although you can change notes on the C1 using the record hand to press note buttons, JohnBeez thought that better music was possible if the record hand was freed up to actually manipulate the record. With that idea in mind, JohnBeez invented the Fretless Fader.

JohnBeez says, "They [Vestax] had all the intentions and they wanted to make the pedal and put it out the way it needed to be put it out, but then it just didn't happen."[100] JohnBeez bought his C1 as soon as it was commercially available, and soon thereafter began experimenting:

> And then I got thinking about it and I was like "You know, we could just move the fader." And the more I thought about it, the more I thought about how that would actually be better. I thought about how I'm supposed to feel using this pedal that they had designed. That could have been really difficult to use if you think about angling your foot for different notes while you are scratching. It would be a lot to do that accurately, like trying to go back and forth between notes with your foot and with some precision…. The funny thing is that the fader control on the C1, nobody actually shows it in a video or actually talks about it, but the way that my Fretless Fader works is the exact duplication of the fader that is on the turntable itself.[101]

The C1 has a fader that allows a player to change notes in the same way the buttons do. Also, the C1 has a MIDI input, which means that any MIDI device can control note changes on the C1. Because of these two features, JohnBeez was able to come up with the idea for the Fretless Fader and then build a prototype, a real challenge because he had no engineering experience.

With the concept of designing a MIDI control that would change notes via the crossfader on a DJ mixer, he began a long experimentation process:

> And literally I had no idea how to build it, I had no idea how I was going to do this…. It was just kind of sitting in the back of my head and I would wait weeks, months at a

time for the next light bulb to come on in the process of building it. I built a sliding crossfader with a cardboard crossfader plate. And that's how it started. "I have the crossfader sliding, now what?" That's how it went, that is the way that it went over and over. "Okay, I can do this, but I can't do that, I have to move this and move that." That was a long process; it took me about a year because I would just sit there for weeks without knowing what to do next or how to make it work. And eventually, once I had the idea and I could find a place to get the parts that I needed to do it, that's how it came together.[102]

JohnBeez premiered his innovation on a YouTube video in February 2009 (see Figure 4.1).[103] What he did was retrofit the Fretless Fader into a Vestax PMC-06Pro mixer. One year later, he released a follow-up video explaining the Fretless Fader in more detail, which revealed that it could change notes through two octaves.[104]

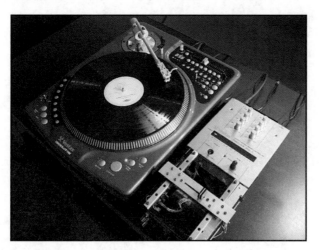

Figure 4.1. The Fretless Fader fitted into a Vestax 06Pro next to a Controller One turntable. Image courtesy of JohnBeez.

He wants to market and sell it as a stand-alone MIDI control device and not just a tool to be used with the C1. In fact, the Vestax PDX-3000mk2 turntable also has a MIDI input, which means that you can manipulate sounds on that turntable using a MIDI control device such as the Fretless Fader or a synthesizer. As an independent inventor, JohnBeez is hoping to sell his idea to a manufacturer who can develop and market it. He says, "I'm not worried about people stealing the idea.... As far as DJ manufacturers go, it's not on their level, they'd rather put out a MIDI controller that they can sell millions of than this thing that will sell a couple."[105] With manufacturers seeking to

dominate the growing digital DJ controller market, the now extremely niche scratch DJ market is not one that many manufacturers are developing products for, never mind such a specialized product.

Although he continues to pitch his idea to manufacturers, JohnBeez is willing to push his innovation on his own. "I don't really know where it is going to go from here, but I definitely still want to do whatever I can to make this thing happen."[106] C1 players who I have spoken with were all excited about the Fretless Fader and that JohnBeez is continuing to push the envelope with this instrument. Mike Boo explains, "I don't think it's up to Vestax anymore; it is up to these engineers, these bedroom engineers that are doing it for the love.... The technology is there now and all you have to do is reverse engineer the turntable and make something better (hopefully) and another manufacturer will pick it up...that is hip-hop for you."[107] JohnBeez's creative process and practice as a bedroom engineer—making his vision and dream a reality without the help of a manufacturer—was inspired by one of the few DJs-as-inventors to precede him: DJ Focus.

DJ Focus: Dedication Is a Must

Within a political economy of the hip-hop DJ, there have been few disruptive technical innovations. Whereas a sustaining innovation improves on an existing product, a disruptive innovation threatens the market and displaces an existing product. These disruptive innovations, according to Tim Wu, usually come from outside the industry because he says the "outsider has nothing to lose."[108] The outsider who develops a disruptive innovation threatens the existing order of the market.

In this book, two disruptive innovations in the DJ industry have been mentioned: (1) SSL and DVS in general (replacing the 12" vinyl single) and (2) digital DJ controllers (replacing turntables and CDJs). While Serato was a small, garage laboratory outsider company, it relied on an established insider, Rane, to help authenticate it and change the market; digital DJ controllers, however, came from within the industry by market leaders.

But there is a third disruptive innovation, one that has had a long-lasting impact on the DJ product industry and hip-hop DJ culture. The influence of the Focus Fader, the first optical and contactless crossfader, still resonates in today's DJ products. The Focus Fader was invented in 1998 by DJ Focus, not only an outsider to the DJ product industry but also a self-described introvert

who spent most of his time alone in his bedroom tinkering with electronics and audio. While some DJs know about Focus's powerful innovations, until this book, the story behind his Focus Fader existed only in folklore.

However, it's worth exploring the ways in which this crossfader is a disruptive innovation before looking at its development. At the time of the Focus Fader's commercial release by Stanton Magnetics in 2000, crossfaders used graphite contacts on the fader. But graphite would wear out within months, causing crackling and bleeding signals (especially for DJs practicing scratching 10 hours a day), so manufacturers such as Vestax and Gemini had built a strong market in the early 1990s selling replacement crossfaders for their mixers (retailing anywhere from $50 to $120). But Focus's innovation was a crossfader that had no contacts; that is, it could last forever.

And, while the Focus Fader's disruption was not necessarily on its release, the innovation changed the industry because soon others would follow with contactless crossfaders: Rane's magnetic crossfader in 2001, EBSel's Pro X Fade, and Audio Innovate's innoFADER (the current standard replacement fader). The Focus Fader and the *idea* of the contactless crossfader benefitted DJ culture because DJs could practice more, for longer, and have a fader that would outlive mixers. It also forced mixer manufacturers to change how they designed and manufactured crossfaders in their products. DJ Focus is a self-taught engineer who had many innovations that were simple yet revolutionary. He is still inventing, too.

Focus grew up and still lives in Mesa, Arizona, where he was the father figure to his three younger brothers in what he describes as an impoverished household. He would find discarded electronics around his neighborhood in the fields and community centers and began taking them apart and figuring out how they worked. It was here in 1986 when the older brother of his then-girlfriend came to his house and showed a young Focus how to scratch a record. From that point forward, Focus was hooked. In electronics class at school, Focus would grab faders and potentiometers from old television sets; eventually, he would use these parts on his first DJ setup. Focus wired his turntable into a volume fader from a TV and wired that fader into his mixer, which was basically the first external crossfader. He says that even in the 1980s, "The path was set that I was going to make something fader oriented."[109]

Although he dropped out of high school, Focus became fascinated with the innovations and philosophies of out-of-the-box thinkers such as Nikola Tesla, Viktor Schauberger, and Walter Russell, thinkers who he says "had the balance between the analytical and intuition." From those innovators Focus's

philosophy was to design products that he thought would allow DJs to improve technique and that were inexpensive. His innovations came from his love of DJ culture and were grounded in his altruism. When he eventually entered the DJ product industry in the early 2000s, he was the Nikola Tesla up against the business-minded Edisons.

In 1996, Focus opened a small shop in Phoenix, Arizona, called The Arena Official Hip Hop Store. He sold DJ products (often at cost to young DJs) and began doing equipment modifications ("mods") out of the store. One of his early mods was called the "soft switch," where he took apart line/"clicker" switches and removed the spring and bearing that puts tension on the bottom for quicker scratching. He also made "stopper plates" for faders that allowed for quicker cut-in times and began doing fader knob modifications as well. "Back in the day I was in love with the turntablist movement, and so I was just trying to share and be a part of it and create things for it," he tells me. "I understood that we get to be a part of history here, you know, this was brand new." But, The Arena did not last long and closed in 1997 or 1998. Focus was back to being broke.

Focus had gained some notoriety locally for his mods. When the Internet allowed for small video and audio files to be posted, Focus gained more credibility as a technical innovator outside the Mesa area. It was around this time that he put out his scratch tools records, first *Turntablist Compositions* in 1997 and shortly thereafter *Tools of Destruction* (records that Focus took months to a year to edit and arrange). Some small boutique DJ companies had reached out to Focus to distribute his mods and records, but those agreements all fell through. But Focus's passion never waned: "I wanted to be a participant in this turntablist thing, I wanted to contribute to it." After these letdowns, Focus says, "That's when I realized I was going to use my strengths, and what are my strengths? I make stuff, I invent shit."

At the time, Focus was doing mods on Melos DMC and Gemini Scratchmaster mixers. He began taking out the crossfaders to disassemble and clean them. Often, he would hold the opened fader and just stare at it and play with it, and saw that when it was apart the fader was smooth and loose. Because many crossfaders were made to have tension for mixing (not loose for scratching), Focus thought that he could either strengthen his hands so the fader felt loose or make the fader itself looser. It became clear to him that the latter was the best option. He spent about a week in the fall of 1998 playing with a fader, flipping it back and forth, and simply analyzing it. Still let down from failed business opportunities, "The only way out of the disappointment was to do something big," Focus explains. "I told myself that

I wasn't going to practice until I could figure it out." And then he had a series of epiphanies.

Focus believes that the equipment is the limitation on DJ skill and technique; that is, the human hand was more advanced than the technology made for manipulating sound. At the time, the crossfader was the greatest technical element that limited creativity. "There was such a burden with the old faders that held back how you could practice," he explains. Most faders in the late 1990s were made of graphite that used a trace from one end to another that allowed progressive electrical resistance, and thus musical signal, to pass through the fader. In the mid- to late-1990s, Vestax, and later Rane, started using voltage controlled amplifier (VCA) systems for faders. Instead of passing more/less musical signal, VCA systems passed more or less voltage through the fader. The Vestax 05Pro and Rane TTM 54 were some of the first to use VCA systems, but Vestax called its fader "optical" because it used optocouplers in the circuitry to control fader curve (cut-in time). This was his first epiphany: the VCA system would allow for a true optical fader with no contacts. "The grand epiphany was like 'oh shit, I just can hook up an optical sensor and transmitter to it because it's voltage, and that will work,'" Focus recalls. But, how would he do this?

Focus went into Zen mode and began putting his energy toward a truly optical fader. At the time he had about $500 to his name, and he spent it on a Vestax 05Pro LTD, which was a DJ Qbert signature mixer. He was so convinced that his idea would work that when it did, the first mixer to have an optical fader would be a Vestax Qbert signature mixer so it would have a larger impact. In October 1998, Focus sat down in his studio with the mixer and optical sensors/transmitters, which are the same type used in motion sensitive outdoor lights. The concept was that the sensors would receive light and let the sound in. "I tried it and it didn't fuckin work," Focus tells me. The sensors were too slow and wouldn't work for scratching. But his next epiphany was that he could use an LED infrared phototransistor. He bought the parts at Radio Shack and it worked. "Oh shit!"

Focus produced four of the original Focus Faders mods, which were made from modified ALPS crossfaders from the Vestax 05Pro (see Figure 4.2). Focus gives props to Vestax for using the VCA circuitry; without it, the Focus Fader would have never existed. The fader had four basic parts: (1) the infrared LED (light source); (2) a resistor to reduce the voltage going to it; (3) the infrared receiver; and (4) a resistor. There it was, the first fader with no contacts to pass signal. It would never wear out and it would never bleed signal.

Now that he had a working optical fader, how would he get it into the hands of DJs? The first idea was to manufacture and distribute the fader through ITF

(International Turntablist Federation), but just the mold for the fader would run $18,000, and so that option fell through. Focus tells me that, in an open source way, he just put his idea for the optical fader on the Internet, and it had some buzz online. However, people did not believe it was real. In 1999, Focus publicly debuted the fader at B-Boy Summit. He went to some trade shows and tried to connect with manufacturers, but nothing panned out.

It was not until DJ Emile put a call into a fledgling DJ company, Stanton Magnetics, that the commercial Focus Fader became a reality. At the time Stanton was the distributor for Vestax in the United States, and it saw all the money Vestax was making off the hip-hop DJ/scratch DJ market and wanted a piece of the pie. Stanton flew Focus and Emile to its headquarters in Hollywood, Florida, where they met with Laurent Cohen. Focus had to get over his fear of flying to make this happen, and he flew out with a modified mixer and some sketches. Impressed with the simplicity and revolutionary nature of the Focus Fader, Stanton agreed to patent the fader, use it in some of its mixers, give Focus a signature mixer, and bring Focus on to work for the company. For a young man from an impoverished background who wanted to make an impact and make history, this seemed like a great opportunity. In 2000, Stanton released the first commercial version of the fader, the Focus Fader V1.0 (see Figure 4.2).

"They [Stanton] wanted to make a big impact as well," Focus explains. "They could have gone in a way different direction. So they went really fucking scratch friendly and started doing lots of scratch stuff. You have to give them a lot of credit for that stuff." With Focus's arrival at Stanton, he pushed for the SA (Scratch Artist) line of products, and he thought these innovations in the products would push the level of artistry in the culture. The Focus Fader first went into the Stanton SK-2F, an imitation of the Vestax 05Pro, but it also worked on other Stanton mixers (i.e., the SA-8 and SA-12) and as a replacement fader for other mixer brands that used VCA circuitry (Vestax and Rane) with a simple mod. Stanton applied for a patent on the innovation—naming Focus as inventor (Ruben Meraz)—in 2000 and was granted patent in 2006 (see Figure 4.2).

The crossfader faired well in the market, and it helped to sell Stanton mixers to hip-hop DJs. Its main impact, however, was on the industry. The Focus Fader made it clear to DJs that a contactless fader with sharp cut-in time, little resistance, and a long life cycle was possible. And, the market demanded it from the producers. Within a year Rane released its then patent-pending magnetic crossfader, and eventually other boutique companies made similar, durable crossfaders. Away went the once robust replacement crossfader market that many mixer manufacturers enjoyed.

On his arrival at the company, Focus improved Stanton's line of crossfaders, and designed the SA-8 Focus Signature Mixer and the SA-12 DJ Craze Signature Mixer, as well as crossfader knobs, slipmats, and numerous other products. Stanton branded his designs with the tagline "From the mind of Focus." But there was an issue: Focus had ideas but their execution in manufacture (even in the Focus Fader V1.0) by Stanton deviated in ways that were problematic. This, however, is common in the DJ product industry as DJs give companies ideas and they interpret and execute them differently for financial or practical reasons. "Stanton went with the lower quality parts and that's when I realized I had to keep quiet and make compromises in order to make it happen," explains Focus. What was in the best interest of Focus was not necessarily in the best interest of Stanton.

"My only real strength is that I'm just friggen a creative guy, just let it all out there, just constantly coming up with stuff," he tells me. "And, at the time Stanton was very open. You got to give them credit for that as well because these companies are out to make money, but regardless, if they were not open they could have been doing other shit." While his impact has been long-lasting, his stint at Stanton and in the DJ product industry was short-lived; he was in Florida for about two to three months before he returned to Mesa. Focus was promised a job at a new Stanton office in California, but that never happened. Although Focus experienced a great deal of success and letdown in a short period of time, he says, "The Stanton thing has been the best thing and the worst thing for me." Focus tells me that his relationship to the company alienated him from other manufacturers, but the fact that Stanton still sells his slipmats and uses knobs he designed keeps his name alive. And, in a culture where contribution through innovation is highly valued, Focus proudly claims, "I got to contribute through the equipment." And, his name and legacy live on in the few Focus features that Stanton still uses.

Focus's innovations were about practicing scratching. He saw his Focus Fader as a practice tool because an optical fader allowed DJs to practice for longer to achieve higher levels of skill.[110] His innovations were also conceptualized holistically, that is, with synergy between innovations, which is in line with his philosophy that life is one energy, movement, and balance. When he was modding and designing in the late 1990s, he saw a parallel evolution between DJ techniques, DJ technology, and DJ scratch tool records. His innovations reflected this triad, with the Focus Fader as the crux.[111]

The SA-8 mixer had several other features that are just now, nearly 15 years later, catching on with DJs and other manufacturers. Focus designed a

post fader cue on the SA-8, which allows you to scratch using the crossfader in the headphones without the signal going over the speakers. The SA-8 also had another original Focus concept: individual direct outputs for each channel. Whereas all DJ mixers have a single master signal output, the individual direct outputs allow a DJ to record the signal from turntable one and turntable two onto separate tracks in recording software. "There was just a lot of years of ideas that I wrote down," says Focus. "This feature came from the scratch/turntablist movement. Because without that [movement] there is no need for that feature."

In 2015 a mixer came out with individual outputs (along with other Focus-esque features), claiming this feature was "a first for any DJ mixer and great for recording your skratches separately": the Thud Rumble TRX Professional DJ Mixer made by DJ-Tech.[112] Because Focus foresaw others copying his ideas down the line, he had Stanton note in its marketing materials and product manuals "Original concepts by DJ Focus." Focus explains: "Because I knew how original these things were, I made it a point to get credit for it. And look, here we are fourteen years later and what's going on? I put that shit in stone basically. But honestly I pretty much thought that as soon as I did that other companies were going to jump on it." Some may say that the SA-8 and other Focus innovations were ahead of their time, but Focus disagrees. "There is a pace that things unravel at. And you have people that are moving at a certain pace. That thing about being ahead of your time, there is no such thing as that. You can be ahead of everybody else's level of awareness, though."

Focus looks at innovation and scratching as "just energy movement, it is equilibrium." His idea sketch books are thick and he always has ideas flowing through him. Even today, after over a decade of meditation outside of the DJ scene, he is still inventing and plans to release a new type of crossfader. "So my new fader and the new stuff that I'm trying to do requires a paradigm shift," Focus explains to me. He has an idea for a fader that is not regular or Hamster, but a complete 180, and is debating just putting it out there online himself or trying to get a manufacturer to release it.

Focus remains true to his core about the nature of innovation. "My theory is that a good idea is a good idea and if you mention it to someone it could resurface later," he says. In some ways he is pleased to see his concepts still making a difference because he has always innovated for the sake of DJ culture, which he contends is a participatory culture. "People want to put stuff out there and participate. This is information. This is open source. It's just energy. You know, information wants to be free. It's trying to express itself." And Focus admits that his love of the culture and the altruistic nature of his innovation

may have been of detriment when it came to the business side of things, but he has made peace with it. His deep-seated passion for and striving to be a part of DJ history is why he has, in a way, been written out of that history. Until now, at least.

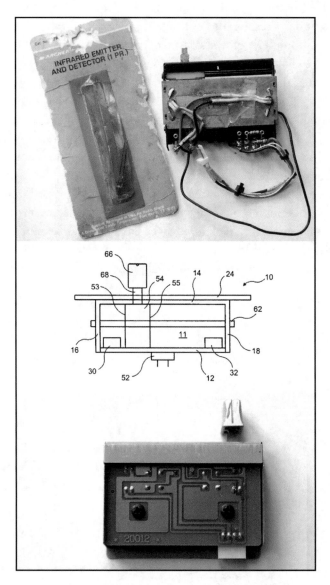

Figure 4.2. One of the original four Focus Fader mods (top), the patent drawing for the Focus Fader (middle), and one of the early runs of the commercial Focus Fader (bottom). Pictures by André Sirois / Courtesy of the DJistory/DJpedia Archive.

This chapter has reviewed the exchange of intellectual properties both broadly and in several case studies, as well as explored the difficulty of assigning credit for technique and technical innovations to singular individuals. We have also seen, under the matrix of technocultural synergism, how intellectual property rights manifest as the right to produce and distribute product in a market, as well as how IP laws also grant exclusive rights. Within exchange and rights, we see how hip-hop DJs often fail to receive credit for innovations, which is partly due to the fact that innovation comes through a creative network, but also how brands and brand names often become linked to innovations as "inventors." R&D and technical innovation, however, reveal how hip-hop DJs can be manipulated *as* intellectual properties.

Although DJs have been used in R&D and are seminal in that process, the authorship of hip-hop DJs is most recognized by manufacturers and industries as brand names. While DJs' ideas are vital to product development, hip-hop DJs realize that corporate recognition of their authorship/creativity is in branding and endorsing products. However, only a select few DJs are able to get signature series products or engage in other endorsement activities. In the next chapter, I will look at the hip-hop DJ as a brand, and how hip-hop DJs have been manipulated *as* intellectual properties to authenticate products in a market.

· 5 ·

THE HIP-HOP DJ AS
INTELLECTUAL PROPERTY

Branding, Endorsement, and the Nature of Convergence

"DJing is writing, writing is DJing."
—*Paul Miller aka DJ Spooky*[1]

When he began DJing with his crew, Bum Rush Productions, in Los Angeles in the late 1980s, Mark Potsic was having a difficult time deciding on a DJ name. His crew joked that he would find his name "just under his nose." At that time, a company called Numark was manufacturing some of the best mixers on the market, and its mixers were the brand of choice among many West Coast hip-hop DJs, Potsic included. One night, he looked down at his Numark mixer, and because his name was Mark, he decided, "Oh the hell with it all, I will call myself Nu-Mark."[2] After more than 25 years of DJing, DJ Nu-Mark, who got his first exposure to global audiences as one of the two DJs in the group Jurassic 5, has become a recognizable brand name and DJ/ producer who is well-respected within hip-hop DJ culture. Nu-Mark is a brand name DJ with a twist on a brand's name.

Although we do not commonly think of people as brands in our day-to-day interaction and consumption of their images, just like famous recording artists, actors, or athletes, DJs are themselves brand names. For example, LeBron James and Taylor Swift, while leaders in their industries, have become brand names that companies pay endorsement deals to in order to associate the authenticity and credibility of their brand names to companies' products/ brands. On a smaller dollar, market, and recognition level, renowned DJs

become brand names that are used by companies to endorse and authenticate products, as well as make manufacturers' brands seem more credible to the DJ market. Thus, in terms of using brand names in the DJ product industry, DJ Nu-Mark is the exception to the rule: he applied a manufacturer's name to his own, borrowing the credibility and visibility of Numark, and built it into his own brand-name identity.

Both DJ Nu-Mark and manufacturers such as Numark rely on what Sarah Thornton calls "subcultural capital," which boils down to one's authenticity and credibility within the hierarchy of a subculture.[3] Within hip-hop DJ culture, subcultural capital is amassed in a variety of ways, including being skillful with turntables and a mixer, having a unique style, naming and popularizing new DJ techniques, winning DJ battles, touring with notable musical acts, owning and collecting rare records, producing tracks, making records or mixtapes, DJing at large venues, and so forth. According to Thornton, who built her concept on Bourdieu's notion of cultural capital,[4] subcultural capitalism involves objects (for instance, records, mixers, and turntables) and knowledge (how to manipulate those technologies with the hands). Within a creative network like hip-hop DJ culture, subcultural capital creates hierarchy and difference and adds value to the recorded music and DJ product industries.

Although Nu-Mark found his DJ name by adopting and modifying a manufacturer's brand name, the process usually works in the other direction. It has become common practice for DJ technology manufacturers to use the names of DJs with the highest levels of subcultural capital to market their products. By attaching the names and likenesses of DJs with high levels of subcultural capital and credibility to products, as well as using these DJs in the marketing of these products, manufacturers use brand-name DJs to authenticate their goods. Companies often lack this type of capital with their market, which is why they need authentic DJs to back their brands. Manufacturers also rely on these DJs to demonstrate the use of their products for both practical measures (i.e., most engineers or product reps lack DJs skills) and to authenticate the product (having a skilled DJ use a product in demonstration at trade shows and in videos gives it authenticity).

Although we have moved into the era of the celebrity DJ (for instance, DJ Paris Hilton, whose exploits were discussed in this book's introduction), manufacturers have yet to use celebrities with such mass cultural capital to endorse products, because these types of DJs are not credible within DJ culture, which is their target market. However, it is possible that as manufacturers look to broaden their market share for digital DJ controllers, this may be a marketing

tactic moving forward. Siphoning from DJs' subcultural capital becomes a way to give a bunch of knobs, faders, and audio components life and identity. In other words, manufacturing companies imbue their products with a human element by associating their brand name with respected DJs.

A DJ's name is one of his or her most valuable assets. Hip-hop DJs who have been used in signature DJ products or endorsements have worked extremely hard to build up their reputations. The name-as-brand is what gets a DJ high-paying gigs, what helps bring people through the doors, and what opens other opportunities within numerous cultural industries. Although distinctiveness is a key element in trademark protection, Thornton maintains that subcultural capital is also hierarchical: distinction does not mean equal difference. In fact, subcultural capital entails claims to "authority" and the presumed "inferiority" of others.[5] "In knowing, owning and playing the music," Thornton writes, "DJs, in particular, are sometimes positioned as the masters of the scene."[6] That is, within music scenes or subcultures, DJs often have the most credibility and subcultural capital, and are at the top of the scene's hierarchy.

DJs who amass subcultural capital become brand ambassadors for manufacturers. Their brand names, which represent their subcultural capital, can also be applied to products. In his study, Herman suggests that a DJ gets authorship by the ways in which he or she is represented under the capitalist system, and thus becomes a "brand-name author-god."[7] Herman explains how DJs' names are a function of their authorship, and that by using DJs' names on signature products manufacturers exploit the DJ as "the ultimate brand name, the moniker under which almost everything is sold."[8] Instead of subcultural capital, Herman concludes that the "social capital of authorship becomes a tool for generating financial capital."[9] A company's investment in a DJ's authorship helps to sell products by allowing consumers to make informed purchases based on a DJ's endorsement. While using brand ambassadors is nothing new in the cultural industries—think of how everything from sneakers to cereal is marketed—analysis of such brand exploitation at the subcultural level in niche markets can illustrate how different forms of selectivity within a network creates particular hierarchies and antagonisms.

A DJ's name as brand is how one is recognized as an author by industry, and this brand name is how a DJ is most valuable to the industry as an intellectual property. When companies use DJs' names on products or associate those names with companies' brands through endorsement deals, we see how industry and culture converge and another example of technocultural

synergism. Through technocultural synergism, branding, just like research and development, reveals how hip-hop DJs are manipulated *as* intellectual properties. By exchanging their brand name and likeness with manufacturers, hip-hop DJs allow manufacturers the right to exploit their subcultural capital in a marketplace. But, it's important to remember that hip-hop DJs associating themselves with manufacturers also helps to authenticate them as DJs.[10] This dialectic exemplifies the type of synergism outlined throughout this book.

Hip-hop has witnessed a number of conflicts over names and names-as-brands. For instance, Jazzy Jay, a pioneering South Bronx hip-hop DJ who got his start in the Zulu Nation, commonly goes by The Original Jazzy Jay because of all the DJs who have used Jazzy Jay as a name. The same can be said of the Original Spinbad from Philadelphia, with the "original" used as a way to differentiate him from another DJ Spinbad hailing from New York City. Another example would be Jazzy Jeff, an old school emcee of Funky 4 + 1 fame, who sued his label, Jive Records, in the mid-1980s because the label also signed DJ Jazzy Jeff & the Fresh Prince. Jazzy Jeff won the suit and the right to use the name; however, winning the lawsuit to use his name did not prevent DJ Jazzy Jeff from using it as well (see Figure 5.1).

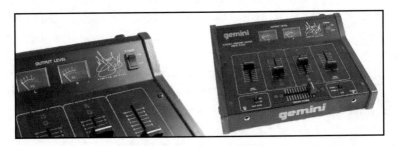

Figure 5.1. Image of the Gemini PMX-2200 DJ Jazzy Jeff signature mixer. This mixer was released in the mid-1990s as Gemini was losing its hold on the hip-hop DJ market to Vestax and Melos, making an effort to remain relevant in that market by attaching DJ Jazzy Jeff's name to the product/company. Picture by Zane Ritt / Courtesy of the DJistory/DJpedia Archive.

Another interesting case of brand names and intellectual property rights is that of the X-ecutioners DJ crew, originally known as the X-Men. The X-Men—founded by DJs Roc Raida, Steve Dee, Sean C, Johnny Cash, and Dr. Butcher—was a crew of DJs that formed in the late 1980s to challenge DJ Clark Kent and his Supermen DJ Crew. The X-Men continued to be the name of the crew as new members Rob Swift, Mista Sinista, and Total Eclipse joined Roc Raida to make it one of the most recognized crews during the

mid-1990s boom in turntablism. The problem was that as the X-Men grew in popularly and began releasing actual albums, their name was technically infringing on the X-Men trademark held by Marvel Entertainment (now a Walt Disney Company subsidiary). Although the use of the name was never an issue when the X-Men were well-known within the DJ scene, entering into the recording industry and making albums with major labels made such usage problematic.

The X-Men changed their name to the X-ecutioners before releasing their album *X-Pressions* on the independent label Asphodel Records in 1997. Rob Swift recalls the situation in which the name change took place after they released a 12" single as the X-Men[11]:

> Shortly after the release, our label informed us that their lawyers were concerned the attention the group was getting would eventually raise issues because of the connection between the X-Men brand and Marvel Comics. So to avoid an imminent lawsuit, the group decided to change our name to The X-ecutioners. We never got an actual cease and desist from Marvel. Asphodel's lawyers wanted to avoid it even reaching that point.[12]

Changing the crew's name was not an easy process for the group, especially changing the name only in fear of a potential trademark lawsuit. However, Rob Swift says crew members eventually embraced the new name and considered the change symbolic:

> At first we were all bothered by the idea we had to change the group name. It's like asking someone to change their real name. But I think the name change to X-ecutioners also symbolized a change within the group. It's like we were reinventing ourselves. We went from battle DJs as The X-Men to recording artists as The X-ecutioners and it didn't take long before we embraced the new name.[13]

A DJ's name, as we can see in Rob Swift's statement, is more than just a name. It serves as an identity for an artist, but it is most valuable to industries as a brand. When the X-Men were reborn as the X-ecutioners, it took significant labor to create an awareness of who the X-ecutioners were. They had to figure out how to re-brand themselves under the new moniker, which they did as recording artists. While changing a crew name is a complicated process, individual DJs can also face similar conflicts between their professional identities and brands.

What if Asphodel had asked Mista Sinista (a DJ in the X-men/X-ecutioners DJ crew) to also change his name because it could possibly infringe on another Marvel/X-Men character, Mister Sinister? What if the DJ

product manufacturer Numark sent DJ Nu-Mark a cease and desist letter for trademark infringement? In the following sections, case studies of signature DJ products—those that use a DJ's name and subcultural capital on the actual product—and the branding process are explored. By deconstructing how DJs' brands are used on products and in endorsements, I hope to illuminate how brand-name DJs' primary authorial function, and therefore value, within the industry is their names that represent their subcultural capital. Also, under the matrix of technocultural synergism, this type of exchange of IP demonstrates another way in which DJs are manipulated as IP. The chapter concludes by using testimonials from interviews to begin deconstructing the relationship between hip-hop DJ culture and industry, and thus highlights the nature of technocultural synergism as it is perceived by those directly involved.

Adventures of Grandmaster Flash on the Wheels of Steel

In the 1970s, when hip-hop was still only performed live in the parks, recreation centers, and school gyms, the DJ was the name that brought people to the parties. Herc, Baron and Breakout, Bambaataa, Flash, Disco Wiz, DJ Hollywood, and other pioneering DJs had earned their reputations and credibility with their skills, record collections, and sound systems. In other words, branding was a key element in hip-hop culture even during its infancy. And in many ways, these larger-than-life breakbeat DJs from the 1970s were the first brand ambassadors for technology companies, despite the fact that they were unaware of it. For example, by using a certain brand mixer or turntable at a park jam, hip-hop's first DJs authenticated particular products, leading up-and-coming DJs in attendance to purchase similar ones. Thus, DJs such as Herc, Bambaataa, and Grandmaster Flash established how subcultural capital could be valuable in a market, as well as how their names could be recognized as authors. In the late 1970s, Grandmaster Flash and his group of emcees, the Furious Five, were the biggest hip-hop act in New York City, but it was the Grandmaster Flash name that was the main draw with consumers.

In 1980, following the success of "Rapper's Delight," Grandmaster Flash and the Furious Five signed with Sugar Hill Records. The group put out several hits on the label including "Freedom" and "The Message." However, these singles did not include the DJ skills of Flash, but instead used session

musicians to re-create Flash's quick mix. Although the recordings were sold as "Grandmaster Flash and the Furious Five," Flash did not perform on the records or get songwriting credit. Instead, Sugar Hill Records used Grandmaster Flash solely as a brand to authenticate and sell records to hip-hop fans. Flash's name was used for its brand equity because he was the most popular DJ at the time, and in the 1970s the DJ was the main celebrity in hip-hop culture.

Flash's only chance at making a record, and in fact replicating what "real" breakbeat hip-hop was at the time, came in 1981 with "Adventures of Grandmaster Flash on the Wheels of Steel." It was the first record to be made solely from other records as Flash demonstrated his quick mix theory and codified the technique on vinyl.[14] Recorded in 10–15 takes, Flash used three turntables and mixed and cut in nine different songs. Even on the "Adventures" record, Flash received no authorial or publishing credit. He was the author by brand name but not one recognized by copyright.[15]

Because Flash was basically brushed aside by Sugar Hill Records and only allowed to be an active player in live performances with the group, he left the label in 1983 and sued the company for using his name to sell records without paying him any royalties. Grandmaster Flash and his attorney, Morton Berger, sought $5 million in damages from Sugar Hill Records; in turn, Sugar Hill Records claimed that it owned the rights to "Grandmaster Flash" and that Flash could not use that name to make new recordings without them (Flash signed with Elektra Records around 1984, which complicated the matter).

Grandmaster Flash says, "Sugar Hill also claimed to own the words 'Grandmaster' and 'Flash' and said that I couldn't use them together for any reason.... The case was pending, but the long and short of it was that I was fighting for my own name."[16] Judge Brient, who presided over the case, ruled in favor of Flash in that there was no clear evidence that Sugar Hill owned a trademark on the Grandmaster Flash name.[17] The judge explained that Flash had put considerable effort into building his brand and that he should be able to exploit that name in the market; in fact, Flash had, by using the name to distinguish himself as a DJ in New York City, earned a common law trademark. This common law trademark, which is granted by using a name as a mark of product or service, and thus is a sign of that product or service, gives the user of the name monopoly within a geographical region and within a product market.[18] After the lawsuit the lead emcee of the Furious Five, Melle Mel, changed his name to Grandmaster Melle Mel, and Sugar Hill Records released titles under Grandmaster Melle Mel & the Furious Five with the hope that consumers would think Grandmaster

Flash was still with the group. Being able to use Grandmaster Flash would prove to be valuable for Flash in the DJ product industry.

According to his biography, Flash ran into a series of personal issues that took him out of DJing during the mid-1980s.[19] In the late 1980s the most popular scratch technique was the transform scratch, a technique innovation developed by Philadelphia DJs. Because of these personal problems that kept him away from DJing for several years, Flash could not perform the transform scratch well when he came back on the scene. Thus, in 1988, Grandmaster Flash and the American DJ product manufacturer Gemini teamed up to produce the Gemini FF-1 FlashFormer (see Figure 5.2). The device hooks up between a turntable and mixer and allows a DJ to perform what sounds like a transform scratch by pressing a button instead of using a crossfader.[20] Here is how Gemini explains the FlashFormer in its manual:

> The only signal transforming device that lets rock, rap, hip-hop and mainstream amateur or professional disc jockeys create a clean, high-quality *scratch* effect, even with one hand tied behind their back.
>
> *The complicated technique of moving a record back and forth with the needle in the groove to create a rhythmic scratching effect popular in the current music scene.
>
> "I thought I heard you say, you want to be a D.J. Rock it with my FLASHFORMER, Because it's the only way!"
>
> DESIGNED BY:
> –Grandmaster Flash–[21]

Gemini stated that the FlashFormer would allow DJs to save on the wear and tear on their mixers, which, at the time, was a valid claim because manufacturers did not have mixers with replaceable crossfaders; practicing the transform scratch for hours and days would ultimately ruin the crossfader and the mixer would have to be replaced.

The FlashFormer was probably the first DJ product to bear a DJ's name and, of course, the signature of Grandmaster Flash. Although the FlashFormer was ultimately a failure since most DJs at the time saw it as a cheat,[22] it was the first product to add a famous DJ's brand to a product for authentication purposes. This is not too different from the same tactics employed by Sugar Hill Records when it used Grandmaster Flash as a branding and authentication tactic for records. Thus, we see how Flash's winning the rights to use Grandmaster Flash was important, not only for him but also for corporations seeking to use his name as a brand.

Figure 5.2. Image of the Gemini FF-1 FlashFormer and box. The piece bears the signature of Grandmaster Flash. Picture by Zane Ritt / Courtesy of the DJistory/DJpedia Archive.

Executives at Rane Corporation admit that when Grandmaster Flash called its offices in the early 2000s, they had no idea who he was; they quickly learned. After being dissatisfied with products on the market, as well as products that had been designed for him, Grandmaster Flash decided to call Rane and pitch some of his ideas for a mixer. After a few phone calls, Flash flew out to Mukilteo, Washington, to share his ideas with Rane. Flash has a reputation for being a challenge to work with, but Rane's executives managed to develop a solid working relationship with him. The result of their exchanges was the Rane Empath. Released in 2002, the Empath is a 3-channel club mixer that combines the vision of Grandmaster Flash and the engineering of Rane (described in Chapter 3). Mike May, Rane's National Sales Manager for Retail & DJ Products, says, "At first we had to push back a little bit and go 'no no, we can't do this,' but we ended up doing a lot of the things that he wanted in the mixer and we made the Empath mixer as a result of his input…. It wasn't all his design ideas, but he brought a lot of creative things to the mixer."[23]

Flash was particular about what he wanted in this mixer, and according to Dean Standing, Rane's Director of Sales, it was a frustrating process for Flash because, unlike other signature products, he didn't want to just put his name on a piece of gear he was unsatisfied with. "He knew what was possible

and not possible," says Standing.[24] "When you hear him talk about the mixer you can tell it wasn't just an artist who said, 'Put my name on it and give me money.' We respected that and, ultimately, it was a lot of fun working with him," Standing explains.[25]

But the process of designing the Empath may have not been as much "fun" for Flash and Rane's senior analog engineer, Rick Jeffs. Flash claims he "flooded" Rane with ideas, most of which were the byproduct of his frustrations with products in the previous 25 years. Flash says:

> I met with Rick and that was probably the closest thing to a fistfight that it could possibly get. With his genius he'd say, "Flash, but it's not normally done this way." And I'd say, "Well, you gotta squeeze it...." After months went by, he began to understand. As I gave him my wish list, he'd have to keep going back to the schematic diagram and make it work. Rick was so helpful.[26]

This exchange seemed to characterize the R&D process on this product, and while we see that Flash surely contributed heavily on the Empath's design, in the end the value for Rane was tapping the Grandmaster Flash brand.

Rane released several versions of the Empath, including the Grandmaster Flash Gold Signature Edition. The credibility and authenticity gleaned from this connection helped solidify Rane's place in the market, and Mike May thinks that out of the relationship with Flash came a great product:

> And he's a great DJ, and he's a great personality in the DJ world, and hey, he deserves the credit that is due. He is one of the guys who made it through tough times and has stayed in the business, and is a very credible personality in this business. We were fortunate to have a relationship with him and to build a product that he believes in and uses.... And that relationship just came from his interest in the quality of products that we build.[27]

Being able to use the subcultural capital of Grandmaster Flash to not only authenticate the Empath mixer, but also the Rane brand itself, is likely how the company benefitted from this relationship (over profits from sales of the mixer). As May states, Flash is "credible," and Rane got to use his credibility in the form of subcultural capital to enhance the company's brand. While it may be coincidence or the byproduct of market conditions at the time, shortly after the Empath hit market with the buzz that Rane was working with Flash, the Rane TTM 56 took off with hip-hop DJs and replaced Vestax as the standard model for 10" battle-styled mixers. This case study of Grandmaster Flash highlights not only DJ products but also the DJ *as* product. Under

technocultural synergism, the lines between DJ and product are quite blurry. While the relationship with Flash and Rane demonstrates one way in which manufacturers and DJs can mutually benefit from branding and endorsement, or, under technocultural synergism, manipulating DJs as IP, it is important to explore this industrial manipulation and convergence in more detail.

Harnessing Subcultural Capital

Thus far, we have seen the value of hip-hop DJs to manufacturers in respect to R&D of new products. While the use of hip-hop DJs in R&D is an important element in manufacturers delivering products to the market, hip-hop DJs have also been seminal in branding and endorsing products. Grandmaster Flash was the first to have a signature product, while DJ Trix designed and endorsed the Vestax PMC-05 TRIX mixer, which was the first mixer to feature a DJ's signature as endorsement. This trend continued with other manufacturers that reached out to the most popular and credible DJs to make products bearing their name as a sign of authenticity. DJs such as Jazzy Jeff, Qbert and ISP, DJ Craze and the Allies, Z-Trip, and DJ Focus have all had signature mixers made with their names and subcultural capital attached.

DJ crews such as the Beat Junkies, Invisibl Skratch Piklz, and the X-ecutioners have had prominent endorsement deals, specifically during the high point of the turntablist movement in the late 1990s/early 2000s. Typically this means that individual DJs and their crews are featured in advertisements, they use these products at their performances, and sometimes they showcase new gear made by their sponsors at trade shows. Often, endorsed DJs will appear on other marketing materials for a manufacturer, such as slipmats, T-shirts, and posters, or other technologies in a product line (e.g., needles or headphones). The benefits for DJs sometimes includes cash (this is rare), free gear, equipment servicing, and prominence in a manufacturer's marketing materials.

These relationships also contribute to a DJ's subcultural capital and help build a DJ's credibility in the culture/market. Manufacturers are able to attach the brand value of the DJs to products, have DJs with skills who can actually showcase products, and get the benefit of an audience watching these DJs use the products in performances, which all helps to sell products. Sometimes (and rarely) DJs who have signature products receive royalties based on units sold. The deals vary between companies, and there is no standard deal in the DJ product industry.

DJ Shortkut, who has had numerous endorsement deals and has seen the DJ product industry increasingly reach out to big-name DJs, thinks that these sorts of deals benefit all parties involved. Shortkut explains, "Over time they [manufacturers] started getting the heavyweights in there and made it more credible.... It's good for the company, it's good for the product, and it's especially good for the DJ because the DJ can shine."[28] DJ Marz, who has worked with Rane and Numark, says that at the time when companies started seeking out DJs in the mid-1990s, DJs were surprised because nobody ever thought that corporations would take the art form seriously. "I mean at that time for people it was like, 'Wow, really, I went from being just some DJ to now there are people calling me to do this corporate stuff,' and it was just so new to everybody."[29] Many of the DJs that companies were reaching for in the mid-1990s were just out of high school, and it forced DJs to quickly figure out the business side of the industry.

Chuck Ono, VP at Vestax, says, "Having these people backing up your product and using your product definitely shows in importance to the brand, and not only that, it does show that there is a strong bond and an understanding between the brand and the DJ and why he is using it."[30] Mike May from Rane suggests that having DJs endorsing products adds credibility:

> Although manufacturers are going to pick their group of stars and performers who, because of the work ethic they have and because of their star power and their recognition in the industry, you want them to have your gear and you want them to use your gear...without them you don't have the genuine aspect of the products that you are trying to get in their [consumers'] hands.[31]

When May says "genuine aspect," he is alluding to the authenticity of DJs backing a product, which comes from their subcultural capital. While manufacturers sometimes reach out to DJs, many times DJs are reaching out to companies with the hopes of establishing an endorsement deal. Rane has a group of full-time endorsing artists who give advice and product feedback, but May suggests that all of the thousands of Rane users "mentor" the products as well. May says that having these relationships are a "blessing for us because we do have really good DJs who believe in what we're doing and have been supporting us and we try to do the same thing right back. And that helps because they are the guys who supply a great number of the ideas."[32]

Thierry Alari, the independent designer of the Scratchophone, says, "Artists as product ambassadors is a must."[33] Alari proposed that Qbert have

his own custom Scratchophone, what Alari calls his "best move ever." Qbert and Thud Rumble made a video of Qbert using the Scratchophone, and Alari says that this exposure and the connection to Qbert adds credibility to the Scratchophone, as well as instant sales. This sort of branding is integral to the success of a fledgling product such as the Scratchophone.[34]

Ono says that Vestax uses big-name DJs just like companies in other industries. "Where Nike has their Jordans or their LeBron James or whomever, we have our Qberts, Mix Master Mikes, and Paul Van Dykes, but obviously on a different level of dollars and markets as well."[35] Ono stresses the importance of keeping these DJs on board and satisfied, as the brands of the company and the DJs are interrelated—the relationship is dialectical. Although product feedback comes from many DJs, Vestax picked a few stars to become the face of its products, essentially asking DJs to act as marketing tools. DJ JS-1 recalls how vital the Vestax endorsement deal with the Invisibl Skratch Piklz (ISP) was in the mid-1990s: "Qbert and Mike basically said, 'Go get a Vestax and we are using those' and everybody and their mother was like 'I need a Vestax.' Immediately, everybody was all over that," JS-1 explains.[36]

Because Qbert has put out so much product, from scratch records to DVDs, DJ Kico thinks that he could be considered a brand in and of himself. "Qbert is a brand now. You have to have 'Qberts' now. You have to have Qbert slipmats or Qbert needles…. He is a prime example, the epitome of what DJ should do."[37] Shortkut says that what Qbert and Yogafrog have done with the Thud Rumble company "changed the game" in respect to DJs being involved in the business. "It made it so that you had to get your business up and get your business straight for a lot of these companies to start messing with you and take you seriously," says Shortkut.[38]

DJ Craze, who won the World DMC DJ Championships for three consecutive years (1998–2000), says numerous manufacturers approached him in the late 1990s during his title runs. Craze tells me he would endorse anything because he was young and broke at the time. "So for me being sponsored back then was all about the loot. About the loot and just trying to get my face on a DJ box. But like now I'm a little bit more picky because I want to use the product that has my name on it."[39]

Stanton approached Craze after he won one of his world titles, and he eventually put his name on a signature series needle/cartridge (Stanton 520 SK) and the SA-12 DJ Craze Signature mixer. Craze explains the situation:

The first thing that they approached me with was having the needles. Back then I was really using Stanton 500s. And that's why they approached me because they had seen me in battles using the 500s. So they were like "yeah, we'll make a 500 with your name on it, make a signature series. It is going to be the same thing, you just pick the colors or whatever you want, and then you put your name on it." And I was like "alright cool." And then they asked me to do the SA-12, and it was kind of like on the same deal. I was using Stanton needles and I was like "shit, why don't I try using one of your mixers?"[40]

Because Craze had so many other DJ opportunities from his DMC winning streak, he never got to fully test and work out the kinks on the SA-12, a mixer designed by DJ Focus with Laurent Cohen. Craze was so busy touring, he could not get enough test-time on the SA-12:

And I really didn't get down to specifications, and what I need in the fader, and all this stuff. I really didn't get to play with it and get hands-on.... I couldn't make it how I wanted to make it. So I just ended up okaying the second thing that they showed me. And I was like "yeah let's roll with this, let's put my name on it. Let's do it." So I wish I could have designed that one better.

Craze's relationship with Stanton is a great example of the DJ being manipulated as IP, specifically exploiting his brand equity. With some signature products DJs are involved heavily in the R&D (e.g., the Rane Empath), but for these two Stanton products the primary goal was to use Craze's signature and subcultural capital to sell units and to authenticate the Stanton brand within the market. (Craze notes that he did get a small royalty for these products.)

DJs who win championships such as the DMC Worlds definitely become commodities within the industry. Roli Rho suggests that manufacturers seek out these types of DJs so that consumers can see them on new equipment, which creates a buzz around the gear. Often consumers then assume that the endorsing DJs contributed to the R&D process.[41] DJ Neil Armstrong, who DJs for Jay-Z, has an endorsing deal with Rane and considers DJs marketing tools for manufacturers: "You see me on stage with Jay using a Rane 57, an impressionable youth might be like 'oh wow, that's the mixer to use right there.'"[42]

DJ Babu, who has had numerous endorsements with Rane, Vestax, and Shure, says, "As far as endorsements go I've always looked at that as a relationship and never expected to get paid."[43] While Babu says that manufacturers "break bread" when he has done trade show demonstrations for them, the real bonus comes through the exposure gained by working with these companies. "It really means more for me to have that official relationship and have them

recognize who they included on the roster.... It's a visibility and perception angle of it is how we get paid."[44] This "visibility" that Babu speaks of helps to further authenticate endorsed DJs and their brands, and is an investment in their subcultural capital.

Thus far, the relationship between hip-hop DJ culture and the DJ product industry has been detailed as a dialectical one. DJs influence companies and then in turn are themselves influenced by the technologies companies produce. In Marxist terms, in intellectual property exchange and rights, we see how the superstructure influences the economic base because hip-hop culture reaches into all levels from production to consumption. In other words, there is no easy way to separate hip-hop culture from the products that DJs use. We have also seen the general nature of IP exchange/rights and how DJs are manipulated as intellectual properties whose main authorial function is to be a commodifiable brand name. It is imperative to further explore the perceptions of this relationship held by DJs and people in the DJ product industry. This convergence, framed as technocultural synergism in this book, is a feedback loop between industry and culture that produces new hardware, techniques, and tensions in the name of "progress." In the next section I continue with the process of using excerpts from interviews to help deconstruct this relationship and elucidate how this convergence is perceived by those involved.

DJs and the DJ Product Industry

Looking at collective intelligence and convergence in the case of hip-hop DJs helps to illuminate a two-way flow of information between industry and culture. A result of this exchange is that DJs get better tools, while companies hope to see profit margins. Because hip-hop DJs manipulate corporate texts and technologies, we see a powerful dialectic beyond that of fandom and remix culture. Hip-hop DJs' fandom and remix practices involving corporate commodities have helped build the DJ product industry; in return, technical innovations have come from the industry that can expand the creative possibilities of DJs. This relationship is technocultural synergism in its purest form. Many of the collaborators interviewed for this book suggest that there is a strong feedback loop between culture and industry; however, most DJs feel that DJ culture has the upper hand.

Siya Fakher, a DJ and director at EBSel, thinks that culture and industry "feed off each other," and DJ culture is a large part of industrial behavior.[45] For

DJ Quest, both DJs and industry take a piece from the "pie," and he says, "I guess we need them just as much as they need us."[46] Although there is an interdependence, DJ Marz suggests, "We like to know each other, but it's always an awkward situation."[47] Marz suggests that the awkwardness comes from the fact that hip-hop DJs try to be more business-like while industry representatives try to be more hip-hop.

Chuck Ono thinks "hip-hop culture kind of made Vestax" because the products the company made were what hip-hop DJs wanted and needed. "They [DJs] really built Vestax in regards to some of the products that you saw heavily used by the hip-hop community."[48] Ono suggests it was the ability of Vestax's founder, Hidesato Shiino, to listen to the ideas of DJs and then to make products that seemed needed. By having such an ear open to hip-hop DJs, Ono suggests that DJs made the 05Pro possible, a mixer Ono says is "one of the most historic mixers in the hip-hop community."[49]

Mike May feels that Rane is a part of DJ culture, but only by invitation. "I think that we developed with the culture, we learned, and it's an ongoing process where we're learning every day about what DJs need and what they want to use."[50] May says that Rane wants to be part of DJ culture and be recognized for building standard tools used by DJs. He explains:

> I believe that we are involved in the culture and I believe that we have influenced the culture, but the DJs decide, they are the culture. So look to them.... It's about the fair exchange with people who are musicians and fortunately for us a lot of those people are DJs. And that's a two-way street.... Those guys do things and are involved in the world that we are glad to be a part of, but we are not living and breathing that in our day-to-day.[51]

May states that Rane acknowledges the contributions from DJs, but thinks that the tools Rane makes are a part of DJ culture because DJs have accepted the brand.

Smaller manufacturers also see the dialectical nature of this relationship and respect the DJ's role in building the industry. Elliot Marx says that his company is "heavily involved" in hip-hop DJ and turntablist culture. While admitting that he is not a DJ or involved in the culture in that way, Marx tries to learn from his customers and works directly with DJs in R&D. Marx says, "I think a manufacturer's main task is to make products that can be embraced by the DJs they're intended for.... If the product is good and what DJs want, the DJs will come and embrace it automatically.... I wouldn't have any sales if it wasn't for turntablists who are constantly promoting our product because they

like it."[52] Marx thinks that listening to DJ feedback and delivering a product that benefits the culture is the main way in which manufacturers are involved with DJs.

Some hip-hop DJs also believe that companies play a large role in the culture. Mike Boo thinks that even though manufacturers have not necessarily compensated DJs properly for IP exchange, they have taken DJs' input and made some standard products. Boo explains, "I think they play a huge part, a huge part.... I don't think they play all of it, it's up to the users as well, but for them to create that and have it available to the masses for other creative people to use, they played a major role."[53] DJ Woody also considers companies that made the standard products, such as Vestax, Rane, and Serato, as "completely part of the culture." Woody says it is in everybody's interest that these companies succeed and that they "have changed and affected the development of our culture, from the PMC-05Pro to Serato, these products have shaped the way we as DJs/turntablists create."[54]

While he admits that these companies are presently part of the culture, DJ JayCeeOh thinks that "no corporate motherfucker...had anything to do with Grandmaster Flash doing what he did" and that DJs ultimately push the industry forward.[55] Filmmaker John Carluccio suggests the most important thing companies bring to the culture is responding to the audience, although they are not a part of that audience.[56] Carluccio uses a restaurant metaphor to describe the relationship: "They're kind of like just cooking the food but they have not necessarily bought the restaurant."[57]

DJs have played a significant role in the formation of the DJ product industry, and some believe that it reacts to and is primarily influenced by the culture. "It's never about the gear, it is what you do with the gear," says DJ Steve Dee.[58] He thinks hip-hop DJs are more responsible for selling equipment than are manufacturers: "They put out the device, but it's what we do with these devices that make the devices sell." Because DJs do amazing things with technical innovations that inspire others, and with their involvement in R&D and branding, DJ Steve Dee suggests that "it's not just *their* device, it's *our* device."[59] Both DJ Craze and Babu agree that companies just make the tools that DJs use, and while this is important, it is about how DJs put those technical innovations to use. Babu explains:

> At the end of the day man, they are just tools until someone gets on and starts using these tools. For them [manufacturers] to get gassed at any point or feel that they are in the position of totally changing the culture, they got another thing coming. They

have definitely made a lot of contributions but it all depends if the right artist gets on their tools and find out that their tools make their job better.[60]

DJ Kico sees the industry as an amalgam of companies that "cater to our culture," while DJ Vinroc says that "we're the ones who are driving innovation.... They're the ones who are creating the tools that we want."[61] Vinroc also suggests that as long as DJs are buying a particular type of product, manufacturers cater to the demand until DJs have moved on to other types of tools.

In many ways, DJs interviewed in this book see manufacturers as consumers of what DJs produce, as followers rather than leaders, which is a unique characteristic as the perception of most electronics' consumers (computers, phones, etc.) is that companies are the sole inventors of new products. DJ Quest feels like DJs have invested far more time into elevating styles and developing techniques than companies have put into making equipment, and that DJs are the driving force. Quest explains, "I'm really happy to be part of that, man, because it shows that the thing that kicked off hip-hop [the DJ] is still kind of in the lead, so to speak."[62] Quest and other DJs look to Grandmaster Flash as a great example of how, from the beginning, it has been the DJ at the vanguard. At the end of the day, manufacturers see profits from sales and DJs earn money by using those tools, but some DJs suggest they'd like to see manufacturers give back to the culture more, and do more than endorse and sponsor a select few DJs. Giving back to the culture seems problematic and it is hard to understand why a company would do that. Apple does not give back to its users and Ford does not give back to its drivers, but they sell products and we use them. It is possible that this desire and expectation by consumers is something only seen in niche markets.

What is considered giving back to the culture varies. For most companies, giving back is perceived as listening to DJs, endorsing them, sponsoring events, and creating better tools. But some DJs think this is not enough. Siya Fakher asks, "Of course it's a business but is it sustainable to have the soul ripped out of the culture strictly for profits and no resources being put back into the culture?"[63] Some people I interviewed note that the reliance on manufacturers to sponsor events, or advertising money they give to websites/media, allows them to wield too much control over these events, incorporate product placement and product marketing, as well as censor unfavorable product reviews/news.

With the high cost of performance mixers and other DJ products, Turntablist Disk does not consider manufacturers a large part of the

community. He says, "If you're going to be part of the community then throw a party for the community and give back.... That's giving back. Not creating a new mixer and charging $1 billion. That's not helping us, dude!"[64]

While manufacturers produce tools that make DJs' jobs easier or allow them to make better art, hip-hop DJs understand that the drive to develop these technologies is largely to make a profit and expand markets. Dr. Butcher thinks this has been an ongoing trend between hip-hop culture and industry, as "everybody's profited off of hip-hop except for hip-hop," he says.[65] While companies support some DJs in various ways, Dr. Butcher believes that it "is only to attach the name to the culture, not that they are really part of the culture, but they are trying to attach their name to the culture because they know who is the backbone of their business."[66] He suggests that while this support helps some DJs, it is disingenuous in nature because the motivation is sales and is only extended to a small percentage of DJs. Although it may trickle down in different ways, the majority of DJs are strictly consumers of these manufacturers' goods.

Because hip-hop DJs are steeped in the industrial side of this political economy, Steve Dee, as well as others, wish that there could be more manufacturers that are "For DJs, By DJs." Although DJs may work for manufacturers in various capacities, allocative and operational control of these corporations are not in the hands of DJs. Steve Dee claims that DJs could just use all the ideas that they have given to companies: "We can get the same parts from their makers and distributors and then go get a distribution deal with somebody and they will push your product.... So it can be done, but how many people are going to do it?"[67]

Dr. Butcher thinks if a group of DJs who found venture capitalists to invest in them could create a company and then place the DJs who have given all these design ideas and done R&D a position on the board of directors. He suggests that other manufacturers would go out of business because DJs would flock to a company run by DJs.[68] Christie Z-Pabon, organizer of the DMC USA battles, stands behind the idea of a "For DJs, By DJs" company but explains that the problem is "not everyone who's a DJ is going to be an expert engineer at building new technology or knows how to set up a company or has the passion to pursue a worthwhile invention through to the end."[69]

Some hip-hop DJs interviewed for this book think that the distribution of wealth between culture and industry could be fairer, but do not necessarily feel exploited by the industry. They also see the value in what manufacturers do, in terms of how technical developments help open creative doors, but

do not always see corporate support as being altruistic. Mike Boo, who has worked for and with companies in the DJ product industry, says, "They are corporations, they are in it for the money and they are all about the market.... But at the same time, the culture defines that market."[70]

DJs typically see the culture as creating the market; manufacturers cater to it and develop product to meet DJs' demands. Commercialization of hip-hop and hip-hop DJs, and maybe culture broadly speaking, is in some ways taken for granted. Hip-hop culture has given birth to many marketable commodities and has opened itself up to corporate exploitation. DJ Craze says, "Everything that is cool gets exploited...then it gets corny, and you move on to the next thing."[71]

DJ Shiftee, however, has a particularly positive outlook on DJ culture's relationship with industry. He says that the temptation is to say that commercialization is "bad and it is diluting the culture, but my opinion is that it is all good and that it's good that it is expanding and it is making it more accessible and also expanding what a DJ can do."[72] Shiftee thinks that companies such as Native Instruments and its competitors are working with the best interest of DJs in mind. With his experiences teaching at Dubspot, an electronic music production and DJ school in New York City, and in the DMC battle circuit, Shiftee knows the importance of corporate sponsorship and thinks it makes for a more vibrant culture:

> I'd like to see more commercialization because that means we are all making more money and that the battles can put on better events.... but as far as commercialization goes, you need money to put on these events, in order to have good events you need a budget to do that and the budget comes from a company, and it might as well be a DJ company. I don't know, I don't have any problems with an element of commercialization being involved in DJing, you know there are probably negatives that go along with that but in the end it just means that you have a more well-funded, and probably as a result, I would say healthy scene.[73]

One could argue hip-hop DJs need—or at least have embraced—corporate support, especially when it comes to putting on events. While multinational brands such as Red Bull and Scion have sponsored DJ events, it is mainly pro audio and DJ manufacturers that put money and product into them. However, this type of giving through sponsorship also is a branding and advertising opportunity that commodifies the audience. Nothing—it seems—is free.

Reviewing the DJ as brand name and the value of a DJ's brand to industry helps elucidate another way in which hip-hop DJs are manipulated *as*

intellectual properties. Whereas DJs are seldom given credit for IP exchange in R&D, the sole function of branding and endorsement is using a DJ's subcultural capital and brand name and tying it to a product or a manufacturer. Without a DJ's authorship as brand, companies and their product lack that authenticity for their products. A problem with branding and endorsement is that DJs used to brand or endorse a product are often considered to be the designers or "inventors" of the product by consumers. The confusion undermines the creative network and exchange of ideas that materializes in product design; in 100 years, we may only remember and credit the brand names as innovators and write out the important exchange of certain DJs' ideas that have led to iconic and important innovations (both technical and technique). While R&D shows how hip-hop DJs are manipulated as intellectual properties in a subtle fashion, using DJs for their subcultural capital and brand equity in signature products and endorsements demonstrates how industry can explicitly manipulate hip-hop DJs as IP.

We also see that hip-hop DJs and the DJ product industry, through both R&D and branding, are not necessarily discrete sides but a continuum. The powerful relationship of technocultural synergism highlights convergence and collective intelligence, and therefore bolsters my belief that hip-hop DJ culture is new media. While hip-hop DJ culture represents a new media ideology, in the next chapter I explore digital DJ technology and its negotiation within the culture. Throughout this book I have mentioned Serato Scratch Live and DVS in the context of technical innovation and industry, but the next chapter considers the complex negotiation process of a culture born out of analog technology. In many ways this discussion will return us to the introductory chapter of the book, where I highlighted the celebrity DJ as a byproduct of the democratization of DJing that has been granted by digital technology. Many of the technical and technique innovations described to this point have helped pave the way for this digital moment, and this last chapter hopefully sheds light on what this moment looks like from the perspective of culture.

· 6 ·

SCRATCHING THE DIGITAL ITCH AND THE CULTURAL NEGOTIATION OF DVS

"So I think that bedroom DJ mentality definitely has taken over the masses, and it's really just incredible."

—*DJ Babu*[1]

On August 18, 2010, it was announced that Fat Beats Records was officially shutting down both its NYC and LA retail locations. Due to the dual impact of digital downloading and the rising cost of rent in those cities, the record stores were losing money.[2]

Fat Beats—founded by Joseph Abajian in 1994 as a basement retailer of strictly hip-hop music—was not only a proponent of vinyl records but also one of the primary distributors of hip-hop music on vinyl. Fat Beats Distribution is especially known for handling the manufacturing and distribution of vinyl for other independent hip-hop record labels.[3] Branded as "The Last Stop for Hip Hop," the NYC store had become an iconic location that was synonymous with the great boon in independent hip-hop music in the mid-1990s and the launch pad for many groups. Its NYC and LA stores had been managed by DJs included in this book (DJ Eclipse and DJ Babu), and numerous DJs who I interviewed were once Fat Beats employees.

Despite the notoriety that the brand enjoyed with consumers of hip-hop music, shifting dynamics of the music industry took their toll. As the production of vinyl 12" hip-hop singles was phased out by most record labels by 2008, the Fat Beats retail locations were selling everything from posters to hip-hop belt buckles just to keep inventory on the shelves. The loss of Fat

Beats, as well as the Technics 1200s described in Chapter 2, are symptoms of the disruptive nature of the standardization of digital vinyl systems and music distribution formats, emphasizing the changing tastes, technologies, and consumption habits of DJs.

In Chapter 1, the meanings associated with the tools of hip-hop DJs—turntables and vinyl records—were explored, elucidating the value of analog tools to DJs. Noting that vinyl records are responsible for hip-hop's birth, Katz writes, "Vinyl is a precious substance in hip-hop. It is authentic, it is elemental, it is fundamental...vinyl carries with it the whole history, the DNA, of hip-hop."[4] Given the importance of having and using vinyl records, this chapter deconstructs the hip-hop DJ's complex process of negotiating the standardization of digital DJ technology, specifically Serato Scratch Live (SSL). Here I explore the ways in which digital innovations have both added value to the culture and taken things away from it. I begin by delineating the hip-hop DJ's process of negotiating digital DJ technology, and then look at perceptions of the democratization of DJing in the digital era. The chapter concludes by reviewing the life cycle of the 12" vinyl maxi single. While the last few chapters of this book have looked at how hip-hop DJs have affected technical innovations, here I ask: Have digital DJ technologies changed hip-hop DJ culture?

Digital Negotiation

It seems cliché to suggest that all media were once "new" media, but theorists and philosophers have given considerable thought to the cultural shift from old/mass media in the read-only era to new/digital media in the read-write era. The process of this shift from analog to digital technology is often referred to as "remediation." For Manovich, new media relies on and breaks from old media and, importantly, does not break radically with the past but he says it "distributes weight differently between the categories that hold culture together."[5]

In their book *Remediation: Understanding New Media*, Bolter and Grusin lay out their theory of remediation, in which there is a dialectical relationship between old and new. "What is new about new media comes from the particular ways in which they refashion older media and the ways in which older media refashion themselves to answer the challenges of new media," they write.[6] In remediation, the newer, digital technology emphasizes its difference

from the old and offers itself as an improvement. "Each new medium has to find its economic place by replacing or supplementing what is already available, and popular acceptance, and therefore economic success, can come only by convincing consumers that the new medium improves on the experience of the old," write Bolter and Grusin.[7] However, Straw argues that technical innovations gain acceptance and become standards by appealing to older consumers; their successes are based on the "capacity to keep alive the past."[8]

Farrugia and Swiss's study looks at how DJs negotiated digital vinyl systems (DVS) in both practice and discourse with the introduction of Stanton FinalScratch in the early 2000s. They suggest there is resistance to new technology because it threatens the existing order and they find that record collecting is a claim of expertise. In their study, they conclude that DVS brings to the fore the "ideological enforcement of standards for discerning the value and authenticity of certain DJ practices."[9] Other studies have shown similar resistance within hip-hop DJ culture to digital technology in general.[10]

In *Groove Music*, Katz writes that one the most significant changes brought on in the digital age is "the transformation of mixing from a largely aural skill to a much more visual skill" because DJs look at their laptop screen to use the software instead of listening and mixing using their ears.[11] Essentially, DVS has brought a visual element to DJ practice (although DJs have always used stickers and other visual cues on their records). Katz specifically notes that there are three areas where the "effects" of using DVS for DJing are most prominent: (1) transportation of records; (2) acquisition of records; and (3) the manipulation of records.[12] We will see that there are also other changes linked to the digitization of the technology and the culture.

From the practical side of things, the introduction of stable DVS products such as SSL provided many benefits to a working DJ. Most of the DJs I spoke with were not only working DJs but also touring ones, so the ability to travel with a laptop instead of record boxes is a major money-saver. There are also plenty of stories about DJs who have had record boxes stolen or damaged at an airport. Thus, DVS has made travel easier for working DJs. There are also other benefits, which Rane and Serato have touted from the beginning: (1) you do not have to play your valuable records; (2) you can have access to all the music on your computer at a gig instead of being limited to what you brought on vinyl; (3) you can manipulate two copies of the same song; (4) you can play your own music if you are a producer or remixer; (5) you can manipulate any recorded sound without having to press it on vinyl; and maybe most importantly, (6) you are still manipulating music using 12" vinyl discs. There

are also plenty of other bells and whistles within the software that give DJs increased options (e.g., looping, digital cue points, sample player, etc.). For most of the DJs I spoke with, once it was accepted, DVS proved to be a great tool that lessened the more labor-based, time-consuming activities of DJs, which allowed them to focus more energy on creativity.

DVS technology has allowed hip-hop DJs to realize their ideas more easily, which is because a song or sound does not need to be pressed on vinyl for it to be manipulated. DJ Nu-Mark says that even the vinyl purists have gone to DVS because there are too many advantages to the computer generation of DJing, which he believes has made him a better DJ.[13] DJ JS-1, who tours internationally, says, "I am excited to DJ now; I don't have to carry nothing with me. It's fuckin' great!"[14] Also, because pressing records is expensive, DJ Platurn fully embraced DVS once he realized he could play his own remixes at his gigs. "I have always wanted to be able to do that but I've never had the means," he says. "I could treat the program like my own personal record press. I could play my shit, play the homies' shit, all that."[15]

Of all the hip-hop DJs I interviewed or surveyed (nearly 100), only four were not using any DVS. And, in my personal experience in the field, few DJs that I know use vinyl exclusively anymore. For DJ Wicked, the reason he stays on vinyl is because he has been DJing with his records since 1992 and the medium has served him well. He considers it an "if it ain't broke, don't fix it type thing."[16] While DJ Shame has not made the move to DVS yet, he uses CDJs for many of the same reasons that others use DVS: "But the CDJs, it's another tool that made it more convenient for DJs, in my opinion. It's a lot easier to carry a book of CDs than it is carrying crates of records."[17] Bobbito Garcia does not object to DVS and acknowledges its utility for hip-hop DJs, but he says, "I just spent a whole lot of years getting my fingers dusty and dirty and digging for records and I don't feel like neglecting what I worked so hard to compile."[18] But as less new music is released on vinyl and more record stores and pressing plants have shut down, Bobbito stresses that it is a difficult time for people who prefer vinyl.

For scratch DJs such as Qbert or Turntablist Disk who are mainly interested in precision scratching, DVS programs cannot keep up with their hand speed. Disk says, "Me personally, it doesn't move fast enough. I'm way too fast for the program...it just doesn't give me the real feeling. I need real vinyl. I need the sound to be there."[19] None of the DJs I spoke with fully rejected DVS, but merely preferred using vinyl records. For other DJs who have made the transition from the analog era to the digital era of DJing and embraced the remediation of vinyl, this has been a complex process.

Many of the DJs I talked to characterized DVS (like other technical inno-
vations) as paradoxical. Steve Dee, who stresses that the most important tech-
nology is the DJ, says, "I think that is what technology does, it will cheapen
and at the same time broaden the very things that we are doing. The technol-
ogy is already in us."[20] Shortkut calls it a "give-and-take," and for something
new to come in and be helpful, "some shit has got to suffer."[21] Kutmasta Kurt
views the negotiation process as an evolutionary one,[22] while Neil Armstrong
says, "If you're not able to adapt to the game, you're going to be done sooner
or later anyway.... I don't mind the technology, I'd rather have it than not
have it."[23]

DJ Babu specifically refers to DVS as a "double-edged sword" because,
even though some experienced DJs are getting paid more money and traveling
to gigs is easier, DVS is also allowing any celebrity or rapper with some sort
of brand value to buy the equipment and instantly become DJs. Babu calls it
"a bit of an insult to people who have been into it 10-plus years" and have in-
vested into the art and culture. Babu says, "Now everything is really easy and
you're able to skip a lot of rungs on the ladder to get to the point that usually
took us 10 years to get to."[24] DJ JS-1 also notes the good and bad of this tech-
nology: DVS has made his job much easier and simultaneously has made it
easy for everybody to become a DJ. JS-1 says, "I would say go with technology,
fuck it, at this point you can't fight it."[25]

Skeme Richards suggests that the need for DJs to buy/collect vinyl records
was a gatekeeper to DJ culture: "If there was no technology going on and you
had to buy records there would be 99 percent less people calling themselves
DJs."[26] The issue of the ease of access to DJing enabled by digital technology
will be addressed in more detail in the next section, but it is important here
to note that the element of "democracy" of access has been a major point in
the cultural negotiation of DVS. Like in other professional fields where tech-
nology is vital, such as photography or filmmaking, inexpensive new digital
media has opened those fields up to amateurs who are marketing themselves
as professionals.

One of the key elements in the negotiation of DVS and ultimately the
standardization of SSL is the remediation of vinyl records. DJs note that there
are differences in the feel and sound of DVS, but in general those differences
are minimal. J.Period, who considers DVS the greatest development in DJ
technology, thinks that it ultimately takes the user back to a time of using re-
cords to scratch and mix on; thus, DVS still uses the "same mechanism as the
origin of it."[27] While claiming that without vinyl records the cultural element

is missing, Teeko argues that hip-hop DJ culture can be based on DVS because it is a "replication" of the foundational practice of mixing vinyl.[28] Thus, in a way, DVS is taking the "old school" of hip-hop culture and bringing it to the "new school" of computers.

As part of the negotiation process, vinyl control records used in DVS have become infinite sound controllers. DJ Daddy Dog explains that "one piece of vinyl could contain 1 million songs if you really wanted it to."[29] And, although a control record is in fact a real vinyl record with a tone pressed in its grooves, the "realness" of those records are a matter of perception. "Serato is vinyl to me," says DJ JS-1. "I am using vinyl when I am cutting it up."[30] JohnBeez considers DVS a "halfway" point between digital and analog "because you have an analog feel with the digital medium."[31] While these DJs express different opinions about DVS, they seem to agree that there is something vital about the turntable and tactile experience of manipulating 12" vinyl discs.

Because those systems still require DJs to use turntables, a mixer, and control records, DVS keeps the *idea* of the original art form intact. DJs agree that this is an important point, especially in the face of the popularity of digital DJ controllers that entirely displace both turntables and records from DJ practice. Dr. Butcher thinks that DVS has helped keep vinyl alive in some ways, as he explains: "The essence of the turntable and the real DJs are still there, but brought into the modern world of electronics."[32]

Similarly, both DJ Platurn and DJ Nu-Mark have come to accept and embrace SSL, specifically because it keeps the essence of turntables and vinyl in play. In light of other out-of-the-box DJ software that does all the mixing for the user (i.e., the "sync" button for controllers), Platurn says that with DVS "you still do have to know how to mix, you have to know how to use pitch control, you have to understand very basic elements of DJing in order to do that.... You know you still have to use the turntables, you still have to know how to do that shit."[33] Platurn, like other DJs interviewed for this book, calls SSL a great tool and "a program for making good DJs better." In other words, DVS replicates and extends methods of manipulating preexisting recordings that are rooted in analog DJing.

Hip-hop DJs collect and value vinyl records for many different reasons. In *Making Beats*, Schloss notes four secondary functions of diggin'[34] and amassing vinyl record collections for hip-hop producers and DJs that extend beyond being only raw material for making music: (1) commitment to hip-hop tradition; (2) paying dues; (3) education about music; and (4) diggin' as socialization.[35] While he primarily looks at hip-hop producers (although he notes

SCRATCHING THE DIGITAL ITCH

that most producers are DJs), Schloss finds that diggin' and collecting vinyl
ritualistically connects DJs to hip-hop history and is a central act of hip-hop
DJ culture. Collecting and diggin' for records is a sign of knowledge and au-
thenticity, and the act provides DJs with vital information about music pro-
duction, artists, style, etc. Last, a community forms around collecting vinyl,
one that engages in physical spaces and now online (Web forums, Facebook,
and Instagram). At first, Nu-Mark thought DVS was terrible and a "tough pill
to swallow" because "people can just steal each other's record collections and
it takes the art away of diggin'."[36] Nu-Mark now calls himself a huge fan of
it, but also stresses that a major part of being a DJ is manipulating turntables.

Skeme Richards also says that while he loves DVS, he thinks there is
something important lost when DJs do not get to experience real vinyl:
"Those people that have never touched a record is like saying that 'I never
had a girlfriend, I have a blowup doll.' Like, you've never actually touched a
warm body."[37] This analogy, one that is gendered and sexualized, suggests we
consider the physical, even sensual, embodied relationship that (mostly male)
DJs have with their equipment and records.

While the remediation of vinyl in DVS still encourages the use of the
authentic instrument of hip-hop DJ culture (the turntable), many DJs who
had come from the tradition of vinyl records simply did not feel like "real"
DJs when they first began using the digital technology. Nu-Mark says, "I was
resistant because I felt like I wasn't going to be considered a real turntablist,
or a real DJ.... So it would just feel weird to play original soul and funk on a
computer. It felt cold to me."[38] However, what mitigated the lack of authen-
ticity for many of the DJs interviewed in this book was how they applied the
new technology—essentially, how it was used. That is, hip-hop DJs employed
DVS in the same way that they used vinyl, but took advantage of new fea-
tures in DVS that extended their creativity beyond what vinyl allows for.
"Technology, you just have to embrace it," says Shortkut. "It's the way that
you use it. It adds on to how you DJ."[39]

Not having to travel with or carry vinyl records, coupled with the ability
to apply the hip-hop DJ aesthetic to new digital media, helped DJs overcome
feelings that DVS was not true to the art form. While there are vinyl purists
who completely reject the use of DVS and consider it a "fake" way to DJ, no
one I interviewed outright rejected it or challenged the authenticity of those
who use DVS. However, there seems to be a spectrum of opinions regarding
when the use of DVS is or is not appropriate. For example, DJ Marz, who says
that he only uses DVS in his studio, prefers to see DJs who play out in public

actually using vinyl records. He gives credit to those who use real vinyl and explains, "I would rather see a really shitty DJ who has a good selection of records and can't mix or scratch…it's more real to me than Serato."[40] He explains that plenty of DJs are playing out using DVS but cannot mix or scratch, so he has more respect for poorly skilled DJs who at least try to use vinyl.

In general, DVS has reduced the more labor-intensive elements of hip-hop DJing, mainly by eliminating the need to transport, organize, and maintain vinyl records. DJ Kico suggests that aside from eliminating the physical stress of carrying vinyl to gigs, DVS has also changed the labor involved in obtaining music. He says that the physical labor that's involved in diggin' for records "is much more difficult physically to do than it is just to sit on your computer."[41] For Kico, this both makes his job easier but takes away from the fun of diggin'. JayCeeOh says that the concept of "e-diggin'" (searching for digital recordings online) is similar to physical diggin', but is a "whole different beast" because it entails online research and hunting blogs. "Diggin' used to be a physical thing, like you'd go diggin' and after you'd be passed out tired.… I would say that what is accomplished is extremely similar but the means to do it is just way different," JayCeeOh explains.[42]

DJs tend to think that "e-diggin'" has devalued music and the practice of DJs collecting and curating those collections. DJ Daddy Dog talks about the time and money that he put into his vinyl collection, which gave him a closer connection to it. "Nowadays music comes and goes.… You download it, you delete it if you don't like it. But back then it definitely meant a whole lot more to give shit up," Daddy Dog explains. "You download with no regrets."[43] In other words, the ritual of physically diggin' for records and sorting them for gigs gave those pieces of music increased value to the user. The process of obtaining, sorting, and disposing of vinyl in a collection is far more complex than downloading and dropping files into virtual folders or trashcans. That is, dealing with music in a record collection involves more emotional investment; MP3s do not lead as easily to such bonds because they are disposable and there is little commitment to obtain/maintain them.

DJ Daddy Dog, who compares DVS to the abacus, makes an interesting analogy:

> The way that I look at Serato, which I don't know if it is good or bad to look at it like this, but back when they had the abacus everyone was using it, when that was the standard. But when the fuckin' calculator came out nobody was going back to the abacus because there are more efficient ways and easier ways to do math. So the

same with the DJing, I feel like our standard was vinyl, then Serato or digital shit like CDs came and everyone shifted over to the digital side because it makes life so much easier.[44]

DJ Platurn suggests the work that hip-hop DJs from the vinyl era put into the craft to become a DJ made them value the culture/art form more than those who have just become DJs. When DJing was not as readily available and people had to put in work to be able to DJ, Platurn thinks that it made the craft much more valuable to the user. "These are things that you have to make some sacrifices for [vinyl] and I think that at the end of the day it just becomes that much more valuable to you and just to the art form as a whole... but there's certain things that by doing those things you learn rules."[45] These rules, both spoken and unspoken, were a way of keeping up-and-coming DJs in check, and in the age of digital DJing many new DJs simply do not know these "rules" since the vinyl-as-cultural gatekeeper has dissolved and older DJs are not schooling them on these rules.

DJs speak of a right of passage where DJs pay dues and "graduate" to DVS. DJ Babu calls DVS a "privilege" he has earned because he has put in the work, but now DVS is a more practical way for him to do his job. Babu claims that DVS has not changed what he does but is an "incredible extension and inspiration" in his craft. He adds, "Anything that enables me to do that better, I'm going to fuck with it."[46] But those who come from the vinyl era and made sacrifices to obtain vinyl and lugged records to gigs feel they have *earned* the *right* to use DVS.

Roli Rho admits that because other DJs were e-diggin' and more music was only being distributed digitally, he was falling behind other DJs by only using the music available on vinyl. Thus, he made the switch because he was losing out to the competition. In a different situation, DJ Nikoless made the transition to DVS after he actually found himself in the minority of hip-hop DJs using vinyl, and it was problematic. At a show with other DJs, Nikoless realized it was time to change:

I went to a show and they had set up Serato wrong some kind of way. I was the only DJ there with vinyl and they set it up so vinyl couldn't play. So there was a mistake and I ended up not being able to DJ. And I was like, "Wow, I'm the guy with vinyl, I'm the guy with the problem." I was like "I am the problem right now?"...So I went and got Serato out of what I call "necessity."[47]

Thus, as DVS and SSL became increasingly standardized and the production of vinyl diminished, DJs like Nikoless and Roli Rho found themselves unable

to perform their art as well with vinyl records, so to "survive" they made the digital transition.

One of the central considerations in negotiating DVS goes back to the meanings that hip-hop DJs attach to vinyl records. Initially, on the introduction of FinalScratch and later SSL, there were cries that it would kill vinyl, which is partly true in that it rendered the 12" vinyl maxi single obsolete. However, Rob Swift and others suggest that it was not necessarily DVS that killed vinyl, but it was DJs themselves. "I think people are killing the whole record shop culture.... I don't see where on the Serato software or packaging where it says 'you shouldn't buy vinyl after you purchase this item.'"[48] He thinks that DJs simply got lazy, and when given an easier option—one that gave them the option to not buy vinyl—DJs decided to stop buying vinyl records.

DJ Kico takes some responsibility for vinyl's woes and says that the "digital game kind of killed vinyl, but we did too, like we didn't support it enough."[49] With music more accessible and more people owning laptops, Kico thinks that the popularization of DVS shut down vinyl culture: "And it was easy, and it didn't take long," he adds.[50] After a few years of not buying vinyl, DJ Daddy Dog feels terrible about contributing to the decline of the vinyl market, and says, "This is why it's dying, and it's because of assholes like me who are not picking shit up."[51] DJ Craze, who was demoing and using FinalScratch in its initial days, says that he would catch a lot of flak as audience members would scream at him that he was killing vinyl. "Just like the Internet killed record sales and CD sales...Serato deaded vinyl because ain't no DJ in his right mind going to carry records nowadays," Craze suggests.[52]

J.Period thinks that DVS did not kill vinyl but "killed the usefulness of vinyl."[53] This is an important point, because much of the meaning and attachment to vinyl records comes from their use value in DJ practice. DVS, as we have seen, remediates vinyl records so closely that many hip-hop DJs interviewed in this book no longer need to use vinyl as a tool. As DJs negotiated DVS's use and accepted the technical innovation, the recording industry responded by pressing less current music onto 12" singles. Although DJ Eclipse, who managed the Fat Beats store in New York, is pleased that SSL keeps the idea of vinyl alive and makes his job easier, he says, "From a retail perspective it's bad, from a retail perspective, it killed the 12". You know there is no reason to really put anything out anymore because you can have everything as if it is on vinyl through Serato."[54] Mr. Len thinks that DVS has hurt vinyl but it also forced people to reevaluate what they are pressing. Mr. Len also stresses

that "if hip-hop can claim anything it is that it kept vinyl around maybe 20 or 25 years longer than it was expected to."[55] Later in this chapter I will look at vinyl sales figures that support Len's theory.

DVS has made the art/practice/job of DJing easier for established DJs. Simultaneously, digital DJ technology has allowed anybody with a digital music device (laptop, tablet, smartphone) to become a DJ and do so with little effort and without paying dues, essentially without learning the "rules" of DJing and the business end of the craft. With companies putting out DJ controllers and software that are "out of the box" DJ tools, this flood of DJs has brought us into the era of the Microwave DJ, where celebrity socialites, washed-up musicians, and spoiled teenagers are becoming DJs. This is changing the economics and image of what a DJ is, and maybe what it should be.

Microwaving Democracy

"Microwave DJ" is a pejorative term that refers to DJs who instantly "become" DJs by purchasing digital DJ technology and an MP3 library. The term first appeared on the Serato Scratch Live Web forum around 2006:

> A "microwave" DJ is a DJ that became one (or thinks he is one) just because he's got Serato or any other digital software/hardware that lets them manipulate digital media. They think they can become DJ's just like that (microwave fast) and many don't realize they're lacking lots of knowledge that's learned (or earned) from years of experience using conventional dj tools.... Do not confuse the term "microwave" with technology. The term "microwave" refers to "fast" and nothing more. There's a misconception that DJ's who dislike "microwave" dj's hate technology. We actually embrace it as well. We just use technology to our advantage instead of depending completely on it.[56]

It is important to remember that this term derives from DJs who also use DVS. The main issue revolves around DJs who have not "paid dues" and have gone into the market for DJ gigs and undercut veterans. Unless you are a big-name DJ who plays in casinos or festivals and has large followings (those brand-name DJs' rates have increased exponentially in the digital age), DJs' wages have declined. For DJs who were professional pre-DVS and are in the lower-paying stratum or working-class DJs, which are the majority, democracy of access to DJing presents both economic and artistic challenges.

In the field of recorded music, this is nothing new. In the late 19th and 20th centuries, many musicians thought that the player piano and talking

machines would have a negative effect on musicianship. These concerns have also been expressed regarding the relationship between pianos and keyboards/synthesizers, acoustic and electric guitars, drums and drum machines, and turntables and CDJs. With the expansion of access to music and music manipulation devices, new technology threatens old orders. Similar rifts and antagonisms in other media, including those between bloggers and print writers, film and digital video artists, and film and digital photographers, have mirrored this dialectic.

In a culture like hip-hop, which has always placed a premium on being authentic, the issue of what is considered "real" carries great importance. Debates about DVS in hip-hop DJ culture are a case in point of authenticity discourse. In McLeod's study of authenticity claims in hip-hop and rap music, he writes that authenticity claims establish in-group/out-group distinctions.[57] He finds that hip-hop community members distinguish authentic expressions from the inauthentic as a mechanism for protecting their culture, and McLeod finds that type of identity talk by cultural members is "structured, meaningful, and a way of comprehending central elements of hip-hop culture from a native's point of view."[58] When DJs speak of microwave or controller DJs and "real" DJs, this is discourse about authenticity. The fact that this topic came up numerous times in my interviews testifies to the centrality of technical innovations in the culture's construction of authenticity.

The majority of the DJs interviewed for this book did not respond positively to the fact that digital technology allows anybody with a computer to call themselves a "DJ." As mentioned previously, despite all the benefits of DVS that most of these hip-hop DJs enjoy, many feel that there were valuable rules, standards, and skills learned by "paying dues," which this new breed of microwave DJs totally miss out on. J.Period sums up the general sentiment: "Because really, this is only made for a few people. This is made for everybody to enjoy but only a few people to do."[59] As McLeod suggests, comments like this from J.Period represent how hip-hop DJs construct authenticity and build distinctions between in-groups/out-groups.

However, some DJs think that the democracy of access granted by digital DJ technology could be a benefit to hip-hop DJ culture. While acknowledging that the overall talent level is being diluted because anyone can DJ, DJ Shiftee thinks that this access is changing what it means to be a good DJ. Before digital DJ products, a great deal of a DJ's credibility and value were based on his or her collection of records, but now everyone has access to the same music. Shiftee explains, "So what separates one DJ from another now

isn't based so much on what records they were able to find but it's more based on personal artistry and style and how they put things together."[60] Sugarcuts thinks that what killed the turntablism movement of the late 1990s was that it was an exclusive club that did not make sense to the average person. He explains that this new democracy can be positive: "Again, lowering the barrier of entry you potentially have a greater value of and a greater number of young talented people to enter into the market."[61]

Both Sugarcuts and Shiftee, however, seem to be in the minority of those I spoke with. DJ Nikoless suggests that digital technology is great when it "comes to those who are true to the culture" and that it advances culture. "I don't think technology should be held back to avoid people from being suckers.... I just think that we should point out who the suckers are once it happens," says Nikoless.[62] In other words, the filter or standards that were imposed in the days of vinyl have dissolved and there is less quality control; however, there were still inauthentic or "sucker" DJs in the vinyl era. For instance, there have always been kids who come from lots of money who bought all the nicest equipment and a record collection but never built their skills. Or, also common were DJs who got on radio and had large brand names but also lacked skill. In general, inauthenticity was (and to a degree, still is) measured by skills in manipulation. Furthermore, inauthenticity differed between generations and was often related to technologies used: Pioneer hip-hop DJs from the 1970s thought the 1980s DJs were suckers for using breakbeat compilation records instead of originals, 1980s DJs thought 1990s hip-hop DJs were suckers for using scratch DJ tool/break records for battles, and 1990s DJs thought 2000s DJs were suckers for using custom-pressed dub plate records for battles.

DJs feel there is a sense of entitlement among the new breed of microwave DJs, but becoming a professional DJ is about paying dues and doing legwork.[63] It is a rite of passage where you earn your rank.[64] JohnBeez thinks that microwave DJs skip the fundamental skills that came from learning with vinyl records and now just stare into the screen of their laptops. "If you handed them a crate of records they would be clueless," JohnBeez says, "Kids that are used to spinning on a laptop who look at waves and instead now they have to use headphones, it will fuck them up."[65] What JohnBeez is referring to is DVS software that visually depicts sound waves so that you can visually mix songs without even having to rely on your ears. Many microwave DJs cannot mix without the crutch of visual representation; they cannot use their ears and mix in a traditional fashion.

DJ Platurn considers the actions of microwave DJs to be disrespectful to the art form: "There are these DJs that came along before a lot of these guys—you know the blog DJs and the laptop DJs—who really had to put a lot of work in, man, really come up with your own style and your own personality. And that was everything; your personality is what drove you as an individual artist when it comes to the DJ thing. Nobody does that anymore."[66] Many DJs I interviewed claim that DJ sets are starting to sound the same as new DJs are unable to put their own style into the music because they lack the technical skills, creativity, and crowd reading ability. It is not to say that new DJs may not develop style, but they are out there DJing in public without having put the time into the craft.

For the DJs interviewed in this book, DJing was a love first and a job second. They got into the culture because it was their passion, but also to get girls, to get attention, to show off, etc., and as DJing became more popular and there was more demand for DJ performances, money was eventually available. DJ JayCeeOh claims there is a difference between "DJs who DJ because they want to be cool and DJs who DJ because they want to DJ."[67] My collaborators suggest that the new breed of DJs got into it *only* to get girls, to feel like celebrities, or to get free drinks, etc. For hip-hop DJs who hear these new digital DJs, the differences are noticeable. DJ Mighty Mi says, "I feel that you can still tell a Serato generation DJ from a DJ who did vinyl before, it's just something in the way they play and you can kind of tell that the vinyl DJs still kind of know their records better and they know when to bring in records."[68]

Digital DJ technologies have helped give rise to the celebrity DJ, who is not a celebrity because of DJ ability (i.e., A-Trak or Z-Trip) but because they are already famous brand names. (For instance, Paris Hilton, Tommy Lee, Lindsay Lohan, Pete Wentz, as well as famous rapper Lil Jon are all being booked as DJs.) Numerous socialites and B-list or reality television celebrities have been able to become DJs because of the access provided by digital technologies.[69] It's important to note that most of these celebrity DJs use digital controllers and not DVS because DVS still requires the user to know how to manipulate vinyl and turntables. Both celebrity and microwave DJs are taking gigs from established professional DJs and changing the market economics of the craft. And, maybe most problematically, the celebrity DJ is changing the image of the DJ and what it means to be one; impressionable youth follow suit. Since most of the DJs interviewed for this study survive financially on DJ-related endeavors, this has become an increasingly sensitive topic in the negotiation of DVS.

There is now growing competition in the market for DJs that has threat-ened some of the old order. Obviously, club and bar owners/promoters have more booking options because of this competition. Many times veterans who have worked their way up to a certain pay level are having to take cuts be-cause they are, in the eyes of a promoter, easily replaced by a microwave DJ. It is important to note that this competition is primarily for the mid- to low-er-level paying gigs, but DJ wages are down across the board (unless you are a top-notch casino club or festival DJ earning tens of thousands of dollars per gig). While digital DJ technologies have allowed aspiring DJs to enter the market quickly, the overall sentiment from established DJs is that this has not been a great thing for DJ culture.

In many instances, microwave DJs will get booked at clubs because they promote their events or can bring in a wealthy crowd. DJ Kico, a 2005 USA DMC Champ who currently does more work in the clubs than in the battle scene, thinks that most microwave DJs are in it to look cool and they also give clubs too much cheap promotion:

> Now here's the thing that pisses me off about microwave DJs. Microwave DJs will come in and they will say, "Yeah man, I can pretty much do the same thing that he did, but I could do it for 50 bucks. But on top of that I can guarantee you a crowd. I can guarantee that I will bring in people." They will promote themselves, they will get on MySpace, they will get a Facebook, they will get on Twitter and they will promote the hell out of themselves for $50. That's the problem, because they are giving away too much and giving away what the promoter wants for too cheap.... For the most part they are not in my situation, like I have to eat off of that, I have to be on point or else I am not going to eat. Then, they might already have a job or be in school or be rich and just do it just for the hell of it, and put DJs like me, who actually do it for the means, out of business. So that's who I have a problem with, those DJs.[70]

Traditionally it has been the job of the venue to promote an event and get heads in the door; the DJ is there to make those who come through the door have fun and dance. According to Kico, this allows promoters/venues to ex-ploit the labor of microwaves and then also expect this level of labor from established DJs. There is increasing pressure on established DJs to promote events online, design flyers, hang flyers, etc., and only be compensated at their normal wage or less. The working-class DJ is no longer simply an entertainer, but in fact a promoter, a designer, and a sound engineer who sets up a system.

"Well, if you have a laptop you can essentially call yourself a DJ, which has fucked up the whole game of DJing," says DJ JayCeeOh.[71] JayCeeOh also explains the economics of microwaves undercutting experienced DJs: "Like in

New York City, for instance, clubs that you used to get $800–$1,000 for you are lucky to get $400 for because some little dickwad will do it for 200 bucks. And they [clubs] don't care as long as motherfuckers are coming in. The general crowd doesn't care, I mean they do, but the majority of them are just dumb."[72]

One of the points that kept coming up in my interviews was that the audience does not seem to care about a DJ's skills. As more microwave DJs have moved into the market, the audience has actually been groomed to accept the lack of skills in mixing and selection. This has been exacerbated by many promoters/venues that hire microwaves. Generally it is felt that the audience does not know or care about the difference in DJs because they just want to drink and hear the songs from their iTunes playlist.[73] But, this may suggest that the audience now has different expectations from DJs more generally, and that the skills audiences expect are not those that hip-hop DJs prize (manipulation of recordings in real time). It's possible that audiences are now more concerned with *what* songs a DJ plays instead of *how* he or she plays them.

DJ Eclipse suggests that the phenomenon of lesser experienced DJs undercutting established ones was going on before digital technology, but that digital DJ technologies have exacerbated the problem. "So it's just one of those battles that has always been around and is always going to be around, and unfortunately with new technology it just makes it easier for anyone…it just opens up the playing field so more people can jump on the bandwagon and do it," Eclipse explains.[74] And, more and more, DJs are also being replaced by beautiful models who wear lingerie and play premixed "mega-mixes" (15–30 minute mixes) from iPods (there are Craigslist ads that pop up like this looking for this type of "DJ"). Even club bouncers are being promoted to the DJ booth, as long as it saves the venue money. DJ JS-1 thinks that if DVS and other digital DJ technologies were taken out of the picture, there would be fewer DJs because it is much harder to build up a record collection and get a foot in the door at paying gigs. According to DJ JS-1, this means a lot of older DJs would still be having more jobs and be making more money while younger kids would be working to get to that level.[75] He thinks that if it were harder to get access to the music and thus the ability to DJ, a lot of microwaves would not be DJing. Vinyl was in its own way a gatekeeper to the culture and market for DJing.

Another major change attributable to microwaves relates to the DJ's selection. There is an unspoken rule among DJs about requests: Either you do not take them at all or you accept them and try to work them into your set if the music is something that is in your repertoire. However, DJs who did not learn some of these rules will play any request at any point of the night, and

many audience members now expect this from all DJs, an expectation also shared by many venues/promoters. Therefore, more promoters are challenging the DJ's creative control and, in larger clubs, even giving some DJs playlists. Not many of the pre-digital DJs are happy with this trend, which is helping to squeeze them out of the DJ market. As DJ JS-1 explains: "To tell you the truth, most guys either quit or they give in because what are you going to do?"[76] When DJing is your livelihood, has been your job for the last 25 years, and is all you know how to do, you conform or quit. Dr. Butcher says, "If guys need to make a living then they are going to conform and do what they have to do to keep the crowd happy.... That kind of sucks."[77]

"I'm not a jukebox," says DJ Quest, who views the DJ as both an entertainer and an educator. "You know, a DJ should be able to play some shit and educate the audience," he says, "Out of 100 people in the room and if you're the DJ, who do you think is the most educated about music?"[78] It is getting harder and harder for some DJs to get gigs where they are able to play music they love and want to share; DJs admit that even experienced DJs are caving into the requests of promoters and audiences. Much of the reason why promoters and the audience feel more entitled to impose their tastes on DJs' sets is because they now have an understanding of what the DJ is doing. DJ Nikoless comments:

> They realize it's a laptop, they realize it's a CD player, and that it's things that are accessible to even them. Not everybody had a pair of turntables back in the day.... Now the audience is so equal to the DJ because in the mass perception the DJ is the guy who pushes a button and even the audience goes "Hey I'm going to give you an iPod, can you plug it in and play a song real quick?"[79]

The notion that everybody can be a DJ has also accelerated because DJs are using technologies that are used every day by audience members, who sometimes try to give DJs smartphones, CDs, or ask them if they can stream a song off of YouTube or download and play it. Making and imposing requests has become much easier in the digital age; audience members at pre-digital venues did not bring vinyl records with them and ask DJs to play them. In the era of the digital DJ, the expectations of the DJ have changed along with the technology.

Thus far, this chapter has reviewed the negotiation of new digital technologies and some of the ways in which the economics of DJing have been changing in the digital age. Democracy of access to DJing as granted by new technology has both its pros and its cons, but all of these factors have figured into the standardization of DVS. In the era of the digital DJ most new DJs

are not even using turntables, but instead they are using plastic controllers, and veteran DJs are using DVS, which has had a huge impact on production and sale of vinyl records. While DJs' consumption and use habits have been addressed in earlier sections, I would like to explore a format innovation pioneered by DJs and a silent victim of the digital era: the 12" maxi single.

Current Music Market and the 12" Maxi Single

The MP3 format was originally designed to compress video files in the early 1990s. Unlike nearly all of its predecessors—from the disc record to the CD—companies within the recording industry did not introduce MP3 technologies. Rather, the software and hardware used in the playback of digital music were developed and marketed by huge computer technology corporations that had little interest in the sale of recorded music.[80] The MP3 is a format that came from beyond the confines of the recording industry and eventually disrupted and displaced the market for CDs; however, interestingly, during the era of the MP3 there has been a huge uptick in the sale of vinyl LPs.

Global revenues for recorded music were approximately $15 billion in 2013.[81] After a series of mergers and acquisitions earlier in the decade, by 2014 there were three large recording companies that controlled the market at the distribution level: (1) Universal Music Group (UMG, 38.9 percent); (2) Sony Music Entertainment (Sony Music, 29.5 percent); and (3) Warner Music Group (WMG, 18.7 percent). Independent record labels represented 12.3 percent of the market for recorded music in 2013.[82] The U.S. market is still the largest global market at $7 billion, which is where it has been steadily holding from 2010–2014. Other than vinyl LP sales, physical product sales continue to plunge (only 34 percent of the market).

In 2013, vinyl sales were up 33 percent from the previous year with 6.1 million units sold (9.4 million vinyl LPs shipped).[83] After some abysmal years for vinyl pressing in the United States (approximately 2004–2008 being the lowest and the worst for consumers since the retail costs were very high), the recent upsurge in LP sales has been increasing productivity at pressing plants. Although there was fierce competition in the 1970s between several dozen pressing plants that may have averaged 30,000–70,000 records pressed per day, currently there are about 15 plants operating in the United States (12 of those are more boutique and smaller facilities). Presently the largest

are United Record Pressing (pressing about 20,000–40,000 records per day),[84] Rainbo Records (pressing about 25,000 records per day, six days per week), and Record Technology, Inc. (pressing for major labels and the Serato control records).

In general, a majority of vinyl LP sales are reissues of back catalog titles. Since back catalog titles have already been marketed, they are low-risk sources of revenue and typically represent easy profit. One estimate states that back catalogs can make up more than 40 percent of sales and 70 percent of profits for a typical major label.[85] Jeremy Lascelles, a chief executive at Chrysalis, says that back catalogs become "an easy fall-back for a music company which owns lots of old rights to exploit them. They are dealing with the tried and tested as opposed to the brand new and speculative."[86]

The exponential increase in the sale of vinyl records in the era of digital music and digital DJing deserves closer scrutiny. While sales are up on vinyl, the market is primarily geared toward a LP album collectors' market and not DJs buying records to use as tools. Although sales have gone up more than 1,000 percent in the last decade, these statistics do not reflect what has happened to hip-hop DJs and their format of choice: the vinyl 12" maxi single. The format is an innovation that came from DJ culture and it is the format that kept vinyl alive through the 1980s and 1990s as it was the primary way DJs consumed music. The format began as a way to distribute edits of popular club hits that had DJ-friendly drum loops at the beginning and end for mixing between tracks. It is also the format whose "death" has come at the hands of digital DJ technology and changes in DJs' consumption habits, and thus the reason why DVS and specifically Serato Scratch Live is a disruptive innovation; DVS has, as we will see here, replaced the market for the 12" vinyl single.

Although it has been claimed that vinyl LP sales have skyrocketed over the last few years, the RIAA data suggests that this is *relative* because 12" vinyl single sales have fallen off the charts. While LP vinyl sales have increased over the last decade, according to RIAA shipment data, these numbers have yet to eclipse figures from 1990. The reason why the news media has, in some ways, falsely reported and hyperbolized vinyl sales is because they rely on SoundScan data. SoundScan tracks sales of retailers that partake in its data collection. And, most importantly, SoundScan started in 1991, the worst year in vinyl sales since the RIAA began tracking data in 1973. In other words, the rise in vinyl LP sales appear to be so dramatic in part because the collection of sales data began at a historic low point for LP sales.

Vinyl has generated more revenues in the United States: $210 million in 2013, compared to $62.7 million in 2009 and $39.2 million in 2004. According to RIAA data, the last time total vinyl revenues were this high was in 1997 when $68.9 million came from vinyl sales. At first glance, it would seem that vinyl sales are producing profit for the industry as the only physical format generating an increase in sales. However, the vinyl 12" maxi single disappeared during the 2000s. In 2001, 5.5 million 12" maxi singles were shipped, but from 2009–2013 only 300,000 vinyl singles hit the market annually, which is more than a 1,800 percent drop. In the same era when vinyl LP sales/shipments increased at a high rate, vinyl single sales decreased at an even faster rate. It was not until 2013 when vinyl LP sales eclipsed 2001 revenues for 12" vinyl single sales. The reports of "vinyl's resurgence" in the media have been somewhat exaggerated.

In 1973, when the RIAA began tracking these figures, 228 million vinyl singles shipped. This number is high because vinyl singles included 12" maxi singles and 7" 45rpm singles, and during the early 1970s, most singles sold as 45s. By the beginning of the 1990s, vinyl singles shipments dipped to 27.6 million units, and by the end of that decade was down to 5.3 million units. This drop could be due to the fact that most labels stopped producing 45s as commercial singles or for jukeboxes (largely because they started to play CDs). What is interesting is that in 1989 both vinyl LP and single sales were about even (34.6 million for LPs and 36.6 for singles); however, by the mid-1990s vinyl singles were out-shipping LP/EPs at a 15:1 ratio. From 1989 until 2006 vinyl singles outsold LPs, and did so at nearly a 3:1 ratio with 2007 being the first year LPs out-shipped vinyl singles since 1988. By 2009, LPs were out-shipping vinyl singles tenfold. In 2013, vinyl singles only generated $3 million in revenues and vinyl LP/EPs were up 35.2 percent to $210 million in revenues. As we can see, 12" vinyl single sales have decreased dramatically in the last decade.

Since most of the vinyl singles in the 1990s were 12" maxi singles—the format used by DJs—these numbers suggest that DJs were partly responsible for keeping vinyl records alive through the 1990s and into the new millennium (recall that vinyl LP sales dropped over 80 percent in the 1980s, largely because of the CD). This is because the 12" single is literally a format created by DJs for DJs.

By the 1970s, vinyl singles were typically pressed onto 7" 45rpm discs. The demands of disco DJs and remixers for longer and louder tools, together with a little bit of circumstance, led to the commercialization of the vinyl 12" maxi single. Unlike most of the history of recorded music, the 12" single

was introduced as a result of consumer demand rather than record company innovation.[87] This development involved Tom Moulton, a successful disco music remixer in the 1970s, who would remix commercially released songs, essentially changing their structure (maybe adding a drum break), and then press those mixes onto 7" 45s for DJs to use in the clubs. At the time the typical destinations for 7" 45s were radio and jukeboxes, which forced recording artists to produce 3–3.5 minute versions of songs. Not only did this limit the length but also the quality. Furthermore, 12" discs offered more physical space for the DJ's hand to manipulate and back-cue records than 7" discs.

In the early 1970s, Moulton went to have one of his remixes cut and the vinyl pressing plant had run out of 7" blanks. Moulton, then in a rush to get his remix to DJs, adjusted the gain and EQ for the song and cut it on a 10" disc. "Oh, when I heard it I almost died," says Moulton, who had more copies of the 10" pressed. "So it was by accident.... But for the next song we cut, we went for the 12" format instead of the 10" and the song was 'So Much for Love' by Moment of Truth. That was the birth of the 12" single."[88] Moulton's remixes were popular in the club scene, but partygoers could only purchase the original mix and not the remixes heard in the clubs. In 1976, Salsoul Records decided to meet the demand and produced the first commercial vinyl 12" maxi single, "Ten Per Cent" by Double Exposure. Shortly thereafter, the 12" single became a commercial format used by record labels (first independent disco labels and then major labels) and made popular by DJs and club-goers.

Dance clubs and DJs became valuable promotional tools for recording companies;[89] record labels produced 12" singles of their releases once the market for those songs was established. When rap records first came out in 1979, the 12" single was the primary delivery format. In fact, in the United States, "Rapper's Delight" was only released as a 12" maxi single. At the time most of the early rap records sounded similar to and were structured like disco records, and the music industry treated rap and disco genres the same: as passing fads (which proved to be the case with disco). Through these early rap records being pressed on 12" singles, from the beginning the 12" single was a part of hip-hop DJ culture. The 12" would become an important tool for most DJs during the 1990s, and for hip-hop DJs who were engaged in heavy-duty manipulation, it became the standard format.

Earlier in this chapter, we saw how Fat Beats, a store whose primary income had come from 12" vinyl single sales, negotiated the lack of both supply and demand of the format by closing its physical stores. Since DVS and SSL began standardization around 2005, shipments of 12" singles have decreased

1,167 percent to 300,000. Therefore, it is worth exploring the political economics of the indie rap 12" during the 1990s–2000s through interviews with industry professionals from that era.

During the late 1990s, unless a label was doing a lot of 12" presses, maybe 5,000 or more, there was not a great deal of profit made. First, a label had master plates pressed, which cost about $300. For a 5,000–10,000 press in the early 2000s, it cost about $1–$2 per record pressed; additional costs were incurred for a picture cover. Labels would then sell 12" discs to distributors for about $3.50/unit, distributors would sell them to retailers for about $5/unit, and customers paid $6–$7. An LP was potentially more profitable because it involved one disc and one sleeve, but would retail for $15–$18. Even though it cost more to manufacture a double LP, there was more money to be made than with a 12" single. The cost of manufacturing color picture jackets also had a lot to do with overall price, and because pressing operates on an economies of scale model, many labels/distributors ordered more covers than needed with the hopes that there would be more pressings.

In other cases, independent hip-hop record labels received cash advances from distributors to deliver singles, and then the distributor picked up the production costs (sometimes called a "P&D deal," which stands for production and distribution). DJ Mighty Mi, who owned and operated the now inactive label Eastern Conference (EC) Records, an imprint that sold 30,000 copies of some titles, had an advance deal with Rawkus Records. Might Mi says that EC delivered an artist's song to Rawkus for a cash advance; the label/recording artist received royalties only when Rawkus recouped its investment. Mighty Mi says, "They [Rawkus] would withhold 20 percent for months in case other record stores returned the vinyl and then they would get peanuts for that. So that would always be your profit margin. And then you have to explain it to the artist. It is just a huge shit show."[90] This "shit show" Might Mi speaks of relates to a problem that spans the history of the music industry: recording artists not getting paid at all for their work, or paid significantly less than they expect.

Double J, who is a co-owner of the promotion company Foundation Media and released six 12" singles through his label Trilogy Records, explains: "So it wasn't so much about making money off of the 12s, it was more about making our money back off of the 12s and using the 12s to create other opportunities."[91] In the 1990s/2000s DJs would buy 12"s at a rapid rate, but as DVS became standard, labels were making fewer 12"s and DJs' buying patterns changed. Adam Walder, aka Quest, the CEO of UGHH.com, one of the

world's largest retailers of hip-hop recordings, says, "Back in the day people would walk out of a store with 15 or 20 12" singles and not even think about it…. Now it would be like people really needed something to be super special for them to buy the 12" up."[92] Quest notes that his company is selling far more LPs than in the past because there is a market of non-DJs who want vinyl records, especially limited edition collector's items. And, because 12" singles are not being manufactured as much, the only option for consumers who want a song on vinyl is to purchase the LP.

While a lot of independent hip-hop record labels do not necessarily lament the disappearance of the 12" because of the small profit margins, the 12" single was the bread and butter for some labels. Papa D, who works for Traffic Entertainment Group and is a co-owner of Brick Records, a Boston-based hip-hop label, relied on vinyl 12" sales:

> Our entire business was based on singles and vinyl, but we would put out a single with no cover, a die cut jacket, no picture cover, the crappiest looking labels you could ever come up with, and we could sell 2,000. Day one, we would be able to ship 2,000 without doing any kind of promotion whatsoever…. So we could sell 2,000 without doing anything, literally without doing anything. And 2,000 we would consider a failure back then. If we sold 10,000 records, anywhere from 5,000 to 10,000, we would consider it a success.[93]

Up until 2007, most of Brick's releases were only on 12" vinyl.

Papa D says that it was around 2006 when Brick realized that vinyl was "pretty dead," signaled by the closure of numerous pressing plants around the United States. As pressing plants shut down, it also meant that independent labels, who pressed far fewer units than majors, kept seeing the manufacture dates of their products being postponed as the larger orders by majors received priority. These delays exacerbated the problem in 2008. DJ Nikoless, who does retail marketing for Rhymesayers Entertainment, an underground hip-hop label based in Minneapolis, Minnesota, says RSE stopped pressing 12" singles because they stopped selling. "The same people that were buying records eight or nine years ago, I am sure that a good percentage of them are still DJs. Maybe 70 percent of them still DJ. But how many of them are still buying vinyl? Are we [DJs] the problem?"[94]

While Nikoless suggests that DJs stopped buying 12" singles, Papa D contends that DVS technology and music downloading are mostly to blame: "There is no reason for them [DJs] to buy 12s anymore, none, zero. I don't blame them…. That technology [DVS] has made the need for singles

completely meaningless."[95] However, Papa D admits that in the end it is everybody's fault: DJs started using digital vinyl and stopped buying 12" singles, and record labels stopped producing them.

DJ Eclipse, who started working at the New York City Fat Beats store in 1994, says that digital distribution and downloading hurt the store, and this was compounded by DJs going digital in the mid-2000s. For Fat Beats Distribution, a division of Fat Beats that handles the manufacturing and shipment of vinyl for a large portion of independent hip-hop labels and has shipped 20,000+ units on some titles, both labels and distributors have become more cautious about what and how much they press. Whereas 10 years ago they would start by pressing 3,000 copies, post-2010 Eclipse says it is more like 500. "You just have to cut back a lot on the titles that you take in and can't take any chances," explains Eclipse. "You have to look for more name value stuff, names that still mean something in the buyer's market."[96]

The 12" single format was costly to manufacture/distribute and retail was limited to the DJ market. Double J suggests that for labels looking to cut costs, the first thing dropped from production was the 12" single, which was used by many labels as a marketing tool for radio and club play. Most third-party music promoters and record labels are now digitally promoting their music to DJs and radio. Many of the people I talked to for this book said that not only have labels shed the manufacturing costs of producing 12" singles, but also they no longer have to pay for shipping and handling to get music into DJs' hands. Instead, they "blast off" emails to radio and club DJs. This has leveled the playing field as start-up labels or artists no longer have to promote their music via costly 12" singles; it has democratized music distribution and promotion as well.

Jessica Weber, who now owns co-sign collective but was Vice President of SPECTRE Entertainment Group for almost a decade, thinks that the absence of vinyl has also devalued the music. Weber explains: "It's helped and it's hurt...but sending someone an MP3 and getting them excited about that is not as easy as sending them a piece of vinyl because people love products, especially the people that we are sending records to because they are music lovers, they are collectors, they are heads, they are diggers. So a MP3 just doesn't have the same meaning really."[97]

Havana Joe, who does promotion and marketing for Stones Throw Records, suggests that sending DJs physical copies of music is more meaningful than sending an email.[98] When vinyl 12" singles were the prominent promotional format, DJs had more incentive to play and chart certain records. Double J jokes that "vinyl was a carrot that we had to dangle in front of DJs'

faces" and he likens the promo 12" single to a "gift" given for DJs. For Double J this exchange is sort of symbolic of working together with DJs to make a record a success, but "now we really don't have that gift because getting an MP3 is not the same as getting a piece of vinyl."[99] Papa D now promotes Brick Records's releases to DJs/radio and thinks that what is missing in the digital age are the personal relationships with DJs; email communication feels cold in comparison to phone or in-person communication.

Nevertheless, the overseas market is still strong for vinyl LPs and even CDs. Quest says that UGHH.com is now selling more vinyl LPs than they had in the past, and surprisingly their CD sales are up as well. Digitization, though, has in some ways made it tougher for consumers since there is no quality filter for what gets distributed. But this also has its pros and cons. In the 1990s and 2000s, Double J and Papa D both note that having a vinyl 12" single is what made you official and separated you from the rest of the pack, and now that threshold is gone. While digital distribution and promotion has reduced manufacturing and shipping costs, the MP3 also erases costs associated with storing and hiring workers to maintain physical product. Further, MP3s prevent the government from taxing distributors or retailers for existing inventory.

Papa D says that Brick is still producing physical product because "we are old school and we want to be able to go into a CD store and see our CD there."[100] Labels and distributors are committed to making physical product, but selling LPs/CDs requires catering to a collector's market by creating limited items and box sets. Many indie labels and distributors have found it more profitable to reissue old titles, which already have a built-in market, but do so with inventive packaging. To sell physical product in the digital era, DJ Eclipse says, "One, the music has to be worth buying and the second thing is that you have to do something else extra with the packaging…. It might cost a little bit more but it's kind of like the only way that you are guaranteed that you are going to run through it."[101] Labels and distributors have gone all out in this respect by releasing special box sets that include related products, from lunch pails and trading cards to slipmats and T-shirts. Papa D says that the physical market is now more of a niche market, and while the music is still important, it's "how you sell them, how unique they are, how limited they are that makes them unique, that's going to sell."[102] DJ Nikoless says Rhymesayers realizes that to get physical sales, they have to make special products that give fans reasons to make a purchase beyond the digital release. While these sorts of sales "gimmicks" have been prevalent in other genres (i.e., rock) for several decades, it is newer territory for hip-hop and rap records.

This brief overview of the vinyl market provides more insight as to how the recording industry's priorities have changed along with the development of DJ technology. However, I believe that data show that changes in production are linked to DJs' consumption habits, which have shifted in the digital era. As DJs continue to use DVS or controllers, I would think that conditions for the 12" maxi single will only worsen, primarily because the format has lost its usefulness as a tool.

Digital vinyl systems like Serato Scratch Live remediate vinyl records, and have in many ways supplanted the use of vinyl recordings. DVS has been successful because of "its capacity to keep alive the past" in that it keeps the *idea* and *feeling* of vinyl alive and is simply easier to maintain than a vinyl record collection. Given the value of vinyl records—symbolic, utility, or otherwise—DJs coming from the vinyl era have been through a complex period of negotiating the meaning and uses of DVS. I have found that digital products have not "changed" the culture, but tastes and values of the culture have changed along with the evolution of the gear because DJs have contributed so heavily to these technical innovations.

While DVS presents value to hip-hop DJs by reducing their physical labor and actual costs of DJing, and expands creativity, it has also paved the way for a generation of microwave and celebrity DJs. Whereas vinyl was once a gatekeeper to the culture, now hip-hop DJ culture has been democratized, and, like in other fields grounded in technology, this democracy has had both positive and negative effects on the culture. Now that anybody with a computer, an MP3 collection, and a control system (DVS or controller) can become a DJ, the economics of DJing are changing and the "rules" of DJing are being undermined. The general sentiment from these veterans is that DJing is earned, but digital democracy makes it easily obtainable and may be of less value to the new generation. At the same time, for those who know how to employ the technology and do not rely on it as a crutch, DVS is vastly expanding the creativity of hip-hop DJs.

This chapter brings us back to the introduction of the book and looking at how digital democracy has paved the way for the age of the celebrity DJ and the fact that "anybody" can become a DJ. While DJs commonly blame DVS and digital products for this, the point I want to make clear is that DJs have played a huge role in this process. Digital products have come through technocultural synergism over several decades, and during that time period there has been a dialectical shift in production and consumption patterns of hip-hop DJs. It is important to understand this digital moment as just one point

in the process of technocultural synergism; it is not an end but a node in the network. If some of the stories in this book are any evidence, many technical and technique innovations lie ahead.

In this book I have outlined *a* political economy of the hip-hop DJ and its creative network, which is composed of various technique innovations, technical innovations, manufacturers, industries, and DJs. The network, as I frame it, has both open source and proprietary logic, and advancements come through the dialectics of technocultural synergism. With the barriers to DJing crumbling in the digital age and more and more people becoming DJs, understanding technocultural synergism and the histories of various innovations that brought us to this point of democratization are of vital importance to the future of the art form and culture.

EPILOGUE

In the last months of finishing up this book, two videos were posted on YouTube that generated a lot of discussion within hip-hop DJ circles. Both of these videos address many of the issues covered in this book—specifically digital democracy and credit for innovation—and make important statements about hip-hop DJs and our history. The first was posted on October 2014 with the #REALDJING hashtag affixed to it and features three-time world champ DJ Craze performing a highly technical DJ set titled "New Slaves Routine."[1] The video begins with Craze watching television images of Paris Hilton, Pauly D, David Guetta, and Steve Aoki: four of the highest paid celebrity DJs in the world. The audio coming from the television is a pitched down version of a skit from *Tosh.O* called "Bad DJ," where Daniel Tosh says (in part), "You know why everyone thinks they can DJ? Because everyone can. It's easy, pat your head and rub your stomach. There, you're an amazing DJ."

Seeing these celebrity DJs on television motivates Craze to show the audience what #REALDJING is, and the video cuts to Craze in front of his own DJ setup (turntables, mixer, etc.). In the "New Slaves Routine," Craze deploys the same digital technology and innovations that allow anybody to "become" a DJ overnight, but in the most creative way possible, manipulating buttons and discs to transform Kanye West's 2013 song "New Slaves" into an entirely

new work. Taken as a whole, the routine critiques the state of DJing and the perception of what "real" DJs are. His video makes a powerful statement about authenticity by linking it to having skills with an equally strong display of how the DJ *is* the technology and not a "slave" to it.

The second video was posted on YouTube in April 2014, a 90-minute documentary called *Founding Fathers*.[2] The film contests the common narrative of hip-hop's beginnings, a story I retold in part in Chapter 1. *Founding Fathers* focuses on the DJs and crews from the late 1960s and early 1970s from Brooklyn, New York, who were throwing disco-styled park jams. The film suggests that DJs such as Pete "DJ" Jones, the Disco Twins, and DJ Hollywood laid the foundational practices that would become the hip-hop DJ style. *Founding Fathers* ruffled some feathers and had a lot of pioneering hip-hop DJs firing shots at the claims made in the film.

The film looks at how some of these DJs modified technology and also influenced what would become the DJ product industry. In one interview, D.J. Vernon recalls the technical ingenuity of Ricky Grant of the Nu Sounds crew. Vernon says before DJ mixers were commercially available that Grant took a Sony MX 14 mixer and "y-jacked" the channels, allowing him to mix with independent control of the volume levels coming from the turntables (now a "gain" or "trim" feature on DJ mixers). Vernon then tells a story that is touched on in this book and one that is embedded in the grand narrative of innovation broadly: "And from that, slick ass engineers at GLi saw the idea, copied it, and came out with the first 3800. They stole ideas from Ricky Grant."[3] The GLi 3800 was one of the first commercially available DJ mixers and one of the first mixers that Kool Herc (the DJ commonly regarded as the "inventor" of hip-hop) used. And GLi, which was based in Long Island, New York, also went on to make an influential mixer among hip-hop DJs in the late 1970s and early 1980s: the PMX 9000.

Important to this book, *Founding Fathers* further elaborates on the creative network of hip-hop DJ culture, effectively highlighting the collaborative nature of innovation and issues surrounding credit for innovating. At the end of the film, DJ Hollywood, a popular disco DJ in the 1970s who was loosely tied to early hip-hop culture, raises some important issues:

> And a lot of people don't know the beginnings of mostly anything. Usually the inventor of whatever it is never gets the chance to get to shine out of it. And they never get to see the money that's generated behind it. Whenever they want to speak on hip-hop in any shape, form or fashion, if it don't start with me, that's a story you're

watching that left out the meat of the story.... They bypassed the beginning of that
story and went to the next page.[4]

Hollywood, like many of the DJs in this book, is seeking credit for something
he helped to create; he wants his contributions to be added to the legacy of
hip-hop, which, in turn, adds to his legacy. Like other DJs who innovate,
credit produces subcultural capital and adds to his brand value. The film en-
capsulates one of the many problems I highlight in this book: giving credit to
an individual when innovation comes through a creative network.

This book has used a political economy of the hip-hop DJ to highlight and
outline a theory of technocultural synergism. Technocultural synergism, as I
describe it in the book, is a cycle that begins where it ends: with the manipu-
lation of intellectual property (IP). New innovations, such as recordings and
hardware, hit the market as intellectual properties that are manipulated by DJs,
and then this creative work leads to exchange and rights in an ongoing feed-
back loop of creation. In some cases, DJs themselves are manipulated as IP in
branding and R&D (specifically, see Chapters 4 and 5). While the story of the
hip-hop DJ is one example of how culture can be manipulated *as* intellectual
property, the implications surely reach other industries and markets as well.[5]

Some people may read this book and think that I have a negative view of
new DJ technologies. Maybe some people will feel that I use the word *exploit*
or *manipulate* too much, or that my account of how DJ practices have changed
with digitization is presented in an unflattering light. That kind of bias is not
my intention. My hope is for us to be able to look at the stories and opin-
ions that I have collected and analyzed here to see how the world of digital
technologies contributes to the creative network of the hip-hop DJ. I want
us—both DJs and non-DJs—to have a discussion about these issues. I also
want us to be able to look back 50 years from now and know that the idea for
a contactless crossfader came from DJ Focus (although Stanton commercially
produced it). I want stories of other techniques and technical innovations—
such as the Vestax 05Pro, Rane TTM 54, and Hamster style—to inspire the
same type of admiration and reflection as other stories we tell about hip-hop's
origins and development. In other words, I want us to remember how the
exchange between DJs and technology companies changed the market, the
industry, and the culture. If we only remember the brand names associated
with technique and technical innovations, then we have a problem, because
we are leaving out the role of technological synergism that led to their devel-
opment. And, finally, I want to shift the focus away from simple notions of

"invention" and toward the ongoing process of reinvention. Simply, I want us to think more critically about how *we* create.

With that said, my personal belief is that hip-hop DJing is going back underground, back to its core. With manufacturers, major clubs, and multinational companies focusing on other types of DJs, such as EDM DJs, I think now is a time when hip-hop DJs can start doing more grassroots work. If there ever were a time for a "for DJs, by DJs" type of company, now is the time. Big corporate sponsorships from alcohol, energy drink, and fast food companies are not culturally sustainable in the long term, and at some point it will be up to us to create our own products, events, and businesses.

In this book there is a lot of talk about digitization and the "death" of analog artifacts such as the Technics 1200 and the 12" vinyl maxi single. I think that the evidence here shows there is a clear link between their passing and how DJs have engaged with digital DJ products. While this is presented and discussed with some contention, the positive takeaway is that we have entered the era of the "green" DJ. Making PVC, pressing vinyl, making and printing jackets/sleeves, and shipping the end product has a huge carbon footprint. A lot of fuel is used in the process of turning PVC into a record in your crate. Vinyl records for DJs are now pressed and consumed with consideration. Without DVS or digital DJ controllers, think about how many new pop hits with a short shelf-life—the tracks that many working DJs need—would be pressed and then basically sent to a landfill two years later. In the era of disposable music, today's hit is tomorrow's garbage. Disposing of vinyl that nobody wants can be a major environmental issue, and the recycling centers (record stores and second-hand stores) cannot do anything with these types of records. So, this may be one positive takeaway from digitization. Simply put, producing, distributing, and disposing of MP3s does not have the same negative effects on the planet.

It is clear to me that some perspectives, stories, technologies, and histories are missing from this book, and that may be problematic for readers. However, I think that this book has provided another starting point for scholars who want to look at hip-hop DJ culture and technology through other lenses, including gender, race, and other theories of identity. The culture and industry of hip-hop DJs remains predominantly, but not exclusively, male, but it is also ethnically diverse. While gender and race are beyond the scope of this book, I do think that exploring DJ products and the industry, as well as technocultural synergism, through those lenses could really generate valuable scholarship.

I want the research presented here to have an impact on hip-hop DJ culture. In the midst of writing my dissertation, on which this book is based, I started to think about how cool it would be to put the research to work in a way that could be meaningful for scholars, hip-hop DJs, and DJs in general. After talking with a friend of mine, DJ Calibur, we thought we had arrived at a strategy for making this research accessible: We founded DJistory and the DJpedia Archive. Our goal is to run a nonprofit organization to host a physical and digital archive for DJ technologies and media, and since 2010 we have been building the physical archive with hopes of launching an online interactive museum and wiki soon. This book is one of the first major products of this archival research, but www.djistory.org will be the crux of the work and will be *free*, and you will be able to contribute and be a DJstorian. We, the DJs, make DJistory.

I want to say this loudly, and this should go for larger markets/industries as well: We are the technology. We make knobs and buttons and faders and screens have value through how we use and misuse them. We create the market. We innovate. By nature we want to share information, and because of that same nature we are open source. We innovate and share ideas because we love the things we do; we do it for the love. Companies and brands are always a few steps behind us, and the laws and rights used to exploit ideas in a market tarnish the collaborative nature of human creativity. The hip-hop DJ is an important case study on how we innovate and how we are the technology. We are the story that is designed from scratch.

NOTES

Introduction

1. TMZ Staff, "Paris Hilton, I'm One of the Top 5 DJ's in the World...Seriously," *TMZ*, December 26, 2013, accessed April 28, 2014 at http://www.tmz.com/2013/12/26/paris-hilton-top-5-highest-paid-dj-world/.
2. Zach O'Malley Greenburg, "Electronic Cash Kings 2013: The World's Highest-Paid DJs," *Forbes*, August 14, 2013, accessed April 28, 2014, at http://www.forbes.com/sites/zackomalleygreenburg/2013/08/14/electronic-cash-kings-2013-the-worlds-highest-paid-djs/.
3. Scott T. Sterling, "Simon Cowell's 'Ultimate DJ' Competition TV Show Is Actually Happening," April 29, 2014, accessed May 3, 2014, at http://radio.com/2014/04/29/ultimate-dj-competition-tv-show-is-actually-happening/.
4. *EDM* is an acronym for electronic dance music, which is both a genre and a buzzword used by the recording industry to market this type of music.
5. Raymond Williams, *Television: Technology and Cultural Form* (New York: Schocken Books, 1974).
6. Lloyd Morriset, "Technologies of Freedom," in *Democracy and New Media*, ed. Henry Jenkins (Cambridge: MIT Press, 2003), 22.
7. Hip-hop DJs come from all races, ages, and gender, although the culture started with teenage African American and Puerto Rican males. However, while there are some amazingly talented and influential female hip-hop DJs, the culture remains mostly male. And, the industry that serves this culture is likely 99.9 percent male. While gender inequity in hip-hop DJ culture and the DJ product industry is worthy of inquiry, there is little female

perspective in this book because it reflects the reality of it. Gender and race are beyond the scope of this book; however, for analysis and interview data on gender, see Mark Katz, "Men, Women, and Turntables: Gender and the DJ battle," *Musical Quarterly* 4 (2006): 580–599, or Mark Katz, *Groove Music: The Art and Culture of the Hip-Hop DJ* (New York: Oxford University Press, 2012), pages 241–246.

8. For instance, the computing, gaming, and television industries commonly incorporate ideas from prosumers, modders, and extreme fans into products and programs.

9. Nancy Macdonald, *The Graffiti Subculture: Youth, Masculinity and Identity in London and New York* (Hampshire, UK: Palgrave Macmillan, 2003).

10. DJ Majesty was actually played by a prominent DJ of that time, DJ Richie Rich, aka Daddy Rich of the Supermen DJ crew. And, while Omar Epps tried to act out the scratching as DJ GQ, he could not, so his "stunt hands" are those of Plazticman (also part of the Supermen DJs).

11. Joseph G. Schloss, *Making Beats: The Art of Sample-Based Hip-Hop* (Middletown, CT: Wesleyan University Press, 2004).

12. Jeff Chang, *Can't Stop Won't Stop: A History of the Hip-Hop Generation* (New York: St. Martin's Press, 2005).

Chapter 1

1. Walter Benjamin, The *Arcades Project*, ed. Rolf Tiedemann, trans. Howard Eiland and Kevin McLaughlin (Cambridge: Harvard University Press, 1999), 205 [H1a, 2].

2. Jeff Chang, quoted in *Copyright Criminals*, DVD. Directed by Benjamin Franzen and Kembrew McLeod, Asotria, NY: IndiePix Films, 2009.

3. Lawrence Lessig, *Remix: Making Art and Commerce Thrive in the Hybrid Economy* (London, Penguin, 2008), 28.

4. Before hip-hop DJs, appropriation art was an avant-gardist project consumed by small groups of people. While artists such as John Cage and Pierre Schaeffer have been cited as precursors to hip-hop DJing and turntablism because they manipulated sound (i.e., Katz, *Capturing Sound*), their appeal and influence was on a small group of people.

5. Books such as Fricke and Ahearn's *Yes Yes Ya'll*, Ogg and Upshal's *The Hip Hop Years: A History of Rap*, Brewster and Broughton's *Last Night a DJ Saved My Life*, Katz's *Groove Music*, and Chang's *Can't Stop Won't Stop* are examples of texts that delineate these histories.

6. See Christopher Cox and Daniel Warner, *Audio Culture: Readings in Modern Music* (New York: Continuum International Publishing Group, 2004), 329. Also see Paul D. Miller, *Rhythm Science* (Cambridge: MIT Press, 2004), 33.

7. Dick Hebdige, *Cut 'n' Mix: Culture, Identity, and Caribbean Music* (London & New York: Routledge, 1987), 140.

8. Ulf Poschardt, *DJ Culture*, trans. Shaun Whiteside (London: Quartet Books, 1998), 163.

9. Cox and Warner, *Audio Culture*, 320.

10. Katz, *Groove Music*, 83.

11. Justin A. Williams, *Rhymin' and Stealin': Musical Borrowing in Hip Hop* (Ann Arbor: University of Michigan Press, 2013), 1.

12. Jamaican toasting involved improvised lyrics over the records as they played.

13. David Toop, *Rap Attack #3: African Rap to Global Hip Hop* (London: Serpent's Tail, 2000), 104.

14. Chang, *Can't Stop*, 30.

15. Tricia Rose, *Black Noise: Rap Music and Black Culture in Contemporary America* (Hanover, NH: University Press of New England, 1994), 79.

16. Ibid., 90.

17. The documentary *Founding Fathers*, April 7, 2014, accessed April 20, 2014, https://www.youtube.com/watch?v=1G13bR0B0-8&sns=fb, highlights how mobile discos were happening before Herc and in Brooklyn.

18. DJ Afrika Bambaataa, quoted in Toop, *Rap Attack*, 238.

19. Richard Shusterman, "Challenging Conventions in the Fine Art of Rap," in *That's the Joint!: The Hip-hop Studies Reader*, eds. Murray Forman and Mark Anthony Neal (New York: Routledge, 2004). Katz also discusses the relationships between disco and hip-hop in *Groove Music*, 32–35.

20. To read about Grasso and some of his influences on DJ culture, see "Interviews: Francis Grasso," accessed April 13, 2014, http://www.djhistory.com/interviews/francis-grasso.

21. The mixer is a piece of electronic equipment that both turntables wire into, and the mixer wires out to an amplifier and speakers. A mixer allows a DJ to control which turntable's signal plays out over the speakers and uses headphones to cue up and mix in other records. To mix between turntable signals, DJs use a crossfader or channel faders to fade between each turntable's signals. This is the basic function of a mixer, but as DJ technique evolved so have mixers.

22. "Rane History," accessed April 10, 2014, http://dj.rane.com/about-rane/history.

23. David Cross, "A History of the Development of DJ Mixer Features: An S&TS Perspective," B.A. Thesis, Cornell University, 2003, 44.

24. Hip-hop culture is typically considered to consist of four elements: (1) DJing; (2) emceeing; (3) graffiti writing; and (4) b-boyin'/b-girlin', aka "breakdancing."

25. For instance, see Hebdige, 1987; Rose, 1994; and Chang, 2005.

26. For instance, Pete DJ Jones, DJ Breakout, DJ Baron, Grandmaster Flowers, Red Alert, Disco Wiz, Disco King Mario, DJ Afrika Islam, DJ Hollywood, and Lovebug Starski were other active and popular DJs at the time. There are many others.

27. Toop, *Rap Attack*, 21.

28. S. Craig Watkins, *Hip Hop Matters: Politics, Pop Culture, and the Struggle for the Soul of a Movement* (Boston: Beacon Press, 2005), 28.

29. Dan Charnas, *The Big Payback: The History of the Business of Hip Hop* (New York: New American Library, 2010).

30. For instance, Herc played everything from James Brown's "Give It Up or Turnit Loose" to Michael Viner's "Apache" to Babe Ruth's "The Mexican."

31. The raw, open drum section of a song, which was also considered the most danceable part of the song or the "get down" part.

32. DJ Kool Herc, quoted in Kembrew McLeod, *Freedom of Expression: Overzealous Copyright Bozos and Other Enemies of Creativity* (New York: Doubleday, 2005), 70.

33. Poschardt, *DJ Culture*, 163.

34. Sophie Smith, "Compositional Strategies of the Hip-Hop Turntablist," *Organised Sound* 5 (2000): 76.

35. Chang, *Can't Stop*, 112.

36. Williams, *Rhymin' and Stealin'*, 25.

37. Juliana Snapper, "Scratching the Surface: Spinning Time and Identity in Hip-Hop Turntablism," *European Journal of Cultural Studies* 7 (2004), 10, no. 1: 9–25.

38. Grandmixer DXT, quoted in *Scratch*, DVD. Directed by Doug Pray, New York: Palm Pictures, 2002.

39. Chang, *Can't Stop*, 79. Note that this practice of obscuring labels and keeping music secret was an evident proprietary practice in a competitive environment. It's important to note that hip-hop DJs were not purely open source, but instead many of their practices reflected that mentality; however, keeping music secret gave DJs a way to monopolize a neighborhood's parties.

40. DJ Jazzy Jay, quoted in Brewster and Broughton, *Last Night*, 213.

41. As a former warlord in the Black Spades gang, Bam was able to use his eclectic tastes, street credibility, and network to throw parties at the Bronx River Community Center. The energy that had once powered gang culture was harnessed through breakin', writing graffiti, emceeing, and DJing. As a teenager, Bam turned his party activities into the Universal Zulu Nation, an awareness group of socially conscious hip-hoppers who organized youth events to spread the positive messages of hip-hop—mainly that of youth solidarity using the motto "Peace, Love, Unity, and Having Fun." The Zulu Nation is still highly active with chapters all over the world.

42. Bam is credited with introducing songs such as "Dance to the Drummer's Beat," "Jam on the Groove," and "The Champ" into the collective hip-hop consciousness.

43. DJ Afrika Bambaataa, quoted in Dave the Ruf, "Knowledge of Godfather—A Conversation with Afrika Bambaataa," accessed December 16, 2010, http://www.mrkd.co.uk/rufmouth/rufsays/bam_interview.html.

44. Chang, *Can't Stop*, 112.

45. For instance, both the Meteor Clubman Two and the GLi 3880 mixers, which were popular at the time in both discos and with mobile DJs, retailed for $425 (almost $1,800 in 2015 when inflation is taken into account).

46. I have heard all sorts of personal stories from pioneering hip-hop DJs about how they mixed records using DIY manipulation. Some would wire two home stereo receivers together and wire a turntable into each receiver and then use the volume knobs to mix between the two turntables. Other DJs would use one stereo receiver, wire one turntable into the left channel and one into the right channel, and then use the pan control to fade between turntable signals.

47. Grandmaster Flash, quoted in George, *That's the Joint!*, 49.

48. Grandmaster Flash, quoted in Brewster and Broughton, *Last Night*, 216.

49. Taking two copies of the same record and extending the break into a breakbeat was first called the "zugga zugga," then "cutting," which is another technique Flash popularized.

50. nodfactordotcom, "GrandMaster Flash at Master of the Mix," accessed December 27, 2010, http://www.youtube.com/watch?v=X8-0M-jSOE4.

51. DJ Francis Grasso is said to have been using slipmats years before in the disco scene. Slip-mats allow DJs to put a hand on the record and move it back and forth without moving the turntable platter itself.

52. Chang, *Can't Stop*, 114.

53. Theodore also perfected the art of "needle dropping" and is largely credited with this innovation. Instead of spinning a record back, utilizing the clock theory, he would pick up the needle and move it back a couple grooves on the record to the beginning of the break. While Herc had employed the needle drop as part of his merry-go-round years before, it was by chance that he would be able to drop it on beat. Theodore, being a student of Flash, was able to do it scientifically and soulfully.

54. Grandmaster Flash, quoted in George, *That's the Joint!*, 49.

55. For example, see Poschardt, *DJ Culture*; Brewster and Broughton, *Last Night*; Chang, *Can't Stop*; and Watkins, *Hip Hop Matters*.

56. Nelson George, *Hip Hop America* (New York: Viking Penguin, 1998), 154.

57. Kembrew McLeod, *Owning Culture: Authorship, Ownership & Intellectual Property Law* (New York: Peter Lang, 2001), 79–80. I would like to note that by most accounts, break-beat DJing and hip-hop more generally were fading out in the late 1970s. While often derided, "Rapper's Delight" helped to keep hip-hop culture alive and allowed it to make its way out of New York City.

58. Basu, 2005, 258.

59. Schloss, *Making Beats*, 42.

60. On most of the early hip-hop records, publishing rights and royalties were often not awarded to these producers but were kept by the owners of labels.

61. For detail on this history, see Katz, *Groove Music*, Chapters 4 through 7.

62. For example, see Souvignier, *The World of DJs*; Cox and Warner, *Audio Culture*; and Mark Katz, *Groove Music: The Art and Culture of the Hip-Hop DJ* (New York: Oxford University Press, 2012).

63. DJ Babu, telephone interview with author, November 24, 2009.

64. Turntablist Disk, telephone interview with author, November 9, 2009.

65. Pierre Bourdieu, "The Forms of Capital," in *The Sociology of Economic Life*, eds. Mark S. Granovetter and Richard Swedberg (Boulder, CO: Westview Press, 1986/2001).

66. DJ Quest, telephone interview with author, December 26, 2009.

67. DJ Daddy Dog, telephone interview with author, January 6, 2010.

68. DJ Qbert, telephone interview with author, January 7, 2010.

69. DJ Nu-Mark, telephone interview with author, December 1, 2009.

70. Ricci Rucker, email interview with author, November 17, 2009.

71. See Williams, *Rhymin' and Stealin'*, the concept of musical borrowing is central to his thesis and this book.

72. DJ Babu, telephone interview with author, November 24, 2009.

73. Williams, *Rhymin' and Stealin': Musical Borrowing in Hip Hop*, 171.

74. Katz, *Groove Music*, 61–66 specifically.

75. DJ Platurn, telephone interview with author, December 5, 2009. Turntablist Disk, telephone interview with author, November 9, 2009.

76. DJ Steve Dee, telephone interview with author, December 6, 2009.

77. DJ Nu-Mark, telephone interview with author, December 1, 2009.
78. Steven Webber, telephone interview with author, November 26, 2009.
79. Katz, Groove Music, 62.
80. Mr. Len, telephone interview with author, November 17, 2009.
81. DJ Rob Swift, telephone interview with author, November 17, 2009.
82. DJ Babu, telephone interview with author, November 24, 2009.
83. DJ Shiftee, telephone interview with author, December 13, 2009.
84. DJ Steve Dee, telephone interview with author, December 6, 2009.
85. Mike Boo, telephone interview with author, November 19, 2009.
86. JohnBeez, telephone interview with author, November 10, 2009; emphasis added.
87. DJ Shame, telephone interview with author, February 6, 2010.
88. Teeko, telephone interview with author, November 9, 2009.
89. Ricci Rucker, email interview with author, November 17, 2009.
90. DJ Qbert, telephone interview with author, January 7, 2010.
91. For instance, DJ Quest, DJ Eclipse, DJ Shame, and Skeme Richards all mentioned this with emphasis in their interviews.
92. DJ Shame, telephone interview with author, February 6, 2010.
93. DJ Kico, telephone interview with author, December 6, 2009.
94. DJ Babu, telephone interview with author, November 24, 2010.
95. Jared Boxx, telephone interview with author, March 30, 2010.
96. DJ JayCeeOh, telephone interview with author, December 3, 2009.
97. DJ Craze, telephone interview with author, December 29, 2009.
98. DJ Nikoless Scratch, telephone interview with author, January 27, 2010.
99. J.Period, telephone interview with author, January 12, 2010.
100. DJ Quest, telephone interview with author, December 26, 2009.
101. DJ Nu-Mark, telephone interview with author. December 1, 2009.
102. DJ Nikoless Scratch, telephone interview with author, January 27, 2010.
103. It's important to note that often DJs are collectors, broadly speaking, and collections could range from sneakers to films to magazines to toys, etc.
104. Mike Boo, telephone interview with author, November 19, 2009.
105. In Williams, *Rhymin' and Stealin'*, 167, he also cites hip-hop as an "open source" culture, partly because of its value on borrowing from the past.

Chapter 2

1. Bob Moog quoted in Mike Berk, "Technology: Analog Fetishes and Digital Futures," in *Modulations—A History of Electronic Music: Throbbing Words on Sound*, ed. Peter Shapiro (New York: Caipirinha Productions, 2000), 208.
2. David Quick, "Panasonic Ceases Production of Iconic Technics Analog Turntables," *gizmag*, November 4, 2010, accessed January 30, 2011, http://www.gizmag.com/panasonic-ceases-production-of-technics-turntables/16840/. Panasonic had also claimed that sales of 1200s had dropped 95 percent since 2000.

3. This sponsor relationship lasted through the 2009 competition series and the 1200 became the exclusive turntable used in the competition. I am pretty sure that I have not seen any other brand used in DMC competitions, even after 2009.

4. Panasonic had apparently exhausted its stock of 1200s but claimed it would continue to support warranties and supply spare parts for the line as long as it could. Some people think that the reason why Technics stopped making turntables is because the 1200s are extremely durable, and thus DJs never had to replace them. Others have suggested that, other than a few minor upgrades, 1200s remained relatively the same since the late 1970s and failed to keep up with the needs of new DJ techniques. Still other DJs fault CD turntables (CDJs) or digital vinyl systems (DVS), both of which played a part in the standardization of digital DJ technologies, and thus opened the floodgates for controller systems. Thus, in this sense we can see how DVS and the digital DJ controllers are disruptive technologies, essentially replacing the market for other technologies used by DJs. I have also heard many DJs over the years suggest that Technics did not care about DJ culture, never gave back to the culture, and that it only sponsored the DMC battles to market its product line. Unlike other manufacturers, Technics never officially endorsed any DJs. Thus, DJs went looking for other brand turntables that could live up to the rigors of heavy-duty manipulation. My guess with a company as large as Panasonic is that the DJ market/culture probably had more interest in Technics than Panasonic had in DJs. It is a multinational corporation that raked in $75.8 billion in 2013, which by luck or fate produced a line of turntables that happened to work very well for DJing.

5. "Global Markets Continue to Regain Ground," *Music Trades*, December 2013, 71, accessed April 15, 2014, http://digitaleditions.sheridan.com/publication/?i=184058.

6. "The 2014 Music Industry Census," *Music Trades*, April 2014, 80, accessed April 15, 2014, http://digitaleditions.sheridan.com/publication/?i=203399.

7. For some time Vestax was making mixers and had its own retail store; however, distribution outside of Japan was always handled by other companies, which proved to be problematic for Vestax.

8. Pioneer sold the DJ division to apparently focus on car audio, but will retain a 15 percent share of the company. Dan White, "Pioneer DJ Sold for $551 Million; Pioneer to Focus on Car Audio," *DJTechTools*, September 16, 2014, accessed December 3, 2014, http://www.djtechtools.com/2014/09/16/pioneer-dj-sold-for-551-million-pioneer-to-focus-on-car-audio/.

9. Mark Katz writes that the Beat Junkies were the DJ crew who introduced the M44-7 to American hip-hop DJs. Both D-Styles and Shortkut have also been a part of both the Beat Junkies and ISP. See Katz, *Groove Music*, 120.

10. See the 6:46 mark on BEAT4BATTLE TV, *Turntable TV 4: Toiret for Godzirra*, April 20, 2011, accessed May 16, 2014, https://www.youtube.com/watch?v=GwpZTeQkeYc.

11. DJ Shortkut, telephone interview with author, January 11, 2010.

12. Ibid.

13. Since conducting research for this book from 2009–2011, Native Instruments would likely be another company I would include in more detail. Its Traktor Scratch digital vinyl software and its Kontrol Z2 mixer are now competitive in the hip-hop and scratch DJ market, with Traktor Scratch being the main competitor with Serato.

14. For instance, see Eileen R. Meehan, Vincent Mosco, and Janet Wasko, "Rethinking Political Economy: Change and Continuity," *Journal of Communication* (1993) 43; Vincent Mosco, *The Political Economy of Communication: Rethinking and Renewal* (London: Sage Publications, 1996); and Janet Wasko, "The Political Economy of Communications," in *The Sage Handbook of Media Studies*, eds. John D. H. Downing, Denis McQuail, Philip Schlesinger, and Ellen A. Wartella (London: Sage Publications, 2004).

15. Peter Golding and Graham Murdock, "Culture, Communication and Political Economy," in *Mass Media and Society*, 3rd ed 70-92, eds. James Curran and Michael Gurevitch (London: Edward Arnold, 2000), 70.

16. Paul Théberge, *Any Sound You Can Imagine: Making Music/Consuming Technology* (Hanover, NH: Wesleyan University Press, 1997), 7.

17. Keith Negus, *Popular Music in Theory: An Introduction* (Hanover, NH: Wesleyan University Press, 1996), 36. In his other work and in the context of the recording industry, Negus suggests the record industry is an example where *"an industry produces culture and culture produces an industry."* This type of thesis underlies my examination using technocultural synergism. Keith Negus, *Music Genres and Corporate Cultures* (London: Routledge, 1999), 14.

18. Jonathan Sterne, *The Audible Past: Cultural Origins of Sound Reproduction* (Durham, NC: Duke University Press, 2003), 225.

19. David Hesmondhalgh, *The Cultural Industries*, 2nd ed. (London: Sage Publications, 2007), 12.

20. Daniel Mato, "All Industries Are Cultural," *Cultural Studies* 23 (2009): 73.

21. René T. A. Lysloff and Leslie C. Gay, *Music and Technoculture* (Middletown, CT: Wesleyan University Press, 2003), 7.

22. Ibid., 18.

23. For example, see Chanan, *Repeated Takes*; Chanras, *The Big Payback*, 136; and Mark Coleman, *Playback: From the Victrola to MP3, 100 Years of Music, Machines, and Money* (Cambridge, MA: Da Capo Press, 2003), 118.

24. *Forbes*, "Global 500 2013," accessed April 20, 2014, http://fortune.com/?s=panasonic.

25. Although Technics popularized DDS, it was the Swiss high-end audio manufacturer Thorens who developed and then applied for a French patent on a direct drive turntable in 1929. Thorens, however, did not bring DDS turntables to market until the early 1950s.

26. DJ Kool Herc quoted in djhistory.com, "Interviews: Kool Herc," accessed January 21, 2011, http://www.djhistory.com/interviews/kool-herc.

27. After the release of the MK2, Technics introduced four more models (MK3, MK4, MK5, and MK6), two special models (SL-1200LTD and SL-1200GLD), as well as a CD turntable (SL-DZ1200). Other than some minor changes in color and added options, the SL-1200 series remained essentially true to the MK2 and thus little R&D went into this product line. The MK2 became the base for the SL-1200 series and was Technics's oldest turntable in production.

28. U.S. Patent No. 4,072,315 assigned to Matsushita Electrical Industrial Co., Ltd. The patent for this direct-drive system was filed for on March 30, 1976, and granted on February 7, 1978.

29. Patents filed after June 8, 1995, received a 20-year term; those filed before had a 17-year term.

30. Perelman, *Steal this Idea*, 195.

31. It is worth noting that Grandmaster Flash developed many of the DJ techniques that are used by all DJs today on a Technics SL-23, a belt-driven turntable.

32. The 1200 MK2 and its progeny were not cheap either; from the 1980s until it was discontinued in 2010 it retailed for $300–$500.

33. Technics has been publicly critiqued by many DJs for ignoring the culture and not endorsing DJs, and it only started offering new models of the 1200 in the 1990s when the popularity of scratch and hip-hop DJing was peaking. Technics never sponsored or endorsed a DJ, although in the late 1980s the company discussed endorsing one DJ, but it never happened: DJ Cash Money. (Cash Money told me this informally via text message.)

34. Charnas, *The Big Payback*, 135–136.

35. Run-D.M.C., "Rock Box," 1984, https://screen.yahoo.com/rock-box-002627433.html.

36. More recently, 1200s paired with Rane mixers have appeared on the NBC programs *Community* and *Law & Order: Special Victims Unit*, as well as on MTV's *Jersey Shore*.

37. Note that DMC has had other sponsor-based technology restrictions in its competitions. The most controversial was from 2005 until 2008, when the needle manufacturer Ortofon provided $10,000 prizes for world champs in the three battle categories, and in exchange all entrants had to use its needles. With the Shure M44-7 still being the needle of choice, many were bothered by the "Ortofon rule," as it was called.

38. DJ Shiftee, who won the 2009 World Championships, told me that because Technics was not an official sponsor of the battle that DMC actually had to buy the turntables and then have them gold-plated. DJ Shiftee, telephone interview with author, December 13, 2009.

39. Technics and DMC also worked together to produce numerous DJ commodities bearing the Technics logo, including record bags and boxes, slipmats, key chains, hats, hooded sweatshirts, and wallets. The access to its users/market granted through sponsorship and corporate synergy with DMC provided Technics with unprecedented exposure to its consumers.

40. Frannie Kelley, "Hip-Hop's Turntable Goes to the Great Lock Groove in the Sky," *NPR*, November 18, 2010, accessed June 20, 2013, http://www.npr.org/blogs/therecord/2010/11/18/131418593/technics-1200-hip-hop-s-war-horse-goes-to-the-great-lock-groove-in-the-sky.

41. The rise in price and activity is not necessarily rational; recall that there are more than 3.5 million SL-1200s in the world.

42. To add some support of Panasonic's lack of attention to the DJ market, Technics's website had last been updated in 2005.

43. DJ Craze, telephone interview with author, December 29, 2009.

44. Mr. Len, telephone interview with author, November 17, 2009.

45. DJ Roli Rho, telephone interview with author, April 12, 2010.

46. DJ Skeme Richards, interview with author, January 20, 2010.

47. DJ Nu-Mark, telephone interview with author, December 1, 2009.

48. DJ Neil Armstrong, telephone interview with author, December 30, 2009.

49. Mark Settle, "Musikmesse 2014: About that Pioneer Turntable Rumour…." *DJWORX*, March 12, 2014, accessed March 12, 2014, http://djworx.com/musikmesse-2014-pioneer-turntable-rumour/#.U0hi_se9i8U.

50. The PLX-1000 is retailing for $700, and the main difference between it and the 1200 are a greater pitch range (up to +/- 50 percent) and removable RCA cables. Beyond that, it completely copies the 1200's design and layout.

51. DJ Daddy Dog, telephone interview with author, January 6, 2010.

52. DJ JayCeeOh, telephone interview with author, December 3, 2009.

53. DJ Eclipse, telephone interview with author, April 7, 2010.
54. For some of this analysis, see Williams, *Rhymin' and Stealin'*, 29–36.
55. DJ Steve Dee, telephone interview with author, December 6
56. DJ Quest, telephone interview with author, December 26, 2009.
57. While "giving back" can take shape in the form of sponsoring events, such as the DMC, with cash or prizes, this type of sponsorship is only altruistic in the sense of commodifying audiences who are exposed to logos, ads, and products. Not all DJs I interviewed saw sponsoring in this light, but many raised this issue; however, most DJs did not see Technics's long-time sponsorship of the DMC DJ battles as a form of giving back but as marketing. The same could be said of endorsement and R&D; it's about expanding markets and not about giving for giving's sake. It's all about business, although, as we will see, some businesses are more altruistic in their relationship with the culture.
58. DJ Vinroc, telephone interview with author, December 29, 2009.
59. Hoovers, "Vestax Corporation Company Information," accessed February 13, 2011, http://www.hoovers.com/company/VESTAX_CORPORATION/jsfjscjth-1.html.
60. "Controller One," Vestax Corporation, accessed February 19, 2011, http://www.vestax.com/v/products/detail.php?cate_id=42&parent_id=7.
61. "Artists," djay for Mac, accessed February 15, 2011, http://www.algoriddim.com/djay-mac/reviews/artists. (Note that this is no longer on the site, but I did get screen images when it was up.)
62. Spin, "Company," accessed February 12, 2011, http://vestaxspin.com/vestax/.
63. OEM refers to a company that manufactures components under the brand name of another company who purchases the products from the OEM company to resell under its brand name. It can also be a manufacturer who sells a completed product to a reseller who puts the reseller's brand name on it.
64. DJ Trix, email interview with author, April 20, 2011.
65. Ibid.
66. The TRIX had a 20mm fader interchangeable with a 45mm fader, the latter being the standard length at the time.
67. Curve adjustments to crossfader cut-in allow DJs to control how fast the signal from another turntable cuts into the mix. A slow curve is good for mixing or crossfading between two records while a fast cut-in is good for scratching.
68. Charles Ono, telephone interview with author, April 19, 2010.
69. I have seen and have pictures of the drawing that Toshi had done, and it's not the design that was executed in the 05Pro.
70. Although I talked to Shortkut about finding this and publishing it here, when he had found the napkin in storage it had been ruined by condensation.
71. DJ Shortkut, telephone interview with author, January 11, 2010.
72. Ibid.
73. Charles Ono, telephone interview with author, April 19, 2010.
74. DJ Qbert, telephone interview with author, January 7, 2010.
75. thudrumble, "DJ Qbert DJ Qbert + Yogafrog + MC UB Discuss the Development of the PMC-05 Pro," August 3, 2011, accessed August 5, 2011, https://www.youtube.com/watch?v=ehKkeKOKTxw.

76. Before the 05Pro, Vestax was a mixer brand that was mainly used in Asia and Europe, likely because of distribution. Over the years, Vestax had various distributors to get its products to the U.S. market, but the 05Pro was really the first Vestax mixer to get a heavy distribution push in the United States.

77. DJ Shortkut, telephone interview with author, January 11, 2010.

78. See Katz, *Groove Music*, specifically Chapter 7.

79. Charles Ono, telephone interview with author, January 11, 2010.

80. DJ Shortkut, telephone interview with author.

81. DJ Go, email interview with author, April 26, 2010.

82. Charles Ono, telephone interview with author, April 19, 2010.

83. Ibid.

84. DJ Qbert, telephone interview with author, January 7, 2010.

85. Ibid.

86. The QFO notably featured the Dynamic Balance Straight Arm, 2-band EQ, and +/- 60 percent pitch, as well as Qbert's Thud Rumble logo. Shortly after releasing the Qbert signature model, Vestax released the QFO LE, which was a technically stripped down version. Given the high price point of the original QFO, Vestax removed some of the features from the QFO LE, so the price fell to $600 –$900. Vestax notably replaced the cutting-edge Dynamic Balance Straight Arm system with the standard A.S.T.S. tonearm, which, in some ways, defeated the QFO's purpose of being portable and being able to be used when tilted completely sideways. Also missing on the QFO LE were the EQs, the 3-position pitch mode switches; plus all the knobs had been replaced with plastic rotary dials. Vestax, however, did add components for DVS compatibility. The simplification of the QFO was considered a way for it to be affordable to a larger audience, but also a sign that the original did not live up to its expectations.

87. Rucker, email interview with author, November 17, 2009.

88. Vestax, "Controller One."

89. Vestax Corporation, "Concept: Vestax Products," accessed February 17, 2011, http://www.vestax.com/v/concept/v_products.php.

90. Vestax Corporation, "Concept: The Vestax People," Vestax Corporation, accessed February 10, 2011, http://www.vestax.com/v/concept/v_people.php.

91. Ean Golden, "Is Vestax Out of Business?," *DJTechTools*, October 15, 2014, accessed October 16, 2014, http://www.djtechtools.com/2014/10/15/is-vestax-out-of-business-closing-bankrupt/.

92. Anthony Polis, "Vestax Files for Bankruptcy," *DJ City*, December 10, 2014, accessed December 10, 2014, http://news.djcity.com/2014/12/vestax-files-for-bankruptcy.html.

Chapter 3

1. DJ Focus, telephone interview with author, April 16, 2014.

2. I have also had follow-up emails and phone interviews with Mike May.

3. Mike May, interview with author, Mukilteo, WA, September 23, 2009.

4. I came across my first Rane mixer, a Rane TTM 52, in 2000 when I met DJ Cue Two in college (he was a 2001 USA Regional DMC Champion). At the time, the Vestax 05Pro, 06Pro, and 07Pro were still market-leaders in the hip-hop DJ mixer segment. Up until that point I only had owned low-end mixers, but when Cue Two let me try his 52 it felt like a tank and had a smooth crossfader. I bought my first Rane, a TTM 52, at a Guitar Center in the spring of 2001. Unlike other brands, Rane had a two-year warranty that could be extended to three years, and at the time had a strong reputation with DJs for quality and service. Since 2001, I have bought, broke, and sold five Rane mixers and currently own a TTM 57SL and a TTM 56s. Like many DJs who are loyal to mixer brands, I want to make my relationship as a consumer with Rane products known here in this book so that my potential biases are exposed. To be clear, I currently own mixers by Gemini, Vestax, Numark, Stanton, DJ Tech, and numerous other brands; however, the mixers I use on a daily basis for gigs and work are Rane products.

5. "The Rane Story," Rane Corporation, accessed May 20, 2010, http://www.rane.com/ranebio.html.

6. Ibid.

7. *Music Trades*, "The Global 225 Ranking," December 2013, http://digitaleditions.sheridan.com/publication/?i=184058.

8. Mike May, interview with author, September 23, 2009.

9. "The Rane Story."

10. "The Rane Factory," Rane Corporation, accessed May 25, 2010, http://www.rane.com/upclose.html.

11. Long designed sound systems at some of the world's most iconic disco-era clubs (i.e., Studio 54). See "Rane History." And, Long was originally the fix-it man for Alex Rosner, the engineer behind Rosie, the first DJ mixer. See djhistory.com, "Interviews: Francis Grasso," for a bit more on Long and Rosner.

12. In 1997, Rane introduced what would become its popular line of mobile and club mixers, the Mojo Series, which was a cheaper product line than most of Rane's other signature gear.

13. Mike May, interview with author, September 23, 2009.

14. The magnetic fader was registered as patent number 6,813,361, with Rick Jeffs and Paul Mathews listed as inventors. As is standard with industrial patenting, the patent was assigned to Rane Corporation.

15. Mike May, interview with author, September 23, 2009.

16. Rick Jeffs, "The Evolution of the DJ Mixer Crossfader," *RaneNote*, 1999, accessed July 1, 2010, http://www.rane.com/pdf/ranenotes/Evolution_of_the_DJ_Mixer_Crossfader.pdf.

17. The U.S. Patent and Trademark database shows that Rane Corporation holds at least 14 patents, although the magnetic fader patent is most relevant to hip-hop DJs.

18. Mike May, telephone interview with author, April 9, 2010.

19. "Rane History."

20. Mike May, interview with author, September 23, 2009.

21. Ibid.

22. Ibid.

23. DMC had allowed DVS in the team competitions a couple years before.

24. NYCelectro.com, "the DMC DJ Competition is Going Digital! Its Official, for real… (up-date)," October 20, 2010, accessed October 22, 2010, http://nycelectro.com/2010/10/20/the-dmc-dj-competition-is-going-digital-its-official-for-real/.

25. Ibid.

26. Sam Gribben quoted in Richard Thorne, "Serato Audio Research—TURN IT UP, soft-ware genius at work," NZ *Musician* 13 (2007), accessed February 19, 2011, http://www.nzmusician.co.nz/index.php/pi_pageid/8/pi_articleid/1222/pi_page/1.

27. Sam Gribben quoted in Gizmo, "Serato Interview—Sam Gribben—November 2006," *Skratchworx*, 2007, accessed January 15, 2009, http://www.skratchworx.com/rf_serato_interview.php.

28. Mark Settle, "INDUSTRY: CEO Sam Gribben to leave Serato," *DJWORX*, January 23, 2014, accessed January 28, 2014, http://djworx.com/industry-ceo-sam-gribben-leave-serato/.

29. "TGB Performance Report 2005/06," TGB Performance Information, 2006, accessed May 20, 2008, www.frst.govt.nz/files/TBG%20Performance%20Report.pdf.

30. Sam Gribben quoted in Thorne, "Serato Audio Research."

31. Working together with select hardware partners (Vestax, Allen & Heath, Denon, Nu-mark, and Pioneer), the ITCH software allows for the manipulation of audio files without using turntables or CDJs.

32. Sam Gribben quoted in "Serato's General Manager Talks Straight About NS7 and What It Means for DJs," *Dolphin Music*, March 25, 2009, accessed May 22, 2010, http://www.dolphinmusic.co.uk/article/3430-interview-sam-gribben-of-serato.html.

33. Sam Gribben quoted in "Whitelabel.NET Launches," Serato, October 6, 2008, accessed May 22, 2008, http://serato.com/news/2206/whitelabelnet-launches.

34. Whitelabel.net downloaded MP3s have a built-in security mechanism as files play as high-quality 320kbps MP3 format through Serato DJ, ITCH, and Scratch Live, but as low-quality 32kbps files in other playback software (e.g., iTunes); essentially this is Serato's form of digital rights management (DRM).

35. "UMG AND SERATO ANNOUNCE INNOVATIVE SECURE DIGITAL DELIVERY SERVICE FOR DJs WORLDWIDE," Universal Music Group, November 4, 2009, ac-cessed May 22, 2010, http://www.universalmusic.com/corporate/news35701.

36. Vincent Freda quoted in UMG, "UMG AND SERATO."

37. Dave George quoted in Thorne, "Serato Audio Research."

38. Bill Mitsakos quoted in "Serato Pressings—Music and Control Tone on Limited Edi-tion Records," Serato, December 1, 2008, accessed April 20, 2009, http://serato.com/news/2517/serato-pressings-music-and-control-tone-on-limited-edition-records.

39. "Serato DJ with DVS Is Here," Serato, September 4, 2013, accessed October 20, 2013, http://www.youtube.com/watch?v=Pm8OwXefnNw&feature=youtube_gdata_player.

40. This is when a commodity takes on a "double form" where the market for the product (e.g., DJ software) is interdependent with the market of another related product (e.g., DJ mixers). Therefore, any manufacturer of new hardware must consider the production of new software, or vice versa, which clearly affects end users (Apple has been doing this with its operating systems and hardware for a while now, essentially forcing customers to update their hardware to use the new OS or apps/software).

41. "Serato DJ with DVS Is Here."

42. Products include the Sixty-Eight, Sixty-Two, and Sixty-One mixers and SL2, SL3, and SL4 interfaces.

43. Serato's only U.S. patents were awarded in 2013 and 2014 for a turntable keyboard; however, it was denied application for Whitelabel.net.

44. Sam Gibben quoted in Gizmo, "Serato Interview."

45. Anthony Harrison, "'Cheaper than a CD, Plus We Really Mean It': Bay Area Underground Hip Hop Tapes as Subcultural Artefacts," *Popular Music* 25 (2006): 287.

46. Watkins, *Hip Hop Matters*.

47. Mark Katz, *Capturing Sound: How Technology Has Changed Music* (Berkeley, CA: University of California Press, 2004), 120.

48. Michael Endelman, "Scratching Without Vinyl: A Hip-Hop Revolution," *New York Times*, December 3, 2002, accessed October 6, 2007, http://query.nytimes.com/gst/fullpage.html?res=9500E0DD1F38F930A35751C1A9649C8B63.

49. Serato Scratch Live works a bit differently than timecode systems in that noise is embedded into its control records rather than time stamps.

50. Bill Werde, "The D.J.'s New Mix: Digital Files and a Turntable," *New York Times*, October 25, 2001, accessed October 12, 2007, http://www.nytimes.com/2001/10/25/technology/the-dj-s-new-mix-digital-files-and-a-turntable.html.

51. Latency refers to a time gap between the action of a DJ with his or her hand and the reaction of the sound through the software.

52. Peter Kirn, "NI Ends Legal Dispute Over Traktor Scratch; Digital Vinyl's Twisty, Turny History," *Create Digital Music*, April 28, 2008, accessed September 15, 2010, http://createdigitalmusic.com/2008/04/ni-ends-legal-dispute-over-traktor-scratch-digital-vinyls-twisty-turny-history/.

53. In all fairness, I wish that I was able to research and report more on Native Instruments. When I was conducting research for this book in 2009, Traktor Scratch did not have as large of an impact and did not serve as competition to Serato products like it does in 2015. NI has grown considerably, and its DJ mixers and software are slowly chipping away at the Serato DVS monopoly.

54. *Kotori Magazine*, "RZA Talks to Kotori About Inventing Final Scratch Technology," October 31, 2007, accessed November 20, 2008, http://www.youtube.com/watch?v=TXsYX-Mqw4Zc&feature=player_embedded.

55. Ibid.

56. Ibid.

57. However, there was some proof of The Replicator on the Ghostface Killah *Supreme Clientele* (2000) album, produced from 1997–1999, which featured an instrumental by RZA that sounds like it used a technology similar to The Replicator.

58. steeldj69, "1995 Whirlwind Replicator First Digital Vinyl Ever!," November 17, 2013, accessed November 22, 2013, https://www.youtube.com/watch?v=GnK5SneOMoE.

59. "Stanton Legacy Products," Stanton Magnetics, accessed December 22, 2010, http://www.stantondj.com/stanton-legacy-products.html.

60. For example, see patents U.S. 7012184 B2 and U.S. 7238874 B2.

61. *N2IT Holding B.V. v. M-Audio LLC*, http://dockets.justia.com/docket/virginia/vaedce/2:2008cv00619/238013/.

62. Gizmo, "N2IT Sues the DJ Scene, and Will Probably Win," *Skratchworx*, May 8, 2009, accessed December 15, 2010, http://www.skratchworx.com/news3/comments.php?id=1218.
63. Steven Carroll, "Who Invented Digital Vinyl?," September 20, 2010, accessed December 26, 2010, http://www.who-invented-digital-vinyl.co.uk/.
64. Sam Gibben quoted in Gizmo, "Serato Interview."
65. Carroll, "Who Invented Digital Vinyl?"
66. Chris Bauer, "the spacede project," November 30, 1998, accessed February 17, 2011, http://bauerindustries.com/projects/?p=229.
67. Carroll, "Who Invented Digital Vinyl?."
68. John Acquaviva quoted in Gizmo, "N2IT Sues the DJ Scene."

Chapter 4

1. DJ Steve Dee, telephone interview with author, December 6, 2009.
2. While battling has been a part of hip-hop DJ culture (see Katz, *Groove Music*) from the pioneer days in the 1970s, a time when DJs would also cover the labels of their records so other DJs did not know what they were playing (discussed in Chapter 1), simply performing their techniques in front of a crowd made those techniques public domain. While proprietary measures were taken to monopolize markets and build brands, what DJs were doing in the parks was open source. Maybe they were showing off their skills to build subcultural capital and to rise up in the DJ hierarchy, but in my opinion this type of public performance where anybody could see and hear techniques was a form of open source sharing.
3. Rosie had two vertical faders, one for each turntable, which allowed Grasso to manually crossfade between music playing on both turntables. It also had a headphone cue, a mic input, and another channel input for a tape player.
4. Many of the early DJ mixers were designed by companies (such as Meteor Light & Sound, Co. and GLi) in and around New York City, where DJ culture as we know it began to take shape.
5. A phono/line switch allowed you to switch between a phonograph signal for a turntable and a line signal for a cassette or CD player on a channel. However, DJs subverted the use of this switch and employed it like a crossfader to quickly/sharply scratch in a phono signal. Because nothing was hooked into the line input, this switch acted like an on/off switch for a turntable's signal.
6. Henry Jenkins, *Convergence Culture: Where Old and New Media Collide* (New York: New York University Press, 2006).
7. Henry Jenkins, *Fans, Bloggers, and Gamers: Exploring Participatory Culture* (New York & London: New York University Press, 2006), 154.
8. DJ Shortkut, telephone interview with author, January 11, 2010.
9. Ibid.
10. Turntablist Disk, telephone interview with author, November 9, 2009.
11. DJ Babu, telephone interview with author, November 24, 2009.
12. DJ Nu-Mark, telephone interview with author, December 1, 2009.

13. DJ Vinroc, telephone interview with author, December 29, 2009.
14. DJ Rob Swift, telephone interview with author, November 17, 2009.
15. Ibid.
16. Siya Fakher, email interview with author, November 23, 2009.
17. Mike May, interview with author, September 23, 2009.
18. Ibid.
19. Ibid.
20. Ibid.
21. Ibid.
22. DJ Roli Rho, telephone interview with author, April 12, 2010.
23. Ibid.
24. Thierry Alari, email interview with author, May 21, 2010.
25. Katz, *Groove Music*, 120.
26. DJ Jazzy Jeff and the Fresh Prince's album, *Rock the House* (Jive/RCA Records, 1986).
27. Katz, *Groove Music*, 114–121.
28. DJ Steve Dee, telephone interview with author, December 6, 2009.
29. Ibid.
30. DJ Skeme Richards, telephone interview with author, January 20, 2010.
31. For instance, Band-Aid, the bandage manufacturer has had to make sure that "band-aid" is not a generic term used to describe bandages, and Google has fought hard to make sure that "google it" or "googling" are not common terms used to describe searching the Web.
32. I want to thank my lawyer friend Andrew Lopata for the insight on this.
33. DJ Shortkut, telephone interview with author, January 11, 2010.
34. DJ Qbert quoted in Peter Hartlaub, "Turntable Star Qbert Talks About *DJ Hero 2*," *San Francisco Chronicle*, October 6, 2010, accessed October 15, 2010, http://www.sfgate.com/cgi-bin/article.cgi?f=/c/a/2010/10/06/DD2I1FKCQ2.DTL.
35. D-Styles, email interview with author, April 6, 2014.
36. This cost includes a patentability search, application preparation, filing fee, drawings, issue and publication fees, and a "prosecution" fee if an attorney has to argue the case at the U.S. Patent and Trademark Office.
37. Katz, *Groove Music*, 136.
38. Ibid.
39. Elliot Marx, email interview with author, March 11, 2010.
40. Ibid.
41. Ibid.
42. Ibid.
43. Mike May, interview with author, September 23, 2009.
44. Ibid.
45. Charles Ono, telephone interview with author, April 19, 2010.
46. Elliot Marx, email interview with author, March 11, 2010.
47. DJ Babu, telephone interview with author, November 24, 2009.
48. Turntablist Disk, telephone interview with author, November 9, 2009.
49. DJ Roli Rho, telephone interview with author, April 12, 2010.
50. Ibid.

51. AES is the Audio Engineering Society.
52. At the time, Tableturns was an open turntable event in New York City founded by Sugarcuts, an event that was a major element of hip-hop and scratch DJ culture and, ultimately, the first place where many world-class DJs tried the Rane TTM 54.
53. DJ Big Wiz quoted in Gizmo, "Interview with Big Wiz—November 2006," *Skratchworx*, 2007, accessed January 22, 2011, http://www.skratchworx.com/rf_bigwiz.php.
54. Ibid.
55. Ibid.
56. DJ Sugarcuts, telephone interview with author, April 11, 2010.
57. Ibid.
58. Ibid.
59. Ibid.
60. Mike May, interview with author, September 23, 2009.
61. DJ Big Wiz quoted in Gizmo, "Interview with Big Wiz."
62. DJ Sugarcuts, telephone interview with author. April 11, 2010.
63. Ibid.
64. DJ Big Wiz quoted in Gizmo, "Interview with Big Wiz."
65. DJ Sugarcuts, telephone interview with author, April 11, 2010.
66. DJ Quest, telephone interview with author, December 26, 2009.
67. DJ Focus, telephone interview with author, April 16, 2014.
68. DJ Quest, telephone interview with author, December 26, 2009.
69. Ibid.
70. Ibid.
71. From the Rane TTM 52i manual, original empheses in.
72. DJ Quest, telephone interview with author, December 26, 2009.
73. See Katz, *Groove Music*, 179–213, for an in-depth delineation of this.
74. Felicia M. Miyakawa, "Turntablature: Notation, Legitimization, and the Art of the Hip-Hop DJ," *American Music* 25 (2007): 101.
75. This is San Jose State University's student radio station.
76. Teeko, telephone interview with author, November 9, 2009.
77. D-Styles, email interview with author, April 6, 2014.
78. Charles Ono, telephone interview with author, April 19, 2010.
79. Ibid.
80. Mike Boo, telephone interview with author, quoting Ricci Rucker, November 19, 2009.
81. Ibid.
82. DJ Woody, email interview with author, April 8, 2010.
83. Ibid.
84. Ibid.
85. Ibid.
86. Charles Ono, telephone interview with author, April 1, 2011.
87. Teeko, telephone interview with author, November 9, 2009.
88. DJ Woody, email interview with author, April 8, 2010.
89. Ibid.
90. Ricci Rucker, email interview with author, November 17, 2009.

91. Ibid.

92. Ibid.

93. Teeko, telephone interview with author, November 9, 2009.

94. JohnBeez, telephone interview with author, November 10, 2009.

95. DJ Woody, email interview with author, April 8, 2010.

96. Mike Boo, telephone interview with author, November 19, 2009.

97. Ibid.

98. Ibid.

99. Polis, "Vestax Files for Bankruptcy."

100. JohnBeez, telephone interview with author, November 10, 2009.

101. Ibid.

102. Ibid.

103. JohnBeez, "Fretless Fader MIDI Prototype with Vestax Controller One," February 22, 2009, accessed May 3, 2009, https://www.youtube.com/watch?v=CWe412hSLiU.

104. JohnBeez, "Fretless Fader 2010 Update from JohnBeez—HD," February 14, 2010, accessed March 6, 2010, https://www.youtube.com/watch?v=TJyvkL2q8uk.

105. JohnBeez, telephone interview with author, November 10, 2009.

106. Ibid.

107. Mike Boo, telephone interview with author, November 19, 2009.

108. Tim Wu, *The Master Switch: The Rise and Fall of Information Empires* (New York: Vintage Books, 2011), 20.

109. DJ Focus, telephone interview with author. Note that all quotes in this section come from this interview, April 16, 2014.

110. Over the years, he has released other products, including the P7 Portable Scratch Practice Pad, Slider slipmats that have holes cut into them to reduce friction, 7" gripping slipmats (Gripmats), a vinyl beat counting system, *The Formula* battle break record, and *Precision Incisions Scratch Training* volumes one and two with Turntablist Disk, which was the first 7" battle break record. Focus had many other concepts that were later implemented by manufacturers. He also designed straight tonearms for Technics SL-1200 turntables and retrofitted controls on the front of mixers years before that was a standard for manufacturers. Focus also designed the Stanton DSM9F Aerodynamic Slipmat by DJ Focus and the Stanton ISM-3, which is an audio interface that up to six DJs can plug into and play as a team.

111. For instance, Focus made scratch records with different sounds on the stereo image that played at once (e.g., an "ahhh" sample on the left channel and a "fresh" on the right), so when you would scratch the audience would hear the "ahhh" in the left speaker and the "fresh" in the right one. Thus, he designed the SA-8 mixer with a stereo/mono switch so that you choose between scratching the ahhh/fresh simultaneously or just one of the samples in mono.

112. Mark Settle, "NAMM 2014: Thud Rumble TRX Scratch Mixer—Exclusive Pics!," *DJWORX*, January 14, 2014, accessed January 20, 2014, http://djworx.com/namm-2014-thud-rumble-trx-scratch-mixer/#.U62Rw41dXtB.

Chapter 5

1. Miller, *Rhythm Science*, 57.
2. DJ Nu-Mark, telephone interview with author, December 1, 2009.
3. Sarah Thornton, *Club Cultures: Music, Media, and Subcultural Capital* (Hanover, NH: University Press of New England, 1996).
4. Pierre Bourdieu, *Distinction: A Social Critique of the Judgment of Taste*, trans. Richard Nice (Cambridge: Harvard University Press, 1984).
5. Sarah Thornton, "The Social Logic of Subcultural Capital," in *The Subcultures Reader*, 2nd ed., ed. Ken Gelder (New York: Routledge, 2005), 185.
6. Ibid., 187.
7. Bill D. Herman, "Scratching Out Authorship: Representations of the Electronic Music DJ at the Turn of the 21st century," *Popular Communication* 4 (2006): 22.
8. Ibid., 31.
9. Ibid., 33.
10. However, there are plenty of authentic, touring, well-paid, highly skilled DJs who have no association with a manufacturer.
11. Their first 12" single with Asphodel, "Musica Negra" b/w "Word Play," was released as the X-Men.
12. DJ Rob Swift, email interview with author, October 28, 2010.
13. Ibid.
14. For a discussion on Flash's quick mix theory and other techniques, please see Chapter 1.
15. Because of publishing rights of copyright law, Flash, even though he manipulated sound in an original way using records like guitar strings, could not be recognized as an author. Thus, the laws, and industries that have helped create the laws and standard practices, fail to view this type of creativity as "original," which is odd because the same practice using digital sampling technology does in fact recognize producers as authors who receive publishing.
16. Grandmaster Flash, quoted in Saddler and Ritz, *The Adventures of Grandmaster Flash*, 200.
17. Presumably facing this lawsuit, Sugar Hill Records filed for federal trademark protection on Grandmaster Flash & The Furious Five (serial number 73440727) on August 24, 1983. The mark was abandoned on November 30, 1984, likely because Flash had won the right to use his name in court, which would effectively make using it as part of Grandmaster Flash & The Furious Five infringement.
18. Flash currently has one federally registered trademark on his name for the entertainment service market (serial number 78270544). He has held several federal marks over the years.
19. Saddler and Ritz, *Adventures*.
20. Since the Flashformer, other manufacturers have released products that allow for cheats. A "cheat" is basically a technology that allows for a DJ to perform a technique without having the actual skills used to do it. For instance, the Vestax Samurai mixer line had a crossfader technology that allowed DJs to add two to three "clicks" to their fader techniques. So, when using the fingers to click the crossfader on and off, these mixers would

add two or three clicks and thus make it sound like the DJ was performing a far more complex technique. Another cheat would be the sync function on most digital DJ controllers, which allows you to mix two songs together by pressing a button.

21. Taken from the Gemini FF-1 Flashformer manual.
22. It actually sold pretty well to beginning DJs who wanted to be able to do the transform sound but could not do it yet with a crossfader, or those who idolized Flash.
23. Mike May, interview with author, September 23, 2009.
24. Dean Standing quoted in Jim Tremayne, "The Master Unplugged," *DJ Times*, March 2003, 12.
25. Ibid.
26. Grandmaster Flash quoted in Jim Tremayne, "The Master Unplugged," *DJ Times*, March 2003, 12.
27. Mike May, interview with author, September 23, 2009.
28. DJ Shortkut, telephone interview with author, January 11, 2010.
29. DJ Marz, telephone interview with author, January 28, 2010.
30. Charles Ono, telephone interview with author, April 19, 2010.
31. Mike May, interview with author, September 23, 2009.
32. Ibid.
33. Thierry Alari, email interview with author, May 21, 2010.
34. The Scratchophone is a portable, custom scratch instrument. It is has a turntable, mixer controls and crossfader, and speakers built in. You can learn more about the Scratchophone at www.scratchophone.com.
35. Charles Ono, telephone interview with author, April 19, 2010.
36. DJ JS-1, telephone interview with author, November 24, 2009.
37. DJ Kico, telephone interview with author, December 6, 2009.
38. DJ Shortkut, telephone interview with author, January 11, 2010.
39. DJ Craze, telephone interview with author, December 29, 2009. DJ Marz, telephone interview with author, January 28, 2010.
40. Ibid.
41. DJ Roli Rho, telephone interview with author, April 12, 2010.
42. DJ Neil Armstrong, telephone interview with author, December 30, 2009.
43. DJ Babu, telephone interview with author, November 24, 2009.
44. Ibid.
45. Siya Fakher, email interview with author, November 23, 2009.
46. DJ Quest, telephone interview with author, December 26, 2009.
47. DJ Marz, telephone interview with author, January 28, 2010.
48. Charles Ono, telephone interview with author, April 19, 2010.
49. Ibid.
50. Mike May, interview with author, September 23, 2009.
51. Ibid.
52. Elliot Marx, email interview with author, March 11, 2010.
53. Mike Boo, telephone interview with author, November 19, 2009.
54. DJ Woody, email interview with author, April 8, 2010.
55. DJ JayCeeOh, telephone interview with author, December 3, 2009.
56. John Carluccio, telephone interview with author, December 20, 2009.

57. Ibid.
58. DJ Steve Dee, telephone interview with author, December 6, 2009.
59. Ibid.
60. DJ Babu, telephone interview with author, November 24, 2009.
61. DJ Kico, telephone interview with the author, December 6, 2009. DJ Vinroc, telephone interview with the author, December 29, 2009.
62. DJ Quest, telephone interview with author, December 26, 2009.
63. Siya Fakher, email interview with author, November 23, 2009
64. Turntablist Disk, telephone interview with author, November 9, 2009.
65. Dr. Butcher, telephone interview with author, December 21, 2009.
66. Ibid.
67. DJ Steve Dee, telephone interview with author, December 6, 2009.
68. Dr. Butcher, telephone interview with author, December 21, 2009.
69. Christie Z-Pabon, email interview with author, February 11, 2011.
70. Mike Boo, telephone interview with author, November 19, 2009.
71. DJ Craze, telephone interview with author, December 29, 2009.
72. DJ Shiftee, telephone interview with author, December 13, 2009.
73. Ibid.

Chapter 6

1. DJ Babu, telephone interview with author, November 24, 2009.
2. After a series of blowout sales and tribute shows, the NYC location was shut down on September 4 while the LA store shut its doors on September 18. Fat Beats, however, kept its label, distribution, and online retail units open, thus maintaining its vertically integrated structure.
3. It still handles this, but the vinyl record part of its business has diminished as fewer labels are pressing vinyl.
4. Katz, *Groove Music*, 218.
5. Lev Manovich, *The Language of New Media* (Cambridge: MIT Press, 2001), 229.
6. Jay David Bolter and Richard Grusin, *Remediation: Understanding New Media* (Cambridge: The MIT Press, 1999), 15.
7. Ibid., 68.
8. Will Straw, "Consumption," in *The Cambridge Companion to Pop and Rock*, eds. Simon Frith, Will Straw, and John Street (Cambridge, UK: Cambridge University Press, 2001), 58.
9. Rebekah Farrugia and Thomas Swiss, "Tracking the DJs: Vinyl Records, Work, and the Debate Over New Technologies," *Journal of Popular Music Studies* 17 (2005), 31.
10. For instance, Katz, *Capturing Sound*; Katz, *Groove Music*; Snapper, "Scratching the Surface"; and Miles White, "The Phonograph Turntable and the Performance Practice in Hip Hop Music," *EOL* 2 (1996), accessed May 17, 2007, http://www.research.umbc.edu/eol/2/white/.
11. Katz, *Groove Music*, 226.
12. Ibid., 223.
13. DJ Nu-Mark, telephone interview with author, December 1, 2009.

14. DJ JS-1, telephone interview with author, November 24, 2009.
15. DJ Platurn, telephone interview with author, December 5, 2009
16. DJ Wicked, telephone interview with author, December 25, 2009.
17. DJ Shame, telephone interview with author, February 6, 2010.
18. Bobbito Garcia, telephone interview with author, December 30, 2009.
19. Turntablist Disk, telephone interview with author, November 9, 2009.
20. DJ Steve Dee, telephone interview with author, December 6, 2009.
21. DJ Shortkut, telephone interview with author, January 11, 2010.
22. Kutmasta Kurt, telephone interview with author, January 8, 2010.
23. DJ Neil Armstrong, telephone interview with author, December 30, 2009.
24. DJ Babu, telephone interview with author, November 24, 2009.
25. DJ JS-1, telephone interview with author, November 24, 2009
26. Skeme Richards, telephone interview with author, January 20, 2010.
27. J.Period, telephone interview with author, January 12, 2010.
28. Teeko, telephone interview with author, November 9, 2009
29. DJ Daddy Dog, telephone interview with author, January 6, 2010.
30. DJ JS-1, telephone interview with author, November 24, 2009.
31. JohnBeez, telephone interview with author, November 10, 2009.
32. Dr. Butcher, telephone interview with author, December 21, 2009.
33. DJ Platurn, telephone interview with author, December 5, 2009.
34. "Diggin'" or "diggin' in the crates" are terms used to describe the DJ's activity of finding records, sometimes rare or previously unused by other DJs/producers in the culture. This practice and the value of finding records was established by pioneering hip-hop DJs.
35. Schloss, *Making Beats*, 91–100.
36. DJ Nu-Mark, telephone interview with author, December 1, 2009.
37. Skeme Richards, telephone interview with author, January 20, 2010.
38. DJ Nu-Mark, telephone interview with author, December 1, 2009.
39. DJ Shortkut, telephone interview with author, January 11, 2010
40. DJ Marz, telephone interview with author, January 28, 2010.
41. DJ Kico, telephone interview with author, December 6, 2009.
42. DJ JayCeeOh, telephone interview with author, December 3, 2009.
43. DJ Daddy Dog, telephone interview with author, January 6, 2010.
44. Ibid.
45. DJ Platurn, telephone interview with author, December 5, 2009.
46. DJ Babu, telephone interview with author, November 24, 2009.
47. DJ Nikoless Scratch, telephone interview with author, January 27, 2010.
48. DJ Rob Swift, telephone interview with author, November 17, 2009.
49. DJ Kico, telephone interview with author, December 6, 2009.
50. Ibid.
51. DJ Daddy Dog, telephone interview with author, January 6, 2010.
52. DJ Craze, telephone interview with author, December 29, 2009.
53. J.Period, telephone interview with author, January 12, 2010.
54. DJ Eclipse, telephone interview with author, November 17, 2009.
55. Mr. Len, telephone interview with author, November 17, 2009.

56. "Microwave DJ," *SSL-Wiki*, no date, accessed May 3, 2007, http://ssl-wiki.help.bootlegs. de/Microwave_DJ.

57. McLeod, *Owning Culture*, 146.

58. Ibid.

59. J.Period, telephone interview with author, January 12, 2010.

60. DJ Shiftee, telephone interview with author, December 13, 2009.

61. DJ Sugarcuts, telephone interview with author, April 11, 2010.

62. DJ Nikoless Scratch, telephone interview with author, January 27, 2010.

63. DJ Shame, telephone interview with author, February 6, 2010.

64. DJ Eclipse, telephone interview with author, April 7, 2010.

65. JohnBeez, telephone interview with author, November 10, 2009.

66. DJ Platurn, telephone interview with author, December 5, 2009.

67. DJ JayCeeOh, telephone interview with author, December 3, 2009.

68. DJ Mighty Mi, telephone interview with author, January 11, 2010.

69. Katz addresses the celebrity DJ phenomenon in *Groove Music*, 227.

70. DJ Kico, telephone interview with author, December 6, 2009.

71. DJ JayCeeOh, telephone interview with author, December 3, 2009.

72. Ibid.

73. I think that eventually some company will come up with an algorithm that can program famous DJs' styles, fetch songs from a database, and field requests via smartphones and be intelligent enough to mix in similar songs, which will completely replace DJs in smaller venues. With software that can mix (sync) and similar selection algorithms (i.e., Pandora), an innovation like this may be the next step in saving money for smaller bars and clubs.

74. DJ Eclipse, telephone interview with author, April 7, 2010.

75. DJ JS-1, telephone interview with author, November 24, 2009.

76. Ibid.

77. Dr. Butcher, telephone interview with author, December 21, 2009.

78. Quest, telephone interview with author, February 6, 2010.

79. DJ Nikoless Scratch, telephone interview with author, January 27, 2010.

80. iTunes, which is probably the most powerful example, is a service developed by the computer giant Apple, a company with no business in producing or selling recordings. Obviously, Amazon, as well as other streaming services, also represent how the music industry has lost control of its distribution methods and is more in the business of licensing rights to other parties.

81. IFPI and RIAA 2013 data.

82. According to year-end SoundScan data, in 2013, at the level of ownership of master recordings, independent labels had a much larger market share: UMG (28.5 percent), SME (22.3 percent), WMG (14 percent), Indies (34.6 percent). However, market share is usually determined at the distribution level and most major music groups distribute music for independent labels.

83. SoundScan 2013 year-end data.

84. Mark Humphrey, "Record Maker Puts His Stamp on Music History," *USA Today*, February 2, 2007, accessed April 12, 2014, http://usatoday30.usatoday.com/money/media/2007-02-21-vinyl-usat_x.htm.

85. Ashish Singh, Cutting Through the Digital Fog: Music Industry's Rare Chance to Reposition for Greater Profit (Boston: Bain & Company, 2001).

86. Jeremy Lascelles quoted in Katie Allen, "Back Catalogs Spin a New Generation of Profits for Record Labels," The Observer, September 20, 2009, accessed December 20, 2009, http://www.guardian.co.uk/business/2009/sep/20/beatles-emi-back-catalogue-reissues.

87. Brewster and Broughton, Last Night, 180.

88. Tom Moulton quoted in Discoguy, "Tom Moulton," Disco-Disco.com, accessed March 4, 2011, http://www.disco-disco.com/tributes/tom.shtml.

89. Ibid.

90. DJ Mighty Mi, telephone interview with author, January 11, 2010.

91. Double J, telephone interview with author, January 15, 2010.

92. Quest, telephone interview with author, February 6, 2010.

93. Papa D, telephone interview with author, January 19, 2010.

94. DJ Nikoless Scratch, telephone interview with author, January 27, 2010.

95. Papa D, telephone interview with author, January 19, 2010.

96. DJ Eclipse, telephone interview with author, April 7, 2010.

97. Jessica Weber, telephone interview with author, November 14, 2009.

98. Havana Joe, telephone interview with author, February 5, 2010.

99. Double J, telephone interview with author, January 15, 2010

100. Papa D, telephone interview with author, January 19, 2010.

101. DJ Eclipse, telephone interview with author, April 7, 2010.

102. Papa D, telephone interview with author, January 19, 2010.

Epilogue

1. Crazearoni, "New Slaves Routine," October 28, 2014, accessed October 28, 2014, at https://www.youtube.com/watch?v=Ielxe6wjLLE.

2. Founding Fathers, April 7, 2014, accessed April 20, 2014, at https://www.youtube.com/watch?v=1G13bROBO-8&sns=fb.

3. Ibid.

4. Ibid.

5. For instance, video game mods that make it into games, fan videos, or stories that make it into films or books, or open source code incorporated into proprietary software. Maybe we need to look at a company such as Apple, or a media monolith such as Disney, and analyze how these types of companies profit from devoted consumers by encoding their ideas into products that are then sold back to them. Apple is just a brand name, but we should be concerned with the types of collective intelligence that happen under the surface of that brand name and how a select few profit off of the creative network. Apple does not innovate—it is a brand—but all the people who work for Apple and people who consume and reinvent its products (its network) are the innovators. These are questions we should ask and stories we should tell, so I have tried use this book to set up a potential model for telling technocultural histories.

GLOSSARY

Beat Juggle: This is a technique for taking two copies of the same record, or two records, and rearranging the sounds on those records into a new composition or beat.

Cartridge: The cartridge houses the stylus (aka "needle") and connects to the head-shell/tonearm of the turntable.

Channel Fader, aka Upfader: This is another control for signal gain or "volume." Like the crossfader, the channel fader allows for scratching and mixing techniques and can act as an on/off switch for the sound a DJ is scratching.

Controller: A digital DJ controller remediates two turntables and a mixer into a small MIDI controller that works along with software to allow DJs to manipulate MP3 files from a computer.

Crossfader: This is a main component of a hip-hop DJ's mixer and how a DJ mixes between signals from the turntables. It is a main tool in scratch technique and acts as an on/off switch for the sound a DJ is scratching (it is how hip-hop DJs create moments of silence when manipulating a record). With a common set-up for mixing records, when the fader is slid to the left only the sound signal coming from turntable 1 will be heard over

the loudspeakers; when slid to the right only the signal from turntable 2 will be heard; when positioned in the middle both signals will be heard.

Crossfader Curve: Crossfader curve allows a DJ to adjust how quickly the crossfader will move between turntable signals. For scratching, a DJ wants a "fast" curve with little cut-in time between signals; for mixing or transitioning smoothly between signals, a DJ wants a "slow" curve. Basically, with a fast curve the crossfader only has to be moved a few millimeters before the signal is heard. Before this feature was built into mixers, there was no way for DJs to adjust cut-in time, except for using modifications.

Diggin': This is the act of searching for records to be used for manipulation and music production.

Digital Vinyl System (DVS): This is a hardware/software system that allows a DJ to manipulate MP3 audio files from a computer using real vinyl discs as control surfaces.

Direct Drive System (DDS): This is a system for spinning the platter of a turntable using a motor attached to the platter. This is common in most turntables aimed at DJs.

EQ: EQ is a control on the mixer that allows a DJ to adjust the high, midrange, and low frequencies of a sound (what we refer to as treble, mids, and bass).

Gain: Gain is what we commonly consider to be volume. However, gain actually refers to changing the level of the incoming signal from a turntable, which we hear as volume.

Gemini: This is a manufacturing brand for DJ mixers whose line of MX mixers were popular in the 1980s and 1990s (specifically with East Coast DJs and the MX-2200 mixer).

Hamster Style: This is a style of scratching that originated from DJs plugging their turntables into the opposite inputs on a mixer, essentially reversing the direction you moved the crossfader to play a signal through the loudspeakers. DJ Quest is credited for naming this reverse style "Hamster style." Currently, most mixers have a built-in feature called a hamster switch or reverse crossfader. This style became popular because it emulated the movement of the "clicker" switch and therefore was prominent on the West Coast initially.

Headphone Cue: The headphone cue allows the DJ to cue up a record for beat matching or scratching in the headphones while another record plays over the loudspeakers.

Headshell: The cartridge is bolted to the headshell, which is the main connection to the turntable's tonearm.

Invisibl Skratch Piklz (ISP): This crew of DJs was prominent in the development of DJ technique and products of the 1990s.

Line/Phono Switch: This is a switch on a mixer that allows a DJ to select what type of incoming signal a channel is receiving (a line level or phonographic level device). However, DJs in the 1980s (primarily on the West Coast) began using this switch as a way to cut sound from a turntable on and off for scratching. Before crossfader curve, this was a sharp cutoff of the sound. It became known as a "clicker," and some mixers now have labeled it "transform switches."

Melos: This is a manufacturing brand for DJ mixers whose PMX-2 mixer was popular in the early 1990s and the only mixer allowed at the World DMC battles from 1990–1996.

Merry-go-Round: This is the name that DJ Kool Herc gave to his technique or style of playing the small drum break sections of records back to back and in isolation from the rest of the song.

Mixer: The mixer is the main signal control unit of a DJ's setup, the brain, if you will. The mixer offers controls for volume (gain), panning, EQing, headphones/cueing, microphone, and a range of other options. The mixer amplifies the phono-signals from the turntables and sends those signals to a sound system. The mixer also houses the crossfader and channel faders, the primary controls for hip-hop DJing and scratching.

Musical Instrument Digital Interface (MIDI): This is a connectivity standard or "language" between a computer control hardware. It is used to manipulate data that is then reflected in the manipulation of audio.

Numark: This is a manufacturing brand for DJ mixers whose line of DM mixers were popular in the 1980s and 1990s (specifically with West Coast DJs and the DM-1150a mixer).

Original Equipment Manufacturer (OEM): OEM refers to a company that manufactures components under the brand name of another company who purchases the products from the OEM company to resell under its brand name. It can also be a manufacturer who sells a completed product to a reseller who puts the reseller's brand name on it.

Pan: Pan allows you to change from a balanced signal to an unbalanced signal. Typically, you want the signal to be balanced between the left and right speakers, but this allows DJs to adjust how much of a signal will be heard through the left and right speakers.

Pitch Fader: Sliding this fader will either increase or decrease the speed of a record's pitch (not tempo) on a turntable. This is often how DJs will beat-match and mix between two different records.

Platter: In a direct-drive turntable system, the platter attaches directly to the motor, which gives the motor more torque and is intended to reproduce sound more accurately. The slipmat goes on top of the platter.

Quick Mix Theory: This is the name Grandmaster Flash gave to his technique/ style of taking a section of music on two copies of the same record, usually a drum break, and cutting between them on-time; essentially, a way of rearranging songs and manual looping.

Scratching: Scratching refers to moving a record back and forth rhythmically or musically over the loudspeakers.

Serato Scratch Live (SSL): This is a popular DVS system.

Slip Cue: While using the headphone cue, the slip cue is a mixing technique of holding or moving a record back and forth while the platter rotates beneath it so the record can be released and mixed in with the record playing over the loudspeakers.

Slipmat: The slipmat is a piece of felt or other slippery material that goes be-tween the turntable platter and the record and allows the platter to spin while a DJ holds, scratches, or cues the record. It is supposed to reduce friction in manipulation.

Stylus: This is the "needle" that follows the bumps encoded into the grooves of a vinyl record. It is attached to the cartridge.

Tonearm: This is main connection between the cartridge system and the turn-table. As the cartridge picks up sound, the sound travels through cables in the tonearm directly to the DJ's mixer.

Transform Scratch: A scratch technique, which originated in Philadelphia and was popular in the 1980s/1990s.

Turntablism: This is a neologism for distinguishing a DJ who merely plays records from one who manipulates records to create an entirely new composition.

Voltage Controlled Amplifier (VCA): This is a system for controlling audio signal level or loudness and often directly affects faders on a DJ mixer. Instead of controlling audio signal directly by allowing more audio sig-nal to pass through a fader, it controls how much power (voltage) passes through and then that is reflected in the amount of audio signal.

BIBLIOGRAPHY

Interviews and Personal Communications

Alari, Thierry. Email interview with author, May 21, 2010.
Boo, Mike. Telephone interview with author, November 19, 2009.
Boxx, Jared. Telephone interview with author, March 30, 2010.
Carluccio, John. Telephone interview with author, December 20, 2009.
DJ Babu. Telephone interview with author, November 24, 2009.
DJ Craze. Telephone interview with author, December 29, 2009.
DJ Daddy Dog. Telephone interview with author. January 6, 2010.
DJ Eclipse. Telephone interview with author, April 7, 2010.
DJ Focus. Telephone interview with author, April 16, 2014.
DJ Go. Email interview with author, April 26, 2012.
DJ JayCeeOh. Telephone interview with author, December 3, 2009.
DJ JS-1. Telephone interview with author, November 24, 2009.
DJ Kico. Telephone interview with author, December 6, 2009.
DJ Marz. Telephone interview with author, January 28, 2010.
DJ Mighty Mi. Telephone interview with author, January 11, 2010.
DJ Neil Armstrong. Telephone interview with author, December 30, 2009.
DJ Nikoless Scratch. Telephone interview with author, January 27, 2010.
DJ Nu-Mark. Telephone interview with author, December 1, 2009.
DJ Platurn. Telephone interview with author, December 5, 2009.

DJ Qbert. Telephone interview with author, January 7, 2010.
DJ Quest. Telephone interview with author, December 26, 2009.
DJ Rob Swift. Telephone interview with author, November 17, 2009; email interview with author, October 28, 2010.
DJ Roli Rho. Telephone interview with author, April 12, 2010.
DJ Shame. Telephone interview with author, February 6, 2010.
DJ Shiftee. Telephone interview with author, December 13, 2009.
DJ Shortkut. Telephone interview with author, January 11, 2010.
DJ Steve Dee. Telephone interview with author, December 6, 2009.
DJ Sugarcuts. Telephone interview with author, April 11, 2010.
DJ Trix. Email interview with author, April 20, 2011.
DJ Vinroc. Telephone interview with author, December 29, 2009.
DJ Wicked. Telephone interview with author, December 25, 2009.
DJ Woody. Email interview with author, April 8, 2010.
Double J. Telephone interview with author, January 15, 2010.
Dr. Butcher. Telephone interview with author, December 21, 2009.
D-Styles. Email interview with author, April 6, 2014.
Fakher, Siya. Email interview with author. November 23, 2009.
Garcia, Bobbito. Telephone interview with author, December 30, 2009.
Havana, Joe. Telephone interview with author, February 5, 2010.
J.Period. Telephone interview with author, January 12, 2010.
JohnBeez. Telephone interview with author, November 10, 2009.
Kutmasta Kurt. Telephone interview with author, January 8, 2010.
Leanrock. Telephone interview with author, May 12, 2010.
Marx, Elliot. Email interview with author, March 11, 2010.
May, Mike. Interview with author, Mukilteo, WA, September 23, 2009; telephone interview with author, April 9, 2010.
Mr. Len. Telephone interview with author, November 17, 2009.
Ono, Charles. Telephone interview with author, April 19, 2010; telephone interview with author, April 1, 2011.
Papa D. Telephone interview with author, January 19, 2010.
Quest. Telephone interview with author, February 6, 2010.
Ricci Rucker. Email interview with author, November 17, 2009.
Skeme Richards. Telephone interview with author, January 20, 2010.
Teeko. Telephone interview with author, November 9, 2009.
Turntablist Disk. Telephone interview with author, November 9, 2009.
Volk, Jeremy. Telephone interview with author, May 15, 2010.
Webber, Steven. Telephone interview with author, November 26, 2009.
Weber, Jessica. Telephone interview with author, November 14, 2009.
Z-Pabon, Christie. Email interview with author, February 7, 2011.

Books, Films, and Articles

Allen, Katie. "Back Catalogs Spin a New Generation of Profits for Record Labels." *The Observer*, September 20, 2009. Accessed December 20, 2009. http://www.guardian.co.uk/business/2009/sep/20/beatles-emi-back-catalogue-reissues.

Attali, Jacques. *Noise: The Political Economy of Music*. Translated by Brian Massumi. Minneapolis: University of Minnesota Press, 1985.

Basu, Dipannita. "A Critical Examination of the Political Economy of the Hip-Hop Industry." In *African-Americans in the U.S. Economy*. Edited by Cecilia A. Conrad, John Whitehead, Patrick Mason, and James Stewart, 258–270. Oxford: Rowman & Littlefield, 2005.

Bauer, Chris. "The spacedeck project." November 30, 1998. Accessed February 17, 2011. http://bauerindustries.com/projects/?p=229.

BEAT4BATTLE TV. *Turntable TV 4: Toiret for Godzirra*. April 20, 2011. Accessed May 16, 2014. https://www.youtube.com/watch?v=GwpZTeQkeYc.

Benjamin, Walter. *The Arcades Project*. Edited by Rolf Tiedemann. Translated by Howard Eiland and Kevin McLaughlin. Cambridge: Harvard University Press, 1999.

Berk, Mike. "Technology: Analog Fetishes and Digital Futures." In *Modulations—A History of Electronic Music: Throbbing Words on Sound*. Edited by Peter Shapiro, 188–209. New York: Caipirinha Productions, 2000.

Bettig, Ronald V. *Copyrighting Culture: The Political Economy of Intellectual Property*. Boulder, CO: Westview Press, 1996.

Bolter, Jay David, and Richard Grusin. *Remediation: Understanding New Media*. Cambridge: MIT Press, 1999.

Bourdieu, Pierre. *Distinction: A Social Critique of the Judgment of Taste*. Translated by Richard Nice. Cambridge: Harvard University Press, 1984.

Bourdieu, Pierre. "The Forms of Capital." In *The Sociology of Economic Life*. Edited by Mark S. Granovetter and Richard Swedberg, 96–111. Boulder, CO: Westview Press, 1986/2001.

Brewster, Bill, and Frank Broughton. *Last Night a DJ Saved My Life: The History of the Disc Jockey*. New York: Grove Press, 2000.

Carroll, Steven. "Who Invented Digital Vinyl?" September 20, 2010. Accessed December 26, 2010. http://www.who-invented-digital-vinyl.co.uk/.

Chanan, Michael. *Repeated Takes: A Short History of Recording and Its Effects on Music*. London: Verso, 1995.

Chang, Jeff. *Can't Stop Won't Stop: A History of the Hip-Hop Generation*. New York: St. Martin's Press, 2005.

Chapple, Steve, and Reebee Garofalo. *Rock 'n' Roll Is Here to Pay: The History and Politics of the Music Industry*. Chicago: Nelson Hall, 1977.

Charnas, Dan. *The Big Payback: The History of the Business of Hip Hop*. New York: New American Library, 2010.

Coleman, Mark. *Playback: From the Victrola to MP3, 100 Years of Music, Machines, and Money*. Cambridge, MA: Da Capo Press, 2003.

Cox, Christopher, and Daniel Warner. *Audio Culture: Readings in Modern Music*. New York: Continuum International Publishing, 2004.

crazearoni. "New Slaves Routine." October 28, 2014. Accessed October 28, 2014. https://www.youtube.com/watch?v=Ielxe6wjLLE.

Cross, David. "A History of the Development of DJ Mixer Features: An S&TS Perspective." B.A. Thesis, Cornell University, 2003. Online at www.mickmusicpage.net/ita/08_links/DJ_Mixer_History.pdf.

D, Davey. "Interview w/ DJ Kool Herc. 1989 New Music Seminar." *Davey D's Hip Hop Corner*. Accessed May 19, 2007. http://www.daveyd.com/interviewkoolherc89.html.

Dave the Ruf. "Knowledge of Godfather—A Conversation with Afrika Bambaataa." Accessed December 16, 2010. http://www.mrkd.co.uk/rufmouth/rufsays/bam_interview.html.

Demers, Joanna. *Steal this Music: How Intellectual Property Law Affects Musical Creativity*. Athens: University of Georgia Press, 2006.

Discoguy. "Tom Moulton." *Disco-Disco.com*. Accessed March 4, 2011. http://www.disco-disco.com/tributes/tom.shtml.

djay for Mac. "Artists." Accessed February 15, 2011. http://www.algoriddim.com/djay-mac/reviews/artists.

djhistory.com. "Interviews: Kool Herc." Accessed January 21, 2011. http://www.djhistory.com/interviews/kool-herc.

djhistory.com. "Interviews: Francis Grasso." Accessed April 13, 2014. http://www.djhistory.com/interviews/francis-grasso.

D-Styles. *Phantazmagorea*. Beat Junkies Sound compact disc PHAN-001, 2002.

Eisenberg, Evan. *The Recording Angel: Music, Records and Culture from Aristotle to Zappa*. New Haven, CT: Yale University Press, 2005.

Endelman, Michael. "Scratching Without Vinyl: A Hip-Hop Revolution." *New York Times*, December 3, 2002. Accessed October 6, 2007. http://query.nytimes.com/gst/fullpage.html?res=9500E0DD1F38F930A35751C1A9649C8B63.

Farrugia, Rebekah, and Thomas Swiss. "Tracking the DJs: Vinyl Records, Work, and the Debate Over New Technologies." *Journal of Popular Music Studies* 17 (2005): 30–44.

Forbes. "Global 500 2013." *Forbes*. Accessed April 20, 2014. http://fortune.com/?s=panasonic.

Founding Fathers. April 7, 2014. Accessed April 20, 2014. https://www.youtube.com/watch?v=1G13bR0B0–8&sns=fb.

Franzen, Benjamin, and Kembrew McLeod. *Copyright Criminals*. DVD. Astoria, NY: IndiePix Films, 2009.

Fricke, Jim, and Charlie Ahearn. *Yes Yes Ya'll: The Experience Music Project Oral History of Hip-Hop's First Decade*. New York: Da Capo, 2002.

Frith, Simon. "The Industrialization of Music." In *Music for Pleasure: Essays in the Sociology of Pop*. Edited by Simon Frith, 11–23. New York: Routledge, 1988.

Frith, Simon. "The Popular Music Industry." In *The Cambridge Companion to Pop and Rock*. Edited by Simon Frith, Will Straw, and John Street, 26–52. Cambridge, UK: Cambridge University Press, 2001.

Gelatt, Roland. *The Fabulous Phonograph: 1877–1977*, 2nd edition. New York: Macmillan Publishing, 1977.

George, Nelson. *Hip Hop America*. New York: Viking Penguin, 1998.

George, Nelson. "Hip-Hop's Founding Fathers Speak to the Truth." In *That's the Joint!: The Hip-Hop Studies Reader*. Edited by Murray Forman and Mark Anthony Neal, 45–60. New York: Routledge, 2004.

Gizmo. "Interview with Big Wiz—November 2006." *Skratchworx*, 2007. Accessed January 22, 2011. http://www.skratchworx.com/rf_bigwiz.php.

Gizmo. "Serato Interview—Sam Gribben—November 2006." *Skratchworx*, 2007. Accessed January 15, 2009. http://www.skratchworx.com/rf_serato_interview.php.

Gizmo. "N2IT Sues the DJ Scene, and Will Probably Win." *Skratchworx*, May 8, 2009. Accessed December 15, 2010. http://www.skratchworx.com/news3/comments.php?id=1218.

"Global Markets Continue to Regain Ground," *Music Trades*, December 2013. Accessed April 15, 2014. http://digitaleditions.sheridan.com/publication/?i=184058.

Golden, Ean. "Is Vestax Out of Business?." *DJTechTools*. October 15, 2014. Accessed October 16, 2014. http://www.djtechtools.com/2014/10/15/is-vestax-out-of-business-closing-bankrupt/.

Golding, Peter, and Graham Murdock. "Culture, Communication and Political Economy." In *Mass Media and Society*, 3rd edition. Edited by James Curran and Michael Gurevitch, 70–92. London: Edward Arnold, 2000.

Greenburg, Zach O'Malley. "Electronic Cash Kings 2013: The World's Highest-Paid DJs." *Forbes*, August 14, 2013. Accessed April 28, 2014. http://www.forbes.com/sites/zackomalleygreenburg/2013/08/14/electronic-cash-kings-2013-the-worlds-highest-paid-djs/.

Harrison, Anthony. "'Cheaper than a CD, Plus We Really Mean It': Bay Area Underground Hip Hop Tapes as Subcultural Artefacts." *Popular Music* 25 (2006): 283–301.

Hartlaub, Peter. "Turntable Star Qbert Talks About DJ Hero 2." *San Francisco Chronicle*, October 6, 2010. Accessed October 15, 2010. http://www.sfgate.com/cgi-bin/article.cgi?f=/c/a/2010/10/06/DD2I1FKCQ2.DTL.

Hebdige, Dick. *Cut 'n' Mix: Culture, Identity, and Caribbean Music*. London: Routledge, 1987.

Herman, Bill D. "Scratching Out Authorship: Representations of the Electronic Music DJ at the Turn of the 21st Century." *Popular Communication* 4 (2006): 21–38.

Hesmondhalgh, David. *The Cultural Industries*, 2nd edition. London: Sage Publications, 2007.

Hoovers. "Vestax Corporation Company Information." Accessed February 13, 2011. http://www.hoovers.com/company/VESTAX_CORPORATION/jsfjscjth-1.html.

Humphrey, Mark. "Record Maker Puts His Stamp on Music History." *USA Today*, February 2, 2007. Accessed April 12, 2014. http://usatoday30.usatoday.com/money/media/2007-02-21-vinyl-usat_x.htm.

Jazzy Jeff. "Jazzy Jeff on Serato." Accessed October 12, 2007. http://www.youtube.com/watch?v=VR8McH5pe64.

Jeffs, Rick. "The Evolution of the DJ Mixer Crossfader." *RaneNote*, 1999. Accessed July 1, 2010. http://www.rane.com/pdf/ranenotes/Evolution_of_the_DJ_Mixer_Crossfader.pdf.

Jenkins, Henry. *Convergence Culture: Where Old and New Media Collide.* New York: New York University Press, 2006.

Jenkins, Henry. *Fans, Bloggers, and Gamers: Exploring Participatory Culture.* New York: New York University Press, 2006.

JohnBeez. "Fretless Fader MIDI Prototype with Vestax Controller One." February 22, 2009. Accessed May 3, 2009. https://www.youtube.com/watch?v=CWe412hSLiU.

JohnBeez. "Fretless Fader 2010 Update from JohnBeez—HD." February 14, 2010. Accessed March 6, 2010. https://www.youtube.com/watch?v=TJyvkL2q8uk.

Katz, Mark. *Capturing Sound: How Technology Has Changed Music.* Berkeley: University of California Press, 2004.

Katz, Mark. "Men, Women, and Turntables: Gender and the DJ Battle." *Musical Quarterly* 4 (2006): 580–599.

Katz, Mark. *Groove Music: The Art and Culture of the Hip-Hop DJ.* New York: Oxford University Press, 2012.

Kelley, Frannie. "Hip-Hop's Turntable Goes to the Great Lock Groove in the Sky." *NPR*, November 18, 2010. Accessed June 20, 2013. http://www.npr.org/blogs/therecord/2010/11/18/131418593/technics-1200-hip-hop-s-war-horse-goes-to-the-great-lock-groove-in-the-sky.

Kenney, William Howland. *Recorded Music in American Life: The Phonograph and Popular Memory, 1890–1945.* New York: Oxford University Press, 1999.

Kirn, Peter. "NI Ends Legal Dispute over Traktor Scratch; Digital Vinyl's Twisty, Turny History." *Create Digital Music*, April 28, 2008. Accessed September 15, 2010. http://createdigitalmusic.com/2008/04/ni-ends-legal-dispute-over-traktor-scratch-digital-vinyls-twisty-turny-history/.

Kotori Magazine. "RZA Talks to Kotori About Inventing Final Scratch Technology." October 31, 2007. Accessed November 20, 2008. http://www.youtube.com/watch?v=TXsYXMqw4Zc&feature=player_embedded.

Lessig, Lawrence. "The Problem with Patents. The Industry Standard." April 23, 1999. Accessed February 10, 2010. http://www.lessig.org/content/standard/0,1902,4296,00.html.

Lessig, Lawrence. *Free Culture: The Nature and Future of Creativity.* New York: Penguin, 2005.

Lessig, Lawrence. *Remix: Making Art and Commerce Thrive in the Hybrid Economy.* London: Penguin, 2008.

Lysloff, René T. A., and Leslie C. Gay. *Music and Technoculture.* Middletown, CT: Wesleyan University Press, 2003.

Macdonald, Nancy. *The Graffiti Subculture: Youth, Masculinity and Identity in London and New York.* Hampshire, UK: Palgrave Macmillan, 2003.

Manovich, Lev. *The Language of New Media.* Cambridge: The MIT Press, 2001.

Manuel, Peter. *Cassette Culture: Popular Music and Technology in North India.* Chicago: University of Chicago Press, 1993.

Mao, Chairman. "You Spin Me Round (Like a Record Baby): Last Night a DJ Saved Hip-Hop." In *The Vibe History of Hip-Hop.* Edited by Alan Light, 68–79. New York: Three Rivers Press, 1999.

Mato, Daniel. "All Industries Are Cultural." *Cultural Studies* 23 (2009): 70–87.

McChesney, Robert, Russel Newman, and Ben Scott. *The Future of Media: Resistance and Reform in the 21st Century.* New York: Seven Stories Press, 2005.

McLeod, Kembrew. *Owning Culture: Authorship, Ownership & Intellectual Property Law.* New York: Peter Lang Publishing, 2001.

McLeod, Kembrew. *Freedom of Expression: Overzealous Copyright Bozos and Other Enemies of Creativity.* New York: Doubleday, 2005.

Meehan, Eileen R., Vincent Mosco, and Janet Wasko. "Rethinking Political Economy: Change and Continuity," *Journal of Communication* 43 (1993): 105–116.

"Microwave DJ." *SSL-Wiki*, no date. Accessed May 3, 2007. http://ssl-wiki.help.bootlegs.de/Microwave_DJ.

Millard, Andre. *America on Record: A History of Recorded Sound*, 2nd edition New York: Cambridge University Press, 2005.

Miller, Paul D. *Rhythm Science.* Cambridge: MIT Press, 2004.

Miyakawa, Felicia M. "Turntablature: Notation, Legitimization, and the Art of the Hip-Hop DJ," *American Music* 25 (2007): 81–105.

Morriset, Lloyd. "Technologies of Freedom." In *Democracy and New Media.* Edited by Henry Jenkins, 21–31. Cambridge: MIT Press, 2003.

Morton, David. *Off the Record: The Technology and Culture of Sound Recording in America.* New Brunswick, NJ: Rutgers University Press, 2000.

Mosco, Vincent. *The Political Economy of Communication: Rethinking and Renewal.* London: Sage Publications, 1996.

N2IT Holding B.V. v. M-Audio LLC. http://dockets.justia.com/docket/virginia/vaedce/2:2008cv00619/238013/.

Neal, Mark Anthony. "Postindustrial Soul: Black Popular Music at the Crossroads." In *That's the Joint!: The Hip-Hop Studies Reader.* Edited by Murray Forman and Mark Anthony Neal, 363–387. New York: Routledge, 2004.

Negus, Keith. *Popular Music in Theory: An Introduction.* Hanover, NH: Wesleyan University Press, 1996.

Negus, Keith. *Music Genres and Corporate Cultures.* London: Routledge, 1999.

Noble, David F. *America by Design: Science, Technology, and the Rise of Corporate Capitalism.* Oxford, UK: Oxford University Press, 1977.

nodfactordotcom. "GrandMaster Flash as Master of the Mix." Accessed December 27, 2010. http://www.youtube.com/watch?v=X8-0M-jSOE4.

NYCelectro.com. "The DMC DJ Competition is Going Digital! Its Official, for real... (update)." October 20, 2010. Accessed October 22, 2010. http://nycelectro.com/2010/10/20/the-dmc-dj-competition-is-going-digital-its-official-for-real/.

Ogg, Alex, and David Upshal. *The Hip Hop Years: A History of Rap.* London: Macmillan, 1999.

Oldschoolhiphop.com. "GrandWizzard Theodore & the Fantastic Five." January 7, 2010. Accessed May 17, 2010. http://www.oldschoolhiphop.com/artists/emcees/fantastic5.htm.

Perelman, Michael. *Steal this Idea: Intellectual Property Rights and the Corporate Confiscation of Creativity.* New York: Palgrave Macmillan, 2002.

Polis, Anthony. "Vestax Files for Bankruptcy." *DJ City*, December 10, 2014. Accessed December 10, 2014. http://news.djcity.com/2014/12/vestax-files-for-bankruptcy.html.

Poschardt, Ulf. *DJ Culture*. Translated by Shaun Whiteside. London: Quartet Books, 1998.

Pray, Doug. *Scratch*. DVD. New York: Palm Pictures, 2002.

Quick, David. "Panasonic Ceases Production of Iconic Technics Analog Turntables." *gizmag*, November 4, 2010. Accessed January 30, 2011. http://www.gizmag.com/panasonic-ceases-production-of-technics-turntables/16840/.

Rane Corporation. "Rane History." Accessed April 10, 2014. http://dj.rane.com/about-rane/history.

Rane Corporation. "The Rane Factory." Accessed May 25, 2010. http://www.rane.com/up-close.html.

Rane Corporation. "The Rane Story." Accessed May 20, 2010. http://www.rane.com/ranebio.html.

Read, Oliver, and Walter T. Welch. *From Tin Foil to Stereo: Evolution of the Phonograph*. New York: Howard W. Sams, 1976.

Rose, Tricia. *Black Noise: Rap Music and Black Culture in Contemporary America*. Hanover, NH: University Press of New England, 1994.

Run-D.M.C. "Rock Box." 1984. https://screen.yahoo.com/rock-box-002627433.html.

Saddler, Joseph, and David Ritz. *The Adventures of Grandmaster Flash: My Life, My Beats*. New York: Broadway Books, 2008.

Schloss, Joseph G. *Making Beats: The Art of Sample-Based Hip-Hop*. Middletown, CT: Wesleyan University Press, 2004.

Scholtes, Peter S. "Abilities Talks Turntablism's Bright Future." *A.V. Club*, September 7, 2009. Accessed October 1, 2009. http://www.avclub.com/twincities/articles/abilities-talks-turntablisms-bright-future,32023/.

Serato. "Whitelabel.NET Launches." October 6, 2008. Accessed May 22, 2008. http://serato.com/news/2206/whitelabelnet-launches.

Serato. "Serato Pressings - Music and Control Tone on Limited Edition Records." December 1, 2008. Accessed April 20, 2009. http://serato.com/news/2517/serato-pressings-music-and-control-tone-on-limited-edition-records.

Serato. "Serato DJ with DVS Is Here." September 4, 2013. Accessed October 20, 2013. http://www.youtube.com/watch?v=Pm8OwXefnNw&feature=youtube_gdata_player.

"Serato's General Manager Talks Straight About NS7 and What It Means for DJs." *Dolphin Music*, March 25, 2009. Accessed May 22, 2010. http://www.dolphinmusic.co.uk/article/3430-interview-sam-gribben-of-serato.html.

Settle, Mark. "NAMM 2014: Thud Rumble TRX Scratch Mixer—Exclusive Pics!" *DJWORX*, January 14, 2014. Accessed January 20, 2014. http://djworx.com/namm-2014-thud-rumble-trx-scratch-mixer/#.U62Rw41dXtB.

Settle, Mark. "INDUSTRY: CEO Sam Gribben to leave Serato." *DJWORX*, January 23, 2014. Accessed January 28, 2014. http://djworx.com/industry-ceo-sam-gribben-leave-serato/.

Settle, Mark. "Musikmesse 2014: About that Pioneer Turntable Rumour...." *DJWORX*, March 12, 2014. Accessed March 12, 2014. http://djworx.com/musikmesse-2014-pioneer-turntable-rumour/#.U0hi_se9i8U.

Shusterman, Richard. "Challenging Conventions in the Fine Art of Rap." In *That's the Joint!: The Hip-Hop Studies Reader*. Edited by Murray Forman and Mark Anthony Neal, 459–479. New York: Routledge, 2004.

Singh, Ashish. *Cutting Through the Digital Fog: Music Industry's Rare Chance to Reposition for Greater Profit*. Boston: Bain & Company, 2001.

Slack, Jennifer Daryl. *Communication Technologies & Society: Conceptions of Causality & the Politics of Technological Intervention*. Norwood, NJ: ABLEX Publishing, 1984.

Smith, Sophie. "Compositional Strategies of the Hip-Hop Turntablist." *Organised Sound* 5 (2000): 75–79.

Snapper, Juliana. "Scratching the Surface: Spinning Time and Identity in Hip-Hop Turntablism." *European Journal of Cultural Studies* 7 (2004): 9–25.

Souvignier, Todd. *The World of DJs and the Turntable Culture*. Milwaukee, WI: Hal Leonard Corporation, 2003.

Spin. "Company." Accessed February 12, 2011. http://vestaxspin.com/vestax/.

Stanton Magnetics. "Stanton Legacy Products." Accessed December 22, 2010. http://www.stantondj.com/stanton-legacy-products.html.

steeldj69. "1995 Whirlwind Replicator First Digital Vinyl Ever." November 17, 2013. Accessed November 22, 2013. https://www.youtube.com/watch?v=GnK5SneOMoE.

Steffen, D.J. *From Edison to Marconi: The First Thirty Years of Recorded Music*. Jefferson, NC: McFarland & Company, 2005.

Sterling, Scott T. "Simon Cowell's 'Ultimate DJ' Competition TV Show Is Actually Happening." April 29, 2014. Accessed May 3, 2014. http://radio.com/2014/04/29/ultimate-dj-competition-tv-show-is-actually-happening/.

Sterne, Jonathan. *The Audible Past: Cultural Origins of Sound Reproduction*. Durham, NC: Duke University Press, 2003.

Straw, Will. "Consumption." In *The Cambridge Companion to Pop and Rock*. Edited by Simon Frith, Will Straw, and John Street, 53–73. Cambridge, UK: Cambridge University Press, 2001.

TGB Performance Information. "TGB Performance Report 2005/06." 2006. Accessed May 20, 2008. www.frst.govt.nz/files/TBG%20Performance%20Report.pdf.

"The 2014 Music Industry Census." *Music Trades*, April 2014. Accessed April 15, 2014. http://digitaleditions.sheridan.com/publication/?i=203399.

Théberge, Paul. *Any Sound You Can Imagine: Making Music/Consuming Technology*. Hanover, NH: Wesleyan University Press, 1997.

Thorne, Richard. "Serato Audio Research—TURN IT UP, software genius at work." *NZ Musician* 13 (2007). Accessed February 19, 2011. http://www.nzmusician.co.nz/index.php/pi_pageid/8/pi_articleid/1222/pi_page/1.

Thornton, Sarah. *Club Cultures: Music, Media, and Subcultural Capital*. Hanover, NH: University Press of New England, 1996.

Thornton, Sarah. "The Social Logic of Subcultural Capital." In *The Subcultures Reader*, 2nd edition Edited by Ken Gelder, 184–192. New York: Routledge, 2005.

thudrumble. "DJ Qbert DJ Qbert + Yogafrog + MC UB Discuss the Development of the PMC-05 Pro." August 3, 2011. Accessed August 5, 2011. https://www.youtube.com/watch?v=ehKkeKOKTxw.

TMZ Staff. "Paris Hilton, I'm One of the Top 5 DJ's in the World...Seriously." TMZ, December 26, 2013. Accessed April 28, 2014. http://www.tmz.com/2013/12/26/paris-hilton-top-5-highest-paid-dj-world/.

Toop, David. Rap Attack #3: African Rap to Global Hip Hop. London: Serpent's Tail, 2000.

Tremayne, Jim. "The Master Unplugged." DJ Times, March 2003. Accessed November 21, 2014.

Universal Music Group. "UMG AND SERATO ANNOUNCE INNOVATIVE SECURE DIGITAL DELIVERY SERVICE FOR DJs WORLDWIDE." November 4, 2009. Accessed May 22, 2010. http://www.universalmusic.com/corporate/news35701.

Vaidhyanathan, Siva. Copyrights and Copywrongs: The Rise of Intellectual Property and How It Threatens Creativity. New York: New York University Press, 2001.

Vestax Corporation. "Concept: Vestax Products." Accessed February 17, 2011. http://www.vestax.com/v/concept/v_products.php.

Vestax Corporation. "Concept: The Vestax People." Accessed February 10, 2011. http://www.vestax.com/v/concept/v_people.php.

Vestax Corporation. "Controller One." Accessed February 19, 2011. http://www.vestax.com/v/products/detail.php?cate_id=42&parent_id=7.

Wasko, Janet. "The Political Economy of Communications." In The Sage Handbook of Media Studies. Edited by John D. H. Downing, Denis McQuail, Philip Schlesinger, and Ellen A. Wartella, 309–329. London: Sage Publications, 2004.

Welch, Walter L., and Leah Brodbeck Stenzel Burt. From Tinfoil to Stereo: The Acoustic Years of the Recording Industry, 1877–1929. Gainesville, FL: University of Florida Press, 1994.

Werde, Bill. "The D.J.'s New Mix: Digital Files and a Turntable." New York Times, October 25, 2001. Accessed October 12, 2007. http://www.nytimes.com/2001/10/25/technology/the-dj-s-new-mix-digital-files-and-a-turntable.html.

White, Dan. "Pioneer DJ Sold for $551 Million; Pioneer to Focus on Car Audio." DJTechTools, September 16, 2014. Accessed December 3, 2014. http://www.djtechtools.com/2014/09/16/pioneer-dj-sold-for-551-million-pioneer-to-focus-on-car-audio/.

White, Miles. "The Phonograph Turntable and the Performance Practice in Hip Hop Music." EOL 2 (1996). Accessed May 17, 2007. http://www.research.umbc.edu/eol/2/white/.

White, Phil, and Luke Crisell, with Rob Principe. On the Record: The Scratch DJ Academy Guide. New York: St. Martin's Griffin, 2009.

Williams, Justin A. Rhymin' and Stealin': Musical Borrowing in Hip Hop. Anne Arbor: University of Michigan Press, 2013.

Williams, Raymond. Television: Technology and Cultural Form. New York: Schocken Books, 1974.

Wu, Tim. The Master Switch: The Rise and Fall of Information Empires. New York: Vintage Books, 2011.

Wurtzler, Steve J. Electric Sounds: Technological Change and the Rise of Corporate Mass Media. New York: Columbia University Press, 2007.

INDEX

5th Platoon DJ crew, 55, 67
7" vinyl singles, 4, 159
12" vinyl singles, 4, 22, 65, 139, 140, 144, 148, 157–65
 double LPs, 160
 invention of for DJs, 159
 lack of profitability from, 160
 See also 7" vinyl singles, vinyl records

A

Abajian, J., 139
Acquaviva, J., 74
Akai, 23
Aladdin Shuffle, 88
Alari, T., 85, 128, 129
The Allies, 127
American Engineering Society (AES), 55, 68
analog sampling, 3
Aoki, S., 167

The Arena Official Hip Hop Store, 110
Armstrong, N., 36, 130
Asphodel Records, 121
A-Trak, 58, 152
Audio Innovate, 92, 93, 109
Avid Technology, 70

B

Bambaataa, A., 3, 5, 6–7, 122
Baron and Breakout, 122
Bastian, M.-J., 69, 74
Bauer, C., 72, 73
B-Boy Summit, 112
b-boyin'/b-girlin', xviii
beat juggling, 86, 88, 89
Beat Junkies, 26, 82, 94, 127
beat-matching, xiii
Benjamin, W., 1
Berger, M., 123
Berklee College of Music, 14

Bertenshaw, A.J., 60
Big City Records, 17
Boggs, J., 69
Bolter, J.D., 140, 141
Boo, M., 15, 19, 102, 103, 105, 133, 136
Bourdieu, P., 12, 118
Boxx, J., 17
Bozak CMA-10-2DL rotary club mixer, 80
breakbeat, 86, 89
breakdancing, xviii
breaks, 4, 5, 6
Breaksploitation, xviii
Brick Records, 161, 163
Bullet Proof Scratch Hamsters crew, 98, 100
Bullet Proof Space Travelers, 98
Bum Rush Productions, 117

C

Carluccio, J., 133
Carroll, S., 70, 71, 73
Can't Stop Won't Stop, xix
CD turntables (CDJs), 24, 62, 142
celebrity DJs, xi, xii, 118, 152
Chang, J., xix, 1, 3, 6
Chrysalis, 157
clock theory, 8
Cohen, L., 112, 130
collective intelligence, 81, 131
common law trademark, 123
communication technologies, xiv
Comprehension, 11
controller systems, xiii, 24
convergency culture, 81, 131
copycat, 88
Copyright Criminals, 1
co-sign collective, 162
Cosmic "Strictly Skillz" Kev, 87
Cowell, S., xii
crab scratch, 86, 87
cue points, 8
cultural capital, 118
cultural production, 27

cut 'n' mix attitude, 3
Cutmaster Funk, 68
Cutmaster Swift, 88

D

Deadmau5, xi
Dee, S., 14, 15, 37, 77, 86, 87, 88, 89, 90,
 120, 133, 135, 143
Def Jam, 33
diggin', 144, 145, 146
digital DJ controllers, 24, 108, 118
digital marks, 8
digital sampling. See sampling
digital vinyl systems (DVS), 15, 16, 18, 19,
 38, 84, 108, 137
 advantages to DJs, 141–42, 164
 cultural negotiation of, 139–40
 as a disruptive innovation, 157
 early history of, 66–67, 67–69
 as halfway point between digital and
 analogue, 144
 patent disputes and, 69–75
 SSL and, 58
digitization, xviii
 digital vinyl systems and, 65–75
 shift from vinyl to digital, 140–49
Disco Twins, 168
Disco Wiz, 122
DJ Aladdin, 88
DJ Babu, 10–11, 13, 15, 17, 82, 86, 94, 130,
 131, 133, 139, 143
DJ Big Wiz, 55, 95, 96, 97
DJ Calibur, 171
DJ Cash Money, 86, 87
DJ Cheese, 80
DJ Clark Kent, 120
DJ Craze, 18, 35, 67, 127, 129, 130, 133,
 136, 148, 167
DJ Cue Two, xix
DJ culture
 derivative composition and, 2–3
 discos and, 2–4

sound systems and, 2–4
See also hip-hop DJ culture
DJ Daddy Dog, 12, 36, 144, 146, 148
DJ Eclipse, 17, 37, 139, 148, 154, 162, 163
DJ Emile, 112
DJ Excess, 102
DJ Focus, 56, 94, 98, 101, 106, 108, 127,
 130, 169
 childhood of, 109
 development of Focus Fader, 110–16
 early career, 109–10
DJ Go, 47, 48
DJ GQ, xix
DJ Hollywood, 122, 168
DJ in a box, xix, 149
DJ JayCeeOh, 17, 36, 133, 146, 152, 153
DJ Jazzy Jay, 5, 6, 32, 120
DJ Jazzy Jeff, 58, 86, 87, 127
DJ JS-1, 18, 129, 142, 143, 144, 154
DJ Kico, 15, 17, 129, 134, 146, 148, 153
DJ Kool Herc, 3, 5, 29, 86, 87, 89, 90, 122,
 168
DJ Mighty Mi, 152, 160
DJ Majesty, xix
DJ Marz, 128, 132, 145
DJ mixers. *See* mixers
DJ Nicoless, 18, 147, 151, 155, 161, 163
DJ PACO, 40
DJ Pauly D., xi, xii
DJ Platurn, 14, 142, 144, 147, 152
DJ product industry, 23–28
 as a cultural industry, 28
 digital DJ controllers and, 24
 disruptive innovations and, 108, 157
 hip-hop DJ culture and, 117–22, 122–27,
 127–30
 manufacturing statistics, 23–24
 perception of by DJs, 131–37
 sales statistics, 23–24
 Shure M44-7 and, 25–28
 subcultural capital and, 118, 127–30
DJ Quest, 12, 37, 98, 99, 100, 132, 134, 155
DJ Rhettmatic, 43, 44, 82
DJ Shame, 16, 17, 142

DJ Shiftee, 15, 16, 136, 150, 151
DJ Shortkut, 17, 25, 43, 44, 45, 46, 81, 82,
 90, 91, 128, 129, 143, 145
DJ Spooky, 117
DJ Steel, 68
DJ Supreme, 11
DJ technology, xii–xiii, 23–28
 digitization of, 38
 DJ in a box, xix, 149
 as a site for political struggle, 28
DJs
 ambivalence about DVS, 143
 authorship and, 119
 branding and, 169
 competitions and, xii
 disco, 79–80
 electonic dance music and, 170
 green, 170
 house and club, 80
 "graduating" to DVS, 147
 innovation among, 78, 167
 microwave, 149–56
 motivation for becoming, 152
 move to controllers, 62
 name-as-brand, 117–22
 as product, 126–27
 R&D and, 116, 137, 169
 record collections as part of identity, 17
 relationship with DJ product Industry,
 131–37
 salaries of, xi–xii
 sharing and collaborating, 77–78
 shift from vinyl to digital, 140–49
 subcultural capital and, 119, 137
 sync features and, 64
 taking requests, 154–55
 technological R&D and, 75
 See also celebrity DJs, hip hip DJs
DJ Trix, 40–42, 80, 127
DJ Wicked, 142
DJ Woody, 102, 103, 104, 133
DJDeals.com, 50
DJistory, 171
DJpedia Archive, 171

DJ-Tech, 114
DJWORX, 83
DMC (Disco Mixing Club), 33, 35
DMC Technics European DJ
 Championships, 40
DMC World DJ Championships, 43, 59
dog paddle, 8
Double Exposure, 159
Double J, 160, 162, 163
Dr. Butcher, 120, 135, 144, 155
D-Styles, 48, 91, 102
Dubspot, 136
DV One, 96

E

Eastern Conference (EC) Records, 160
EBSel, 83, 131
EBSel Pro X Fade, 109
e-diggin', 146, 147
electronic dance music (EDM), xii, 24
Elektra Records, 123
embodied cultural capital, 12
emcees, 9, 11
Endelman, M., 66
EROK, 96
exchange, xv

F

Fakher, S., 83, 131, 134
Farrugia, R., 141
Fat Beats Distribution, 139
Fat Beats Records, 139–40, 148, 159, 162
FinalScratch, 66, 68, 73, 74, 141, 148
FinalScratch Open, 69
Focus Fader, 108–16
Focus Fader V1.0, 112
Foundation Media, 160
Founding Fathers, 168
Freda, V., 63
Fretless Fader, 94, 105, 106–8

The Funk, 86, 87, 88, 90
Funky 4 + 1, 120
Furious Five, 122, 123

G

Garcia, B., 142
Gay, L.C., 28
Gemini, 27, 32, 109, 124
Gemini FF-1 FlashFormer, 124
Gemini MX-1100, 80
Gemini MX-2200, 80
Gemini PMX-2200 DJ Jazzy Jeff mixer, 120,
 168
Gemini Scratchmaster, 110
George, D., 63
George, N., 9
Gibbons, W., 4
GLi 3800, 80, 168
GLi 3880, 80
GLi PMX-9000, 80
GM Yoshi, 44
Grandmaster Flash, 5, 6, 7–8, 32, 57, 87,
 122–27, 133, 134
Grandmaster Melle Mel, 123
Grandmixer DXT, 5, 6
Grand Wizard Rasheen, 87
Grandwizzard Theodore, 5, 8, 86, 87, 88
Grant, R., 168
Grasso, F., 3, 4, 80
Gribben, S., 59, 60, 62, 63, 64, 65, 72
Groove Music, 10, 14, 87, 91, 141
Grusin, R., 140141
Guetta, D., xi, 167
Guitar Center, 21, 34

H

Hamster style scratching, 47, 98–100
Hamster switch, 94
hand movement, 12
Harris, C., xi

Harrison, A., 65
Havana Joe, 162
Haven Club, 4
Hawtin, R., 74
Hazzard, A., 47
Hebdige, D., 3
Herman, B.D., 119
Hilton, P., xi, xii, xiii, 118, 167
hip-hop. *See* hip-hop culture
hip-hop culture
 as an African American and Latino
 movement, 5
 as an anti-disco movement, 3
 borrowing aesthetic of, 6
 early history of, 5
 rap music and, 9
hip-hop DJ culture, xvii
 in the 1980s and 1990s, 10
 analog-to-digital culture of, 22
 authenticity and, 150
 collaborative aspects of, 78
 as a decentralized network, 78
 democracy of access due to digitization,
 150, 155
 DJ product industry and, 117–22,
 122–27, 127–30
 going back underground, 170
 as a "hand-me-down" culture, 13
 intellectual properties and, 2, 13
 as a new media culture, 1, 20, 77
 open source and, 20
 resistance to digital technology, 141
 subcultural capital and, 118
 technology and, 5–11
 text, technology, and, 2
 See also DJ culture
hip-hop DJs
 in the 1990s, xix
 affect of technology on, xiv
 ambivalence about DVS, 143
 analog, digital and, 65–66
 antagonism among, 78
 as archeologists, 1
 as archivist, 12

branding and endorsing
 products, 127
celebrity DJs and, xii
creative authorship among, 79, 116
definition of, xiii–xiv
digitization of DJ technologies, 65–66
early days of, xvii
hip-hop product industries and, 11–12
innovation and, xvi, 12, 167
as intellectual property, xvi, 9, 22, 75,
 77–79, 99
invention and, xvi–xvii
name-as-brand, 117–22
patenting techniques, 88
political economy of, xx, 108, 169
race and, xvi
receiving credit for innovations, 86–94
re-coding and, 16
record collections of, 17–19, 65, 144
research and development among, 79–86
shift from vinyl to digital, 140–49
technique and, 11–13
as technologist, 12

I

inMusic, 23
innoFADER, 92, 109
innovations, brand names and, 46
intellectual properties (IP) exchange, xv–
 xvi, 22, 40, 52, 169
 brand names and, 120, 122
 contestations and, 68
 Rane Corporation and, 56
 R&D and, 79–86
 technocultural synergism and, 74
 trademarks and, 90
International Turntablist Federation
 (ITF), 112
Intimidation DJ, 70
Invisibl Skratch Piklz (ISP), 26, 38, 43,
 127, 129
Ishibashi Music Corporation, 50

ITCH software, 61, 63

J

Jam Master Jay, 33, 80
Jamaican dub versioning, 4
Jamaican music, 3
Jamaican sound system, 87, 89
James, L., xi, 117
Jay-Z, 130
Jeffs, R., 55, 58, 126
Jenkins, H., 81
Jersey Shore, xi
Jive Records, 120
JohnBeez, 15, 105, 106, 107, 108, 144, 151
Johnny Cash, 120
Jones, P. DJ, 7, 168
J.Period, 143, 148, 150
Juice, xix, 33
Jurassic 5, 117

K

Katae, M., 47
Katz, M., 3, 10, 14, 87, 91, 140, 141
Kenwood, 29
KKR, 25
KOTORIMAG.COM, 67
Kutmasta Kurt, 143

L

La Rock, C., 6, 9
Lascelles, J., 157
Lessig, L., 1
Lightening Rich, 87
loose crossfaders, 12
Lysloff, R.T.A., 28

M

Macdonald, N., xviii
Making Beats, xix, 144
manipulation, xv
Marvel Entertainment, 121
Marx, E., 92, 93, 132, 133
Marz 1, 55, 95, 97
Master of the Mix, xii
Mato, D., 28
Matsushita Electric Industrial Co., Ltd., 29
M-Audio, 23, 69, 70, 73, 74
May, M., 53, 58, 83, 84, 93, 96, 125, 126, 128, 132
MC. *See* emcee
McDonald's, xii
McLeod, K., 9, 150
Melle Mel, 123
Melos PMX-2, 43, 98, 110
Meraz, R., 112
merry-go-round, 5
Meteor Light & Sound, Co., 80
microwave DJ, 149–56
Middlesex University, 72
Miller, P., 117
Mista Sinista, 120, 121
Mitsakos, B., 63
Mix Master Mike, 44, 47
mixers, 4, 24, 27, 38, 40
 ScratchAmp and, 67
 See also Vestax Corporation
mixing, 64
Miyakawa, F.M., 101
Miz, 87
Moment of Truth, 159
Moog, B., 21
Moulton, T., 4, 159
MP3, 66, 156, 162, 163
Mr. Len, 14, 36, 148
Ms. Pinky, 70, 73
MTV, 33
Musikmesse, 70
music market, current, 156–65
music product industry, 23

Music Trades, 23, 54
Musical Instruments for DJs (MIDJ), 50–51

N

N2IT Holding B.V., 67, 68, 69, 70, 73, 74
Nakama, T., 39, 43, 46, 47
National Association of Music Merchants
(NAMM), 26, 43, 57, 58, 70
Native Instruments, 27, 58, 67, 68, 69, 73,
74, 82, 136
Needles, J., 26
Ned Hoddings, 102, 104
network, xvii
new media culture, 1, 140
New Slaves Routine, 167
New York Times, 66
NoiseMap, 60, 63
Nu Sounds crew, 168
Numark, 34, 43, 49, 68, 118, 122
Numark DM-500, 80
Numark DM-1150A, 38, 80
Nu-Mark, 12, 14, 18, 23, 27, 36, 37, 82,
117, 118, 122, 142, 144, 145

O

Ono, C., 39, 42, 44, 45, 48, 93, 101, 102,
128, 132
open sharing, 77
open source, xvii
open source logic, xv
The Original Jazzy Jay, 120
Original Spinbad, 87, 120

P

PACO, 40
Panasonic Corporation, 21, 29–38
P&D deal, 160
Papa D., 161, 162, 163

Parker, P., 55, 95, 97
participatory culture, 81
patent protection, 31, 73
Pauly D., 167
Phase Linear Corporation, 54
phone dial theory, 8
Pioneer, 25, 27, 66
Pioneer CDJ-500, 66
Pioneer CDJ-1000, 66
Pioneer DJM-900SRT, 64
Pioneer PLX-1000, 36
Pioneer Pro DJ, 25
Pitch 'n Time, 60
Pitt, B., xi
portastudios, 40
Poschardt, U., 3, 5
Potsic, M., 117
Prime Cuts of the Scratch Perverts, 47
Pro X Fade crossfader, 83
punch phrase, 8
Pyramid PR-4700, 99

Q

Qbert, 12, 16, 26, 43, 44, 47, 49, 50, 86, 87,
91, 100, 111, 127, 128, 129, 142
Quest, 160, 161, 163
quick mix theory, 7–8

R

Rane Corporation, xx, 23, 49, 52, 53–54,
54–59, 82, 83, 84, 93, 108, 109, 111,
112, 132
corporate goals of, 55
as current industry standard, 59
description of manufacturing process,
54–55
DMC and, 59
early history of, 54
Grandmaster Flash and, 125
Hamster switches and, 99

partnership with Serato Audio
 Research, 57–59
patent on crossfader, 56
product users as mentors, 128
production of first DJ products, 55–56
sales statistics, 54
Rane Empath mixer, 57, 125, 126, 130
Rane Grandmaster Flash Gold Signature
 Edition Empath, 126
Rane Sixty-Four, 64
Rane TTM 52 mixer, 56
Rane TTM 54 mixer, 54, 55–56, 94, 95-97
Rane TTM 56 mixer, 56, 126
Rane X3000A crossover
rap music, 9
Rawkus Records, 160
read-only culture, 1
read-write practices, 9
#REALDJING, 167
Red Bull, xii, 136
Remediation: Understanding New Media, 140
Replicator, 68, 70
Rhymesayers Entertainment, 161, 163
Rhymin' and Stealin', 13
Richards, S., 36, 89, 143, 145
Rickli, A., 70, 71
rights, xv, 22
Roc Raida, 120
Roli Rho, 36, 84–85, 94, 130, 147
Rose, T., 3
Rosie, 80
Rosner, A., 4, 80
rub, 8
Rucker, R., 13, 16, 48, 49, 101, 102, 104
Run-D.M.C., 33
Russell, J., 71
Russell, W., 109
RZA, 67–68, 70, 71

Schloss, J., xix, 10, 144, 145
Scion, 136
Scratch Studio Edition, 72
ScratchAmp, 67
ScratchAmp 2, 69
scratching, 8–9, 12, 86, 142
Scratchphone, 85, 128, 129
Schauberger, V., 109
Sean C., 120
Self, T., 74
Serato Audio Research, xx, 52, 60–65, 82,
 83, 108
 "creative partnerships" and, 61
 digital distribution of music, 62
 discontinuation of support for SSL,
 63–64
 early history of, 60
 endorsements by sponsored DJs, 61
 licensing of intellectual properties, 65
 listening to consumers, 83–84
 open source and, 65
 partnership with Rane Corporation,
 57–59
 sales statistics for, 60–61
 Web forums and, 61
Serato DJ 1.5, 63, 64
Serato DJ Intro, 63
Serato Pressings, 63
Serato Scratch Live (SSL) digital DJ
 software, 12, 52, 53, 57, 58, 59, 65, 84,
 137, 140, 143, 144, 147, 148
 commercial release of, 60
 as a disruptive innovation, 108, 157
 DVS and, 58
 ITCH software and, 61
 remediating vinyl records, 164
 RZA and, 67–68
 software upgrades and, 64
Serato Whitelabel Delivery Network, 62–63
SFX Entertainment, xii
Sheppard, G., 54
Shiino, H., 39, 40, 132
Shiino Musical Instruments Corporation
 (SMIC), 40

S

Salsoul Records, 159
sampling, 10

Shiino Vesta FIRE Corporation, 40
Shure Inc., 25, 26, 27, 82
Skratchworx, 74, 83
slip-cueing, 4
slipmats, 8
Smirnoff, xii
SMPTE timecode, 73
soft switch, 110
Sony Music Entertainment, 62–63
SoundScan, 157
Spacedeck, 73
SPECTRE Entertainment Group, 162
Spose, xix
standardization, 25–28, 51, 75
Standing, D., 125, 126
Stanton 500AL, 25, 130
Stanton 520 SK, 129
Stanton Magnetics, 27, 34, 67, 69, 109, 112, 129
Stanton SA-8 Focus Signature Mixer, 113, 114
Stanton SA-12 DJ Craze Signature Mixer, 113, 129, 130
Stanton SK-2F, 112
Stones Throw Records, 162
stopper plates, 110
Straw, W., 141
Studio Scratch Edition, 57
subcultural capitalism, 118, 119, 127–30
Sugar Hill Records, 122, 123
Sugarcuts, 55, 95, 96, 97, 151
Sugarhill Gang, 9
Supermen DJ Crew, 120
Supreme La Rock, 96
Swedish House Mafia, xi
Swift, R., 14, 83, 120, 121, 148
Swift, T., 117
Swiss, T., 141
symptomatic technologies, xiv
sync, 64

T

Takada, 44
Tat Money, 87
Technics, xx, 22, 27, 29–38
Technics 1200 turntables, 12, 21–22, 27, 29–38, 140
 competition and, 32
 death of, 34, 35–38, 170
 as the DJ standard, 32
 early innovations, 31
 as icon of hip-hop culture, 32, 36
 as industry standard, 33
 lack of later innovation, 32
 patent for, 30–32
 profit margins on, 32–35
 visual media and, 33
Technics World DJ Mixing Championships, 34
technocultural synergism, xv, xvi, xx, 12, 22, 78, 79, 169
 branding and, 120–21
 DJ products industry and, 28
 intellectual properties and, 74
 Rane Corporation and, 56
 standardization and, 75
 Vestax Corporation and, 43, 48, 52
technology, xiv
 hip-hop DJ culture and, 5–11
 as a network, 28
 technique and, 11–13
Teeko, 16, 101, 103, 104, 144
Tesla, N., 109
Théberge, P., 27
Thorens, 29
Thornton, S., 118, 119
Thud Rumble, 26, 49, 129
Thud Rumble TRX Professional DJ Mixer, 114
Tiësto, xi
timecode technology, 69
T-Mobile, xii
Toadstyle, 102
toasting, 3

Tools of Destruction, 110
Torq Conectiv Vinyl/CD, 69, 70
Tosh, D., 167
Total Eclipse, 120
trademarks, 90, 123
Traffic Entertainment Group, 161
Traktor, 58
Traktor FinalScratch, 67
Traktor Scratch Pro DVS, 67, 68, 69, 82
transform scratch technique, 86, 87, 124
Transmissions Radio, 101
Trilogy Records, 160
Turntable TV 4, 26
Turntable Wizardry Stage 1, 11
turntables
 belt-driven, 31
 CD turntables (CDJs), 24
 death of, 36
 as a mean of production, 3
 as musical instruments, 13–15, 101
 notational systems and, 101
 vinyl records and, 13–20
turntablism, 10, 14, 48, 59, 86, 121
Turntablist Compositions, 110
Turntablist Disk, 11, 14, 16, 94,
 134, 142
DJ Disk, 82
twiddle scratch, 87

U

UGHH.com, xix, 160, 163
Ultimate DJ, xii
Universal Music Group (UMG), 62–63
University of Auckland, 71

V

Vernon, D.J., 168
versioning, 3
Vestax Controller One (C1), 48, 94, 100–5

Vestax Corporation, xx, 22, 27, 38–52, 80,
 91, 92, 93, 106, 109, 111
 early days of, 40
 Hamster switches and, 99
 hip-hop culture and, 132
 International Product Meeting and, 51
 listening to DJs, 40–46, 82, 83
 Musical Instruments for DJs (MIDJ),
 50–51
 rumors of closing, 51
 sale statistics, 39
 support of music industry, 39–40
 third-party distributors, 39
Vestax Grey 05Pro, 100
Vestax PDX-2000, 48
Vestax PDX-3000mk2, 107
Vestax PMC-05Pro, 12, 27, 38–39, 81, 90,
 91, 111
 battle mixer, 42
 as industry standard, 39, 44
Vestax PMC-05Pro LTD, 98
Vestax PMC-05 TRIX, 42, 80, 127
Vestax PMC-06Pro, 98, 107
Vestax PMC-07Pro, 46–48
Vestax QFO Qbert Signature Pro Turntable,
 48, 49–50
Vestax to the Core, 51
Vestax World Finals, 102, 103
Vinroc, 38, 82–83
vinyl records, 13–20, 65, 140, 143–44,
 148, 156
 back catalog titles and, 157
 collectors' market for, 157
 current sales statistics, 156
 "death" of, 161, 170
 distribution of, 160–63
 environmental issues with, 170
 historic sales statistics, 158–59
 manufacturing statistics, 156–57
 overseas markets for, 163
 See also 7" vinyl singles, 12" vinyl singles
voltage controlled amplifier (VCA), 111

W

Walder, A., 160
Wardle, S., 73
Webber, S., 14
Weber, J., 162
West, K., 167
West, S., 60, 71, 73
Whirlwind Replicator, 68, 71
Whitelabel.net, 62–63
Williams, R., xiv, 3, 6, 13
Wu Electronics, 68
Wu, T., 108
Wu-Tang Clan, 67

X

X-ecutioners, 26, 120, 121, 122
X-Men, 120, 121
X-Pressions, 121

Y

Yo! MTV Raps, 33
Yogafrog, 26, 129

Z

Z-Pabon, C., 135
Z-Trip, 127, 152
Zulu Nation, 7, 120

Toby Miller
General Editor

Popular Culture and Everyday Life (PC&EL) is the new space for critical books in cultural studies. The series innovates by stressing multiple theoretical, political, and methodological approaches to commodity culture and lived experience, borrowing from sociological, anthropological, and textual disciplines. Each PC&EL volume develops a critical understanding of a key topic in the area through a combination of a thorough literature review, original research, and a student-reader orientation. The series includes three types of books: single-authored monographs, readers of existing classic essays, and new companion volumes of papers on central topics. Likely fields covered are: fashion; sport; shopping; therapy; religion; food and drink; youth; music; cultural policy; popular literature; performance; education; queer theory; race; gender; class.

For additional information about this series or for the submission of manuscripts, please contact:

Toby Miller
Department of Media & Cultural Studies
Interdisciplinary Studies Building
University of California, Riverside
Riverside, CA 92521

To order other books in this series, please contact our Customer Service Department:

(800) 770-LANG (within the U.S.)
(212) 647-7706 (outside the U.S.)
(212) 647-7707 FAX

Or browse online by series: www.peterlang.com